EMERALD CITIES

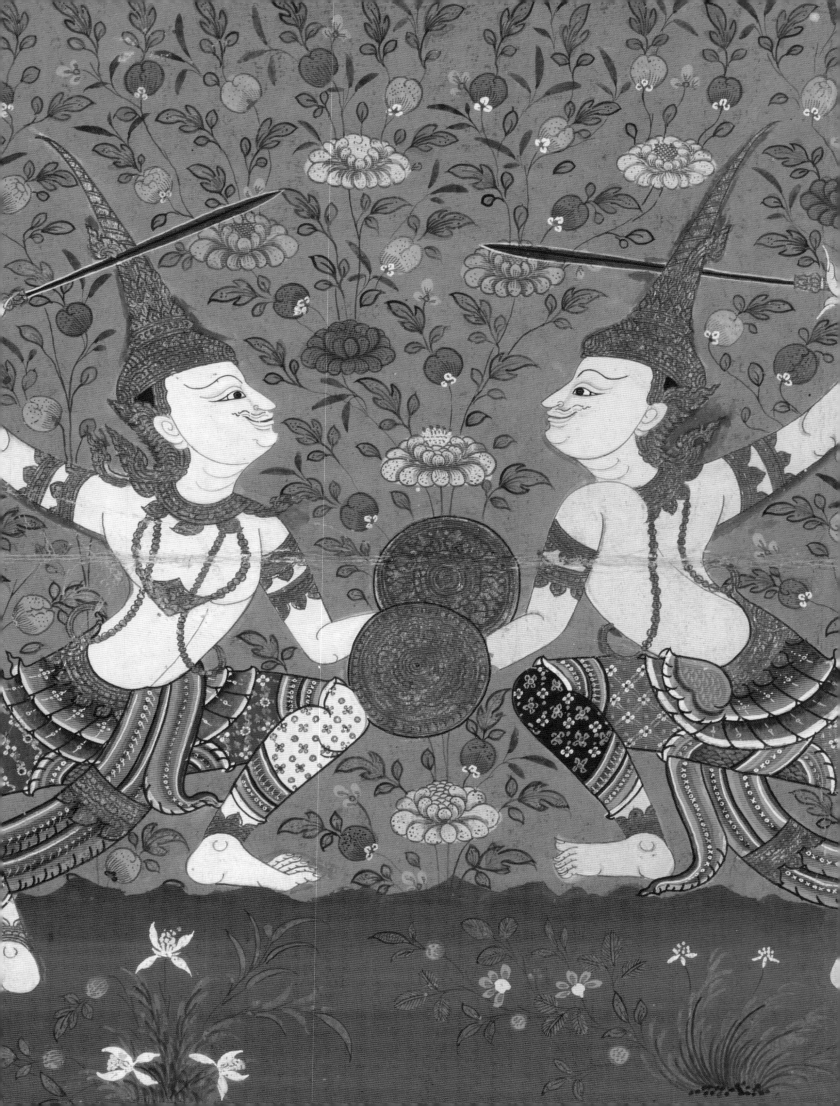

EMERALD CITIES

CITIES ARTS OF SIAM AND BURMA, 1775–1950

Forrest McGill EDITOR

Forrest McGill and M. L. Pattaratorn Chirapravati
EXHIBITION CO-CURATORS

ADDITIONAL CONTRIBUTION BY Peter Skilling

PHOTOGRAPHY BY Kazuhiro Tsuruta

Asian Art Museum
Chong-Moon Lee Center
for Asian Art and Culture

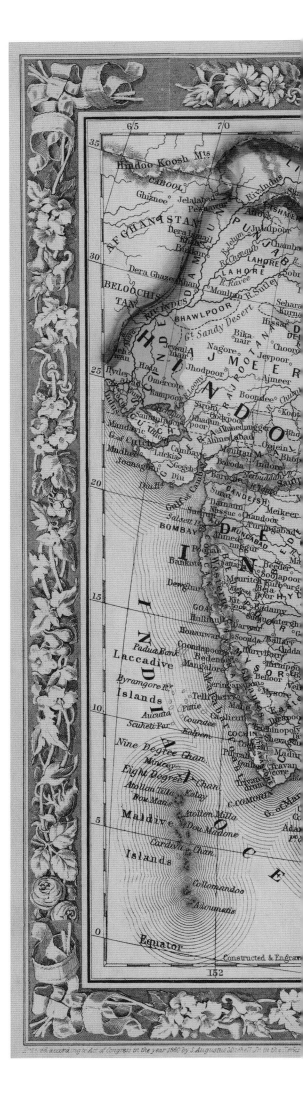

All photographs are by Kazuhiro Tsuruta except as noted below.

Figs. 1, 9, p. 99 bottom left: © British Library Board; figs. 3, 14, 20, p. 199 bottom left and right: Forrest McGill; figs. 8, 10, 11, 63, 64: From Michael Symes, *An Account of an Embassy to the Kingdom of Ava in the Year 1795;* fig. 19: National Anthropological Archives, Smithsonian Institution (INV 04858700); fig. 21: Courtesy of the Library of Congress; fig. 25: From *Wat Bovoranives Vihara;* figs. 35, 38: From Karl Döhring, *Siam.* Der Indische Kulturkreis in Einzeldarstellungen 1; figs. 36, 43, 44: From Henri Mouhot, *Travels in Siam, Cambodia, and Laos, 1858–1860;* fig. 42: M. L. Pattaratorn Chirapravati; p. 89 bottom right: Henry Newton Lowry, courtesy of the photographer's family; p. 99 bottom right: Philip Adolphe Klier, from a postcard dated 1906; p. 199 top: From *Sinlapa satthapattayakam thai nai phramerumat*

ISBN: 978-0-939117-50-5 (cloth)
978-0-939117-51-2 (paper)

The Asian Art Museum–Chong-Moon Lee Center for Asian Art and Culture is a public institution whose mission is to lead a diverse global audience in discovering the unique material, aesthetic, and intellectual achievements of Asian art and culture.

Published on the occasion of the exhibition *Emerald Cities: Arts of Siam and Burma, 1775–1950,* organized by the Asian Art Museum–Chong-Moon Lee Center for Asian Art and Culture. The exhibition was presented in San Francisco at the Asian Art Museum from October 23, 2009, through January 10, 2010.

Presentation at the Asian Art Museum was made possible by the Doris Duke Foundation, the Koret Foundation, Carmen M. Christensen, United Airlines, and the Connoisseurs' Council, with additional support from the James H. W. Thompson Foundation and Dr. and Mrs. David P. Buchanan.

The museum gratefully acknowledges the underwriting of the catalogue by the Society for Asian Art and members of the museum's Avery Brundage Circle: Betty and Bruce Alberts; Fred M. Levin and Nancy Livingston, the Shenson Foundation; Douglas A. Tilden; Rajnikant and Helen Desai; Jess and Jo Anne Erickson; Mary and Bill S. Kim; Alexandra and Dennis Lenehan; Doris Shoong Lee and Theodore Bo Lee; Stephen Sherwin and Merrill Randol Sherwin; Lucretia and John Sias; Judy Wilbur; and Mrs. Diane B. Wilsey; with additional support from Mary Jo Spencer and Carolyn J. Young.

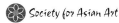

Front cover: Cat. no. 113.
Back cover: Detail, cat. no. 19.
Title page: Detail, cat. no. 104.
Page vi: Detail, cat. no. 52.
Page 74: Detail, cat. no. 25.
Page 102: Detail, cat. no. 41.
Page 118: Detail, cat. no. 119.

1 3 5 7 9 8 6 4 2
First Printing

MAP OF
HINDOOSTAN,
FARTHER INDIA,
CHINA,
AND
TIBET.

SCALE OF MILES.
0 50 100 200 300 400 500

Longitude East 162 from Washington 167

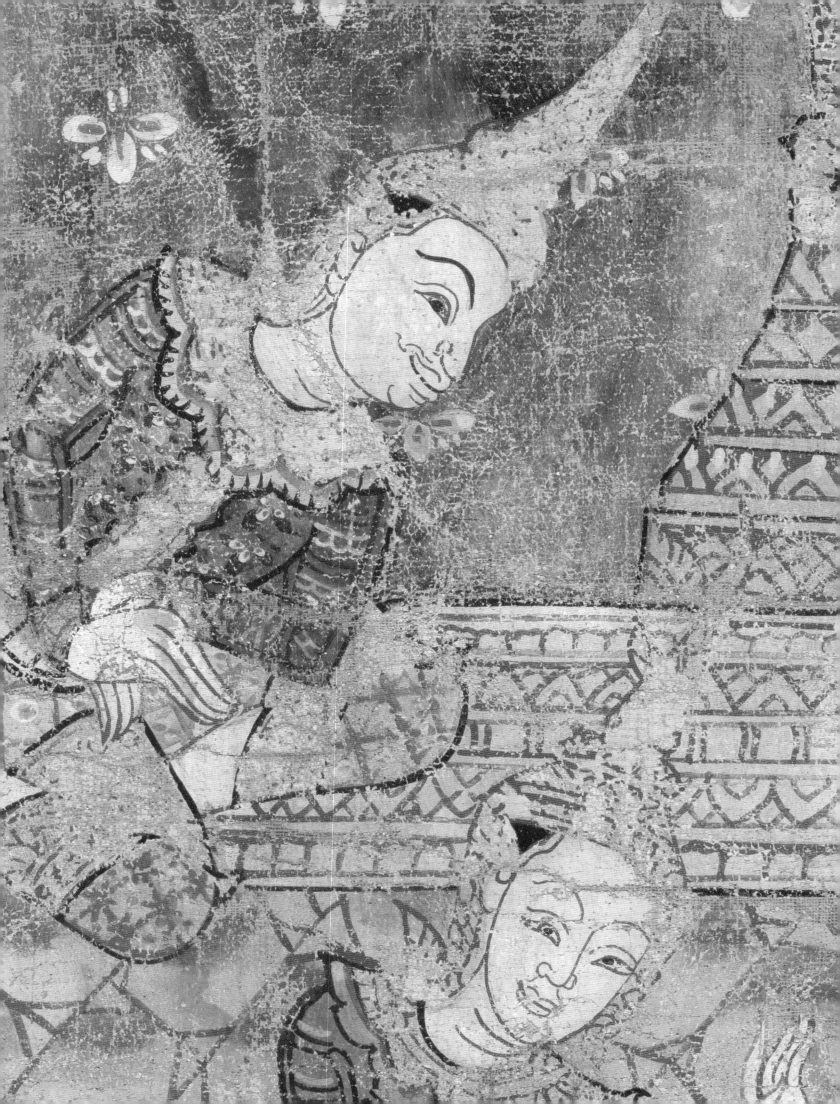

CONTENTS

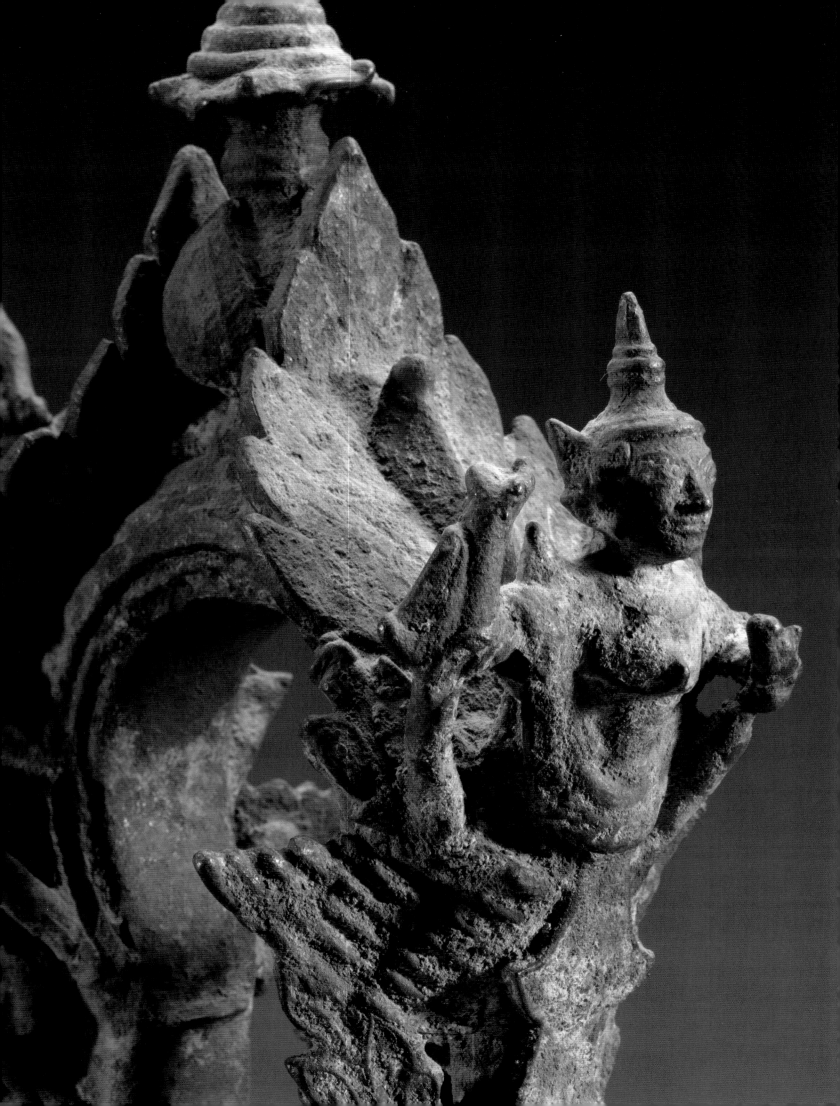

DIRECTOR'S PREFACE

Jay Xu

Many of the Asian Art Museum's special exhibitions feature artworks from the world's major museums, from Manila to Amsterdam. Sometimes, though, as with the 2006 *Hidden Meanings in Chinese Art,* we take the opportunity to delve into the riches in our own storerooms.

The artworks in *Emerald Cities* are drawn entirely from the museum's own collection. Surveying the arts of two important countries through more than a century, the exhibition necessarily shows some traditions in depth and others only superficially, and some traditions, such as village arts and arts in international techniques and styles, can hardly be represented at all. Still, it is remarkable that the first large-scale exhibition in the West to focus on Siam and Burma in the nineteenth century can emerge from our museum's vaults.

That this is possible is due to the foresight and generosity above all of the Doris Duke Charitable Foundation. The museum's founding collector, Avery Brundage, acquired and donated a number of fine Burmese and Siamese artworks, and other collectors and donors whose names are honored in the credit lines of the artworks included in this publication have also been generous. But the core of the nineteenth-century Burmese and Siamese collection comes from the donation of nearly two hundred artworks by the Duke Foundation, and the Duke Collection is the source of 70 percent of the artworks in this exhibition and publication.

Doris Duke was a bold collector, putting together large and interesting collections in areas—Islamic art, and the arts of Thailand, Burma, and to a lesser extent Cambodia— that must have seemed to her peers a bit eccentric. Some of the objects she acquired were not of great quality or rarity, but others, such as cat. nos. 36, 51, 52, 55, 67, 104, and 113, were of considerable importance. Duke's intentions and procedures in putting together her Southeast Asian collection are described in *Doris Duke: The Southeast Asian Art Collection* by Dr. Nancy Tingley, former curator of Southeast Asian art at the Asian Art Museum. That book illustrates many significant objects eventually donated by the Duke Foundation to the Walters Art Museum in Baltimore and other museums, including the Asian Art Museum.

It was our late board chair Jack Bogart who initially learned of Doris Duke's collection of Southeast Asian art and alerted Forrest McGill. Then Jack continued, over several years, to encourage the Duke Foundation to consider the Asian Art Museum seriously as a home for the Duke Collection. He would have been pleased to see this exhibition and publication come about, and he will be in our memories as the exhibition opens.

We are also indebted to the Duke Foundation for funds to support the complex and painstaking conservation of the collection, and for the preparations for this exhibition; early support for the conservation of some of these objects was generously provided by the Institute of Museum and Library Services. Other important funding has come from

the Koret Foundation, Carmen M. Christensen, the James H. W. Thompson Foundation, Dr. and Mrs. David P. Buchanan, and the Society for Asian Art. We also gratefully acknowledge the underwriting of the catalogue by the Society for Asian Art and members of the museum's Avery Brundage Circle —Betty and Bruce Alberts; Fred M. Levin and Nancy Livingston, the Shenson Foundation; Douglas A. Tilden; Rajnikant and Helen Desai; Jess and Jo Anne Erickson; Mary and Bill S. Kim; Alexandra and Dennis Lenehan; Doris Shoong Lee and Theodore Bo Lee; Stephen Sherwin and Merrill Randol Sherwin; Lucretia and John Sias; Judy Wilbur; and Mrs. Diane B. Wilsey—with additional support from Mary Jo Spencer and Carolyn J. Young. We are most grateful to the museum's acquisitions support group Connoisseurs' Council for redirecting their gifts to support the extensive conservation required by several of the works in the collection. Additional support was given by United Airlines, ABC7, and *San Francisco* magazine.

Such an exhibition has long been a goal of Dr. Forrest McGill, the museum's chief curator and Wattis curator of South and Southeast Asian art. Dr. McGill scrupulously oversaw every detail of the exhibition's preparation, from scholarly research through issues of conservation and restoration, through considerations of layout and display, and on to photography of the objects, by museum photographer Kaz Tsuruta, and the preparation of this catalogue. He was brilliantly assisted by his co-curator, M. L. Pattaratorn Chirapravati, who brought a rare sensitivity to the region's cultural nuances as part of her deep understanding of the subject. We are also grateful to Peter Skilling for his invaluable contribution to this catalogue, and we appreciate his permitting us to publish it in an edited and shortened version.

Nearly all the museum's staff is involved in preparing a large exhibition such as this, and it is impossible to name all those whose work was vital. Special recognition, however, goes to staff conservators Katherine Holbrow, Mark Fenn, Setsuko Kawazu, and Shiho Sasaki, and contract conservators Annie Hall, Rowan Geiger, Tonja Morris, and Shelley Smith, and curatorial intern Marie Stewart.

Some of the many others whose work on this exhibition has been invaluable include assistant to the chief curator Skye Alexander; Tom Christensen and his colleagues in the Publications department; Deborah Clearwaters, Ana Hortillosa, and volunteer Tisha Carper-Long in the Education department; Pauline Fong-Martinez and the staff in Visitor Services; Robin Groesbeck and her Museum Services team; Tim Hallman and his colleagues in Public Relations and Marketing; Cristina Lichauco and her colleagues in Registration; exhibition designer Stephen Penkowsky; Brent Powell and the museum preparators; Amory Sharpe and the Development department team; museum librarian John Stucky and the library volunteers; photographer Kaz Tsuruta and Aino Tolme and Jessica Kuhn in Photo Services; and many more. I would also like to thank Christine Taylor, Tag Savage, Melody Lacina, and the others at Wilsted & Taylor for their care and attention to detail in creating this beautiful book.

The Asian Art Museum has had a long-standing commitment to the arts of Southeast Asia, manifested most recently in the 2005 exhibition and publication *The Kingdom of Siam: The Art of Central Thailand, 1350–1800*. May the current exhibition and catalogue also have lasting value in contributing both to scholarship and to public appreciation of the rich and varied artistic traditions of Southeast Asia.

(*facing*) Detail, cat. no. 23.

INTRODUCTION

Forrest McGill

Thailand and Burma, neighboring countries that are approximately the same size in area and population, have many cultural features in common (Theravada Buddhism above all) but have traditionally been adversaries. Burma conquered the primary Thai kingdom of Ayutthaya in 1767, but within a few decades both countries' fortunes began to reverse. Burma lost a series of wars with the British and was eventually overcome and reduced to a colony. Thailand—then Siam—recovered and became more powerful than ever and, though it faced enormous pressure from both the British and the French, was able to maintain a large degree of its independence.

The nineteenth century saw a brilliant efflorescence of all the arts in Thailand, under the patronage of both the aristocracy and wealthy merchant families. Burma's arts flourished similarly in the earlier part of the century, but patronage was disrupted by increasing British encroachment, the eventual fall of the monarchy, and annexation by Britain in 1886.

As was true all over Asia, the arts of Siam and Burma in the second half of the nineteenth century began to be affected by Western styles and attitudes, the development of tourism and mass communication, and new technologies such as photography and power machinery.

The Asian Art Museum houses a large and important collection of Burmese, Siamese, and Shan/northern Thai art objects from the period of about 1780 to 1950. Most of these were donated from the Doris Duke Charitable Foundation's Southeast Asian Art Collection, though other donors also have been generous. We have been eager for the opportunity to display and publish these fascinating objects, and to begin to place them in historical and cultural context.

A number of challenges, both practical and theoretical, presented themselves, and these in fact plague the entire study of Siamese and Burmese art.

The practical challenges concern issues of presentation. Burmese and Siamese artworks in our collection, like those in temples in Southeast Asia and in museums and private collections around the world, are often poorly preserved. Buddha images have had their surfaces reworked; wooden furniture and ceremonial objects have been broken, abraded, or undermined by insects; paintings, when the ceremonies for which they were made were over, have been piled in corners and allowed to crumple and mildew. Our conservators have worked tirelessly to stabilize the art objects here and have cleaned them and replaced broken bits when appropriate, but, as will be seen, parts of objects and paintings are sometimes irretrievably lost, and inscriptions, which might have told us a great deal, obliterated.

The theoretical and methodological challenges are numerous and complex:

- The museum's collection was assembled over many decades and is not systematic or comprehensive.

- The collection, like those of most art museums, emphasizes arts by or for the elites of the cities and is weak in the arts of the village. Also underrepresented are objects in hybrid styles; collectors of the past—certainly the museum's founding collector, Avery Brundage—often preferred what they saw as pure and typical over what was mixed.

- The terminology the world conventionally uses is problematic. We have treated "Burma" and "Burmese," "Siam" and "Siamese" as though they refer to stable, clearly defined entities, but we do so only to avoid repeating long circumlocutions. The boundaries of both countries (and of the Chiang Mai realm and various Shan states) fluctuated greatly, and no booths with agents checking passports existed at the frontiers. The "ethnic" makeup of the populations was very mixed, and complicated by language, religion, and customs. Someone who spoke a central Thai dialect without an accent and dressed like most people in central Siam was probably thought to be "Siamese" whether the person's ancestors had come from Guangdong, Laos, the Mon lands of southern Burma, or, in the instance of one influential family, Persia.

- The dating of the objects in the collection, and of all those of their type and general period, can be extremely difficult.

 - Burmese and Siamese artworks seldom bore dates or other inscribed

The Asian Art Museum's collection includes a number of additional artworks from Thailand and Burma in the period of this exhibition—some of them of major importance—that have not been included in the exhibition because they are on long-term display in the museum's galleries or because of their fragile condition. Images of almost all of these, and more information, can be found in the online database of the museum's collection at www.asianart.org under *Art,* then *Collection,* then *Search the Collection.*

information that would help in placing them in the 1830s, say, rather than the 1860s.

- Historical documentation relating to specific objects either was absent from the beginning or has been lost.
- Artists' names were hardly ever recorded.
- The design and methods of fabrication of some sorts of art objects such as ritual vessels, shadow puppets, and weapons seem to have changed only slowly.
- For more than a century, art objects have been made in "traditional" or neo-traditional styles for both tourists and local customers. The "invention of tradition" and the manipulation of notions of the traditional for reasons of politics, commerce, and identity continue to the present day.[1]

- Both my colleague Dr. Pattaratorn and I are far more familiar with central Thailand than with northern Thailand, the Shan states, and Burma. Northern Thailand and the Shan states in particular have gotten short shrift, hardly being mentioned, for example, in my essay. This lack has nothing to do with our assessment of the importance of the material; it reflects only the thinness of our knowledge.

This book is intended for the general museum-going audience, but we hope it may also offer something of interest to scholars. On subjects such as the special qualities of Buddhism in nineteenth-century Siam and Burma; the workings of aristocratic and monastic patronage; nineteenth-century representations of the epic of Rama or of the tale of the miraculous monk Phra Malai; and changes to conceptions of the Buddha as reflected in the arts,[2] we hope we have offered new insights.

Interested readers should not overlook the catalogue entries, thinking that they may be mainly descriptive. Often these entries include information and discussions that are quite pertinent to the larger matters the exhibition tries to illuminate. The art objects are primary texts; trying to understand who made them and when, how, and for what purposes is essential.

There is one notion more than any other that we hope to dispel: that the culture of nineteenth-century Burma and Siam was unchanging, suspended somehow in timeless tradition. Though different sorts of changes took place at different rates in different places and among different social groups, nothing was static. As an example, compare cat. no. 84 with cat. no. 71. They represent the same scene of the same story, but they show a transformation in ways of envisioning and representing such a scene that is hard to imagine having occurred over just a couple of generations.

NOTES

1 See, for example, Andrew Alan Johnson's 2008 comments in "Re-possessing Lanna." On the "invention of tradition," see Peleggi, *Lords of Things,* 7, referring to a 1983 book edited by Eric Hobsbawm and Terence Ranger.

2 See Nidhi's article "The Life of the Buddha and the Religious Movement of the Early Bangkok Period," reprinted in *Pen and Sail,* 256–288.

EMERALD CITIES

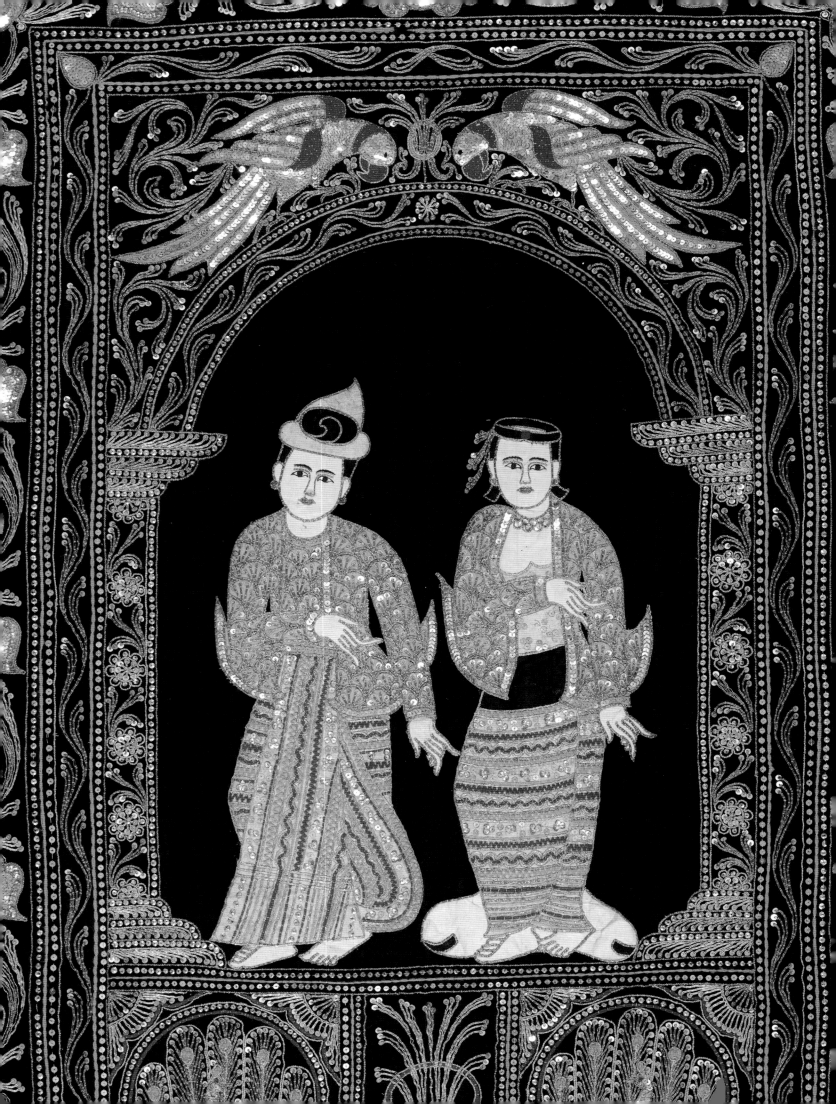

THE CULTURE OF BURMA AND SIAM IN THE NINETEENTH CENTURY

Forrest McGill

On December 3, 1885, Londoners read in the *Times* the usual jumble of the sublime and the ridiculous: disturbances in Nepal, a deficit in the U.S. Post Office Department of $8,381,571, the ongoing struggle of the French to impose control on northern Vietnam, preparations for the funeral of the king of Spain, and the puzzlement of Parisian authorities at rescuing a boy who said he had been thrown into the river by a "circus man."

The editors summed up a story the paper had been following for a month, of the last days of Burma's monarchy (and of its independence):

> The latest of our little wars has been brought by General Prendergast to a speedy and fortunate termination. King Theebaw, with his wives and his suite, is in British Burmah, the forts on the Irrawaddy are disarmed, Mandalay is held by a British garrison, and the Burmese army appears to have given up its rifles.... The Burmese people have offered no resistance, Burmese officials are just as pleased to go under the authority of the Viceroy of India as under that of Theebaw, and the only danger apprehended is that want of government of any kind may lead to general robbery and disorder.[1]

While the British indeed faced "disorder," in the form of strong guerrilla resistance, for years, "robbery" ensued only for a day or two as the royal palace and other parts of the city were looted. Questions flew as to how far the British were involved, either by commission or by omission.[2] But in the palace, at least, a new sort of order was soon established (fig. 1). Some parts became a genteel British club, about which V. C. Scott O'Connor later recorded his mixed feelings: "It seems a desecration of a palace to put it to

such uses, yet for my own part I can only say that some of the happiest days of my life have been passed here." The audience hall of the palace was turned into a church.[3]

Thus the Burmese were defeated in the Third Anglo-Burmese War. After the first, in 1824, they were forced to give up important coastal areas over which they had claimed control. After the second, in 1852, they lost what was called Lower Burma, the agriculturally rich and commercially critical areas around Rangoon, Pegu, and the delta of the Irrawaddy River. Rangoon now became the center of government as well as of trade; Mandalay was seen more and more as the center of culture and memory.

During their eight years in power Thibaw and his court had continued the ancient tradition of royal patronage of the arts, especially in the service of Buddhism. The king oversaw an extended campaign to move and remodel into a monastery the palatial apartment in which his father, King Mindon, had lived and died. (This was possible because in Burma many temple buildings and most pal-

ace buildings were built of wood and could—with considerable trouble—be dismantled and moved.) The queen too founded a lavish temple, finished just shortly before the British invasion.

The fall of the monarchy and the concomitant scrambling of power and status relationships brought about huge changes in patronage and the demand for various sorts of art objects and luxury goods. Former courtiers no longer needed special garments, regalia, and accoutrements for ceremonial occasions at the palace. Not only did they not order new ones, but, it is said, some sold the ones they had. The artisans who made such finery, as well as palace musicians, dancers, and puppet-masters, would have to find new patrons and accommodate their needs and tastes. Sumptuary laws had tightly restricted who could wear or use what; now it was just a question of who could afford what. In Lower Burma, ruled by the British since 1852, wealthy Indian, Chinese, Armenian, and English merchants were already important customers. Now they would loom larger in the clientele

Maps by Thomas Christensen

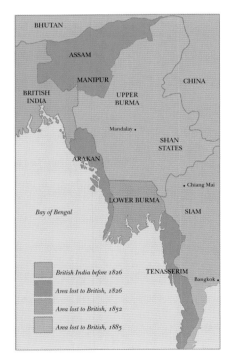

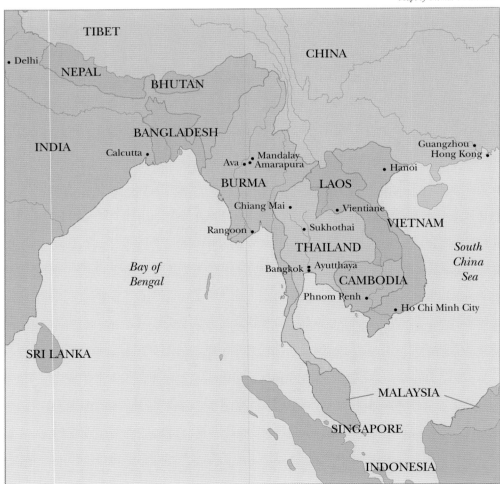

(*above*) Territories lost by Burma to the British, 1826–1885.

(*right*) Southeast Asia in its modern context.

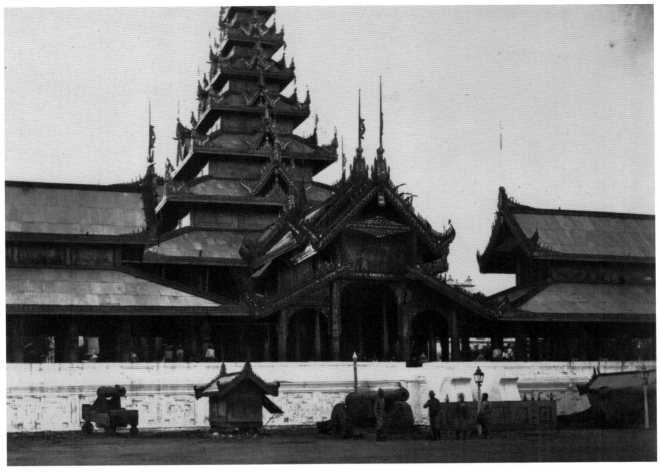

of artists and artisans in Upper Burma too. In an indication of future developments, by the late 1880s curio shops catering to foreigners and filling overseas orders were opening in both Rangoon and Mandalay.[4]

By the time of the formal annexation of Upper Burma at the beginning of 1886 only one Southeast Asian country was left not subjected to European colonial domination—Siam, though it was under pressure from the British in Burma and Malaya and the French in Cambodia and Laos. A number of factors weighed in Siam's favor. Neither Britain nor France wanted the other to gain control; Siam, though forced to sign over some of its tributaries to the Europeans, had not lost an important central section, including its major port, as Burma had. Also, though other Southeast Asian states, including Burma, had had some vigorous, realistic rulers who made valiant efforts against European encroachments, Siam had a succession of effective kings. Though the Siamese royal succession was not free from controversy, the bloody succession disputes that periodically wracked the Burmese court were avoided.[5]

In fact, 1885 had seen an important change related to the succession as the thirty-two-year old Rama V (a.k.a. Chulalongkorn, who had already been on the throne, if not at first in full authority, for seventeen years) abolished the sometimes-powerful post of "deputy king." Earlier Siamese kings had not designated their own heir. The "deputy king," often older and more established than the king himself, and having a palace and armed force of his own, was understood to be a likely successor. The present deputy king had lost out in court machinations some years before and had had his powers systematically reduced, so that when he died in 1885 Rama V took the opportunity to do away with the deputy kingship and establish the position of crown prince. In doing so he consolidated his own power while displaying his commitment to reform and modernity.

"Displaying" is a critical term. Like American spin doctors and ambitious and skillful

Periods in the Later History of Burma and Siam

BURMA

KONBAUNG DYNASTY 1752–1885

SIAM

AYUTTHAYA	1351–1767
THONBURI	1767–1782
BANGKOK (RATTANAKOSIN)	1782–PRESENT

Reigns of Kings of Burma and Siam in the Later 18th and 19th Centuries

BURMA

HSINBYUSHIN 1763–1776

SINGU 1776–1781

BODAWPAYA 1781–1819

BAGYIDAW 1819–1837

THARRAWADDY 1837–1846

PAGAN 1846–1853

MINDON 1853–1878

THIBAW 1878–1885

BRITISH COLONIAL REGIME BEGINS 1886

SIAM

TAKSIN 1767–1782

RAMA I (PHRA PHUTTHAYOTFA CHULALOK) 1782–1809

RAMA II (PHRA PHUTTHALOETLA NAPHALAI) 1809–1824

RAMA III (PHRA NANGKLAO) 1824–1851

RAMA IV (COMMONLY KNOWN IN THE WEST AS MONGKUT) 1851–1868

RAMA V (COMMONLY KNOWN IN THE WEST AS CHULALONGKORN) 1868–1910

RAMA VI (COMMONLY KNOWN IN THE WEST AS VAJIRAVUDH) 1910–1925

End of Thonburi period, beginning of Bangkok period

1800

1850

1900

rulers everywhere, Southeast Asian kings had since ancient times manipulated symbols and gestures to create impressions to further their purposes. For kings of Burma or Siam in the eighteenth century the primary audiences for their political theatrics were the elites of their capitals, their general populations, and the kings and peoples of neighboring realms. In the nineteenth and twentieth centuries, though, the theater expanded, and getting the message across to Europeans and Americans assumed new importance. If Westerners were going to suggest that Southeast Asians were benighted and would gain from being colonized and civilized, then both real self-advancement and effective self-presentation would be needed.

By this time the king, his family, and his courtiers frequently wore Western garments or a combination of Western and Siamese, a practice that had been going on for years (see fig. 36). In architecture, Western elements had been being adapted since the seventeenth century (and perhaps earlier, if fortifications are taken into account), but by 1885 the king had sponsored a Buddhist temple in good Victorian Gothic Revival style and had hired

a British architect to design a major new hall for the Grand Palace complex.[6]

While objects imported from the West or made locally in purely Western styles are not represented in the exhibition, the show does include objects in which the adaptation of Western styles or techniques can be seen. One painting, though it reflects no obvious interest in Western styles, is painted on fabric mounted on a Western-type stretcher (cat. no. 70); others have a Western-style continuous ground plane extending back into the distance and show experimentation with Western linear and atmospheric perspective (fig. 2 [cat. no. 77]; cat. nos. 71–83). An ornate table has a basically Western shape but Thai-style surface decoration of gilded low-relief carving inlaid with pieces of mirrored glass (cat. no. 128).

Bangkok's Grand Palace complex, which includes the hall designed by a British architect mentioned earlier as well as other Western-style buildings, was begun in the 1780s shortly after the establishment of the present dynasty (fig. 3).

The 1780s and 1790s

FIG. 2 Jujaka asks a hermit where Vessantara is staying, a scene from the story of Prince Vessantara (cat. no. 77).

FIG. 3 Dusit Maha Prasat Throne Hall, Grand Palace, Bangkok, First Reign (1782–1809).

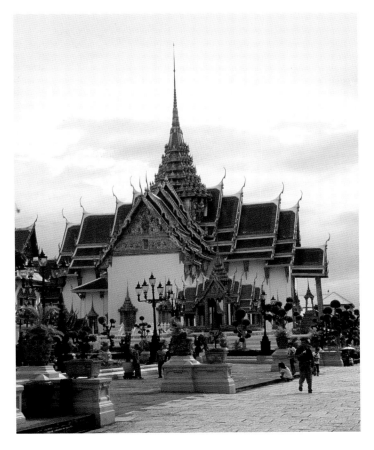

In 1767 the city of Ayutthaya, which had been the capital of Siam for more than four hundred years, had fallen to a Burmese invasion. Not only were the capital and countryside devastated, but thousands of people were killed and thousands more—including nobles, intellectuals, artists, and artisans—were captured and taken back to Burma. Eventually a common-born military leader became king and began to restore order, setting up a new capital in Thonburi, across the river from today's Bangkok. Though progress was made during his reign in reconstituting the kingdom and recovering commercial prosperity, resistance developed. Whether this was primarily because of the king's unorthodox religious beliefs, his alleged insanity, or his displacing of aristocrats connected to the old Ayutthaya elite is still a matter of debate.[7] In any event, he was deposed and executed. The new king, later called Rama I, moved the capital to Bangkok and began construction of important buildings for both the palace and the royal temple, in which was enshrined the legendary Emerald Buddha (fig. 4), which Rama I, when he was still a general, had captured and brought back from Laos.[8] The long formal name given to the new capital celebrated it as the seat of the Emerald Buddha, Indra's jewel.[9]

These buildings survive, affording us a sense of the style of the 1780s. They seem to have been intended to evoke the old capital of Ayutthaya and no doubt did so in a general way. However, systematic comparison that would help in understanding how much stylistic change had occurred since the 1750s and 1760s has not yet been undertaken and is hampered by the obliteration of much of Ayutthaya's architecture.

Rama I's buildings continued to be influential for many decades, and indeed many of the subjects and forms that would preoccupy Siamese artists throughout the nineteenth century can be traced to his reign (1782–1809). This is not to say they were invented then; but aristocratic patrons, monks, writers, and artists in the late eighteenth century seem to have had an interest in recovering, compiling, and recreating—and then possibly surpassing—the cultural and artistic heritage

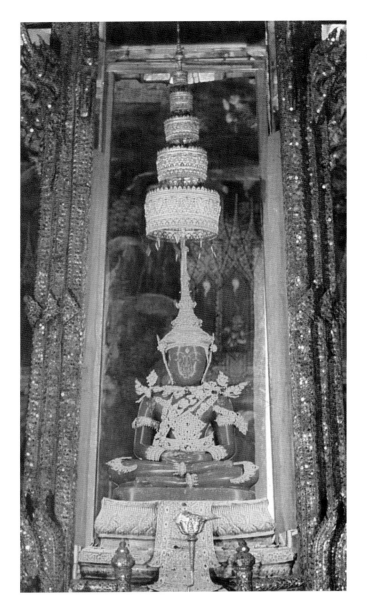

FIG. 4 The Emerald Buddha.

of Siam's earlier centuries. An example can be seen in fig. 5 (cat. no. 45). Between 1793 and 1801 the king sponsored the rebuilding of an old temple near the palace into what became one of the city's most important: Wat Phra Chettuphon, popularly called Wat Pho. More than a thousand Buddha images were collected from Ayutthaya and other old cities such as Sukhothai and Lopburi and set up at Wat Phra Chettuphon (fig. 6). The dynastic chronicles report that artisans were asked to repair these images and "re-beautify them."[10] This re-beautification sometimes involved covering them with a thick layer of stucco; cat. no. 45 is the face from one such covering, formerly belonging to one of the Buddha images brought from Ayutthaya.

The chronicles also describe at length a

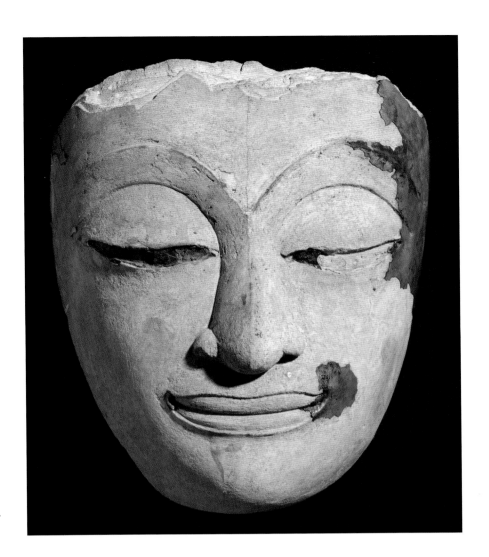

FIG. 5 Head of a Buddha image (cat. no. 45).

great many royal and religious ceremonies carried out during the First Reign, and this emphasis on elaborate public rituals has been highlighted by historians as an important feature of the period.[11] For occasions such as investitures, the coming-of-age of princes and princesses, and royal funerals, elaborate platforms representing the central mountain of the cosmos were constructed, courtiers enacted the roles of gods and celestials, episodes from the epic of Rama and Hindu myths were staged, and lively spectacles from dancing to acrobatics entertained the public for days on end. (Fig. 7 [cat. no. 113] and cat. no. 112 may have been part of the decorations for a royal ceremony.) After the devastation of the old capital and the ensuing disruptions of cultural life, how could such state ceremonies be recreated properly? The chronicles tell us: "The established patterns of conducting the ceremony of shaving the topknot for royalty of *chaofa* rank that had been followed in the Ayutthaya Era

had already been explained by [a surviving daughter of one of the last Ayutthaya kings] at the time of the ceremony of shaving the topknot for the late heir apparent's three children.... This already constituted a guideline to follow."[12]

FIG. 6 Buddha images, Wat Phra Chettuphon (Wat Pho), Bangkok.

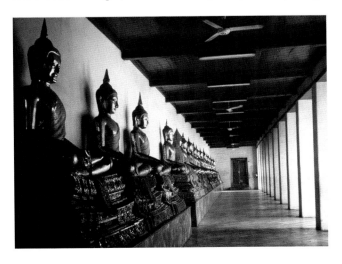

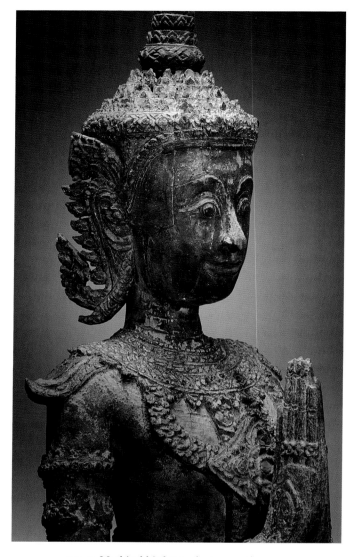

The period of Rama I also saw a thorough revision of the Buddhist canonical texts; a royally sponsored recitation of the story of the Buddha's most important previous life and the ritual donations to accompany it (compare cat. nos. 71–83 and others); an early stage in the popularity of artistic depictions of the legend of the monk Phra Malai (later examples of which are cat. nos. 93–95); the composition of the best-known Thai version of the epic of Rama, the Rammakian (cat. nos. 104 and 105); and the creation of a superb set of murals illustrating the life of the Buddha, which, unlike some other murals of the period, have come down to us in relatively good condition (compare cat. nos. 51 and 52).[13]

While enough monuments and artworks of the 1780s and 1790s survive in Thailand, and can be identified, to allow us to begin to form a picture of the arts of those decades, the same is not true in Burma. The reasons are several. First, the fall of the monarchy and the nobility after the British conquest disrupted not only high-level patronage but also maintenance, especially of palaces and mansions. Second, whereas most palace and temple buildings in Siam were constructed largely of brick, most of those in Burma were of timber, and specially vulnerable to destruction by decay and fire.[14] Records speak over and over of buildings (and their contents) disappearing in flames. Third, kings of Burma moved their capitals with what seems amazing frequency: four times in the kingdom's last century. Previous capitals were largely abandoned and allowed to fall into ruin. The British emissary Michael Symes, sent to the Burmese court in 1795, notes in relation to the transfer of the capital from Ava to Amarapura twelve years previously that "buildings in the Birman country are composed for the most part of wood, and water carriage being here convenient, the old town was speedily demolished, and the present capital rose from its materials" (fig. 8). On visiting the site of the former capital, he continued, "Numerous temples, on which the Birmans never lay sacrilegious hands, were dilapidating by time. It is impossible to draw a more striking picture of desolation and ruin."[15]

King Bodawpaya, who had moved the capital, and whom Symes met, was an aggressive warrior, conquering the neighboring kingdom of Arakan in 1785 and invading Siam, unsuccessfully, in the same year. An important prize from the subjugation of Arakan was a renowned Buddha image, the palladium of the kingdom, which Bodawpaya transported to Amarapura and built a temple to house.[16] Symes judged the temple "magnificent," but unfortunately it caught fire a hundred years later and was subsequently replaced, and so it tells us little of the architecture of the 1780s and 1790s. Another of Bodawpaya's major temples begun in these decades survives in part, the so-called Mingun Pagoda (fig. 9). It is a mesa of brick that was probably intended to support a megalomaniacal tower, but even after twenty years' work it was left unfinished at the king's death.[17] Later damaged in an

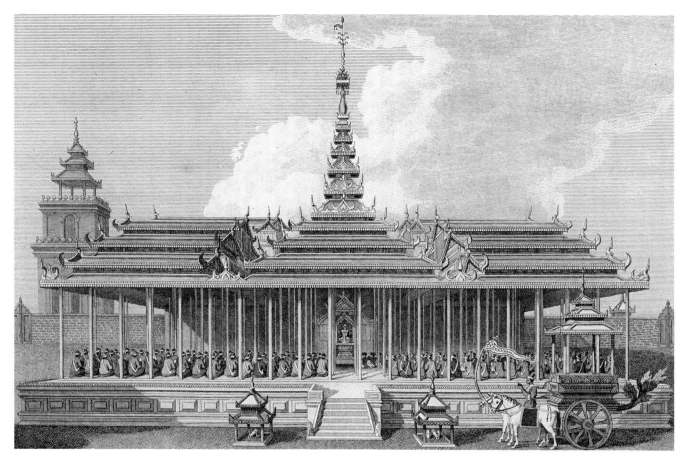

FIG. 8 "View of the Imperial Court at Ummerapoora [Amarapura], and the Ceremony of Introduction," from Symes, *An Account of an Embassy to the Kingdom of Ava in the Year 1795.*

FIG. 9 *Mengoon [Mingun] Pagoda from North West,* by Linnaeus Tripe, 1855.

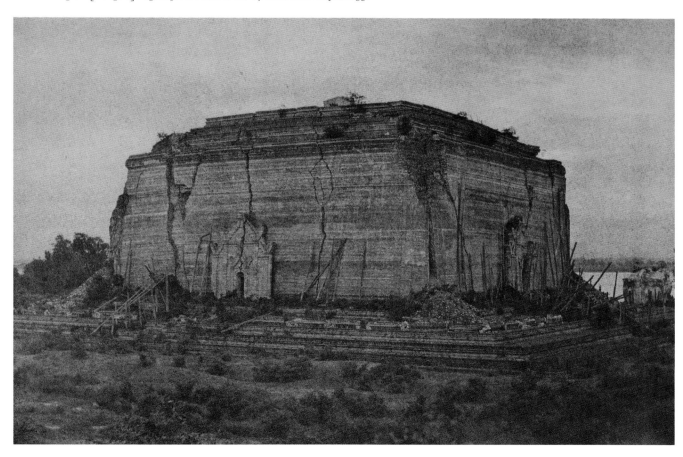

earthquake, it too is not much help in understanding the arts of the period.

Symes himself provides a few tantalizing bits of pertinent information. He mentions the beautiful marble quarried near Amarapura and the large numbers of Buddha images made from it. Major images must have been commissioned specifically, but the ones Symes saw, ranging in scale from a little over life-sized to much smaller, were, Symes tells us, carved first and then sold, their price dependent on their dimensions. Today such marble images are ubiquitous and seem to have been in production continuously since before Symes's visit. Symes twice adds observations that prefigure debates now raging: the sculptors were "extremely civil and communicative" but "would not part with their sacred commodity, I was told, to any except

FIG. 10 "Image of the Birman Gaudma in a Temple at Ummerapoora [Amarapura]," from Symes, *An Account of an Embassy to the Kingdom of Ava in the Year 1795*.

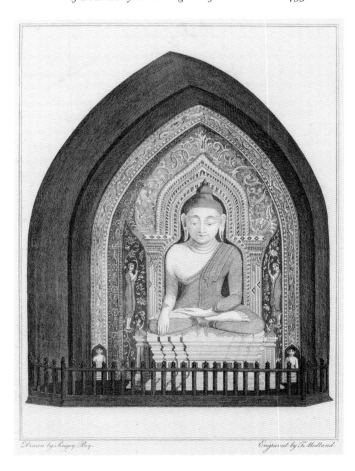

Birmans." "Exportation of their gods out of the kingdom is strictly forbidden."[18]

Symes's attention is also caught by the variety of foreign products imported to Burma: silk, velvet, ivory, gold leaf—all of which would have been used in creating art objects and luxury goods—and china and European glassware, the shapes and designs of which must have been of interest to local artists. The king himself liked glassware and made clear to Symes that he wanted the technical information to allow the beginning of glass manufacture in his own realm.[19] Clearly, however, even though glass was not produced locally, the Burmese taste (shared with the Siamese) for decorating architecture and furnishings with mosaic or inlay of colored mirror had already developed (later examples include cat. no. 28 and many others); Symes mentions temple walls "adorned with bits of different coloured mirrors, disposed with much taste."[20]

Symes had with him a Bengali artist to document—in those days before photography—the flora, fauna, costumes, architecture, and curiosities of Burma. Some of these illustrations were printed in Symes's book and provide rare glimpses of temple and palace buildings and even a Buddha image at Amarapura. They are sad reminders of what has been lost.

Drawings by Symes's artist caught the attention of King Bodawpaya. Then "the king was pleased to desire a specimen of his skill, and sent over a painting on glass, executed by a Siamese artist in his own service, signifying his royal will that it should be copied upon paper." The result pleased the king, and he asked that a famous Buddha image be drawn. When the task was completed a week later the king "condescended to express his approbation."[21]

This episode provides food for thought on how artistic ideas might move, mix, and change. A patron sees a work in an unfamiliar style and is intrigued. He sets the foreign artist tasks, first of copying, then of observation and depiction. Did he then show the foreign works to his own artists as inspiration? And what of the Siamese painter already in Bodawpaya's service? Presumably he was

among the artists and artisans captured in the Burmese conquest of Siam twenty-eight years earlier. But was this painter really "Siamese"? The work presented for copying was on glass. Painting on glass was a Chinese specialty, as hundreds of eighteenth-century China-trade depictions of sailing ships and exotic land-scapes made for the homes of merchants in London and Boston attest. Plenty of Chinese immigrant, or Chinese-Siamese, artisans lived in eighteenth-century Siam (and more were to come, as will be seen); perhaps this painter was among them.[22]

This scenario of artistic interaction is in fact even more complicated. Symes's "Bengal draftsmen" (were there more than one?) later met with "a brother artist in a Siamese painter, who was employed by the court." This is prob-ably the same Siamese painter mentioned earlier. Symes finds the man to be "of much utility; he furnished me with several drawings

descriptive of the costume of the country, which, though executed with little taste, were finished with the most perfect fidelity."[23] He also supplies Symes with drawings of a Bur-mese royal barge. So a "Siamese" artist who may be "Chinese," employed by the Burmese court, is interacting with a Bengali artist and producing drawings of Burmese subjects for a British patron. Hybridity is the name of the game.

Yet another aspect of these episodes is worth noticing. The painting on glass by the Siamese artist that the king sent for copy-ing "represented the mode of catching wild elephants in the forests" (fig. 11). The range of subjects of Siamese and Burmese painting and related arts had always been narrow: the lives of the Buddha, other specifically Bud-dhist stories and themes, occasionally the leg-ends of Rama, and not much more. Within this range artists might have opportunities to

FIG. 11 "Method of Catching Wild Elephants in Ava," from Symes, *An Account of an Embassy to the Kingdom of Ava in the Year 1795.*

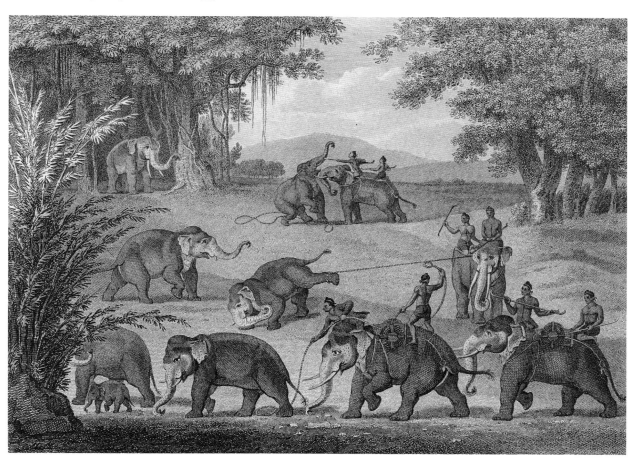

depict landscapes, battles, ships at sea, and the clothes-washing or flirting of daily life, but these were subordinated to the pious or heroic main subjects, not independent. There were no portraits in the usual sense, no representations of historical events, no Mill by a River, and no catching wild elephants—at least not as a stand-alone painting.[24] The broadening of subjects and formats demanded of artists, or for which they could find support, in Burma and Siam is largely a phenomenon of the decades after 1850 but is here foreshadowed.

The 1830s
Siam in the 1830s was secure and prosperous. The threat of invasion by the Burmese had receded, and the defeat of Burma in the First Anglo-Burmese War (1824–1826) further reduced the sense of Burmese might in Siamese eyes (while pointing to new threats, from the British, on the horizon).[25]

Trade continued to expand, above all with China. Already in 1822 the British envoy John Crawfurd had noted the arrival in Bangkok of some 140 Chinese junks carrying dishes, tea, silk, foods, and—most important in the long run—thousands of Chinese workers.[26] Considerable numbers of Siamese junks also participated in the China trade. Siamese exports included rice, sugar, tin, dyestuffs, and junks themselves, as Bangkok had a thriving ship-

building industry; the value of such exports to China exceeded the value of imports.[27]

The importance to Siam of trade with China, and the continuing arrival of Chinese workers, substantial numbers of whom settled down and created new lives, can hardly be overstressed. This trade and immigration had notable effects on the arts. Chinese ceramics, both everyday crockery and luxury wares, were pervasive in daily life, many having been created to appeal to Siamese tastes (for example, fig. 12 [cat. no. 135] and cat. nos. 132 and 133). Chinese figures turn up frequently in paintings (fig. 13 [cat. no. 59]), and Chinese architectural features can be seen in real buildings and in the buildings represented in paintings (cat. no. 91). The Chinese elements in furniture (cat. nos. 48 and 96) are a reminder of the importance of Chinese artisans in Siam, and indeed it is likely that a significant number of artists and craftsworkers were Chinese or part Chinese. (This is not to suggest, of course, that artists of any ethnicity could not make use of Chinese motifs, subjects, or styles.)

Familiarity with, and interest in, things Western was also increasing during this period.[28] The first Westerners and Western products had come to Siam in the sixteenth century, and, as mentioned earlier, there had been a fad for occidentalia already in the 1680s, at the time of an exchange of embassies with the court of Louis XIV.[29] Thus it is not surprising that Crawfurd, visiting the home of a Siamese official in 1822, found that "the window-curtains consisted of a handsome English chintz" and "the room was lighted by a pair of good cut-glass English chandeliers." As usual, however, the questions of where things were actually made, and by whom, and with what culture they would have been associated by viewers, are complicated. On the walls of a building in Wat Phra Chettuphon in Bangkok, Crawfurd reported seeing apparently French and English prints such as "the portrait of an English lady—'la pensive Anglaise!'" but pointed out that these were Chinese copies of such prints.[30]

Portentous new technologies and skills began to be developed in this period. For example, in 1836 the first Thai-language print-

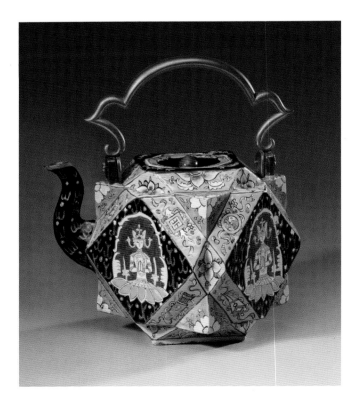

FIG. 12 Teapot (cat. no. 135).

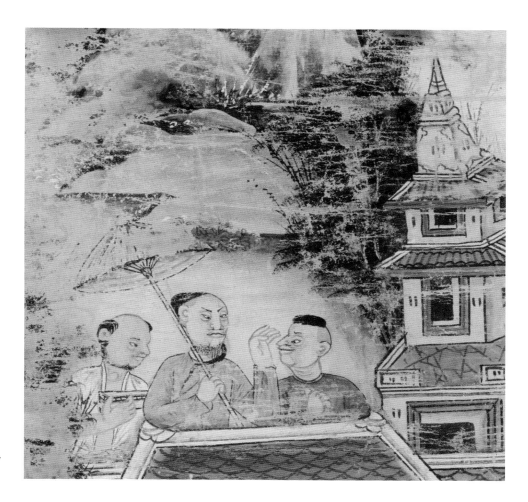

ing press in Siam was set up by missionaries,[31] and though printing in Thai did not become common for decades, for a culture previously reliant entirely on the hand-copying of books and documents, the introduction, however far in advance of widespread use, seems unusually important. When written materials existed in only a few laboriously made copies, it was possible, as happened in the destruction of Ayutthaya, for vast amounts of knowledge to disappear forever.

The 1830s saw the building or restoration of many temples and the (often related) creation of huge numbers of artworks of all kinds.[32] One of the major projects of the decade was the restoration and enrichment of Wat Phra Chettuphon (Wat Pho), the temple complex in the vicinity of the royal palace, the construction of which under Rama I has already been mentioned. The temple had grown shabby, and Rama III took the opportunity not only to repair it but also to remodel it in the style of the day.[33] The role of this temple

as a repository of traditional knowledge was also reinforced and broadened. New paintings, inscriptions, and sculptures were made to embody such lore as the role of massage and exercises in healing (figs. 14 and 15 [cat. no. 98]). A famous series of marble reliefs depicting the legend of Rama was emplaced, and though it is not certain whether the reliefs were made in the 1830s or earlier (and reused), their location on the ordination hall of such an important Buddhist temple emphasized the importance of the Rama stories and of Rama and other characters as models (fig. 16). (The use of depictions of the Rama legend in Buddhist religious contexts may seem incongruous, but it was in fact common [cat. no. 48] and had been so for centuries.[34])

Several of the artworks included here may have been produced in the 1830s—for example, cat. nos. 51 and 52—but the arts of the period have not received the systematic study necessary for attributions to be made with confidence.

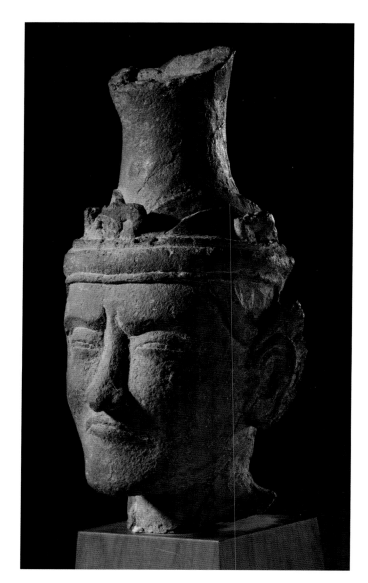

FIG. 14 Figures of hermits demonstrating cures for ailments, Wat Phra Chettuphon (Wat Pho), Bangkok.

FIG. 15 Head of a hermit (cat. no. 98).

The situation in Burma in the 1830s could hardly seem more different from the orderliness and productivity of Siam. The king who had come to the throne in 1819 had had to face, within a few years, war with the British. The superiority of British armaments was overpowering, and the Burmese suffered a stunning defeat. The king moved the capital back to Ava, but no sense of renewal appears to have resulted. Very few major monuments came forth in the 1830s,[35] and it is easy to

FIG. 16 Rubbing of a relief at Wat Phra Chettuphon (Wat Pho), Bangkok, depicting the monkey hero Hanuman finding the demon king Ravana sleeping with a woman whom Hanuman thinks is the heroine Sita, a scene from the Thai version of the epic of Rama.

FIG. 17 (facing) Serpent king (cat. no. 7).

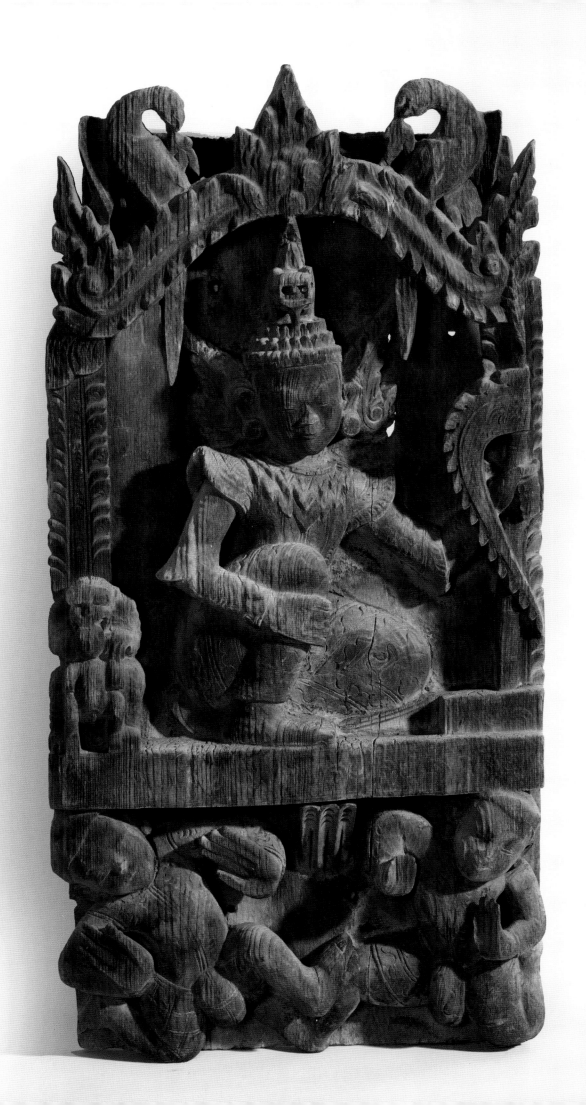

imagine that amid the diplomatic maneuvering, regional conflicts, and dynastic struggles, all topped by the king's increasing mental illness, artists and architects had little work.

The 1850s

...the proper site is Mandalay where the ground level is even and the water in the surrounding channels runs clockwise. Such a place is rare and it is certainly a Jeyabhumi—Land of Victory. In all the old records there are prophecies that "by 2400 [1856 CE] Mandalay would grow into a big city...where a Tuesday born king would start a dynasty that would last for many generations."...Start building it in 1856 and complete the constructions in 1859.... A new capital city and a new palace would bring prosperity to both the Religion and the Kingdom.

Thus the Royal Orders of Burma of January 13, 1857, proclaim the intention, yet again, to move the capital.[36] The fabled Mandalay—"Filled with Jewels," according to its formal name—was born. It is younger than many cities in California.

Making the new capital a Land of Victory must indeed have been on everyone's mind. Less than five years earlier the Burmese had lost yet another war with the British and had been faced with the British conquest and summary annexation into British India of Lower Burma, the area around Pegu and Rangoon. The Burmese kingdom was now cut off from the sea, its maritime trade and communications subject to British oversight.

During the fighting with the British a Burmese prince rebelled against the conservative and ineffectual king and court then in power. He won over important factions and was able, early in 1853, to depose the old king and take the throne.

King Mindon earned greater respect both from the Burmese people and from foreigners than any king in memory. He sought accommodation with the British and instituted or encouraged wide-ranging reforms in government and commerce. In the later years of his reign, numbers of young men were sent to Europe for study, and the telegraph, Burmese-language printing presses, steamboats, Western-style currency, and other innovations were introduced. Amid these reformist efforts—"Mindon was the first ruler of the nineteenth century to...attempt to make the Ava kingdom more internationally viable in the face of British expansion"—the king took his role as exemplary Buddhist ruler seriously, staging grand ceremonies, founding monasteries, sponsoring an ambitious Buddhist council to reedit the Buddhist scriptures, and creating an environment within which the visual and performing arts flourished.[37]

The building of a new capital on a new site must have been a bonanza for artists and artisans (more so than previous moves of the capital from Amarapura to Ava in 1823 and back again in 1837), and the lavish patronage of the pious Mindon and his court during his quarter-century reign kept them busy. Burmese royal documents of the period list, in mind-numbing detail, the royal donations: "fifty offering trees bearing varied gifts," "1,800 offerings of bowls with stands and covers" (of the type of fig. 18 [cat. no. 13] and cat. no. 12), and "seventy water carafes together with drinking cups," "bedsteads decorated with gold and glass" (probably similar to cat. no. 28), and so on and on.[38] Some of the artworks included here may possibly date from Mindon's period, including cat. nos. 1, 2, and 11.

Mandalay, or at least the Mandalay of

FIG. 18 Ceremonial alms bowl with stand (cat. no. 13).

palaces, mansions, temples, and theaters, must have been a glittering place, and Mindon's reign a golden age. It is hard to imagine, though, even after factoring in the effects of hindsight, that many of the capital's citizens did not sense, especially after an unsuccessful palace coup in 1866, that after Mindon might come the deluge.

In spite of the efforts of the king and his administration, the decades after the British conquest of Lower Burma in 1852 saw an increasing shift of wealth and energy southward to Rangoon and the Irrawaddy delta region. Many families involved in both farming and commerce moved into the British-controlled regions, apparently seeking greater assurance of stability and a wider range of opportunities. From 1852 until the fall of the monarchy in 1885, Lower Burma "grew as a sort of 'alternative Burma' which sapped the legitimacy of Mandalay."[39]

All these developments must have been followed closely in Bangkok. Rama IV (Mongkut) had come to the throne just two years before Mindon and shared many of his concerns—political, cultural, and religious. In the 1850s Rama IV acquired his first steamboat, had himself photographed, planned for the minting of Western-type coins, invited missionaries' wives to teach English in the palace,[40] and sent a fact-finding team to Britain; within a few more years his government would begin to hire European advisors.

Twentieth-century Western analyses of Rama IV and his reign tended to emphasize the king's superb intelligence and learning; his voracious curiosity about the world; his personal knowledge of English and the fact that both before and after his accession he seems to have valued serious conversations with educated Westerners; his deeply held, but rationalizing—"Protestant"—Buddhist beliefs; and his willingness, at least occasionally, to break free of protocol: when his first steamboat was launched "the monarch astonished his people by suddenly boarding the vessel for a pleasure ride."[41]

All of these points are true and important for understanding the culture of the period. In recent years, though, additional points have been stressed. Rama IV faced considerable opposition (or marginalization) from old noble families, and his power was much more limited than might be supposed.[42] Further, for all his "modern" qualities, he was no embryonic democrat.[43] The dynastic chronicles of the reign devote many pages, year after year, to describing highly formal royal ceremonies. The king's coronation, for example, was carried out with every attention to the old ways. "The Brahmins sounded the clockwise-spiraled and the counterclockwise-spiraled conch-shell trumpets;…silver and gold trees were also set out;…[there] was placed a *kinnara* statue [cat. nos. 112 and 113], which contained a relic of the Buddha;…there were also items of apparel for the king in order to render him victorious in war;…the Brahmins then sprinkled…wheat-flour which had been blessed with invocations to the god Shiva;… court pandits brought in the Buddhist statue *phrachai* ["sacred victory"], and Brahmins brought in the statue *phra Vighneshvara* [a form of Ganesha]." In this way the ceremonies continued for nearly two weeks.[44]

These royal spectacles may or may not have bolstered the king's power. A Thai scholar writing recently thinks not: "State and royal ceremonies, which supposedly functioned to reinforce the link and hierarchy between the monarch and the nobility, became demonstrations of royal weakness because the great nobles did not attend."[45]

Certainly, however, the use of political theatrics and the manipulation of symbols were continuing preoccupations of the king's. He commissioned a new sort of Buddha image with more naturalistic drapery than had been usual, and lacking the bump on the top of the head (*ushnisha*) that was an ancient and traditional indicator of the Buddha's superhuman nature.[46] He also lectured his people and the monkhood on all sorts of seemingly minor, but symbolically important, matters.

His audience, he clearly believed, was not just the Siamese people but the wider world. Even the cremation ceremony for the previous king was conducted, according to the dynastic chronicles, "to impress the foreign visitors and those of the vassal states, as well as visitors from the towns of first, second, third, and fourth class.… The King hoped that

these visitors would see that Siam had a large number of senior members of the royal family and that this would redound to the honor of Siam in the eyes of foreign countries."[47]

With the great Western powers gobbling up country after country under the pretext of bringing order and civilization, displaying the stability, high culture, and clued-in-ness of Siam was an urgent priority. The king (and occasionally other royals and nobles) sometimes wore Western clothing, staged Western-style dinner parties for foreigners, and built Western-style palaces.[48] In addition to what took place locally, display was projected across the oceans. The king's English-language letters to Queen Victoria and President Franklin Pierce implicitly remind them that he and they are equals, as are his realm and theirs.[49] He also sent them gifts, as any great ruler would do with any other. Gifts sent to the U.S. president in 1856, preserved in the Smithsonian Institution, include a photo of the king and his wife (fig. 19) (one of many wives, but better not draw this to the president's attention), gilded silver vessels (quite like cat. no. 120),

FIG. 19 King Mongkut and Queen Debsirindra in a photo included among gifts sent by the king to the United States in 1856.

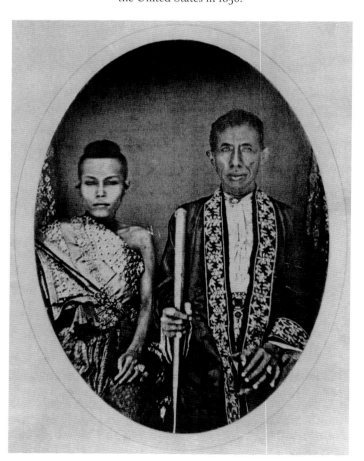

a sword and other weapons, luxurious textiles, and a variety of musical instruments.[50]

Display for the Western public on their home ground was also important. The king (having already opened, in 1856, a private museum in the palace that was shown to members of the royal family and to foreign dignitaries) sent Siamese art objects and products to international exhibitions in London in 1862 and Paris in 1867. At the latter, Siamese objects won two grand prizes and several other medals.[51] Money could not have bought such good publicity.

The first creation of museums and exhibitions suggests the beginnings of modes of thought that become more and more important through the end of the nineteenth century and into the twentieth—a certain distancing, an increasing objectification, an imposing of new meanings and identities onto objects. Buddha images, gilded vessels, and basketry fish traps never had been simply themselves and always had carried multiple significations, but now, in addition, they became Exhibits.

EPILOGUE: CIRCA 1907

We have circled around past the beginning of this essay at 1885 and are moving ahead by twenty-some years. Rama V, King Chulalongkorn, is still on the Siamese throne, looking forward to the fortieth anniversary of his reign in 1908. He has just returned from an extended trip to Europe, his second. Before he left, planning had begun for the creation of a life-sized equestrian statue of the king, a first for Siam, which would be placed in front of a monumental new throne hall built entirely in European style.[52] Meanwhile, the homes of the nobility and rich merchants are weighted down in late-Victorian knickknacks.

Under construction is one of Bangkok's most famous sights, Wat Benchamabophit, the Temple of the Fifth King (fig. 20). It was designed by the gifted architect and artist Prince Naris in traditional style but was to be sheathed in marble—as old temples never were—and would incorporate such innovations as stained-glass windows. Its colonnaded galleries were to be lined with Buddha images, as had been typical in Thai temples

for hundreds of years, and these images had been collected from temples elsewhere and brought together, just as had been done by Rama I at Wat Phra Chettuphon in the 1790s.

Innovative ideas were in play, however. These Buddha images were selected specifically to represent the whole range of styles of different periods and regions. If an image of a certain style was not available in the appropriate size, an enlarged replica was cast.[53] Rama I may well have intended his huge gathering of Buddha images from various parts of the country to signal that his new capital summed up and incorporated all that had gone before, but the curator-like art historical impulse of Rama V's agents was new.

Both the design and the assembly of components at Wat Benchamabophit suggest that the self-consciousness glimpsed in the 1850s and 1860s in the sending to the West of diplomatic gifts and objects for exhibition has developed further. In Rama V's period yet more objects were dispatched for foreign display, and now, as at the international expositions in Paris in 1889 (fig. 21) and St. Louis in 1904,

they had "Siamese" buildings built to contain or accompany them. A neoclassical structure by an Italian architect might be just right for a new throne hall in Bangkok meant to rival anything being built in London or Tokyo, but to represent Siam in some far-off city a building would need to be designed with care to embody Siameseness.

A number of art objects in the current exhibition must have been made during the Fifth Reign (1868–1910), though it is another indicator of the underdeveloped state of research on Thai art history that in many instances it is difficult to be sure. One object—though it dates from a decade later than the Fifth Reign—clearly shows self-conscious Siamizing at work. This gold bowl, fig. 22 (cat. no. 121), was sent to Florida by Rama V's successor as a wedding present for the daughter of an American envoy. Its style could have been more hybrid like that of cat. no. 119, which, though of a traditional Siamese shape, has echoes of international nineteenth-century silver design. Or the king could have ordered a bowl from Tiffany's and saved the trouble of having one delivered all the way from Bang-

FIG. 20 Wat Benchamabophit, Bangkok.

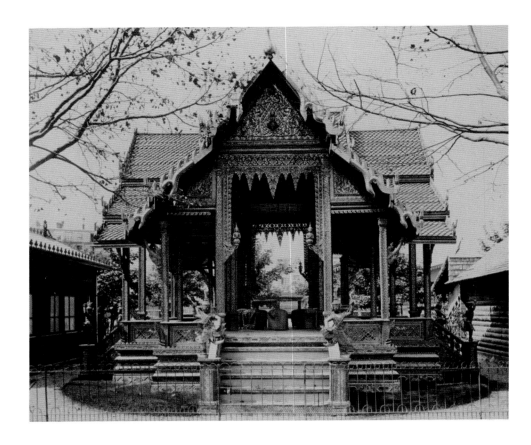

FIG. 21
Pavilion of Siam,
Paris Exposition, 1889.

kok. Apparently, however, it was essential that the bowl be recognizably, characteristically Siamese.[54]

Similar impulses must have been being felt in Burma. While traditional objects were still made for traditional purposes (cat. nos. 4 and 32, for example) and Buddhist temples continued to be built under new sorts of patronage—in 1907 a "charismatic individual" embarked on "an ambitious religious building programme which rivaled that of the former monarchy"[55]—by now curio shops catering to foreigners had opened in Rangoon and Mandalay. Not all the customers of these shops were foreign, though, it seems likely. In a period of what has been called the "invention of tradition,"[56] Burmese customers might have wanted to buy something undoubtedly "Burmese" for a foreign friend or, as the golden age of King Mindon receded, for themselves.

Or perhaps not. The words of a Brit-

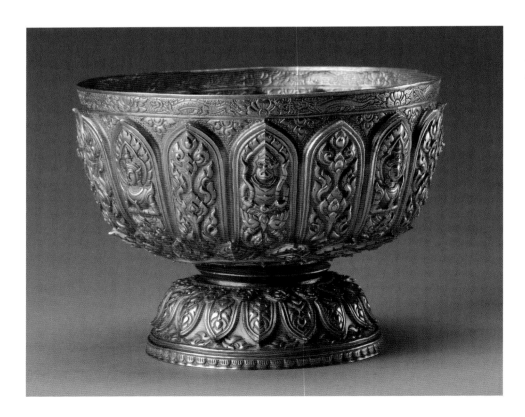

FIG. 22
Gold bowl with garudas
and celestials (cat. no. 121).

ish writer in 1907 highlight the mixture of nostalgia and detachment that Burmese as well as British may have felt (and Siamese too, toward their own past), and they serve as a comfort and a caution to all those who muse on emerald cities. Mandalay, he says, stands for

> a dynasty that is no more, for a court whose splendour and whose etiquette are already fading into oblivion, for a sentiment that has all but ceased to exist. At Rangoon the imagination strains for-ward into years that are yet to come, for some hint of a great Destiny that awaits it; at Mandalay one only wonders how much longer its crenellated walls and crumbling battlements will survive; how much longer its gilded pillars and taper-ing spires will speak to the eye of things that can never live again. Already the keen pressing spirit of Rangoon is impa-tient of the faint rivalry of its once royal neighbor.... "Sweep it away," say the business people, "and let us have done with Mandalay and its tawdry glories."[57]

Notes

1 The conflicting views of the Burmese regime in its final days are suggested in the last few entries in the Royal Orders of Burma. On November 24, 1885, an order went out to all commanders: "Check the advance of invading heretics Stop Send them as prisoners here Stop." Three days later a different sort of message was telegraphed from an officer back to the council of state in Mandalay: "The English said nothing definite though we could guess that the treaty of friendship be renewed by giving all they ask just to save our kingdom Stop Let their ships come right up to Royal Golden Capital without any more resistance Stop Then we could possibly say [stay? (FMcG)] and get [the best out of the terms (Than Tun)] that they dictate Stop"; Than Tun, ed., *Royal Orders*, 9:315. See also Aung-Thwin, "British 'Pacification' of Burma."

2 *Times* of London: "The Burmese War," December 5, 1885; "The Capture of Mandalay," January 6, 1886; "Upper Burmah," February 11, 1886; "A Story of Hidden Treasure," March 29, 1894; "The Alleged Robbery of the Burmese Regalia," May 19, 1894; "Rare Treasures Given Back to Burma after 80 Years," November 11, 1964; *New York Times*, "King Theebaw's Treasures: Some of the Loot From His Mandalay Palace Exhibited," October 10, 1886; Vrdoljak, *International Law*, 70–71.

3 O'Connor, *Mandalay*, 72; in 1917 the Reverend John Ebenezer Marks reminisced, "I now stood with my back to the throne and preached to a large and attentive congregation. In my long intervals of waiting, in days gone by, I often used to think of the various useful purposes to which the different halls of the Palace might be put. But my wildest flights of imagination never assigned a purpose as that to which we were adapting the hall of audience, that of a military chapel for the British garrison!"; in chapter 13 of *Forty Years in Burma*, http://anglicanhistory.org/asia/burma/forty/18.html. In 1901 the viceroy, Lord Curzon, ordered the club and church to be removed, and outlined steps for the preservation of the main parts of the palace complex; see his memo in O'Connor, *Mandalay*, 417–421.

4 Lowry, "Victorian Burma by Post," 659; and Wong Hong Suen, "Picturing Burma," 8. Lowry says Felice Beato's mail-order shop opened in the late 1880s; Wong says it opened in 1892 or 1893.

5 For more thoughts on the comparison of Siam with Burma and other countries in the nineteenth century, see Thant, *Making*, 248–249; and Engle-hart, *Culture*, 105–110.

6 The Gothic temple is Wat Niwet Thammaprawat in Bang Pa-in, built in 1878. The British architect of the hall for the Grand Palace was John Clu-nich; Peleggi, *Lords*, 80–81. See also Koompong Noobanjong, *Power, Identity, and the Rise of Modern Architecture*, 152–157.

7 For example, see Terweil, *Thailand's Political History*, 56–61; and Baker and Pasuk, *History*, 26–27.

8 Rama I's building projects are described in *Dynastic Chronicles, Bangkok Era, the First Reign*, compiled in the fourth reign from earlier materials by Chao Phraya Thiphakorawong and translated by Flood and Flood.

9 Ibid., 85. On the connection between the Emerald Buddha and Indra and important related matters, see Reynolds, "The Holy Emerald Jewel."

10 Thiphakorawong, *Dynastic Chronicles, Bangkok Era, the First Reign*, 232. On the history of Wat Phra Chettuphon, see Matics, *History of Wat Phra Chetuphon* and "Historical Analysis."

11 Terweil, *Thailand's Political History*, 82–83. He lists three reasons for the king's emphasis on cer-

emonies, namely to make his "new Ayutthaya" come to life, to gain merit, and to accord with his own preference for formal protocol. See also the section on "State Ceremony" in Wyatt, "'Subtle Revolution.'"

12 Thiphakorawong, *Dynastic Chronicles, Bangkok Era, the First Reign,* 299–300.

13 In addition to the *Dynastic Chronicles,* see Wenk, *Restoration;* and Wyatt, "'Subtle Revolution.'" On Rama I's sponsorship of the ceremonial recitation, see Gerini, *Retrospective View,* 36. For a First Reign illustrated Phra Malai manuscript dated 1791 in the Asian Art Museum collection, see McGill, ed., *Kingdom of Siam,* cat. no. 80. The murals of the life of the Buddha are in the Phutthaisawan Chapel; see Fickle, *Life of the Buddha.*

14 Central Burma is more subject to earthquakes, as devastation in recent decades has shown, than Thailand. Timber buildings survive earthquakes better than do masonry ones.

15 Symes, *Account,* 101, 280.

16 On this Buddha image and its temple, see Schober, "In the Presence of the Buddha"; and Damrong, *Journey Through Burma,* 112–116.

17 Stadtner, however, argues that "a fresh look at the evidence suggests that the pagoda we see today must have been finished in about 1812 during the patron's reign"; Stadtner, "Burma on the Eve of the Modern Era," 53.

18 Symes, *Account,* 324–325, 429–430. The question also arose whether it was permissible to sell books on Burmese "history and laws" to foreigners. The king referred the matter to a council of priests, who, "after solemn deliberation, determined in the affirmative"; 422.

19 Ibid., 324–325, 347.

20 Marble Buddha images: ibid., 324–325, 429–430; mirror ornament: ibid., 391.

21 Ibid., 346–347. Assuming that this Siamese painter is the same one Symes mentions on pp. 422–423, it is clear that the painter was male.

22 On Chinese communities and Chinese-related art in Siam in earlier centuries, see McGill, ed., *Kingdom of Siam,* passim.

23 Symes, *Account,* 422–423. From our point of view today we might have expected the Siamese painter to be strong in "taste" but weaker in what Symes would have considered "fidelity."

24 One of the plates in Symes's book shows the "Method of Catching Wild Elephants" and is presumably based on a copy his Bengali artist made of the Siamese artist's work. The earliest surviving Siamese paintings of groups of elephants in the wilds that I know of date from the period of Rama III (1824–1851), but these are murals in a Buddhist temple and illustrations in manuscripts; see *Wat Phrachettuphon,* 86–113; Niyada,

Hotrai krom somdet phraparamanuchit chinnorot, 104–228; and Ginsburg, *Thai Manuscript Painting,* 40–41. Murals in the Kyauktawgyi Temple in Amarapura, Burma, of 1847 or shortly after depict elephants in the wilds in a way reminiscent of the illustration in Symes's book; Girard-Geslan et al., *Art of Southeast Asia,* illus. 277.

25 On the continuing Siamese wariness (if not dread) toward the Burmese, see Sunait, "The Image of the Burmese Enemy in Thai Perceptions and Historical Writings." For their part the Burmese resented what they saw as Siamese satisfaction at, if not connivance in, British victories; Maung, *History,* 240.

26 Crawford, *Journal of an Embassy,* 410. In subsequent years smaller, but still substantial, numbers of Chinese ships are reported; Sarasin, *Tribute and Profit,* 192–197.

27 Sarasin, *Tribute and Profit,* 200–201.

28 Wyatt notes that by the 1840s some fifty Western vessels were arriving in Bangkok each year; *Thailand: A Short History,* 170. Western shipping increasingly replaced Chinese; in particular, the Opium War of the early 1840s undermined the Chinese junk trade; Baker and Pasuk, *History,* 45.

29 See McGill, ed., *Kingdom of Siam,* passim; and Jacq-Hergoualc'h, *L'Europe et le Siam.*

30 Crawford, *Journal of an Embassy,* 81, 108.

31 Vella, *Siam Under Rama III,* 52; Baker and Pasuk, *History,* 74.

32 For a convenient listing of buildings and artworks made during the period of Rama III see Vella, *Siam Under Rama III,* 43–51, but note that his brief art-historical discussions and aesthetic judgments are outdated.

33 On the restoration of Wat Phra Chettuphon in the period of Rama III, see Dhani, "Inscriptions"; and Matics, *History* and "Historical Analysis." For detailed photos, see *Historical Illustrations,* and *Samutphap wat phrachettuphon.* For wall paintings, see *Wat Phrachettuphon.*

34 McGill, ed., *Kingdom of Siam,* 159–161.

35 Important temples from two decades earlier survive and await systematic study; these are the Maha Aungmyebonzan in Ava and the Myatheindan (Hsinbyume) in Mingun. The latter encapsulates Buddhist notions of the plan of the cosmos, with Mount Meru encircled by seven mountain ranges and topped by Indra's Heaven centered on, in this instance, the stupa enshrining the Buddha's hair relic. The hair-relic stupa in Indra's Heaven is represented in cat. nos. 36, 93, and 96.

36 Than Tun, ed., *Royal Orders,* 9:47. On Mandalay, see Blackmore, "The Founding of the City of Mandalay by King Mindon"; and *Mandalay Palace.* This last work includes a discussion of Mandalay's name (p. 13). On the city of Amarapura in its

last years as the capital, see Yule's *A Narrative of the Mission to the Court of Ava in 1855*. Note that Europeans spoke of the kingdom as "Ava" even when the capital was not at Ava but at Amarapura. Particularly interesting is Yule's description of foreign communities—Chinese, Armenian, "Mahomedans of Western Asia," and others—in the Burmese kingdom, reminding us that it was by no means completely isolated, and far from monocultural.

37 The quotation is from Thant Myint-U's *Making of Modern Burma* of 2001 (p. 105), which provides the best easily accessible discussion of Mindon's reign. Also valuable is the 1987 dissertation by Myo Myint, "The Politics of Survival in Burma: Diplomacy and Statecraft in the Reign of King Mindon, 1853–1878." On Mandalay, see Blackmore, "The Founding of the City of Mandalay by King Mindon"; and *Mandalay Palace*.

38 Herbert, "Illustrated Record."

39 Thant, *Making*, 207.

40 A photo of the king taken by 1856 is reproduced in McQuail, *Treasures of Two Nations*, 29; see also Cary, "In the Image." The famous, or infamous, Anna Leonowens did not begin as tutor until 1862. A judicious recent assessment of her character and activities is in Terweil, *Thailand's Political History*, 157–159.

41 Terweil, *Thailand's Political History*, 146. Terweil's discussion of the reign is balanced and valuable.

42 See, for example, the 2004 work of the Thai scholar Kullada Kesboonchoo Mead, *The Rise and Decline of Thai Absolutism*.

43 "By using various traditional ways, Mongkut strove for a more hierarchically ordered kingdom under a more elevated monarchy"; Baker and Pasuk, *History*, 50.

44 Thiphakorawong, *Dynastic Chronicles, Bangkok Era, the Fourth Reign*, 6–20; transcription of Thai terms has been altered for clarity in the present context. On images of Vighneshvara in Thai ceremonials, see McGill, ed., *Kingdom of Siam*, 139–140.

45 Mead, *Rise and Decline*, 35.

46 Nidhi, *Pen and Sail*, 277–278. Nidhi associates the changes to this model of Buddha image with the Buddha coming "to be seen more and more as a human being." He finds the theory of Western influence on the conception of this type of Buddha image to be inadequate. I would suggest a complicated process: the new Buddha image resembles Buddha images from the ancient kingdom of Gandhara in Pakistan and northwestern India in a number of ways, from the relatively naturalistic drapery to the legs interlocked rather than laid one atop the other (as they usually were in previous Thai sculpture) to the hand position, fairly uncommon in Thai Buddha images. Conceivably, illustrations of Gandharan Buddha images may have been available in Western books circulating in Siam in Rama IV's day. If this is so, then—not for the last time—Thai Buddhists were becoming familiar with aspects of early Buddhist culture in India through the intermediary of Western books.

47 Thiphakorawong, *Dynastic Chronicles, Bangkok Era, the Fourth Reign*, 83.

48 For a study of a Western-style palace begun in 1859, see the handsomely illustrated *Phranakhonkhiri / Phra Nakhon Khiri*, which is in both Thai and English.

49 Mindon of Burma had also written to the queen and the American president in the mid-1850s; Yule, *Court of Ava*, 195.

50 McQuail, *Treasures of Two Nations*.

51 See the description of a special exhibition at the Bangkok National Museum at http://www.thailandmuseum.com/thaimuseum_eng/bangkok/special_exhibition.htm. Also see Peleggi, *Lords*, 146. Peleggi says that "over the period 1851–1911 Siam participated at none of the exhibitions held in England" (145), but this information seems to be incorrect. The Bangkok National Museum's website just referred to provides an English translation of Rama IV's memo of February 12, 1862, authorizing the gathering and sending of display items to London and says that they were sent.

52 All of this is discussed in fascinating depth in Peleggi, *Lords of Things: The Fashioning of the Siamese Monarchy's Modern Image*. The new throne hall took many years to complete. Both its cost and its appearance were controversial, and it, as well as the equestrian statue, have continued to accumulate complex new political associations.

53 The process of choosing and gathering images is described by Prince Damrong, who was in charge; see Damrong, "Wat Benchamabopit and Its Collection of Images of the Buddha." He mentions that "they have been selected so as to represent the styles of the various periods of Siamese art as well as the styles of different countries." See the discussion in Peleggi, "Royal Antiquarianism," 140–141. For an English-language overview of the history of Wat Benchamambophit and the murals in one of its buildings, see *Phra thinang songphanuat*, 77–87.

54 Again, Peleggi's *Lords* provides thought-provoking background.

55 See Fraser-Lu, *Splendour in Wood*, 140. Her whole section on the colonial and postcolonial eras is relevant.

56 Peleggi, *Lords*, 7, referring to a 1983 book edited by Eric Hobsbawm and Terence Ranger.

57 O'Connor, *Mandalay*, 3. As it turned out, the royal palace and other monuments of Mandalay were destroyed in World War II.

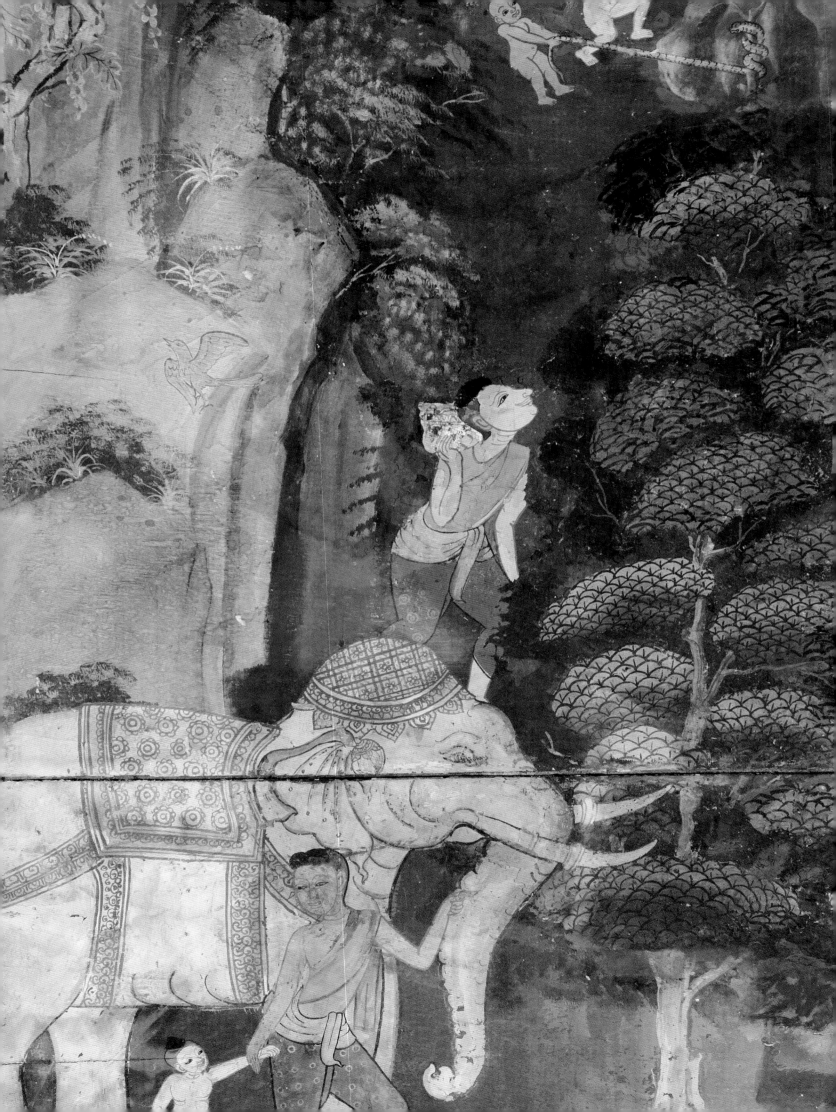

LIVING THE SIAMESE LIFE
CULTURE, RELIGION, AND ART

M. L. Pattaratorn Chirapravati

Rama I established a new dynasty in 1782 and moved the capital across the Chao Phraya River to Bangkok on the east bank. The king had a palace built based on the plan of the destroyed palace in the old capital of Ayutthaya. Bricks were brought from the ruins of Ayutthaya to construct the city's walls and public buildings.[1] David Wyatt describes the early days of Bangkok as being ethnically diverse, cosmopolitan, and lively:

> The City soon bustled with craftsmen constructing a new royal palace and imposing Buddhist monasteries, while princes and officials constructed homes along the network of canals radiating eastward from the palace and Chinese and Indian merchants built their shops and warehouses along the river to the south…here the Chams attached to the army; there a group of Malays who manned naval vessels, clustered around an Islamic house of worship; north of the city, a settlement of Roman Catholics descended from Portuguese and Japanese Christians.[2]

From the moment of birth, a Siamese child's life was intimately linked with religious practices, rituals, and activities. The noted Thai historian Prince Damrong (1862-1943) lists ten auspicious ceremonies that the royal family conducted in celebration of their children between the ages of three days and twenty-five years.[3] Many of these ceremonies were practiced continuously from the Ayutthaya period to around 1930. Common ceremonies included the celebration of birth (on the third day), the celebration at the age of one month, the shaving of the topknot ceremony (tonsure) between the ages of nine and eleven, the ordination ceremony at the age of twenty-

one, and the celebration at the age of twenty-five years. Commoners also practiced some of these ceremonies, such as the birth, the shaving of the topknot, and ordination.

Siamese society was broadly divided into three classes: the royal family and nobility, officials, and commoners. In the early part of the Bangkok period the royal family and nobility had close relations. They were tied not only through marriage but also by partnerships in businesses such as trading. Hence, they shared social and cultural activities. Officials served the king and nobility and had connections with foreign traders. Commoners provided labor and support for the upper classes. Their cultural activities were very different from those of the upper classes during the early part of the Bangkok period; however, literature and performing arts were later exchanged and shared between the classes.

Though Buddhism was the predominant religion of Siam, aspects of Hinduism and animism were to some degree mixed into various aspects of life. While the life of royalty and nobility was more connected to Buddhism and Hinduism, the life of commoners was linked more to animism and popular forms of Buddhism. Upper-class culture often focused on reading not only in Thai but also in learned languages such as Pali, Sanskrit, and Cambodian and used foreign literature as a source of inspiration. Village life was permeated with oral folk tales, local stories, and legends. In spite of the differences among the three classes, they shared a belief in the power of supernatural figures and planetary deities to influence their lives. Consultations with astrologers and fortune-tellers were essential to such events as getting married, building a new house, or choosing an auspicious name for a child. People performed rituals to show respect to different spirits after they received predictions.

In a book on the royal ceremonies of the twelve months, Rama V states that kings performed Buddhist, Hindu, and animistic ceremonies every month to maintain the prosperity of the kingdom.[4] He lists the ceremonies that were continued, discontinued, or added from the end of the Ayutthaya period (mid-eighteenth century) to the period of his reign (1868–1910). Some were large official state ceremonies, while others were small private rituals that involved only the royal family. Buddhist ceremonies such as Visakha Puja (marking when the Buddha was born, attained enlightenment, and entered nirvana)[5] or Kathin (the offering of new robes to monks) were celebrated in most temples in the kingdom by all classes. In this way, people's lives were linked together more or less each month by state ceremonies. The king also lists ceremonies that all citizens celebrated with festivities, some of which continued for many days.

Objects of everyday life, such as furniture, textiles, clothing, and ceramics, were of course produced very differently for various social classes. While the upper classes were exposed to imported products such as Chinese ceramics and furniture, Indian textiles, and Western glass, commoners usually used local products. Because the objects on display in this exhibition belonged mainly to the upper classes, this article focuses on their cultural and social activities.

When the Buddha was born, his father invited brahmans to predict his son's destiny and to give him a suitable name. This particular rite was embraced by the Siamese royal family and nobility. From the date and time of birth, a monk or an astrologer would make calculations that yielded predictions of the child's life. After the numbers were put together in a diagram, the child's destiny could be determined. Astrologers also used divination manuscripts, which provide insight into the calculation and prediction procedures (fig. 23 [cat. no. 105]).[6] If a child received a bad prediction, the parents would perform merit-making in the hope of alleviating the source of the misfortune. The scale of offerings depended on people's resources.

Building a temple and donating images of the Buddha, manuscripts (cat. no. 99), or manuscript cabinets (cat. no. 57) were among the most meritorious acts. Accruing merit from donations continued throughout life, so at the end of life, the accumulation was believed either to benefit the donor's eventual

passage to nirvana or to increase the chances of being reborn during the time of the Future Buddha, Maitreya. Actively and publicly participating in these rituals was one of the predominant social programs of the Bangkok period.[7]

The development of a child's body called for rites of passage. Interestingly, two of the most important ceremonies conducted during childhood are associated with hair: the one-month welcoming ceremony and the shaving of the topknot ceremony. A hair-clipping ceremony at the end of the first month symbolically and officially welcomed the child to the family. Considered a Hindu ceremony, the ritual was performed by a brahman. The child was bathed and the hair trimmed first by the brahman and then by family members. All of the child's hair was then shaved off except at the top of the head;[8] the remaining topknot would not be cut or trimmed again until the shaving of the topknot ceremony.

This ceremony marked the end of childhood and was one of the most significant ceremonies in a person's life. The age at which it was performed ranged between eleven and thirteen for girls and nine and eleven for boys. Ideally, the hair was to be removed before a child reached puberty. The family consulted with astrologers for the most auspicious moment of the most auspicious day; otherwise, it was believed, the child would face uncountable misfortunes. At this ceremony,

the child's hair was totally shaved off. The ceremony was considered an important family affair: the house was carefully prepared, cleaned, and adorned.[9] A Buddha image, candles, and incense were placed on the altar. A brahman performed the actual shaving of the topknot, but Buddhist monks were invited to bless and chant at the ceremony. Both Buddhist and Hindu ceremonial implements were placed on the tables, which were arranged in a circle next to the brahman and the monks. Three pairs of scissors made of gold, silver, and a mixture of copper and gold were used. Other important implements included a conch shell, shears and razors, bowls of water, and gold and silver vessels.[10] In addition, there were several offerings of food, such as sweetmeats, for the tutelary deities of the house.

The child of an aristocratic family wore a special ceremonial robe made of rich brocade adorned with precious stones. The costume also included gold necklaces and many rings, armlets, bangles, and anklets (fig. 24). The topknot was ornamented with a coronet or garland of flowers.

The topknot shaving ceremony lasted for three days. Each day either the brahman or the monks blessed the child with their own special set of chants. The first two days were devoted to chants for blessing and protecting the child. The actual hair shaving was on the third day, when the hair was divided into

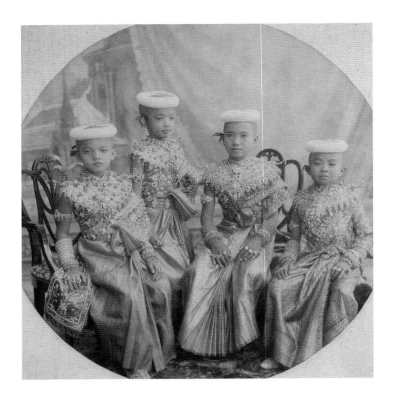

FIG. 24 Noble children dressed for the ceremony of shaving the topknot. One of the children is M. C. Niwasawasdi Chirapravati, the great-aunt of the author. The photo was taken around 1912 or 1913.

ORDINATION

Siamese families wanted to have at least one son to carry on the family name and to take care of elderly parents. In addition, the merit accrued from a son's entering the monkhood even for a short period guaranteed fortunate rebirths for the parents. Thus, to the present day, many men become monks for three months during the rainy season retreat, which starts around the last week of July and ends at the end of October, depending on the moon calendar of that year. Monks are allowed only eight possessions: three robes, an alms bowl, a razor for shaving hair and eyebrows, a case of needles for repairing robes, a belt, and a cloth to filter drinking water (to prevent killing insects). Monks leave the temple very early in the morning to receive alms, particularly offerings of food, from laypeople, then return to the temple to pray and share the food. After this meal, no solid food is allowed in the afternoon; only tea or water is permitted. During the three months at the monastery, young men learn about the Buddha's teachings, they meditate, and they attend merit-making ceremonies (such as weddings and funerals) with other monks (fig. 25).

three locks and decorated with amulets. The highest-ranking guest, such as the king or a royal family member, cut the first lock with the gold scissors. Then the other two locks were cut off by the oldest relatives, such as grandparents. Finally, a barber shaved off the rest of the hair. The long locks of hair and the short hair clippings were placed in separate containers. Monks then poured consecrated water that had been blessed during the ceremony on the child's head.

After a bathing ceremony, the child was dressed in another beautiful and colorful costume embellished with jewels. While the monks ate, the brahman made offerings to spirits for protection of the child's luck and fortune at a shrine built specifically for the occasion. In the custom of aristocratic families in central Siam, the long locks of hair were kept in the house and later presented to the monks at the Shrine of the Buddha's Footprint near the town of Saraburi. The short hair was put into a small vessel made of leaves, which the parents would set adrift in a river or nearby canal.

After the topknot cutting, both boys and girls could legally marry at age fourteen. Sometimes a child would be ordained as a novice or a lay sister for a short period before getting married. Although girls generally married young, boys often waited until they were twenty.

FIG. 25 Rama V during his period as a monk, 1873.

Temples functioned not only as religious institutions but also as centers of learning. Monks taught boys reading, writing, mathematics, and sciences. During the reigns of Rama I to Rama IV, young princes and noble children were sent to study with renowned monks at temples near the Grand Palace such as at Wat Phra Chettuphon (Wat Pho) and Wat Bowonniwet.[11]

THE PREACHING OF THE STORY OF PRINCE VESSANTARA

At the end of the rainy season laypeople customarily listen to readings or sermons about the "Great Life" (or "Great Birth"; Thai: *mahachat*), the last of the many stories (Jatakas) of the previous lives of the Buddha. The story of Prince Vessantara (Thai: Wetsandon) is one of the most popular subjects

FIG. 26 Jujaka encounters the hunter, a scene from the story of Prince Vessantara (cat. no. 89).

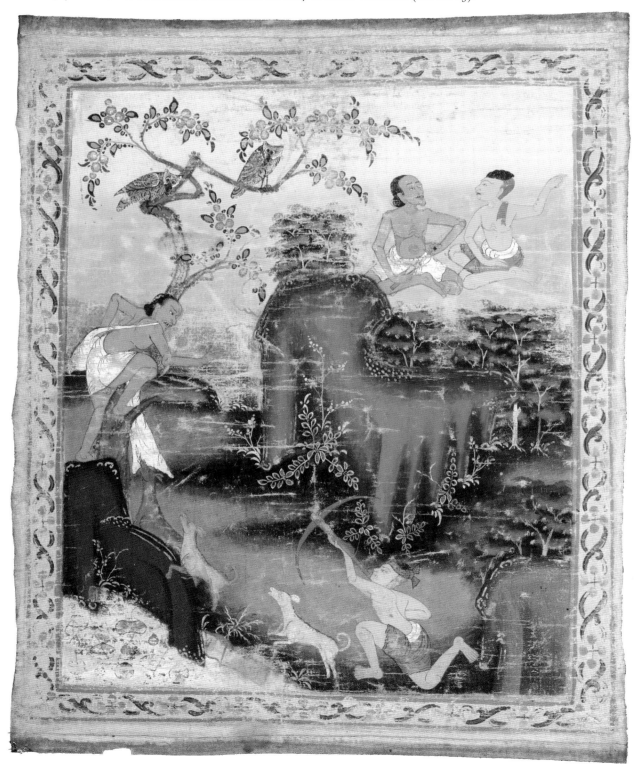

FIG. 27

Vessantara and his family weep for joy at their reunion, a scene from the story of Prince Vessantara (cat. no. 92). Though the inscription at the bottom is badly damaged, the name of the chapter illustrated and the number of its stanzas can be made out.

depicted on manuscripts, wall hangings, and mural paintings (fig. 26 [cat. no. 89], cat. nos. 67–69, 71–88, 90–92). Lay practitioners of all classes commissioned and donated them to temples for making merit. The paintings were used to illustrate the major parts of the story's thirteen chapters during the recitation. In this story, Vessantara achieved absolute perfection of generosity by giving away the most important things in his life, including his wife, children, and kingdom. (The story is recounted in the entries for cat. nos. 71–83, which comprise a complete set of the thirteen paintings that correspond to the thirteen chapters.)

Traditionally, the "Great Life" was recited in temples as well as in upper-class private homes. It was recited from beginning to end in one night, and those who listened to the sermon were believed to accrue great religious merit. The Pali-language version, consisting of one thousand verses, was chanted by monks. Two Thai-language versions exist, one that was recited by monks and the other by laity;[12] the Thai versions made the story accessible to laypeople. Various customs emerged, such as decorating the preaching hall with

banana trees and sugarcane trunks to imitate the legendary forest where part of the story is set. Rama V reports that during "Great Life" recitation days, illustrated screens or paintings were hung on the lampposts in front of a ceremonial hall of the Grand Palace. Ceremonial umbrellas, banners, and sugarcane stalks adorned the hall, and offerings of fresh flowers were placed in tiered receptacles inside.[13]

Drawing on the descriptions of ceremonies for the recitation of the "Great Life" in the story *Khun Chang Khun Phaen,* Chris Baker and Pasuk Phongpaichit believe that local dignitaries sponsored episodes to make merit and display their status. Temples were decorated to resemble the forest where the story was set. In addition, sponsors donated flags and candles in numbers that directly related to the episode's length in stanzas (fig. 27 [cat. no. 92]). For instance, the longest episode contains 101 stanzas, so it required a large donation. Sponsors also had to make offerings of food to the monks.[14] Ernest Young, who resided in Siam in the 1890s, mentions that in earlier times, offerings were made for the decoration of the halls in which the recitation was held, but that by the time he ar-

32

rived the recital had degenerated into a kind of theatrical performance, which was accompanied by pantomime and song.[15] This performance was particularly popular among lay practitioners.

Royal patronage of the recitation ceremonies ceased during the reign of Rama V. Thus, the festival lost popularity and the commissioning of manuscripts went out of fashion, especially following the centralized reform of Buddhism in 1902.[16] Today the making of Vessantara paintings survives only in the northeastern region.[17]

THE OFFERING OF NEW MONK'S ROBES

Around October or November, following the three-month rain retreat, laypeople ordinarily donate new robes to monks. Traditionally the robes were made of strips of cotton cloth sewn together in a single day and night, imitating the Buddha's robe that was said to have been made of rags and fragments of shrouds. Donors believed that by presenting new robes, they would be free from danger and would secure prosperity for themselves and their families. The donation of robes was celebrated with processions on both land and water. In Bangkok, the event was exciting because the king and royal family members, dressed in their ornate costumes, distributed the robes to a number of royal temples along the Chao Phraya River from a procession of royal barges. Ernest Young gives a vivid account of his observations of the festivities during the reign of Rama V:

The water processions in Bangkok are singularly attractive on account of the number of people who take part in them, and the variety of costume, and display of oarmanship which they then exhibit. All day long, lines of canoes, gondolas, and gilded barges carry the worshippers and their offerings to the many temples in the city. The holiday attire is unusually brilliant, and as the numerous colours flash by in the swiftly gliding boats, one begins to wonder if there are any tints or shades of colour that may not be seen on the Menam [River].[18]

The robe-giving ceremony remains popular among lay practitioners. The royal water procession, however, is no longer celebrated annually but is enacted only in commemoration of special occasions, such as (most recently) the fiftieth anniversary of the king's coronation and the king's eightieth birthday.

MARRIAGE AND SETTING UP A HOUSEHOLD

A wedding involved a long protocol between the families of the bride and groom and was considered the beginning of adult life. Unlike at present, when couples initiate their own relationships, in old Siam parents made choices that considered the ranks of and benefits for the two families and the couple.

First, the groom's family sent a respected female elder to approach the bride's family. If the bride's family expressed interest in the groom, the groom's family then sent additional senior members, both male and female, to pay a visit on an agreed-upon day. At that time, the parents and elders of the two families negotiated and planned for the wedding. Etiquette required that the bride's family receive their guests with great politeness and formality. Essentials included serving their guests with their best tea, betel, and tobacco sets (fig. 28 [cat. nos. 122–124]; cat. nos. 117, 118, 125, and 135). Betel chewing was extremely popular at all levels of society in Siam until it was prohibited around 1939–1942.[19] Upper-class people generally had their entourage carry their sets wherever they went, and a set's quality was an indicator of status; a set made of valuable metal signaled that the owners were of high rank. The king sometimes presented sets to officials for their services.

Families paid serious attention to the birth dates of the bride and groom because it was believed that people born in certain years should not marry each other—for example, a person born in the year of the dog should not marry someone born in the year of the rat. An astrologer or fortune-teller would be consulted to determine a good match.

Money and setting up a household were the next important issues. It was common for a new house to be built for the couple on the bride's parents' property; hence the amount offered by the groom's family was an essential

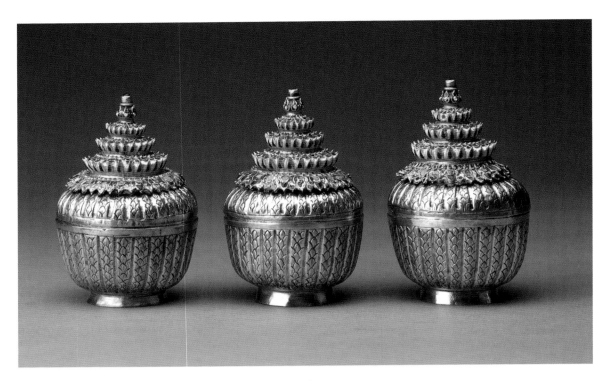

FIG. 28 Lidded containers from a betel set (cat. nos. 122–124).

aspect of the marriage negotiations. Negotia-
tors went over details regarding the number
of rooms, furniture, and wedding festivities.
Once all the points were agreed upon, the
elders from both sides reported their results
to the families. Up to this point, the bride
and the groom still had not met. If the bride's
family accepted the offer, the new house was
constructed immediately, and the money
agreed upon was paid to the bride's parents.
An astrologer fixed the date and time of the
wedding ceremony. Gifts were exchanged
between the families, such as betel sets; con-
tainers decorated with mother-of-pearl-inlay;
and gold, silver, or brass bowls (cat. no. 121).
Gold jewelry was the main gift that the bride
would expect to receive from relatives. A well-
to-do young woman did not work, so if the
marriage fell apart, jewelry would provide
assets on which to live. In old Siam, women
generally had important roles both in the
economy and in society. They ran the house-
holds and took care of finances. Men worked
to support the family, but typically they were
not involved with the financial aspects of the
household.

The wedding ceremony started early in
the morning when the bride's family arrived
in a procession with gifts (the dowry) and a
troupe of musicians and dancers. After monks
performed a long chanting service and ate

their meal, the couple was blessed. The elders
spread the wedding money on the floor and
sprinkled it with rice, scented oil, and flow-
ers. Then the leading elder poured water,
which was consecrated by the monks for the
occasion, over the couple's heads and gave
the couple a blessing. Blessings from other
members of the families followed. The wed-
ding celebration lasted for two days and was
celebrated with festivities and music each eve-
ning. Traditional food at a wedding included
platters of Chinese noodles, savory preserved
meats, and betel nuts.[20]

LIVING QUARTERS

Before the period of Rama V (1868–1910),
when Western-style buildings became fash-
ionable, most upper-class houses were built
of teak and stood on stilts.[21] Houses gener-
ally consisted of several buildings laid out in
a large compound similar to that of a temple,
except that each building contained more
rooms. The oldest house, in the center of the
compound, usually belonged to the head of
the family. Walls were made of teak boards,
and the slanted roofs were decorated with
terra-cotta or colorful Chinese tiles.[22] Gener-
ally, the compound consisted of two quarters,
the living quarter and the outer quarter. The
former (bedrooms, a sitting room, and a din-
ing room) was for family activities; the latter

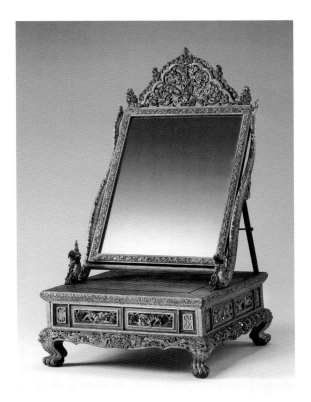

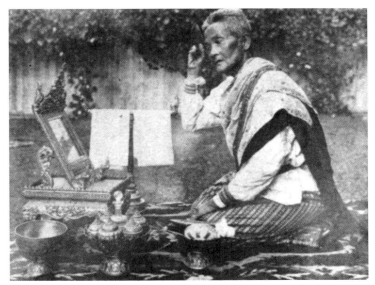

FIG. 29 (*left*) Mirror on stand (cat. no. 129).
FIG. 30 (*above*) Siamese woman attending to her hair and makeup, late nineteenth century.

was for receiving guests and officials. Often the kitchen was in a separate building.[23]

A typical house was decorated with modest objects. Furniture before the mid-nineteenth century was limited and mainly inspired by Chinese pieces, such as large and small low benches, low tables, canopy beds, and cabinets. In general, people sat on the floor, men cross-legged and women with their legs folded to one side. High-ranking aristocrats sat on benches to be higher than other people; sometimes they leaned on a triangu-

lar cushion. Betel and tobacco sets were available in every room of the house, along with spittoons and tea sets.

A woman's common belongings included a mirror (fig. 29 [cat. no. 129]), a towel rack, and a set of cosmetic containers. The mirror stand was sometimes placed on a low table, which was then positioned on a wide bench. The towel rack and the cosmetic containers were placed to the side (fig. 30).

The traditional bed was a low board bed or a Chinese canopy bed (fig. 31). The mat-

FIG. 31
Interior of the "Red House," National Museum, Bangkok.

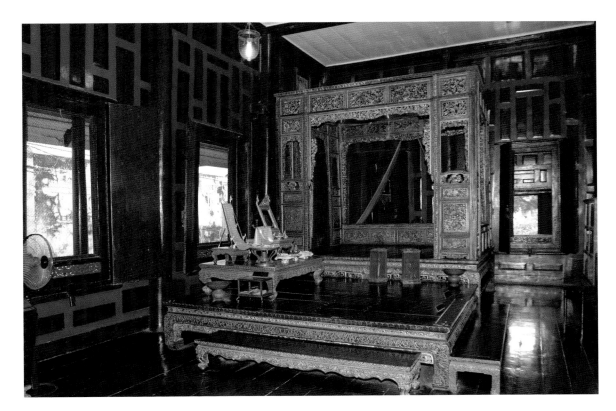

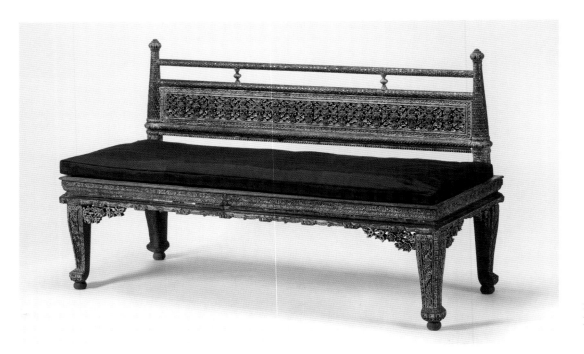

FIG. 32
Bench (cat. no. 127).

tress was stuffed with cotton. The placement of the bed was important; it was considered auspicious to sleep with one's head facing either north or east, since west and south were associated with death.

By around the end of the nineteenth century, Western furniture—tables (cat. no. 128), chairs, benches (fig. 32 [cat. no. 127]), and beds—became fashionable and accessible. The upper classes began to acquire them for their households. This new living style directly and indirectly changed many old customs. For instance, when Western-style chairs and tables replaced low tables for dining, Western-style plates and bowls were also employed, and as a result, the way food was served was changed. The use of flatware replaced the tradition of eating with one's hands.

By the reign of Rama III, Chinese ceramics, which had been popular for centuries among those who could afford them, became even more accessible and the elite acquired a large variety for everyday use. Those that were very expensive were put on display. Ceramics increased still more in popularity during the reigns of Rama IV and V. Rama IV once organized a display of Chinese ceramics at the Temple of the Emerald Buddha on Visakha Puja day.[24] The successful event resulted in serious competitions being held over the next few years. During the reign of Rama V, the vogue for Chinese ceramics continued, but collectors' preference turned from five-colored wares to blue and white, and from single pieces to elaborate matched tea sets. The king ordered blue and white monogrammed tea sets (fig. 33 [cat. no. 137]) and Yixing tea sets as commemorations and gifts for his children and other royal family members.[25]

FIG. 33 Teapot with the monogram of Rama V (Chulalongkorn) (cat. no. 137).

Rama V was also fond of Chinese, Japanese, and Western ceramics and had them displayed in his palaces. During his reign it became fashionable among the elites to display their collections of ceramics in their homes. Later, as Western-style furniture gained in popularity, Chinese-style display cabinets and display table sets were replaced with Western-style cabinets and cupboards.

Textiles play a special role in Siamese households. Indian textiles made exclusively for the Siamese market were imported to Siam and the court of Ayutthaya beginning around the sixteenth century. The motifs were designed by the Siamese and then sent to the southeast coastal area of India for production (fig. 34 [cat. no. 131], cat. no. 130). The finest imported Indian textiles were reserved for the

court. Used both for wearing and for interior decoration, they were given as royal gifts.[26] Long cloths functioned as wall hangings, canopies, curtains, room partitions, throne and platform covers, and floor coverings.

Siamese aristocrats wore colorful textiles made of hand-woven silk and cotton. Traditional Siamese costumes required only lengths of cloth. Both men and women drew up the cloth between the legs in a dhoti-like style. Women also wore a shorter tube cloth like a skirt (*panung*). A long, narrow piece of brightly colored fabric was wrapped around the breasts (fig. 35). Clothing was generally scented and kept in large trunks.

By the reign of Rama V, Western blouses and shirts became popular. Court members and aristocrats often combined Siamese tex-

FIG. 34
Textile (cat. no. 131).

FIG. 35 A Siamese woman in the period of Rama IV
(reigned 1851–1868).

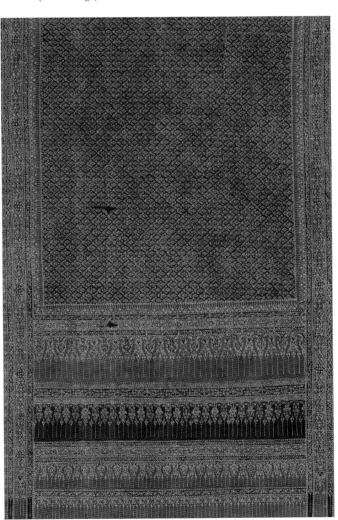

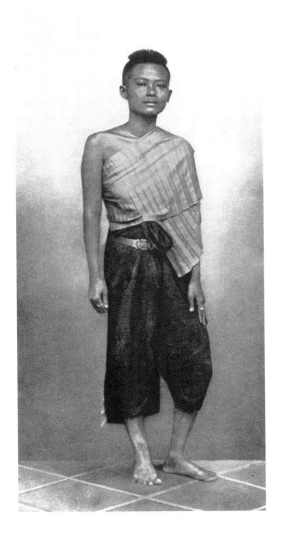

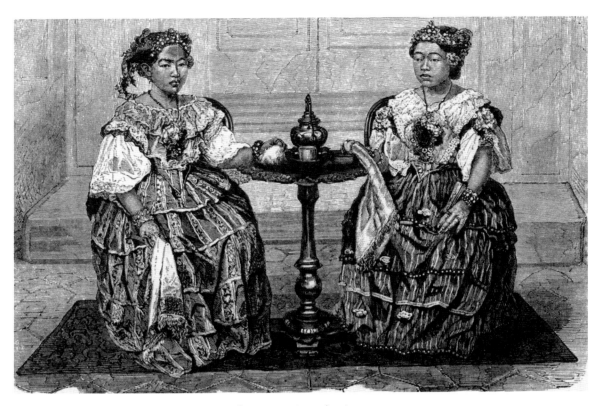

FIG. 36 "Two of the wives of the King of Siam," from Mouhot, *Travels*.

tiles with Western clothes. A typical male out-
fit consisted of an English dress coat and a
dhoti-like lower garment instead of trousers.
A court lady might wear a close-fitting jacket
decorated with lace, with a long breast cloth
worn over the jacket. This would be accompa-
nied by a traditional tube skirt or, like male
dress, a dhoti-like lower garment. Women
adorned themselves with heavy jewelry and,
instead of going barefoot, now wore stock-
ings and shoes (fig. 36).

FUNERAL CEREMONIES

A funeral in Siam was an important event
in a person's life. Because a person's present
life was not considered the last, the funeral
marked the beginning of a new life and thus
called for festivities. Dance and theatrical
performances were key parts of a funeral.
Funerals of royalty and nobility were very
ornate and required various ceremonies and
festivities.

Before the bathing ceremony, the de-
ceased was dressed in his or her finest costume
and jewelry. The family generally donated the
deceased's favorite items for everyday use—
such as betel sets, teapots, and textiles—to
temples for merit making. An ornate Indian
cotton textile formerly owned by the deceased

would sometimes be reused as a canvas for a
painting of Buddhist themes because monks
could not wear such cloths (cat. no. 68).

After being dressed, the body was laid on
a ceremonial bed for the bathing ceremony,
during which relatives poured water on the
right hand of the deceased. The body of a
royal family member or noble person was then
placed in an upright, cylindrical coffin (fig.
37) in a fetal position with the hands together
in a worshipping gesture.[27] An exterior coffin
made of gold was ornately embellished with
large medallions of gems in floral shapes. The
coffin was placed on a high platform, and set
on tables in front of the coffin were the regalia
and insignia along with some of the deceased's
favorite personal belongings (such as a betel
box, a spittoon, or jewelry). The rank of the
deceased dictated the coffin's exact shape.[28]

Every day for the first week after the death,
monks chanted and prayed for the deceased.
The remains were kept until the cremation cer-
emony, during which time they were allowed
to dry out. For high-ranking royal members
and aristocrats, sometimes the body was kept
for several years. A special cremation plat-
form, a highly stylized version of the shape
of Mount Meru, the central mountain of the
cosmos, was built at the Cremation Grounds

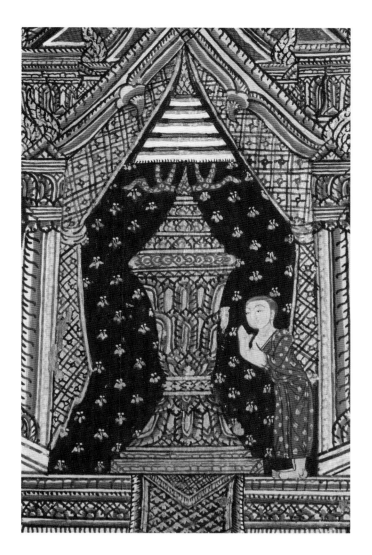

FIG. 37 The Buddha's coffin (detail of cat. no. 63). The coffins used by upper-class Siamese were similar.

(the Sanam Luang, near the Temple of the Emerald Buddha in Bangkok) or at a royal temple. On the cremation day, a procession of chariots and palanquins carrying the coffin and regalia traveled from the Grand Palace to the Cremation Grounds, then circumambulated the Meru platform three times. The largest and most ornate cremation platform in the Bangkok period was built in 1868 for Rama IV's cremation (fig. 38). This traditional funeral custom continues today for members of the king's family and certain high-ranking royalty.

The First Reign (1782–1809) was notable for its cosmopolitan literary taste. A range of classic works was translated or adapted from other Asian languages. Among these were the Chinese *Romance of the Three Kingdoms* (*Samkok* in Thai), the Javanese novels *Dalang* and

Festivals and Theatrical Performances

FIG. 38 Edifices for the cremation ceremonies of Rama IV (Mongkut, reigned 1851–1868).

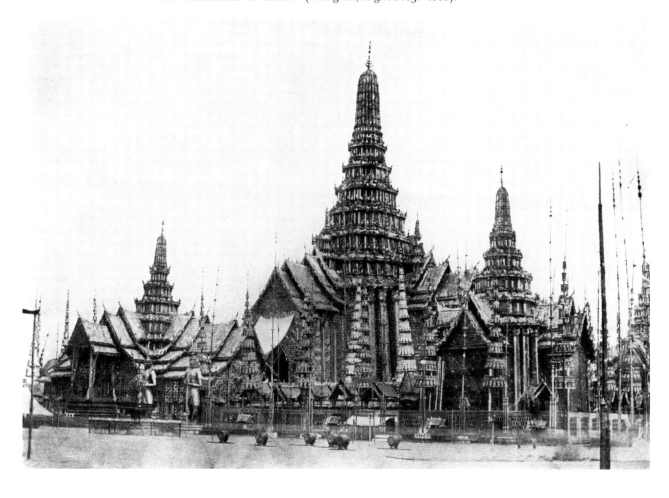

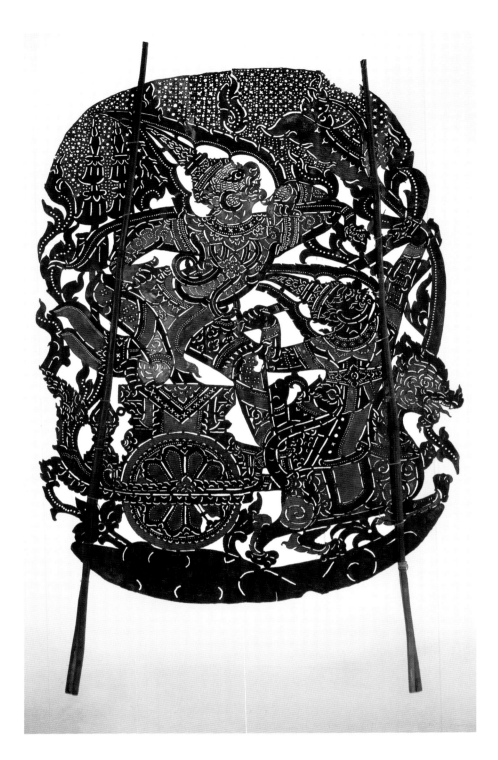

FIG. 39
Shadow puppet of the
monkey hero Hanuman
riding a chariot into battle,
from the Thai version of the
epic of Rama (cat. no. 111).

Inao, the chronicle of the Mon kings of Pegu, *Rachathirat,* and the Sinhalese chronicle *Mahavamsa.* Most important was the Indian epic of Rama. Versions of the tale had been familiar in Southeast Asia for many centuries; Rama I commissioned a significant new Thai version. All these works became major sources for classical performances of various types as well as for manuscript and mural paintings.

Among the most popular theatrical performances were the masked dance-drama of the Siamese version of the Rama epic, shadow-puppet enactments of the Rama epic (fig. 39 [cat. no. 111], cat. nos. 109 and 110), stick-puppet shows, Chinese-style opera, and other sorts of dance-drama (fig. 40 [cat. no. 107]). Such shows were accompanied by a traditional orchestra or a traditional string ensemble (fig. 41 [cat. no. 141], cat. no. 140). Besides theatrical performances, festivals sometimes included boxing, acrobats, juggling, and fireworks.

The Siamese celebrated Buddhist and domestic festivals with similar performances.

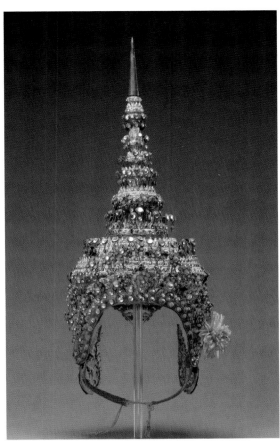

FIG. 40 Headdress for Sita in the dance-drama of the epic of Rama (cat. no. 107).

an indispensable part of royal ceremonies and various festivities.[30] An excellent example of how performances and festivities were conducted at funerals can be seen in the depiction of the funeral of Ravana in the mural painting on the walls of the Temple of the Emerald Buddha (fig. 42). The painting shows the theatrical performances presented in separate theaters around the Cremation Grounds. Such festivities continued in Bangkok until the 1940s. People of all classes attended the free performances, which lasted for seven days before the cremation ceremony. Masked dance-drama performances were also held in palace halls and courtyards.

Siamese dancers and puppets wear costumes of the same style, which reflects old court dress. The costumes, of handmade brocades and sequins, are heavy, stiff, and very tight. Some pieces may be sewn onto a dancer so the costume fits perfectly for the dance movements. The colors of the costumes and the shapes of the headdresses help differentiate a story's prominent roles. For instance, Hanuman, the monkey lord in the Rama saga, is identified by his white costume and white monkey mask. The major characters, Rama and Lakshmana, wear high-tiered crowns (cat. no. 106), and the evil Ravana wears a three-tiered crown that displays his

Simon de la Loubère, a French traveler to Ayutthaya in 1687–1688, reports that while dance performances and the masked dance-drama were presented at funerals and other ceremonies, the dance-drama without masks was performed only at the dedication of a new temple or a new Buddha image.[29] Early Bangkok literature reveals that dramas were

FIG. 41 Two-stringed instrument and bow (cat. no. 141).

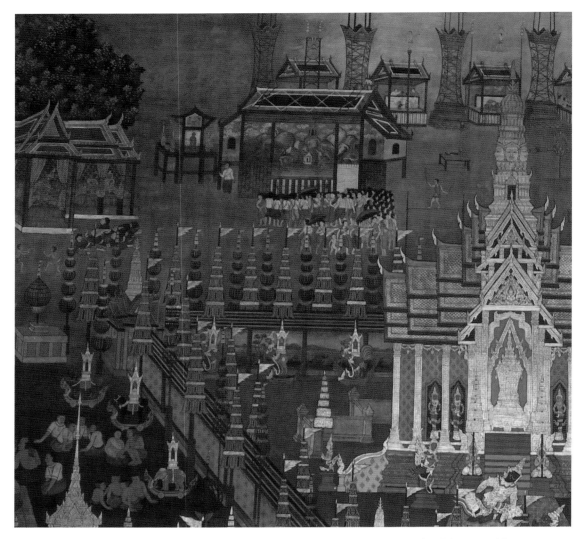

Performances and festivities at the funeral of Ravana in a mural at the Temple of the Emerald
Buddha, Bangkok. Though Ravana and his adversary Rama are supposed to have lived in
ancient India, the architecture, costumes, and activities shown here would have been typical for
a nineteenth-century Siamese royal funeral. The murals at the Temple of the Emerald Buddha were
painted during the First Reign (1782–1809) but have been restored and repainted several times.

multiple heads. They appear with their common attributes, such as bow and arrow, just like sculptures of Hindu gods. Once audience members recognize the attributes, headdresses, and costume colors, they can easily enjoy the entertainment.

Aristocrats often had their own dance troupes and musicians. Many royal performance groups specialized in specific types of dramas. On some special occasions, such as a sixtieth-birthday celebration, each royal family would bring its troupes to perform. Rama II was known for his interest and participation in various forms of theater.

MASKED DANCE-DRAMA AND DANCE-DRAMA

Masked dance-drama (*khon*) was first performed outdoors with continuous recitation by a male narrator. Under the influence of dance-drama without masks (*lakhon*), in which singing is an essential component and is interspersed with recitation and dialogue,[31] masked plays acquired characteristics more similar to those of drama than of shadow-puppet theater. The story is not divided into acts because the audience is expected to know the Rama legend thoroughly and to be able to follow the performance easily.

A typical masked dance-drama lasted longer than ten hours; audience members were not expected to watch a performance from beginning to end and could come and go freely. The only prohibition was that they were not allowed to cross the stage, which was open on three sides. Because of the difficulty of hearing dialogue outdoors, masked dance-

drama performances eventually began to be held indoors. Today masked dance-drama performances in Bangkok focus on specific, shorter episodes, such as the Abduction of Sita or the Burning of Lanka.

The masked dance-drama is considered the most difficult form of Siamese dance. Performers require several years of training from an early age so that their bodies are flexible and can endure difficult bending, lifting, and jumping positions. Dancers are frequently selected to train for specific roles because of their build or size.

Dance-drama plays (*lakhon*) flourished in the early Bangkok period. The two main types, court drama and folk drama, were originally quite different in the late Ayutthaya and early Bangkok periods, but as they borrowed from one another they became almost indistinguishable. Court dramas were traditionally performed in palaces and the homes of aristocrats, while folk dramas were performed during popular temple festivals. Court-drama scripts were written by people of rank and performed by women with sumptuous costumes adopted from *khon* dance-drama. In contrast, folk dramas were performed by men in costumes of inexpensive cloth,[32] accompanied by lively music, singing, storytelling, dance, and improvisation. In present-day Thailand, dance-dramas are performed by both men and women, depending on the story.

SHADOW PUPPETS

Shadow-puppet theater was a traditional form of entertainment in Siam. Its sole story was the Siamese version of the Ramayana epic. A shadow-puppet performance involved manipulating cut-out figures behind a backlit translucent screen. A male narrator, accompanied by a Thai classical orchestra, told the story.

Shadow puppets were generally made of cowhide or buffalo hide (cat. nos. 109–111). Because of their large size (approximately six feet high), each required the skin of one calf. After the skin was dried, it was painted with soot made from coconut husks. The artist sketched the figure's image on the skin, and the figure was then carefully cut out, perforated, and colored. Two long bamboo sticks attached to the sides were used by the pup-

pet master to manipulate the figure. During a performance, puppet masters held the heavy puppets aloft while dancing, mimicking the characters' movements.

THE FATE OF TRADITIONAL THEATER

Traditional forms of theater lost their popularity among the Siamese upper classes as Western influences eventually dominated their lifestyle in the second half of the nineteenth century. Aristocratic taste shifted to a preference for dramas based on Western literature, such as Shakespearean plays. Rama VI, who was educated in England, translated various Shakespeare works into Thai as well as producing and performing in the plays. Although the king did not neglect traditional arts, Western dramas attracted him and the court circle. Nonetheless, such Western aesthetics were foreign to ordinary people. When the sponsors of festivities moved away from local literature, it became apparent that traditional theater could not survive. Not until around the late 1950s were traditional performances of classical dramas revived and promoted by the government.

Conclusion

In the early part of the Bangkok period, Siamese aristocrats may have used more luxurious household belongings than did townspeople, but the lifestyles of the two groups were not distinctly different. Buddhist temples were the center of community life, and Buddhist celebrations dictated monthly activities at all levels of society.

The objects on display in this exhibition reflect upper-class life. Ordinary people's belongings were simpler and made of less expensive materials, but their functions were similar.

By the middle of the nineteenth century, in Siam as in other Asian countries, items associated with Western living (furniture, clothing, dishes, and Western curios) and advanced technology (such as printing and steam-powered transportation) drastically changed the life of the nobility. Concerned about relations with the West, Rama IV and Rama V embraced various aspects of Western culture and recommended them for others.

Western-style buildings, furniture, decorative arts, and clothing were used to project a modern image of Siam. Royalty and aristocrats decorated their homes with Western decorative arts such as glassware, as well as with ornate traditional Chinese and Thai objects. They also adopted new styles of clothing and hair. Within a short period, Western customs also affected the townspeople of Bangkok, though traditional living continued for many more decades outside the capital.

By 1900, young aristocrats and government-funded students were returning home from study and travel in Europe. The new flood of technology and European ways of life they brought made an even greater impact on Siamese life. By this time, many of Bangkok's canals had been covered up to make way for large boulevards, and boats were replaced with cars, trams, and trains.

The most important change occurred when a military coup toppled the absolute monarchy in 1932. Rama VII abdicated, and the new political leader, Phibunsongkhram (aka Phibun),[33] changed the name of Siam to Thailand in 1939 on the grounds that it would signify a new Thai identity and that the country belonged to the Thai. The historian David Wyatt remarks that Phibun's new Thai identity was in many respects as much Western as Thai.[34] Between 1939 and 1942 the government issued a series of twelve Cultural Mandates, all of which Phibun claimed were necessary in the interest of progress and civilization. The citizens of Thailand were encouraged to live their lives along "modern" lines.[35] They were required to dress in modern fashion: men had to wear coats, trousers, and shirts and ties; women had to wear skirts, blouses, and gloves. Hats had to be worn to board buses or to enter government offices. Obviously these new dress codes were hardly suitable for the warm and humid weather of Siam. Outside of the capital city, lives changed more slowly, but by 1960 no region had not seen its ways of life transformed.

Notes

1 Wyatt, *Thailand: A Short History,* 146.

2 Ibid., 145–146.

3 Prince Naritisaranuwattiwong and Prince Damrong Rajanubhab, *San somdet,* vol. 10, 289–290. These ten ceremonies were probably derived from Hindu rituals: the three-day ceremony, one-month ceremony, teeth ceremony (between seven and nine months), one-year-old ceremony, three-years-old ceremony, shaving of the topknot ceremony (between nine and eleven), thirteen-years-old ceremony and novice and nun ordinations, marriage ceremony (between sixteen and nineteen), monk ordination (twenty-one years old), and twenty-five-years-old ceremony.

4 Chulalongkorn, *Phraratchaphithi sipsong duean.*

5 Visakha Puja (Thai: *wisakha bucha*) is celebrated on the full-moon day of the sixth month of the Thai year. That day Buddhist practitioners attend a ceremony commemorating the Buddha's birth, enlightenment, and death.

6 For further information on divination, see Wales, *Divination in Thailand.*

7 Skilling, "For Merit and Nirvana," 76.

8 Every day this long lock of hair was combed, oiled, and tied in a small knot. It was decorated with a jewelry pin, often encircled by a small garland of flowers.

9 The ceremony was much more ornate for the king's children: a huge architectural model of Mount Kailasha, the dwelling place of Shiva, was constructed in which the prince or princess bathed after the shaving of the topknot. See Gerini, *Chulakantamangala.*

10 Commoners borrowed the implements from relatives or temples. Until around the reign of Rama V, the government held a public ceremony for the lower classes near the brahman shrine in Bangkok (Bot Phram). Each child received a small silver coin as a souvenir. Rama V remarks that in general around 150 to 390 children attended the public ceremony, with the number increasing every year; Chulalongkorn, *Phraratchaphithi sipsong duean*, 108. See also Young, *Kingdom of the Yellow Robe,* 82–83.

11 Rama IV also hired a foreign teacher, Anna Leonowens, to teach English to the royal children in the palace. By the reign of Rama V young princes were sent to school in Europe; the first group of princes went to England in 1885.

12 For further information on the Mahachat, see

Nidhi, *Pen and Sail*, 203–208. Nidhi explains that in the central region, reciting the Mahachat took three days. On the first day the monks chanted the "Thousand Verses" from beginning to end. Recitation of the Thai version started on the second day. The "Noble Truths" were recited on the third day. Today monks begin chanting the "Thousand Verses" before dawn in order to finish by the end of the day. Then they recite the Thai version the following morning when the laity participates in the ceremony. Recitation of the Thai version can take as many days as are required.

13 Chulalongkorn, *Phraratchaphithi sipsong duean*, 74–75.

14 Baker and Pasuk, "Phlai Kaeo Ordains as a Novice," 96, nn. 47 and 49. See also these scholars' wonderful web resource on *Khun Chang Khun Phaen* and its translation at http://pioneer.netserv.chula.ac.th/~ppasuk/kckp/index.htm. On the ceremonies for the recitation of the "Great Life," see Anuman, *Thet Maha Chat* (which is in English); and other references listed in McGill, "Painting the 'Great Life.'"

15 Young, *Kingdom of the Yellow Robe*, 324–325.

16 Nidhi, *Pen and Sail*, 200.

17 On paintings and performances of the Vessantara story in the northeast, see Lefferts, "Bun Phra Wet Painted Scrolls of Northeastern Thailand."

18 Young, *Kingdom of the Yellow Robe*, 344–345.

19 Between 1938 and 1944, General Phibunsongkhram, the third prime minister of Thailand, issued Cultural Mandates for the purpose of "uplifting the national spirit and moral code of the nation and instilling progressive tendencies and a 'newness' into Thai life"; Wyatt, *Thailand: A Short History*, 255.

20 Western visitors often remarked in their traveling accounts about these three main dishes. It is curious that betel was included as part of the meal. Chinese noodles and savory preserved meat—dried beef seasoned with salt, sugar, and spices such as coriander seed—are both still common Thai comfort foods.

21 Teak is known for its strength and its resistance to insects.

22 Commoners' houses were made of teak or bamboo. Roofs were thatched with dried leaves, which needed to be replaced every few years.

23 The butlers, cooks, maids, and gardeners lived in other smaller houses in the same compound.

24 Neither Rama V nor Prince Damrong mentions the date of the first competition in their writings, but it was probably held after 1861 because it followed the Second Opium War (1856–1860).

25 Chulalongkorn, *Phraratchaphithi sipsong duean*, 435–437.

26 I am grateful for the advice of John Guy, a curator at the Metropolitan Museum of Art, concerning Indian export textiles to the Siamese court; Guy, *Woven Cargoes*, 127.

27 For commoners, the bathing ceremony was similar, but the coffin was rectangular. Although their funeral activities were more modest than those of the upper classes, people still provided festivities to celebrate the dead before the cremation. The body was cremated at a temple's crematorium.

28 For further information about royal funerals, see Sompop, *Phramerumat phramen lae men*.

29 La Loubère, *The Kingdom of Siam*, 49.

30 Nidhi, *Pen and Sail*, 47.

31 Ibid., 34.

32 Ibid., 42.

33 Born Plaek Khittasangkha, he received military training in France from 1924 to 1927. As an army general, he was granted the rank and title Luang Phibunsongkhram in 1928. An admirer of Mussolini and Hitler, he was prime minister between 1938 and 1944 and between 1948 and 1957.

34 Wyatt, *Thailand: A Short History*, 253–255.

35 Ibid., 255.

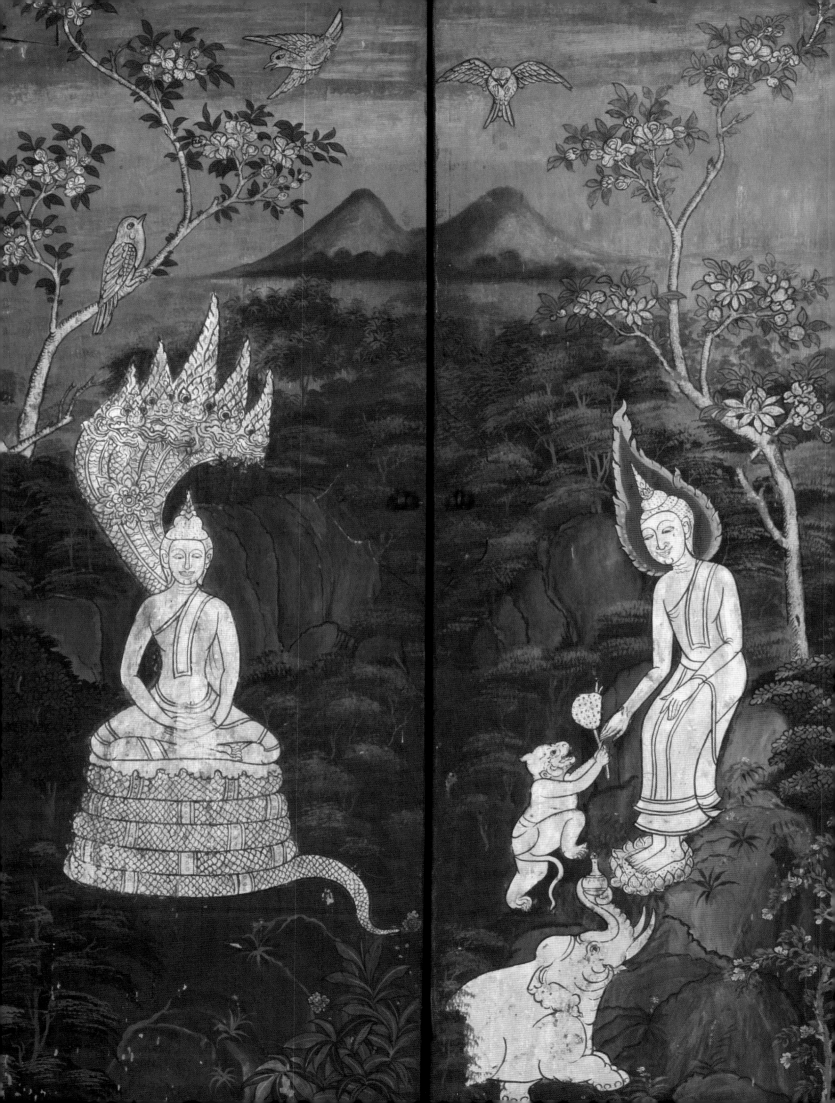

SIMILAR YET DIFFERENT
BUDDHISM IN SIAM AND BURMA
IN THE NINETEENTH CENTURY

Peter Skilling

T his essay concentrates on the Buddhism of central Siam from the late eigh-teenth century to the early twentieth century, especially the royal Buddhism of the capital as expressed in art, architecture, and ritual. I do not mean to deny the importance of regional Buddhism(s) or to marginalize the periph-eries, but the center is much better documented and can be presented as a coherent—and at the same time diverse and creative—set of ideals and representations.

In 1785 Rama I of Siam turned back a Burmese invasion, decisively defeating the invaders. In a poem written to describe the battle and to celebrate the victory, he declared:



I will devote heart and mind
To elevate and exalt Buddhism.
I will ensure the safety of the entire realm
And protect the people and the nobles.



Bangkok— Restoration and Innovation

These lines—even if only the dramatic sentiment of a poem—set the pattern for the dynasty that Rama I had founded in 1782. His successors all devoted themselves to the support of Buddhism, and throughout the nine-teenth century Bangkok was a dynamic hub of Buddhist activity.

The eighteenth century saw the expansion of Siam, Burma, and Viet-nam, the three great powers of mainland Southeast Asia. In the nineteenth century the situation became more complicated as the ascendant colonial powers of Britain and France moved into the region. Dynasties rose and fell, and trade and power relations were radically transformed. This was an age of encounters and expanding borders; relations between center and periphery were redefined, and states and polities that had enjoyed political and cul-

tural autonomy were absorbed by their neighbors. Clashes were inevitable. In 1767 Burma attacked Siam and sacked the capital, Ayutthaya. The Thai rallied and established a new capital in Thonburi on the west bank of the Chao Phraya River. In 1782 Rama I moved the capital across the river to Bangkok, where it remains to this day.

The destruction of Ayutthaya had been traumatic. The ruined city lay only about fifty miles to the north of the new capital, and the sprawling ruins stood as a painful reminder (fig. 43). Memory gave continuity to the collective and renascent identity, but at the same time the defeat and devastation remained a disturbing presence. When the poet Sunthon Phu passed the ruins in 1807, he wrote:

> I see the temples along the riverbanks;
> The reality that I see with my own eyes
> Is more than I can remember and
> memorialize in writing.
> I see the holy stupas everywhere—
> Teaching halls, ordination halls, and
> monks' residences, all in ruins. . . .

> Alas, impermanent—O capital bereft of
> a king,
> Deserted and forlorn, like a wilderness.
> Once the city swarmed with people. The
> din resounded in city and palace—
> Orchestras, oboes, and drums, the
> boisterous sound of bugles and
> conch-shells.
> Look at the capital now, and realize
> impermanence.
> Now there is only the sound of birds
> And the riverbanks are overrun by
> elephant grass.

Rama I initiated a remarkable reconstruction, renovating old temples and building new ones. Nobles participated in the great enterprise. To build a temple was a complex religious, social, and economic undertaking. Public and communal, it was very much a family affair; it accrued spiritual merit for the donor, who would dedicate the merit to deceased ancestors. To build a temple did not just mean to erect a building or two. It was an expensive, long-term commitment. The

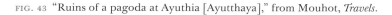

FIG. 43 "Ruins of a pagoda at Ayuthia [Ayutthaya]," from Mouhot, *Travels*.

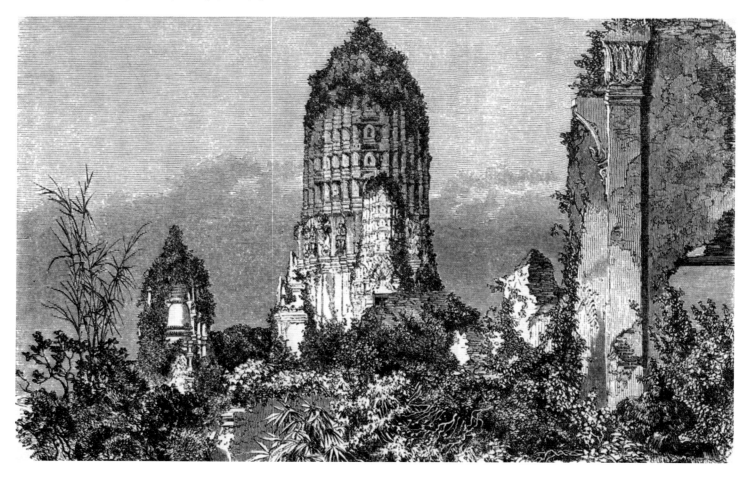

donor had to decorate and equip the temple, to endow it with lands and serfs (rather like medieval "glebe lands" in Europe), and to invite monks to take up residence. When everything was ready there would be a grand celebration, a public festival lasting several days. The donor displayed his social status and power, and gained the satisfaction of having done something to support Buddhism.

Starting in 1797 Prince Men (son of the deposed King Taksin and a daughter of Rama I) renovated a ruined temple to the north of the new capital, taking nearly ten years to complete the work. A poem inscribed in golden letters on a large teak slab describes the renovation. The prince had been inspired to renovate the temple when he saw its dilapidated condition:

> In the temple at the end of the narrow
> channel of Samsen Canal
> I observed that the precincts were a wild
> marsh, overgrown with rushes and
> reeds.
> The temple was in dire straits—no
> longer was it beautiful,
> No longer did it glitter with glass and
> gold.
> There was no assembly hall, only a small
> thatched-roof cell.
> This was no fit place for the Holy
> Conqueror of King Mara;
> It was pitiable, as if the Buddha sat
> amidst the jungle grass.
> It was a difficult place for the monastic
> regimen,
> For monks with faith seeking to
> progress in dharma.

In 1801 Rama I and his younger brother, the deputy king, favored the temple with a visit, coming up the river in a large boat procession:

> The two righteous kings
> Who live in the great capital
> Came by river with their royal retinues
> In a grand flotilla.
>
> When they arrived they stayed in a
> temple pavilion

> And discussed the perpetuation of the
> Buddha's religion
> To the accompaniment of music
> And a hubbub of ebullient cheers.

As the kingdom recovered, the Siamese court and the monastic community renewed contacts with their Buddhist neighbors and with Sri Lanka, a place that the Siamese (and Burmese) saw as a center of Buddhist orthodoxy. Rama I began to take a leading role in the promotion of Buddhism in the region. Rama II sent a monastic delegation to Sri Lanka, by then under British rule; it was well received and returned in 1818 with six bodhi-tree saplings. Rama III sent two missions; they returned with scriptures and letters from high-ranking monks to Prince Mongkut (the future Rama IV), who at the time was still a monk. After Mongkut ascended the throne he sent one delegation to Sri Lanka, in 1852.

The Buddhism of Siam was anything but static. It was dynamic and cosmopolitan, continually responding to currents and countercurrents in society, to new techniques, knowledge, and ideas. The idea that Theravada (the school of Buddhism followed in Siam as well as in Sri Lanka, Burma, Cambodia, and Laos) is "conservative" was a nineteenth- and twentieth-century idea, based on multiple misconceptions. This idea was part of an "orientalist parcel" in which the East was static, and reform could only be inspired by the prodding or the civilizing example of the West. Buddhism had in fact always been self-reforming; it had the potent ideological model of King Ashoka of India (third century BCE) and developed its own internal momentum.

Prince Mongkut spent twenty-seven years as a monk during the Third Reign, before ascending to the throne in 1851 at the age of forty-seven. As a monk the prince was at the center of a regional network of monk scholars. He exchanged letters written in Pali (the learned language of many Buddhist texts) with his fellows in Sri Lanka and Arakan (in western Burma), developing a special script for the purpose. He set up a printing press using this "Ariyaka" script, hoping to promote it as an international writing system that could spread the teachings of the Bud-

dha. But his hopes were not fulfilled. The glo-balization of Buddhism did not lead to the use of a single writing system. Other Buddhist cultures adapted their own vernacular systems to the ancient sacred language of Pali and printed Pali texts in the writing systems of such languages as Mon, Burmese, Cambodian, Shan, Lao, Sinhala, and so on. In India and Nepal the north Indian Nagari script was used, as well as, less extensively, other scripts like Bengali. In Europe and Japan the roman alphabet was used for both Pali and Sanskrit, as it is today.

The nineteenth century was a time of sweeping change, of social movement and technological innovation. Immigration from China grew steadily, and the Chinese role in the exploitation of natural resources, the supply of materials, the burgeoning construction industry, and in business and finance increased proportionately. The hybrid culture of Bangkok readily absorbed new techniques, styles, and ideas. Rama III favored Chinese styles, and temples built during his reign often followed the so-called "preferred royal style." Of the seventy-four monasteries built or renovated during his reign, about one quarter have major buildings in Chinese style—with the caveat that this was often a happy blend of Thai, Chinese, and European materials, techniques, and designs.

Seventeenth-century Ayutthaya had already experimented with European architecture; in the time of Rama IV Western-style buildings increased (fig. 44). Some temples had stained-glass windows; perhaps the most famous is the temple at Bang Pa-in near the old capital. Built to resemble a Gothic church, it was the inspiration of Rama V, who wanted to "offer something unusual to the Buddha."

FIG. 44
"The new palace of the King of Siam, Bangkok," from Mouhot, *Travels*.

Buddhist Devotion

At the core of Buddhist devotion and practice are the "Three Gems," three things so precious and rare that they are like jewels—the Buddha, the dharma, and the sangha. The Buddha is the "Awakened (or Enlightened) One" who discovered the truth of existence nearly 2,500 years ago. The dharma is the truth that he discovered and the teachings that he bequeathed to the world. The sangha is the monastic order that he established. Physical relics and images represent the Buddha; scriptures and practices represent the dharma; and the sangha is the community of monks who preserve and transmit the dharma.

THE BUDDHA AND THE
IMAGE OF THE BUDDHA

Devotion centered on the figure of the Buddha. Daily chants in Pali (which were explained in Thai) praised his many virtues and good qualities. However, as expressed in a Pali poem, his virtues are beyond human calculation:

> If a person had a thousand heads,
> Each head with a hundred mouths,
> And each mouth with a hundred
> tongues;
> If he had great supernormal power,
> And if he could live for an eon—
> He would still be unable to enumerate
> The virtues of the Teacher in full.

Images of the Buddha are not mere art objects displayed for beauty, as in a museum. The physical beauty of the Buddha himself is extolled in texts, and it was an inspiration for image makers and devotees. But aesthetic effect is only one aspect of the Buddha image, which is more than a simple statue. The image is treated as if it were the Buddha himself, and the worshipper has a living relation to the image, expressed through offerings and ritual. Kings formally grant names to images, and a special vocabulary is used when speaking of or to them. For example, one does not *carry* or *move* an image—one *invites* it. Devotees offer robes to the Buddha, just as they offer robes to the monks; the king donates sets of robes to images in royal temples and personally changes the costume of the Emerald Buddha three times a year.

Reshuffling images

Images and relics of the Buddha were central to the life, politics, and art of the region. Statues like the peripatetic Emerald Buddha have their own biographies, composed in Pali in the fifteenth century. According to these texts, five hundred years after the passing of the Buddha the divine architect Vishvakarma fashioned the Emerald Buddha from a block of precious stone that Indra, king of the gods, had obtained for the purpose from the demons on a mythical mountain. Obviously, this is not an ordinary statue. It is said to have begun its career in north India and traveled to Sri Lanka, Cambodia, central Thailand, northern Thailand, and northern Laos before settling down in Vientiane, capital of the central Lao kingdom. It remained there for 225, years until 1778, when the Siamese King Taksin's forces, having invaded the Lao kingdom, brought the image to the new capital of Thonburi. In 1784 Rama I "invited" the image across the river to preside in Wat Phra Si Rattanasatsadaram in the Grand Palace, where it remains to this day. Part of the long formal name of Bangkok instituted by Rama I can be interpreted as the "residence of the Emerald Buddha."

Revered images are often copied, and the power of the original can be ritually transferred to the new statue. Copies of the Emerald Buddha can be seen in temples all over Thailand. In the twentieth century the color photograph became a new means to replicate revered images.

Rama I had hundreds of images brought down from the ruins of the old cities of Sukhothai and Ayutthaya. He had them restored and placed in temples—for example, in the galleries of Wat Phra Chettuphon (Wat Pho) (see fig. 6, p. 9). The largest image that he invited from Sukhothai is the "Shri Shakyamuni" (fig. 45), brought down the river by boat in 1808. This was an enormous operation, and a city gate had to be dismantled to let the immense statue in. It was then pulled from the landing, which to this day is called "The landing place of the Buddha image" (Tha Phra). People worshipped the image as it passed the palace, houses, and shops. Even though he was ill at the time, the king joined

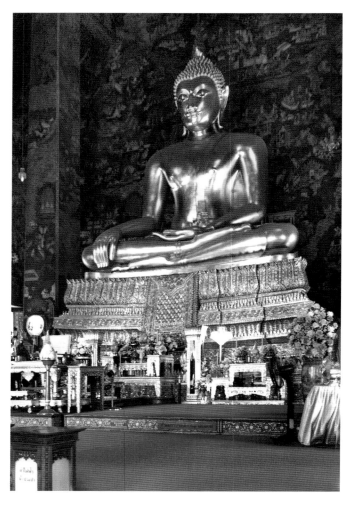

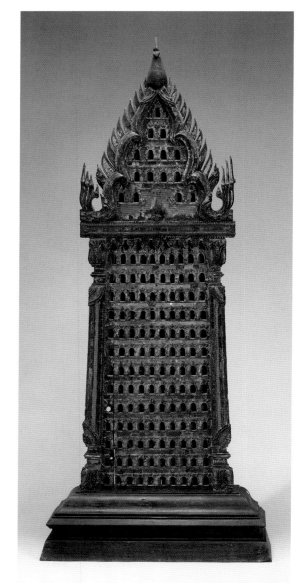

FIG. 45 (*above*) Large Buddha image called "Shri Shakyamuni," at Wat Suthat, Bangkok.

FIG. 46 (*right*) Buddhist tablet board (cat. no. 101).

the procession in his bare feet. The huge hall for the image was not begun until the reign of Rama II, and it was not finished until the time of Rama III.

Rama I began a trend, and today images brought from Sukhothai grace many Bangkok temples. Several images were invited from tributary states, such as the Lao images enshrined in various temples. Some statues, however, did not get on well with each other. The Phra Bang, a standing image that the Lao believe came originally from Cambodia, was brought from Laos by King Taksin together with the Emerald Buddha. Rama I sent it back to Laos to promote good relations. When Rama III conquered Laos, the Phra Bang was brought back again to Bangkok. But Rama IV, influenced by a belief that drought would follow if the Emerald Buddha

and the Phra Bang were kept in the same city, returned the statue to Laos, where it remains to this day as the palladium of Luang Prabang. This old royal city is named after the image.

Images of all sizes

Some fashions carried over from Ayutthaya were perpetuated in Bangkok. Images were gilded and set up on high thrones. Many were large, and some were huge. The largest in Bangkok was at Wat Kanlayanamit. At the other end of the spectrum were tiny images, some less than an inch high. Sometimes these images were fixed in rows in specially made stands or "tablet (or amulet) boards" (fig. 46 [cat. no. 101]). The stand becomes a small shrine enclosing the power of multiple Buddhas. At a temple in Nonthaburi, the poet

Sunthon Phu paid homage to 84,000 small molded Buddhas set in the wall. Small images were also deposited beneath the main Buddha image in a temple hall or in stupas.

The Buddha in royal attire

The Buddha in royal attire—the crowned and adorned image—had a long and complex evolution. By the mid-Ayutthaya period it was connected with the "Story of King Jambupati," in which the Buddha assumed the appearance of a magnificent "Supreme King of Kings" in order to subdue a proud king named Jambupati. In the nineteenth century the story was treated as an episode in the life of the Buddha in the murals of the Phutthaisawan Chapel in Bangkok. The legend was recited in "three-throne sermons,"

. .

CONJUGATING BUDDHAS IN THERAVADA BUDDHISM
PAST, PRESENT, AND FUTURE

One Buddha

Many people think of the Buddha in the singular. There was one Buddha. He was a man who was born in the foothills of the Himalayas, in what is today Nepal. The son of a local ruler, he grew up in luxury. At the age of twenty-nine he left the palace behind and set out in quest of the truth. For six years he experimented with meditation and yoga techniques of the time and even practiced harsh austerities, fasting until he became weak and emaciated. None of this worked. This experience led him to discover the "middle way" between indulgence and self-deprivation. Adopting this way, he attained his goal; seated beneath the canopy of a great fig tree, he at last understood the realities of human existence. From this time on he was known as "the Buddha," which means "the Awakened (or Enlightened) One." His clan name was Gautama, and in English he is often called "Gautama Buddha." He taught tirelessly for forty-five years, traveling on foot over wide areas of northern India. He established a religious order of monks and nuns, who preserved and transmitted his teachings after his death. Tradition is not unanimous about when he died. The date accepted in Siam is 543 BCE; in Burma and Ceylon it is 544 BCE.

Five Buddhas

But tradition places the Awakened One in a much grander and more elaborate frame. Time is told in eons, vast periods that we cannot calculate or imagine, during which Buddhas come and go. The present eon is a "Fortunate Eon" because it is beautifully adorned, as the texts say, with as many as five Buddhas—the maximum number of Buddhas who can appear in any single eon. It is "fortunate" because we have the chance to meet Buddhas and to pursue our own spiritual welfare. "Our" Gautama is the Buddha of the present age, but he is fourth in line in this Fortunate Eon. The Buddha to come is named Maitreya. At present he dwells in one of the higher heavens, and when his time comes he will descend to earth, and, like Gautama and his earlier predecessors, he will achieve awakening and become a Buddha.

Seven, Twenty-four, and Twenty-eight Buddhas

There are other ways to count past Buddhas. Buddhas existed before our current "Fortunate Eon," and we can count back to list seven Buddhas, including Gautama—a number often depicted in early Buddhist art in India. Going back further still, we can find twenty-four or twenty-eight Buddhas. Going back even further, there can be 512,028, 1,024,055, or 2,048,109 Buddhas.

What do these numbers signify? Several answers are possible. One is that the notion of Buddhas of the distant past gives Gautama Buddha a respectable pedigree in relation to the deities and mythologies of other Indian religions, which also dealt with vast time periods in which gods and avatars descended to earth or returned to heaven. The past and future Buddhas are also called on for assistance in the liturgies recited by monks and lay followers.

Note: In the Mahayana and Vajrayana schools of Buddhism there are many more Buddhas, including five or more "cosmic" Buddhas. Some, such as Amitabha, the Buddha of the Western Paradise, are widely worshipped.

in which three monks, facing each other on high preaching thrones, took the parts of different characters. Several temples in which the main image is a crowned Buddha (at Wat Mahathat in Phetchaburi, Wat Nangnong in Bangkok, and Wat Ruak in Luang Prabang, Laos, for example) had mural paintings that illustrated the story of Jambupati. Most are now damaged, but occasionally the narrative can still be made out.

Not all royally attired images refer to the Jambupati story, and the significance of each crowned Buddha must be sought from its context. In some cases a crowned Buddha may be the future Buddha, Maitreya (fig. 47 [cat. no. 50]). In other cases royally attired Buddhas were dedicated to deceased royalty. Rama III dedicated two standing adorned Buddhas to his predecessors. The names he gave to the statues became the posthumous names of the two kings: Phra Phutthayotfa Chulalok is Rama I, and Phra Phutthaloetla Naphalai is Rama II. Today the Buddhas flank the throne of the Emerald Buddha in the temple in the Grand Palace. In this multilayered ideology, the regalia relate the Buddha and deceased royal ancestors to the Universal Monarchs (*chakravartin*) of Buddhist lore.

Thirty-seven Buddhas

The values of late-eighteenth- and nineteenth-century Siam were creative and experimental. Rama III requested one of the leading scholar monks of the time to prepare drawings for a new series of Buddha images based on the ancient texts. The result was thirty-seven postures, each representing an episode or aspect of the life of the Buddha. Some of the postures, like the reclining Buddha entering Nirvana, were well-known "universal" postures from India. Others followed old Thai traditions not known elsewhere. Several were innovative and evocative, such as "the Buddha threading a needle" (the monks, including the Buddha himself, sewed their own robes). The king had thirty-seven bronze images fashioned on the basis of the sketches. His successor, Rama IV, dedicated one statue each to the thirty-seven kings of Ayutthaya and had them installed within the shrine complex of the Emerald Buddha. The number of images

in the series of postures was never fixed. The set of relief paintings at Wat Thong Noppakhun, dating to 1915, has ninety.

Seven great sites

The scholar engaged by Rama III also made sketches for images representing the "seven great sites"—places in the vicinity of the Bodh Gaya in northeastern India where the Buddha spent the first seven weeks after his enlightenment. The sites were represented in mural paintings, on gilded lacquer cabinets (one of the sites is referred to on fig. 48 [cat. no. 57]), and in the compound of the great temple of Wat Suthat in Bangkok. The idea of the seven sites is also important in the Buddhology of Sri Lanka and Burma. In Siam they were depicted in the illustrated "Three Worlds" (Traibhumi) manuscripts, and a liturgy of simple Pali verses pays homage to the sites.

Three floating brothers

The miraculous origins of images such as the Emerald Buddha are recorded in their legendary biographies, canonized by the use of the prestigious Pali language. Other images do not have formal biographies; their stories were passed down orally and eventually written down in Thai and printed for distribution by temples. Today three highly revered images—three "brothers"—reside in their own temples in the Chao Phraya River delta. From the viewpoint of art history the images are quite different, but their origin myths state that they started out together and floated majestically, seated cross-legged, down the waterways from the north. In due course they separated and carried on their individual ways. Along the riverbanks villagers beseeched the images to stop but they refused to do so, continuing until they reached their predestined homes. Versions of the story vary; sometimes there are as many as five Buddhas. One of the "brothers" is Luangpho Sothon in the town of Chachoengsao, who is visited by thousands of people every day. Vows to Luangpho are especially efficacious, and on weekends and holidays his temple hums with activity and is thick with incense. Devotees offer him baskets of boiled

FIG. 47 (*facing*) Seated crowned and bejeweled Buddha, or Maitreya (cat. no. 50).

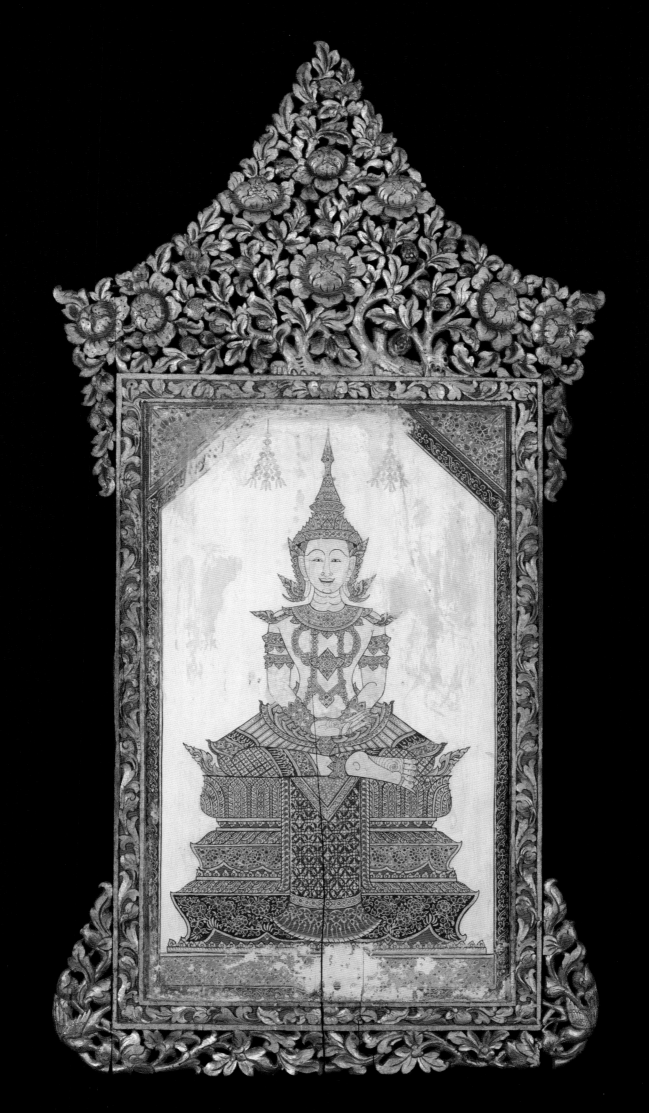

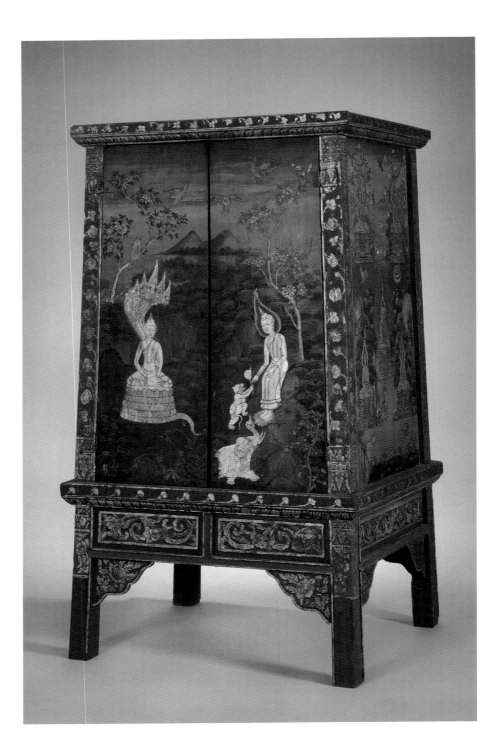

FIG. 48
Manuscript cabinet with
scenes of the life of the
Buddha (cat. no. 57).

duck eggs and sponsor performances of tradi-
tional dance and music for him to enjoy. This
is the result of one of the essential features
of Thai Buddhism, the "exchange vow": one
asks the Buddha for a favor or a blessing and
promises something in return. In this case, it
is believed that Luangpho Sothon is fond of
duck eggs.

THE DHARMA—TEXT AND PRACTICE

On the eve of his passing, the Buddha an-
nounced that he would not appoint a succes-
sor—instead the dharma, his teaching and the

truth, would be the refuge for his followers.
The dharma, then, is the representative of the
Buddha. In some mural paintings the narra-
tive of the Buddha's final days and final nir-
vana is followed by the first council, which
was held just after his passing to recite, col-
late, and preserve his teachings. This shows
the continuity between the living Buddha
and his dharma.

Scriptures and study

Study meant to learn to read and write, to
learn Pali grammar, and to learn how to

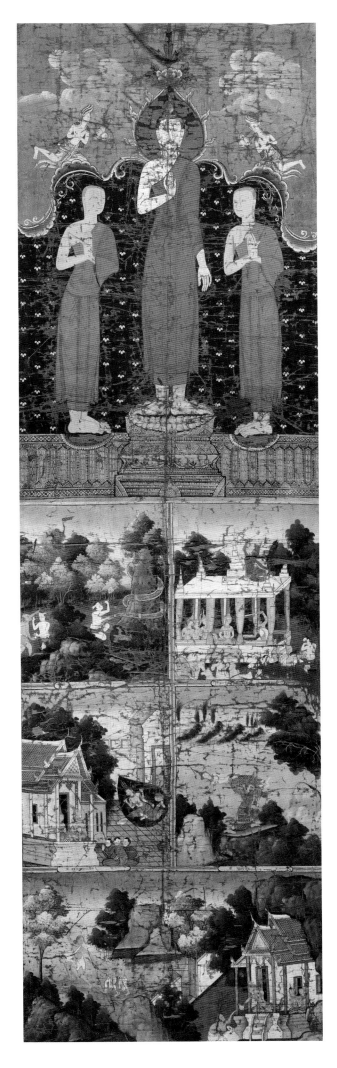

interpret the texts. In the premodern period,
education was offered in the temple and the
court and was weighted heavily in favor of
males. Memorizing texts for liturgical and
ritual purposes was important—the recitation
of texts for blessing and protection was one
of the basic duties of a monk.

The collection of Buddhist texts in the
Pali language is known as the Tripitaka, in
English often called the "Pali canon." "Canon"
has several meanings. The "Pali canon,"
shared by all Buddhists in the Theravada lin-
eage, is a canon in the sense of "a collection
of sacred books accepted as authentic." The
ordinary Buddhist did not have direct access
to the Tripitaka, and even monks did not
read it from cover to cover. The Tripitaka was
a source collection, a database for monastic
and court scholars. No complete translation
into Thai, Burmese, or any other language
existed until the second half of the twenti-
eth century; the Tripitaka was mediated by
monks through sermons, through vernacular
recitation texts, through ritual, and through
art. In the sense of a body of works that were
used, the canon was a wider, fluctuating, and
unbounded collection. In Siam it included
texts unknown in Sri Lanka (thought of as
the font of Theravada orthodoxy), such as the
"apocryphal" *Fifty Jatakas* (*Paññasa Jataka*).

In the Ayutthaya period (1351–1767) the
most important works were the Jatakas, par-
ticularly the Ten Jatakas, and above all the
Vessantara Jataka, the longest and the last
story in the Pali collection. The five hundred
Jatakas of the collection were rarely depicted
as a complete set; the notable exception is at
Wat Khruea Wan in Bangkok, where each
Jataka is given a single frame (see Skilling,
ed., *Past Lives,* 105–107 and passim) (fig. 49
[cat. no. 69]). Certain Jatakas were transmit-
ted separately—for example, the story of "Six-
tusks" (*Chaddanta*), when the bodhisattva
(the Buddha-to-be), reborn as a six-tusked
elephant, sacrificed his life to a hunter. Closely
related to the Vessantara Jataka in both nar-
rative and ritual is the story of Phra Malai.
The life of the Buddha was told in the many

versions of *Pathomsomphot*. One of the most widely used collections was the "Seven books of the Abhidharma" (*Aphitham chet khamphi*). Despite the metaphysical sound of its title, it is in fact a collection of extracts from the seven books of the Theravada *Abhidharma,* which textbooks often call "Buddhist philosophy," for recitation at funerals.

Cosmology was an important subject, and a rich literature was produced in Pali and in Thai. Cosmology situated the individual and society in space and time within a universe that was much vaster than that of, say, Christian Europe of the Middle Ages. World systems stretch without limits in all directions; they evolve and dissolve over eons. Buddhas appear in some eons, but in other "empty" eons there are no Buddhas. Whatever the case, Buddhas arise only in "our" universe, which is therefore called the "Auspicious universe." Cosmology was essential for the setting of narrative and the performance of ritual. Indra's Heaven (called the Heaven of the Thirty-three Gods; Sanskrit: Trayastrimsha; Pali: Tavatimsa) was a locus for important events, such as the Buddha's visit to his mother or Phra Malai's trip to the Chulamani Stupa (fig. 50 [cat. no. 36]), not to speak of many stories involving Indra and other gods. The Thai imagination delighted in the fabulous bestiary of "Himalayan creatures"—horse-elephants, elephant-birds, elephant-lions, herbivorous lions, and so on— that inhabited the slopes of the central mountain on the peak of which Indra's Heaven was situated. Models of such animals were used in funeral processions and other ceremonies (cat. nos. 112 and 113).

It was a royal duty to produce editions of the holy Buddhist texts (the Tripitaka) in order to preserve the teaching of the Buddha. Rama I held a grand assembly to collate the manuscripts of the Pali texts, leading to the production of an "approved edition" inscribed on palm leaves and kept in a specially constructed library in the Temple of the Emerald Buddha compound. Rama III produced many editions; one was written down

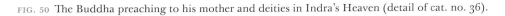

FIG. 50 The Buddha preaching to his mother and deities in Indra's Heaven (detail of cat. no. 36).

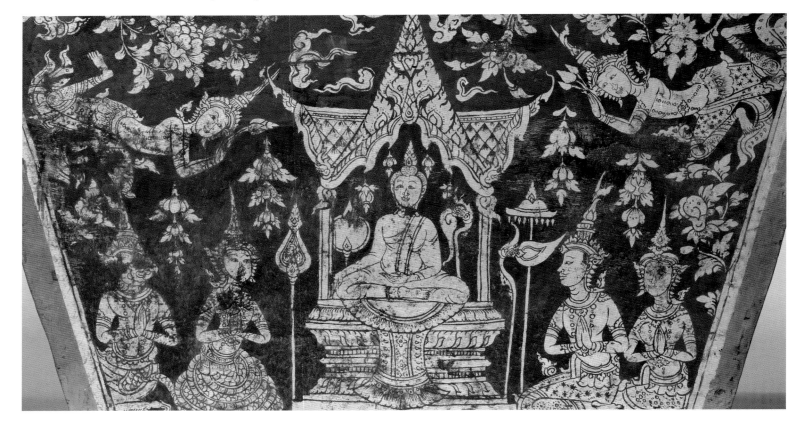

by female scribes. Rama V sponsored several editions, but he was the last monarch to sponsor complete sets of the Tripitaka in the traditional palm-leaf format. He also produced the first printed edition of the Pali collection; "The King of Siam's edition of the Buddhist Scriptures," in thirty-nine volumes, was donated to libraries in Europe, the Americas, and Asia. In 1895 the consul general of Siam distributed forty-nine sets to public and university libraries in the United States.

The "Great Life"— text and ceremony

The story of the Buddha's former life as Prince Vessantara, usually known as "the Great Life (or Birth)" in Thai, exerted an ineluctable fascination on the Siamese. One of the early classics of Thai literature is a royal version composed in the early Ayutthaya period. Since then many more versions have been composed, including royal and local versions. In the north as many as 130 versions exist. The ritual recitation is one of the great ceremonies of the year. It does not have a fixed date but is scheduled by monasteries after the rainy season retreat.

The recitation of the "Great Life" is usually preceded by the story of Phra Malai. This story connects the Vessantara Jataka to the world of the next Buddha, Maitreya—it provides the ideological foundation of the "Great Life" ritual (fig. 51 [cat. no. 93]). Maitreya tells Phra Malai that if a person listens to the thousand verses of the Vessantara Jataka in a single sitting, he or she will be reborn during the time when Maitreya is on earth. The ritual deftly links the devotee to the present and future Buddhas—to the perfections of the present Buddha Shakyamuni as expressed in the Vessantara Jataka and to the future Buddha Maitreya through the teachings of Phra Malai.

The "Great Life" is thirteen chapters long, and the ritual of reciting it lasts a full day, starting well before dawn. Usually one person or group sponsors the recitation of a single chapter. During the festival, cloth

..

SOME EPITHETS OF THE BUDDHA

In Thai the Buddha has many names and epithets, in Pali and in Thai translations as well. Examples from this rich range of names are used in this chapter both to relieve the monotony of the single English word "Buddha" and to show aspects of the idea of the Buddha in Thai literature. Many of the epithets appear in the formal or royal names of Buddha images.

Samana Gautama The ascetic belonging to the Gautama clan.

Buddha The Awakened One. The Buddha has awakened (*buddha*) from the long sleep of ignorance, and he has blossomed (*vibuddha*) like a flower.

Blessed One Endowed with many virtues, the Buddha is the Blessed One (*bhagavat*).

Conqueror The Buddha has conquered all negative states of mind. Therefore he is the Conqueror (*jina*).

Conqueror of King Mara The Buddha has conquered Mara, the god of sensual

desires and the personification of negative states of mind.

Sage The Buddha has obtained wisdom and is a sage (*muni*).

King of Sages The Buddha is the best, the lord, of sages (*muniraja*).

Shakyamuni The Buddha belonged to the royal Shakya family. Therefore he is the sage (*muni*) of the Shakyas.

Teacher The Buddha is the teacher (*sattha*) of his followers—monks, nuns, and laypeople. In chants he is called "the Teacher of gods and humans."

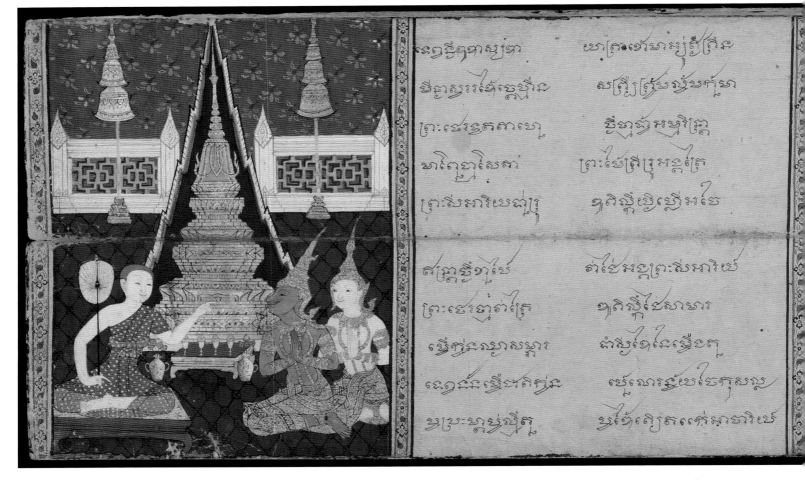

FIG. 51 Phra Malai at the Chulamani Stupa awaiting the arrival of Maitreya (detail of cat. no. 93).

paintings, one for each chapter, are hung in the recitation hall or in the temple precincts (fig. 52 [cat. no. 87], cat. nos. 71–83). (Today the cloth paintings are usually replaced by a set of lithographed illustrations.) Each chapter has a fixed number of Pali verses, and this number is always prominently announced— at the beginning and end of the recitation of each chapter—and in the inscriptions on the mural or cloth paintings. The numbers are important because the sponsorship of a chapter leads progressively to the recitation of the full thousand verses—and to meeting Maitreya in a future life.

Manuscript culture

Up until the end of the nineteenth century, texts were often inscribed with a stylus on palm leaves and then inked. Some texts were written on manuscripts folded accordion style. These include simple notes, monastic financial records, medical formulas, rituals, and collections of chants. Both Siam and Burma produced luxurious, richly illustrated, large-scale paper books. In Burma common

themes are the life of the Buddha, the Jatakas, and royal pageants and donations. Burmese manuscripts of the complete collection of more than five hundred Jatakas take up several volumes. In Siam some of the most complex texts were giant "Three Worlds" cosmological manuscripts—colorful illustrated maps not only of universes, heavens, and hells but also of the holy places of India and of maritime Asia from Korea to Istanbul. Other Siamese paper manuscripts portray the Ten Jatakas and the travels and teachings of Phra Malai (cat. no. 93). In the Thai ritual manuscripts, the texts and pictures do not necessarily correspond (fig. 53 [cat. no. 99]). (The most common text, the Pali chants, do not have any narrative to illustrate.)

Merit and manuscripts

Manuscripts contain and preserve the "jewel of the dharma," the teachings of the Blessed One. Sponsorship of a manuscript brings great merit, and a well-known Pali verse places the production of manuscripts on a par with the production of Buddha images:

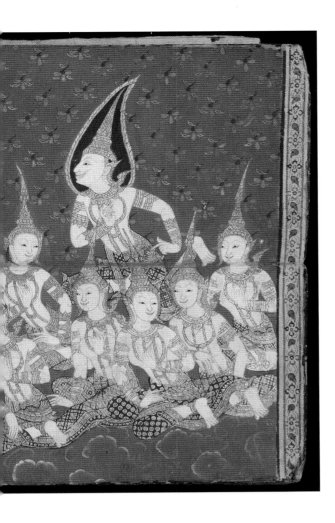

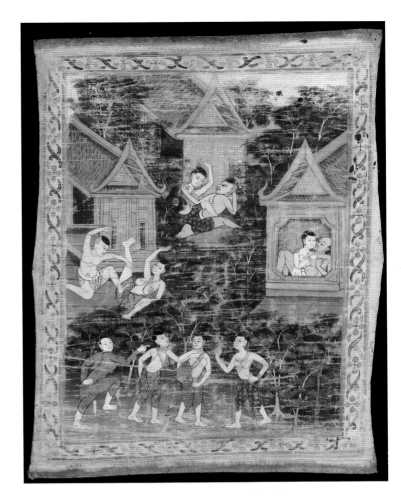

FIG. 52 Painting on cloth representing a scene from the story of Prince Vessantara (the "Great Life") (cat. no. 87).

FIG. 53 Illustrated manuscript of excerpts from Buddhist texts (cat. no. 99).

Because each and every letter equals an
image of the Buddha
Therefore the intelligent person should
have the Tripitaka inscribed.

Like Buddha images, manuscripts deserve
VIP treatment. The edges of the pages were
often gilded. Manuscripts were wrapped
in fine textiles and stored in special chests
or cabinets (cat. no. 57). Usually three, and
sometimes all four, sides of the cabinets are
decorated, most often with gilded designs or
narratives. The main topics include the life of
the Buddha, the Ten Jatakas, and the epic of
Rama.

In Burma as well palm-leaf manuscripts
were lacquered, wrapped, and carefully
stored. One genre of manuscript unique to
Burma is the *Kammavaca,* a collection of short
Pali texts recited in monastic ceremonies,
such as the rites of ordination (fig. 54 [cat.
no. 4], cat. nos. 3 and 5). While these formu-
las are used wherever Theravada monasticism
is practiced, only in Burma were they calli-
graphed in special archaic letters on lavishly
produced manuscripts, their leaves made of
ivory, metal, palm leaf, or cloth.

Sponsorship of manuscript-related para-
phernalia was also a source of great merit. A
Pali work composed in Ayutthaya in the fif-
teenth century devotes a chapter to the ben-
efits gained from copying the Tripitaka. One
of its verses promises "ultimate wisdom" to
those who donate manuscript cords, manu-
script wrappers, and the tools of writing and
goes on to say:

Those who do the copying themselves,
Those who, rejoicing, have others do the
copying—

In future they will all become
Wise disciples of the Conqueror
Maitreya.

Another Pali work, the "Chronicle of the
Councils" composed in 1789 at the beginning
of the Bangkok period, extols the rewards
gained by those who donate containers for
the dharma and pavilions for books.

Indian and Chinese narratives in Thai Buddhist contexts

Thai literary genius and interests went beyond
Buddhism. The brahmanical epics and other
Indian tales were popular, as were Chinese
novels and romances, the former from very
early times, at least the Ayutthaya period, and
the latter from late Ayutthaya. Both Indian
and Chinese narratives were integrated into
the decorative scheme of temples in the Bang-
kok period. While the Indian stories had clear
ideological functions, this is less evident in
the case of the Chinese text.

The "Glory of Rama"

The Thai equivalent of the Indian epic Rama-
yana is the Rammakian, the "Glory of Rama."
Numerous Thai versions have come down to
us, and it is clear that the story was widely
popular from the Ayutthaya period on. Sev-
eral of the Bangkok kings composed their
own versions. The figure of Rama was closely
linked to kingship; from the very beginning
of the Ayutthaya kingdom, rulers sometimes
bore the name "Rama." The Rammakian illus-
trated the conception of the king as Vishnu,
as hero, and as warrior. In some Ayutthaya
texts and in the northeastern Thai and Lao
traditions, Rama was the Buddha in one of his
past lives—that is, he was a bodhisattva. The

FIG. 54 Burmese manuscript of excerpts from Buddhist texts (cat. no. 4).

idea of Rama as bodhisattva does not appear to have contributed directly to Bangkok-period ideology, but the king himself was a bodhisattva and a Universal Monarch (*chakravartin*), and Rama was one of the models for a king to follow.

The Rammakian pervaded mythology and ideology. The story became localized, and many episodes were situated in the landscape of central Thailand. Here, Rama dipped his arrow; there, the mighty monkey Hanuman carried a mountain overflowing with herbs to heal Rama's brother Lakshmana. When the poet Sunthon Phu went on pilgrimage to the Buddha's Footprint in Saraburi, he came to "Broken Mountain":

> At Broken Mountain, I ask about the
> mountain's name.
> The elders explain the point that baffles
> me:
> "In ages past Ten-heads [the demon
> Ravana]—the Lord of Lanka—
> Kidnapped the stunning beauty Sita
> and fled
> With her behind him in his chariot
> Fearing Rama would chase him and
> attack.

> The wheel collided with the mountain;
> It shattered and scattered in pieces;
> The rock face smashed and tumbled
> with the wheel,
> And people gave the name accordingly."

The "Glory of Rama" was enacted in dance-dramas and shadow theater and depicted in manuscripts, temple murals, and many other formats (figs. 55 [cat. no. 48] and 56 [cat no. 104], cat. nos. 109–111).

Protectors and allies:
Indian gods in the Buddhist world

Buddhism began and developed into an institutionalized religion in an India populated by gods, deities, and spirits. Early Pali texts record encounters between the Buddha and divine beings. Radiant gods who came with questions and riddles went away satisfied with the Blessed One's answers. The Buddha overcame aggressive nature spirits (*yakshas*) and local spirits, converting them into protectors. Vaishravana, king of the *yakshas*, offered to protect the Buddha and his followers against malignant beings. Indra, king of the gods, became the Blessed One's follower; he plays a key role in many narratives (fig. 58 [cat. no.

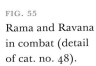

FIG. 55
Rama and Ravana in combat (detail of cat. no. 48).

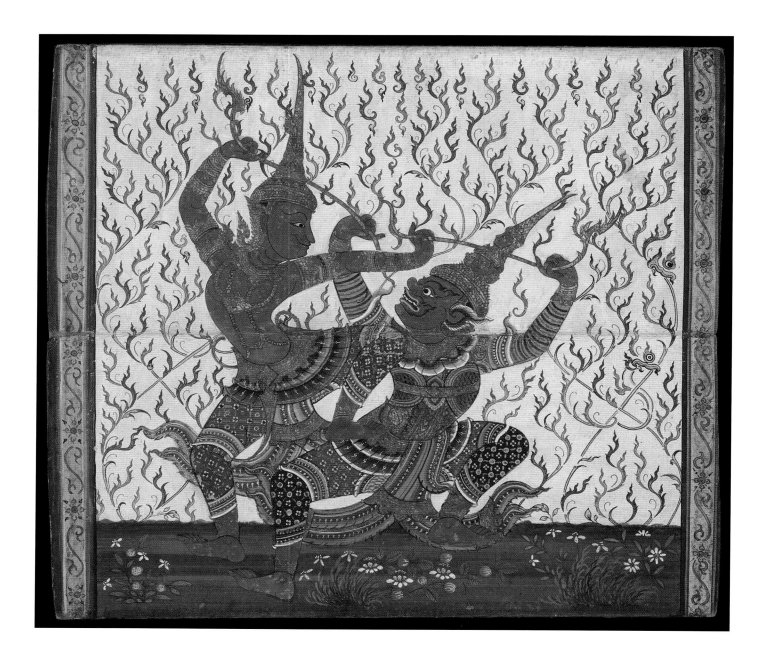

FIG. 56 (*above*)
Rama and Ravana in combat (detail of cat. no. 104).

FIG. 57 (*below*)
Double manuscript page with a pair of guardian figures (cat. no. 100).

FIG. 58 Indra adds delicious flavorings to rice intended for the Buddha-to-be (detail of cat. no. 51).

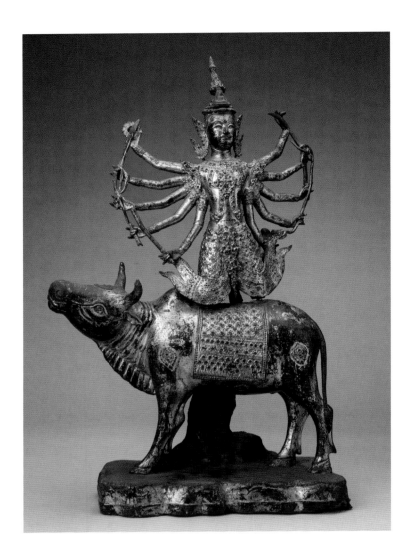

FIG. 59 Shiva, carrying the Buddha on his head, on the bull Nandi (cat. no. 97).

51]), including those of Vessantara and Phra Malai (cat. nos. 36, 62, 64, 71, 80, 96). The four-faced deity Brahma also was a respectful follower. These deities became protectors at the very dawn of Buddhism; often they are mistakenly termed "Hindu gods," but in reality they are ancient Vedic deities who, in Buddhist tradition, became followers of the Buddha from the beginning of his teaching career (and "Hinduism" did not develop until more than a thousand years later). The submission of Vedic gods and local deities to the Buddha symbolized his mastery of the entire universe.

In mural paintings, rows of deities face the main Buddha in tiers—brahmas, *yakshas,* and garudas—with their hands raised in homage as they assemble to listen to the dharma. Chanting ceremonies open with an invitation to the deities to gather:

> May the power of the protective chants
> always safeguard
> The king and his kingdom, army, and
> family.
> May the assembled monks spread
> loving kindness
> And recite the protective chants with
> undistracted minds.
> May the gods from the universes in all
> directions come here
> And listen to the Good Dharma of the
> King of Sages
> Which grants heaven and liberation.

The complex iconography of the gods was transmitted in manuals by the brahmans, who were the ritual specialists and protocol officers at the Siamese royal court. While some of the gods are well known, such as Shiva (fig. 59 [cat. no. 97]) and Ganesha in various forms, some of them are unknown elsewhere and have not yet been identified.

THE SANGHA

The historical or idealized sangha

The sangha of the Buddha's time is regularly represented in art by his disciples (fig. 60

[cat. no. 61]), notably his two most outstanding disciples, Shariputra and Maudgalyayana (cat. nos. 49, 53, 69; cat. no. 2 is a Burmese representation of Shariputra). Shariputra was renowned for his wisdom, while Maudgalyayana was famed for his supernormal powers. In many temples, statues of this "foremost pair" flank the main Buddha image, standing respectfully with their hands raised in homage. Hierarchically smaller, they are dwarfed by the Blessed One (fig. 61 [cat. no. 90]).

Many disciples are depicted in narrative paintings. Although they are not labeled, they can usually be identified from their context. The Buddha's cousin Ananda, who served him as attendant for twenty-five years, appears in many scenes. Kashyapa, the formidable master of the monastic discipline, is shown in one of the last scenes in the Master's life. Kashyapa and his followers were traveling, spreading the Buddha's teaching, when the Buddha passed away. They returned to pay their last respects. When Kashyapa paid

homage to the Buddha's coffin, the Blessed One's feet miraculously emerged from the coffin (fig. 62 [cat. no. 52], cat. no. 63). The scene emphasizes both Kashyapa's deep devotion to his teacher and the Buddha's great compassion.

Monasteries:
centers of knowledge and education

In the capital and in the village, monasteries were centers of traditional learning. The great royal foundation of Wat Phra Chettuphon (Wat Pho) was a university, with a reference library written into its very architecture; similarly, Wat Ratcha-orot, constructed by Rama III, was inscribed with traditional medical wisdom. The monasteries, with their mural paintings and inscriptions (not to speak of their libraries), were encyclopedias that stored and displayed the sum of the knowledge of the time—narrative and Buddhol-

ogy, cosmogony and cosmology, medicine and massage, metrics and poetry. Education was central to the monastic establishment. In order to teach, a monk had to master or at least be familiar with a variety of subjects and skills.

It was the king's duty to support the monastic order. The administration of the monks paralleled in many ways the administrative structure of the country, and it was supervised and supported by the royal court. Bangkok inherited an intricately hierarchical system from the old capital of Ayutthaya. Monks rose through the ranks depending on their education, preaching skills, and connections. As they rose the king presented them with titles and with symbols of their rank. These included ceremonial fans, sedan chairs for monks of the highest rank, and sets of monastic implements, including the paraphernalia of betel-chewing culture.

FIG. 60 The Buddha and young monks (detail of cat. no. 61).

FIG. 61
Standing Buddha flanked
by the disciples Shariputra
and Maudgalyayana
(detail of cat. no. 90).

FIG. 62
Kashyapa pays homage
to the coffin of the
Buddha (detail of cat.
no. 52).

Burmese records for the eighteenth and nineteenth centuries are richer than those of Siam, in part because the Burmese records are supplemented by extensive colonial materials. The intellectual exchange between the British and the Burmese is well documented, enabling us to follow the encounter between the Christian (or often secular) West with its sciences and technologies and the Burmese steeped in Buddhism.

The British official Michael Symes gave a favorable assessment of many aspects of Burma at the end of the eighteenth century in his *Account of an Embassy to the Kingdom of Ava in the Year 1795:*

> The Burmans, under their present monarch [Bodawpaya], are certainly rising fast in the scale of Oriental nations.... Their laws are wise and pregnant with sound morality; their police is better regulated than in most European countries; their natural disposition is friendly, and hospitable to strangers; and their manners rather expressive of manly candor, than courteous dissimulation: the gradations of rank, and the respect due to station, are maintained with a scrupulosity which never relaxes.
>
> A knowledge of letters is so widely diffused, that there are no mechanics, few of the peasantry, or even the common watermen (usually the most illiterate class) who cannot read and write in the vulgar tongue. Few, however, are versed in more erudite volumes of science, which, containing many Sanskrit terms, and often written in Pali text, are above the comprehension of the multitude; but the feudal system, which cherishes ignorance, and renders man the property of man, still operates as a check to civilization and improvement. This is a bar which gradually weakens, as their acquaintance with the customs and manners of other nations extends; ... the Burmans bid fair to be a prosperous, wealthy, and enlightened people. (Symes, *Account,* 122–123 [abridged, with some modification in spelling])

But Burma's passage through the nineteenth century was a troubled one. It clashed irrevocably with Britain, the ascendant power in the Indian subcontinent and in parts of Southeast Asia. In a series of wars the Burmese lost large tracts of territory, and finally their independence.

A result of the Second Anglo-Burmese War of 1852 was that the Burmese court lost control of the sangha of Lower Burma, the vital coastal areas of the south. In 1871 Mindon, the next-to-last king, was permitted to send a jeweled and gilded ceremonial finial to the Shwedagon Stupa in British-controlled Rangoon, but he was not allowed to go there to attend the consecration ceremony. Systems of hierarchy, administration, and education were severely disrupted. With the British annexation of Mandalay in 1885, the old system of royal patronage ended forever. The British, reluctant to become involved in religious affairs, in the end had to administer the education system and the monastic examinations. Some monks were active in the resistance and independence movements. Relations between state and sangha were thus very different than in Siam, where, with some exceptions, the sangha was very much part of the establishment.

Before the British annexation, King Mindon attempted wide reforms in administration, and the court tried to regain its momentum. In 1871 the king held a council in Mandalay with the aim of "purifying" the Pali texts, and he had the Pali texts inscribed on more than seven hundred marble slabs. New monastic lineages were formed, such as the strict and scholarly Shwegyin lineage, founded in 1860.

Later, under British control, the evolution of social patterns and prestige groups led to new and broader patterns of patronage and the active role of lay societies. Printing presses and education brought wider access to texts for the growing middle and mercantile classes. Burmese Buddhists were quick to take advantage of new geographical configurations forged by their incorporation into British colonial Asia, and Burmese temples rose up at the Buddhist pilgrimage sites in

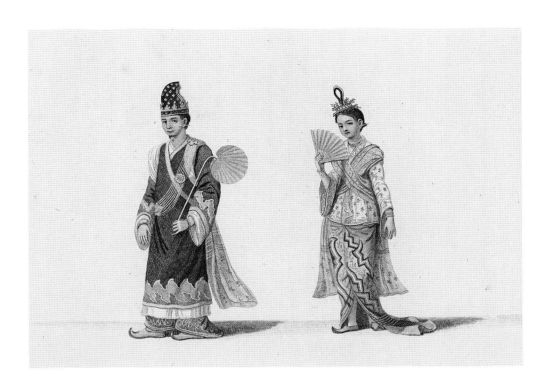

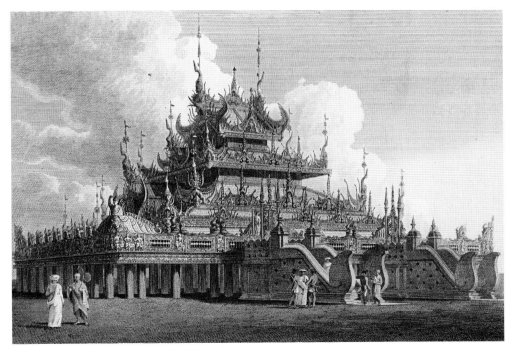

FIG. 63 (*above right*)
"A Woongee or Member of the Chief Council [of Burma] & his Wife in their dress of ceremony," from Symes, *An Account of an Embassy to the Kingdom of Ava in the Year 1795.*

FIG. 64 (*right*)
"A Kioum or Monastery [in Burma]," from Symes, *An Account of an Embassy to the Kingdom of Ava in the Year 1795.*

India and in ports such as Penang and Singapore.

Burma and Siam shared the same classical Pali literature. The Vessantara Jataka was equally important in Burma as in Siam (although Phra Malai was not), and the two societies shared, along with other Buddhist societies in Southeast Asia, cognate ideologies of merit and reward, which inspired devotion to relics and images.

The Burmese monastic establishment, like the Siamese, emphasized study, interpreted as the foundation of Buddhism, and the monks assiduously studied Pali grammar and composed scholarly works in the ancient canonical language. Perhaps because of the uncertainty of the times, scholars were concerned with history and lineage and composed both vernacular and Pali chronicles that traced Buddhism from the time of the Buddha up to the time of the authors.

In some senses the royal courts of Burma

and Siam were worlds away from each other. They rarely enjoyed cordial relations, and although they shared many ideologies they interpreted and implemented them differently. But the landscape of history was more complex. Thai artisans brought to the Burmese kingdom as prisoners of war contributed to Burmese dance, painting, and crafts, and Bangkok had its own Burmese quarter. Thais traveled on pilgrimage to the Shwedagon Stupa in Rangoon. Around the turn of the twentieth century, for example, a group of Thais from near Songkhla—two monks, their father, and a boy—traveled to Rangoon. The journey, on foot and by boat, took twenty-five days. At several points on the trip they ran into other Thai groups, including three monks and five lay followers from Pattani, and traveled together. They also visited Pegu, and before their return they bought souvenirs—a stone Buddha, a bell, a gong, and so on. Their journey was recorded in a long poem that has been preserved in a folding paper manuscript. Although the pilgrims complained periodically that they could not communicate with the Burmese, at the same time they shared and participated in religious ideals and holy sites. Travels like this reflect the similarities and differences of the neighboring cultures of the Thai and the Burmese.

Unless otherwise noted, translations from Pali or from Thai are my own, including the clumsy approximations of Thai poetry.

I am grateful to Santi Pakdeekham for answering countless questions and being helpful at all times. I also thank Peter Nyunt, Arthid Sheravanichkul, Ayako Itoh, and Justin McDaniel for their unstinting help. Whatever errors exist are my own contribution.

[*Editor's note:* Some of Dr. Skilling's preferred terminology has been changed to be consistent with the rest of this publication.]

Readings For a general history of Thailand, see Wyatt, *Thailand: A Short History*. For a history that emphasizes the later period, see Baker and Pasuk, *History*. For a political history from the fall of Ayutthaya to recent times, see Terwiel, *A History of Modern Thailand*. For more on the period of Rama I, see Wenk, *Restoration;* for information on Rama III, see Vella, *Siam Under Rama III*.

For translations of royal chronicles, see Thiphakorawong, *Dynastic Chronicles, Bangkok Era, the First Reign*, and *Dynastic Chronicles, Bangkok Era, the Fourth Reign*.

The essays in McGill, ed., *Kingdom of Siam,* provide a good background to the art of Ayutthaya. The beginnings of modern art in Thailand are discussed in Apinan, *Modern Art in Thailand*. Phillips, *The Integrative Art of Modern Thailand,* gives examples of the work of artists who exploited Buddhist and traditional themes in the second half of the twentieth century. Peleggi, *Thailand: The Worldly Kingdom,* is a recent thematic introduction to Thai history, society, and culture.

For an introduction to Buddhism in general, see Gethin, *Sayings of the Buddha,* which gives a good selection of newly translated Pali texts. The best introduction to Thai Buddhism remains Wells, *Thai Buddhism*. More recently, Kamala, *Forest Recollections, The Buddha in the Jungle,* and *Sons of the Buddha* offer fresh looks at many aspects of Thai Buddhism. See also Skilling, "Worship and Devotional Life" and "King, *Sangha* and Brahmans."

Notton translated vernacular Lanna Thai in *The Chronicle of the Emerald Buddha* and *Pra Buddha Sihinga*. Shorter versions of these and several image chronicles are embedded in Ratanapanna, *The Sheaf of Garlands*.

Waranun, *The Sacred Buddha Images of Thailand,* is a richly illustrated presentation, with text in English and Thai.

Brereton, *Thai Tellings of Phra Malai,* translates a Thai "royal recension" of the story of Phra Malai. Collins, *Nirvana and Other Bud-*

dhist Felicities, appendix 4, gives selections from a Pali version. Ginsburg, "A Monk Travels to Heaven and Hell," studies a selection of illustrated manuscripts.

Saddhatissa, *The Birth-Stories,* translates the stories of the ten future Buddhas starting with Maitreya.

For information on Upagupta, see Strong, *Legend and Cult of Upagupta*.

For more on Jatakas, see Skilling, ed., *Past Lives*. Shaw, *The Jatakas,* gives new translations of selected Jatakas. For a complete translation of the Vessantara Jataka, see Cone and Gombrich, *The Perfect Generosity of Prince Vessantara*. For discussion and a summary, see Collins, *Nirvana and Other Buddhist Felicities*.

Skilling, "For Merit and Nirvana," examines inscriptions and art in the Bangkok period.

Skilling, *Buddhism and Buddhist Literature of South-East Asia,* is a collection of essays mainly focused on Thailand.

Thai monasteries are discussed in Pichard and Lagirarde, eds., *The Buddhist Monastery*.

A recent history of "modern" (in the broader senses of the word) Burma is Thant, *Making*. Charney, *Powerful Learning,* studies "Buddhist literati and the throne in Burma's last dynasty, 1752–1885."

Herbert, "Myanmar Manuscript Art," provides a good introduction to Burmese manuscript art. Herbert, "Illustrated Record," translates a Burmese text on donations made by King Mindon. Herbert, *Life of the Buddha,* presents a fine Burmese manuscript of the life of the Buddha, while Pruitt and Nyunt, "Illustrations," selects superb examples from Burmese manuscripts of the life from the Wellcome Institute collection.

Damrong, *Journey Through Burma,* is a unique record of Prince Damrong's trip through Burma in 1936.

BURMA

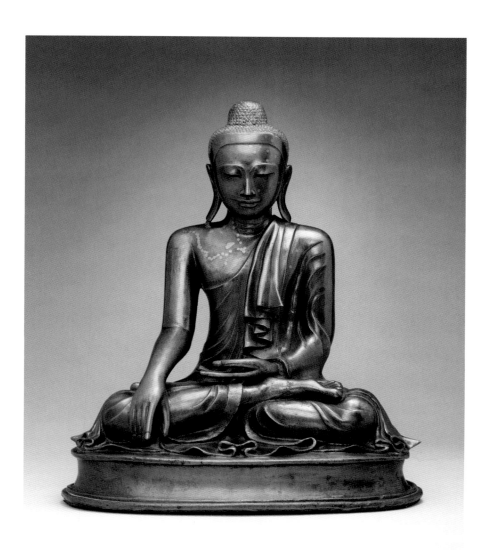

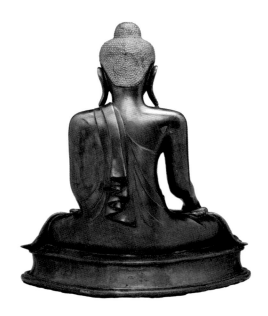

1 Seated Buddha

Approx. 1850–1900
Burma
Copper alloy
H. 47.6 × w. 40.6 cm
The Avery Brundage Collection, B60B230

This image, with its naturalistic drapery, is of a type usually associated with Mandalay in the period when it was the capital, 1857–1885.[1] Earlier Buddha images from Southeast Asia usually have their monastic robes treated schematically. Their artists showed little interest in either the substantiality of the robes or the way they fall and gather around the body.

It is not known exactly when images similar to this one began to be made. An example formed of stucco-covered brick can be seen in the ruins of Amarapura, the capital in the decades before the move to Mandalay.[2] Images of the type are still made today, and their popularity evidently has remained constant since the mid-nineteenth century.[3]

Careful examination of this image by conservators reveals no reason to think it is not old. Like most bronze Buddha images, it was originally covered with lacquer and then gilded. At some point the gilded lacquer was scraped off, presumably because it had begun to flake and was deemed unsightly, but traces remain in protected places, such as the insides of the folds of the robe and under the ears. 　　　　F. McG.

1 Isaacs and Blurton, *Visions,* 135–136.
2 Frédéric, *Art of Southeast Asia,* 126 and fig. 134.
3 See Fraser-Lu, "Buddha Images from Burma, Part 2." Scores of examples can be seen at the Shwedagon Temple in Rangoon. See Moore, Mayer, and U Win Pe, *Shwedagon,* passim. A photo in the British Library, taken in the 1890s, shows an image of this type in the process of being made. See http://www.bl.uk/onlinegallery/onlineex/apac/photocoll/b/019pho0000088s1u00040000.html.

2 The monk Shariputra, chief disciple of the Buddha

Approx. 1850–1925
Burma
Lacquered and gilded wood with colored glass
H. 55.9 × W. 35.6 cm
The Avery Brundage Collection, B60S599

In Burma and Siam the Buddha was sometimes shown flanked by two of his chief disciples, Shariputra and Maudgalyayana[1] (for Siamese examples, see cat. nos. 46, 49, 53, and 69). When depicted as separate, freestanding sculptures, these monks in nineteenth-century Burmese tradition were distinguished by their body positions. Both sat respectfully with their legs to one side. Shariputra, on the Buddha's right, leaned forward as if listening attentively; Maudgalyayana, on the Buddha's left, held his hands together in reverence.[2]

Shariputra and Maudgalyayana, though they were contemporaries of the Buddha and legendary for their piety and power, may have seemed to sculptors more approachable than the Buddha and the celestial deities. Sometimes, as here, the sculptor imparts a touching sense of youthful tenderness.

Sculptures such as this are difficult to date with much precision, as they have continued to be made. This figure was acquired from Berkeley Gallery in London sometime before 1960. Close examination gives no reason to think that it is not rather old.

F.McG.

1 For more information on these disciples and the lore associated with them, see Nyanaponika and Hecker, *Great Disciples*.
2 Such a pair of disciples flanks an enthroned Buddha in an ensemble at the Victoria and Albert Museum; Lowry, *Burmese Art*, nos. 1–3; Isaacs and Blurton, *Visions*, 126–128. See also a photo in the British Library titled "Burmese Idols," taken by Philip Adolph Klier in the 1890s, at http://www.bl.uk/onlinegallery/onlineex/apac/photocoll/b/019pho000000088s1u00041000.html.

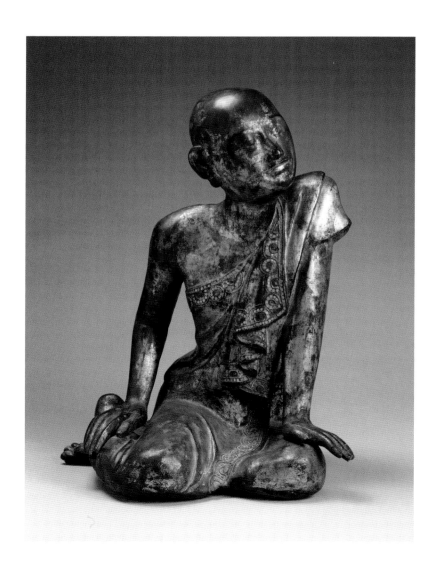

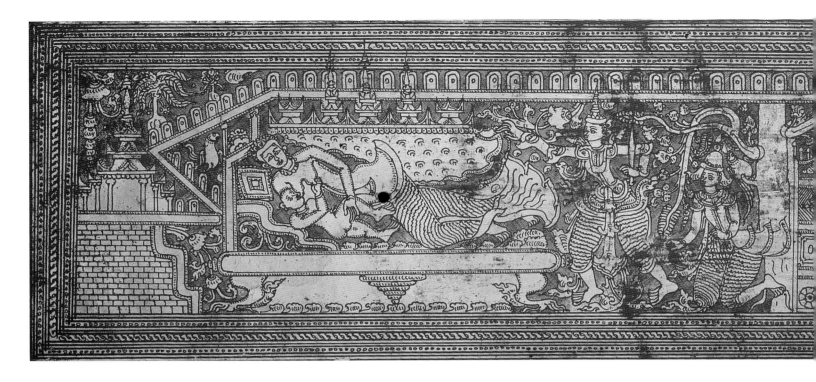

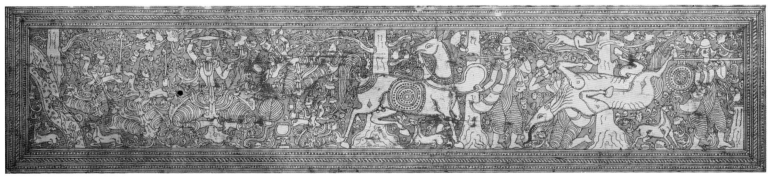

3

BUDDHIST MANUSCRIPTS

Elaborate manuscripts of the *Kammavaca,* excerpts from Buddhist texts regarding the ordination and conduct of monks, were produced in large numbers. Individuals or families often bought and donated them to a monastery at the time of the ordination of a young relation. "This is the most gorgeously ornamented of all the Burmese books," wrote James George Scott, a Scotsman who worked as a teacher and journalist in Burma in the 1870s. "It is written not in the ordinary round character, but in square letters painted on with a thick black resinous gum, and requires a special education to read it. The leaves are formed either of the ordinary palm-leaf, thickly covered with red lacquer, and profusely ornamented round the border and between the lines with gilded figures of nats [spirits and minor deities] and elaborate scroll-work, or, in the case of the more sacred monasteries, of the discarded waistcloths of kings.... [T]he sheets are emblazoned, and the text painted on, the whole being enclosed between richly ornamented teak boards. Few more splendid-looking manuscripts can be seen anywhere. The text is always read in a peculiar way, in a high-pitched, jerky recitative, which is not without a certain impressive effect.... '"Candidate! Art thou affected with leprosy or any such odious malady? Hast thou scrofula or any similar complaint?...Art thou afflicted by madness or other ills caused by giants, witches, or the evil spirits of the forests or mountains?"... To each question the candidate answers—"From such complaints and bodily disorders I am free."... "Art thou a man?" "I am."..."Art thou involved in debts?"..."I am not." "Have thy parents given consent to thy ordination?" "They have."'"[1] Further questions follow, and then the ordination ceremony proceeds.

F.McG.

1 Scott [Shway Yoe, pseud.], *The Burman,* 113–115; Scott quotes the ordination questions from Bishop Bigandet's *The Life or Legend of Gaudama,* first published in 1858, with an expanded edition in 1866. For more on decorated *Kammavaca* manuscripts, see Singer, "Kammavaca Texts"; Fraser-Lu, *Burmese Crafts,* 285–288; and Isaacs and Blurton, *Visions,* 57–58, 78–79, 216.

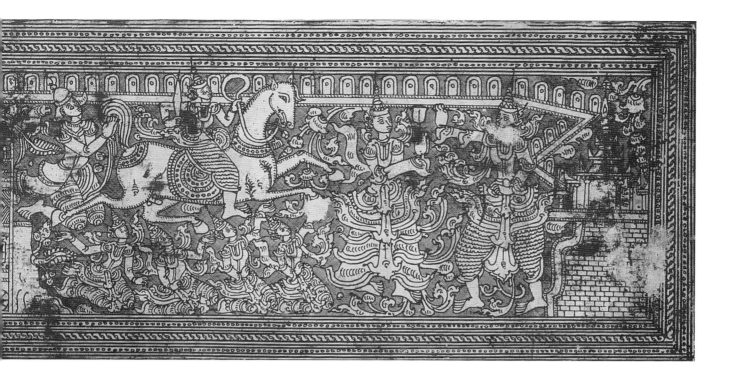

3 Manuscript of excerpts and illustrations from Buddhist texts

Approx. 1800–1850
Burma
Lacquer and gilding on stiffened cloth
with wooden covers
H. 14.3 × W. 61.6 × TH. 6.4 cm
Gift of Jared C. Ede in memory of Emily Mead
Baldwin, 2008.90

This manuscript, though it follows a common format, has unusually fine and interesting decorations, including two pages covered with scenes from the life of the Buddha. All the scenes relate to Prince Siddhartha's leaving his family and paternal home and renouncing his princely station to embark on his spiritual quest. These scenes are appropriate for a manuscript that deals with the ordination of a young man who has similarly left home and set aside worldly attachments to become a monk. (See "Buddhist Manuscripts" above.)

The first illustrated page shows Siddhartha bidding farewell to his sleeping wife and infant son. The lady reclines on an elaborate couch, suckling her baby. Siddhartha, attended by his groom, gestures toward her. Next, we are shown a palace gate, beyond which the prince rides away on his faithful horse, with his groom clinging to the tail. Celestials hold their hands under the horse's hooves to dampen their clacking. The demon Mara tries an unsuccessful dissua-

sion: "Prince, do not attempt to lead the life of a recluse; return forthwith to your palace."[1]

The scenes on the first page all take place within the city, as is shown by the parapet spanning the page. The left side of the other illustrated page signals a move into the countryside: deer rest by the Anoma River teeming with fish. Nearby, Prince Siddhartha performs self-tonsure, using his sword to cut off his long hair. Indra, the king of the gods, swoops down from the heaven over which he rules to rescue the shorn locks, which he will enshrine in his capital. Meanwhile, another deity presents to Siddhartha a fan, an alms bowl, and the other requisites of life as a renunciate,[2] just as do the family members of a monk undergoing ordination.

Next, the prince's horse and groom, having been gently dismissed, look back longingly. The horse's sorrow "grew so great that his heart split into two parts, and he died on the spot." The groom covers his face to weep at losing both his master and the steed, then trudges back toward the city, carrying the horse's fine trappings on a pole over his shoulder.

The text pages of the manuscript are richly adorned with birds and animals amid curling vines. At the sides of some pages appear dancers with theatrical masks—again representing various birds and animals—worn high on their heads. Around them float winged cherubs presumably derived from the decoration of European books.[3]

The date of this manuscript and its illustrations is uncertain. Its dedicatory inscriptions, which appear to cover earlier inscriptions, name its sponsors and their town, some 200 kilometers south of Mandalay, and express the conventional wishes that the sponsors may be happy and achieve nirvana in the future, and that all beings will celebrate their donation by calling out "Well done!"[4] A date, equivalent to 1938, is added in a different hand and color and is almost certainly an intrusion.

Though the development of Burmese painting and book decoration from the eighteenth to the twentieth century is little studied and poorly understood, this manuscript would seem to long predate 1938. The narrative scenes are presented in an essentially flat space; there is little overlapping and none of the experimenting with Western conventions to suggest deep space that might be expected by 1938. Further, while late nineteenth- and early twentieth-century *Kammavaca* manuscripts usually have six lines of script on their text pages, this manuscript has five. Some scholars believe that texts in five lines are earlier than those with six.[5]

This manuscript was acquired from the estate of Henry Ginsburg, former curator of Thai and Cambodian collections at the British Library.

F.McG.

5

1 On the Burmese version of the life of the Buddha, see Bigandet, *Life or Legend of Gaudama* (from p. 63 of which Mara's admonition here is adapted; the subsequent quotations also come from Bigandet). See also the Nidanakatha translated by N.A. Jayawickrama as *The Story of Gotama Buddha*. For very different illustrations of the life of the Buddha from Burmese painted manuscripts, see Herbert, *Life of the Buddha*.

2 Bigandet, *Life or Legend of Gaudama,* 65–66; Herbert, *Life of the Buddha,* 31; Jayawickrama, trans., *Story of Gotama Buddha,* 87.

3 Singer, "Kammavaca Texts," 104.

4 The inscriptions were read by Min Zin.

5 Singer proposes that five-line manuscripts date from the second half of the eighteenth century and the early nineteenth; "Kammavaca Texts," 101.

4 Manuscript of excerpts from Buddhist texts [FIG. 54]

| 1918
| Burma
| Lacquer and gilding on stiffened cloth with wooden covers
| H. 14.0 × W. 57.8 × TH. 5.1 cm
| Gift of John Altman, 2008.94

This manuscript is of a standard type, with conventional elaborate decorations and six lines of script per page.[1] Its inscription gives a date equivalent to 1918, and it names the donors (a husband and wife and four of their children) and their town. It adds the donors' wish that their deed of merit may advance them toward achieving nirvana, and that all beings may laud their generosity.[2]

F.McG.

1 Isaacs and Blurton, *Visions,* 78–79, 216–217.

2 The inscription was read by Min Zin.

5 Manuscript of excerpts from Buddhist texts

Approx. 1850–1900
Burma
Lacquer and gilding on stiffened cloth
or paper with wooden covers
H. 10.8 × W. 54.3 × TH. 5.1 cm
Transfer from the Fine Arts Museums of
San Francisco, Gift of Katherine Ball, 1993.26.2

This manuscript is similar in type to cat. no. 4. Its covers, however, are decorated with birds alternating with celestial beings, rather than with sword-carrying male figures.[1] It bears no dedicatory inscription. F.McG.

1 Compare Singer, "Kammavaca Texts," middle example on p. 101, which he dates to the late nineteenth century.

6 Manuscript covers

Approx. 1800–1900
Burma
Lacquer and gilding on wood
H. 10.2 × W. 55.9 × TH. 3.8 cm
The Avery Brundage Collection, B62M22

Both covers bear eight animals within square or octagonal frames. Eight animals in a set would be expected to be the eight animals associated with the planets and the days of the week in Burma. (Wednesday is divided into two parts.) The animals here, however—an elephant, a bull, a horse, a buffalo, a peacock, two other birds,

and a creature that is perhaps a pig or boar— do not correspond to the standard list.[1]

It is also not certain that the two covers come from the same manuscript. The loose pages they enclosed when they came to the museum were of two different styles and sizes, and clearly did not match. The hatching patterns on the two covers differ, and comparing the drawings of the same animals on the two covers makes it seem doubtful that they came from the same hand. F.McG.

1 Fraser-Lu, *Burmese Crafts,* 235–238; Fraser-Lu, *Burmese Lacquerware,* 57–66.

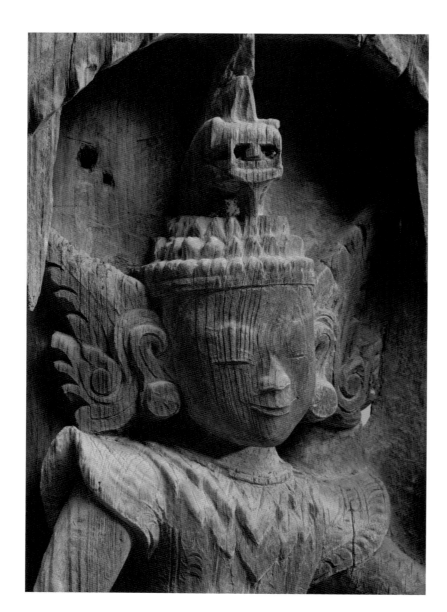

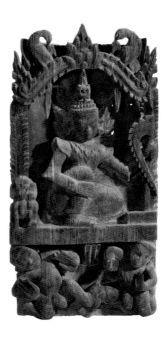

7 Serpent king [FIG. 17]

Approx. 1750–1850
Burma
Wood
H. 94.0 × W. 45.7 cm
Gift of Naomi Lindstrom, 2008.85

Mythical serpents (naga) play a role in several Buddhist legends. They join the praise of the Buddha just before and after the Enlightenment,[1] and they are said to have paid their respects to the great Indian Buddhist king Ashoka.[2] Often, the serpents in legends are specified as serpent kings. They also have the power to transform themselves: "If they want to transform themselves so that they become as beautiful as the *devata* [celestial beings], they can do so."[3]

Here we see a royal figure whose identity as a serpent is indicated only by the serpent head at

the top of his crown. The figure holds an as-yet-unidentified object, possibly a sort of lance with a pennant. To his side are two small figures, also unidentified, that appear to be an animal protecting or threatening a young child or animal. Below, a lively pair of page boys dance.[4]

Such a relief would probably have been attached to the balustrade surrounding a monastery building. F.McG.

1 Malalasekera, *Dictionary*, 484, s.v. "Mahakala"; Bigandet, *Life or Legend of Gaudama*, 87, 91; Jayawickrama, trans., *Story of Gotama Buddha*, 95, 98–99. A serpent-man is seen attending the Buddha on a lacquered chest in cat. no. 36.
2 *Three Worlds*, 176, 178.
3 *Three Worlds*, 91.
4 Thanks to Sylvia Fraser-Lu for this identification and her other comments on this sculpture, including the note on its likely original location; private communication. A related relief is in a private collection in Thailand; see Warren and Tettoni, *Thai Style*, 117.

8 Crowned deity in a position of respect

1750–1850
Burma
Wood
H. 134.6 × W. 27.9 cm
Gift of the Donald W. Perez Family in memory of
Margaret and George W. Haldeman, 2008.86

This figure may represent Indra or Brahma,
Hindu deities who in Buddhist contexts are
powerful but limited and subservient to the
Buddha, or one of the four guardian kings of
the directions.[1] Perhaps, though, its identity
was never more precise than a celestial deity
in an attitude of respect.

The sculptor has kept much of the cylindri-
cality of the tree trunk from which the figure
was carved.[2] Deep undercutting, however, is
especially noticeable from the back. While the
back was likely never intended to be seen, the
sculptor has gone to some trouble to emphasize
its abstract sculptural qualities by swelling and
narrowing the figure and blocking out elements
of the costume.

The figure would have been lacquered and
gilded, but only remnants of these coverings
remain. The face has been substantially recarved,
presumably because its features had weathered
away. F.McG.

1 See Herbert, *Life of the Buddha,* 19, for a celestial deity—
perhaps, according to Herbert, one of the guardian
kings—that is rather similar to this sculpture in its posture
and costume.

2 Other sculptures of celestials in attitudes of respect that
maintain something of this cylindricality can be seen in
Ferrars and Ferrars, *Burma,* fig. 384; and two figures in the
collection of the Center for Burma Studies at Northern
Illinois University, BC2005.2.5 and BC2005.2.15 at
http://www.grad.niu.edu/burma/webpgs/collect
SculptBC200525.html and http://www.grad.niu.edu/
burma/webpgs/collectSculptBC2005215.html.

9

9 **Crowned male figure, gesturing or dancing**

1850–1925
Burma
Painted wood, lacquer, gilding, and mirrored glass
H. 151.1 × W. 69.9 cm
Gift of the Donald W. Perez Family in memory
of Margaret and George W. Haldeman, 2008.87.1

10 **Crowned male figure, making a gesture of respect**

1850–1925
Burma
Painted wood, lacquer, gilding, and mirrored glass
H. 140.1 × W. 52.1 cm
Gift of the Donald W. Perez Family in memory
of Margaret and George W. Haldeman, 2008.87.2

Who are these three-quarters-life-sized figures, with their princely garments, dance-like movements, and wistful expressions? One gestures with open arms; the other assumes a position of respect. They must be minor deities or celestial beings of some sort, because in traditional Burmese contexts mortals, even kings, were rarely represented in sculpture. They might be considered two of the Thirty-seven *nats,* a category of powerful spirits who need to be pacified with offerings, but their characteristics do not match those of any of the Thirty-seven as recorded in manuals.[1]

Other possible identifications would be Indra and Brahma, who reverently attend the Buddha at a number of moments in his legendary life, or two of the four guardian kings of the directions, who also sometimes attend the Buddha.[2]

Old photographs, some as early as the 1870s, show similar freestanding sculptures but provide little help in narrowing an identification.[3]

F.McG.

1 On *nats,* see Spiro, *Burmese Supernaturalism,* 51–55. For lists and illustrations of the Thirty-seven, see Temple, *Thirty-Seven Nats.* While the museum's sculptures do not closely resemble any of Temple's Thirty-seven, they do share features with other minor deities he illustrates on pp. iii and 39, but no firm conclusion seems possible.
2 See, for example, Herbert, *Life of the Buddha,* 10, 14, 19, 80.
3 A photo in the British Library said to have been taken by F. O. Oertel in 1875 shows a "prayer-post" base in the shape of a cosmic mountain with various mythical beings arrayed on its terraces and figures that somewhat resemble the museum's statues, presumably representing the kings of the four directions, at its top. See http://www.bl.uk/onlinegallery/onlineex/apac/photocoll/i/019pho0000125s4u00002000.html. See also Watt, *Indian Art,* pl. 64; Ferrars and Ferrars, *Burma,* fig. 151; Tilly, *Wood-Carving,* pls. VII and XIX; Moore, Mayer, and U Win Pe, *Shwedagon,* 172–173; and Damrong, *Journey Through Burma,* fig. 15.

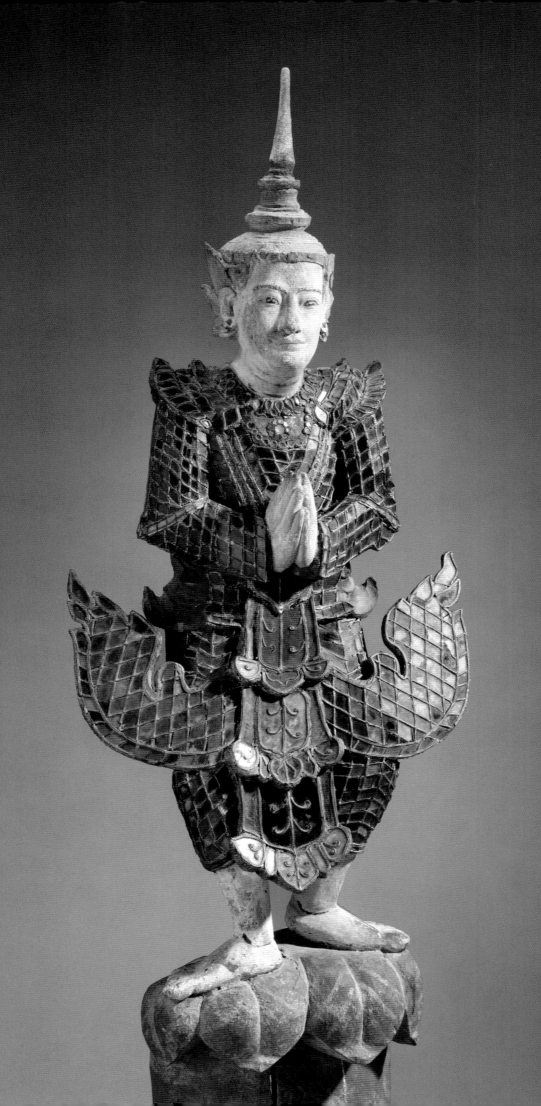

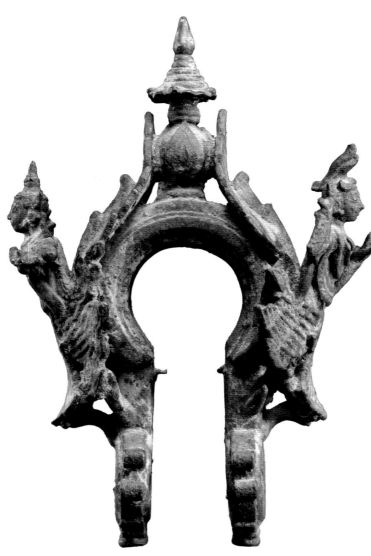

of the guardian spirits and the four worlds what he has been doing. There are always a number of deer's antlers and billets of wood lying near the bell for this purpose. None of them have clappers, and metal is not used to strike them."[1] So reported James George Scott in 1882, after several years of living in Burma.

As numerous as bells were their accessories, such as U-shaped brackets for hanging. Bells typically had a ring at the top; the bracket had at the end of each arm another ring. A heavy bolt passed through one ring of the bracket and the ring of the bell and then out through the other ring of the bracket, holding the bell securely. Above the ring on each arm of this bracket is a composite human-bird creature of the type known in the Hindu-Buddhist world by the Sanskrit terms *kinnara* (male) and *kinnari* (female). Pairs of these gentle creatures were famously devoted to each other.[2] The figures on this bracket, probably a male and a female, differ in their ornaments and headdresses.

Other bell brackets have creatures sometimes said to correspond to the days of the week so that buyers could purchase and donate to the temple a bracket corresponding to the day on which they were born.[3] Kinnaras do not, however, appear in the standard lists of eight animals of the days of the week (two for Wednesdays).[4]

Though bell brackets such as this, decorated with bird-men and -women, are still made today, this example appears old. How old is the question. A major bell cast in 1841 has kinnaras on its bracket, but the bracket may not have been made at the same time as the bell. In any event, the published photo is insufficient for close comparison.[5]

Bells were (and are) traditionally cast of bronze or another copper alloy, and so, presumably, were their brackets. This bracket, however, is cast in iron. Several Western observers of Burma in the nineteenth and early twentieth centuries address the working of iron for tools and weapons, but they say little about casting iron for what amounts to a small sculpture.[6] F.McG.

11 Suspension bracket for a bell

[DETAIL P. VIII]

> Approx. 1800–1900
> Burma
> Cast iron
> H. 34.3 × W. 24.1 cm
> Gift of the Donald W. Perez Family in memory of Margaret and George W. Haldeman, 2008.88

"The love of bells in Burma is somewhat remarkable. Every large pagoda has some dozens of them, of all sizes.... One or two were put up with the central shrine itself; others have been added by the religious.... The use of the bells is to direct attention to the fact of the lauds of the Buddha having been recited. The worshipper, when he has finished, goes to one of the bells and strikes it three times, to bring to the notice

1 Scott [Shway Yoe, pseud.], *The Burman,* 202–204.
2 Moore and San San Maw, "Flights of Fancy," 29.
3 Falconer et al., *Myanmar Style,* 212.
4 Fraser-Lu, *Burmese Crafts,* 235–238; Scott [Shway Yoe, pseud.], *The Burman,* 8–9.
5 Fraser-Lu, *Burmese Crafts,* color pl. 27 and 133–134.
6 Yule, *Court of Ava,* 104; Ferrars and Ferrars, *Burma,* 103–106; Bell, *Monograph on Iron and Steel Work,* passim. On iron casting in Siam, see McGill, ed., *Kingdom of Siam,* 127–129.

VESSELS FOR
TEMPLE OFFERINGS

A variety of elaborately decorated vessels, containers, and stands were made for presenting offerings in Buddhist monasteries. Ornate betel-nut containers used at ceremonies when young men entered monasteries as novices symbolized the luxuries that Prince Siddhartha willingly gave up when he embarked on his spiritual career, and that candidates for the novitiate gave up when they followed his example.[1] F.McG.

1 Fraser-Lu, *Burmese Lacquerware,* 120–133; Fraser-Lu, *Burmese Crafts,* 226–230; Spiro, *Buddhism and Society,* 234–247; Ferrars and Ferrars, *Burma,* 15.

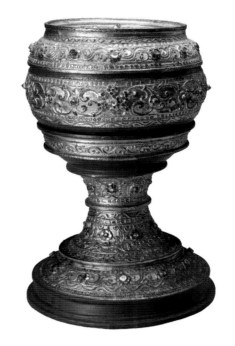

12 Ceremonial alms bowl with stand

Approx. 1850–1950
Burma
Lacquered and gilded bamboo with mirrored glass
H. 52.1 × DIAM. 35.6 cm
Gift from Doris Duke Charitable Foundation's
Southeast Asian Art Collection, 2006.27.108.A–C

13 Ceremonial alms bowl with stand [FIG. 18]

Approx. 1850–1950
Burma
Lacquered and gilded bamboo, wood, and ferrous metal with mirrored and non-mirrored glass
H. 79.4 × W. 53.3 × D. 54.0 cm
Gift from Doris Duke Charitable Foundation's
Southeast Asian Art Collection, 2006.27.107.A–E

This elaborate stand holds a glass bowl that is presumably a version of the ceremonial monk's alms bowl seen in the previous object. F.McG.

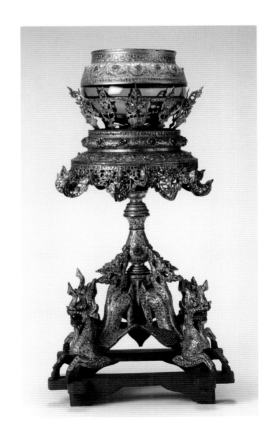

14 Offering stand

Approx. 1850–1950
Burma
Lacquered and gilded wood with mirrored glass
H. 63.5 × W. 57.1 cm
Gift from Doris Duke Charitable Foundation's
Southeast Asian Art Collection, 2006.27.123.A–B

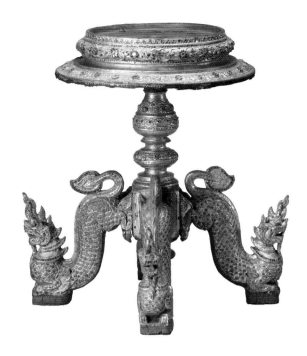

It is not known whether this stand was used as we now see it, or had another component on the top. The lower edge of the top was originally decorated with a lacquered and gilded cut metal skirt[1] (of which fragments remain) like that of cat. no. 13. The legs have cylindrical holes on their lowermost surfaces, suggesting that the stand may have rested on a square frame, again like cat. no. 13. The mythical beasts forming the legs all once had horns of some sort, for which only holes remain.

The fitting of the top of the stand to the stem is not perfect, and it is possible that they do not belong together. F.McG.

1 A similar stand with its skirt intact can be seen in Fraser-Lu, *Burmese Lacquerware,* 131; another without a skirt can be seen in Falconer et al., *Myanmar Style,* 173.

15 Betel leaf holder

Approx. 1850–1950
Burma
Lacquered and gilded ferrous metal and wood
with mirrored-glass inlay
H. 53.3 × DIAM. 20.3 cm
Gift from Doris Duke Charitable Foundation's
Southeast Asian Art Collection, 2006.27.109.A–B

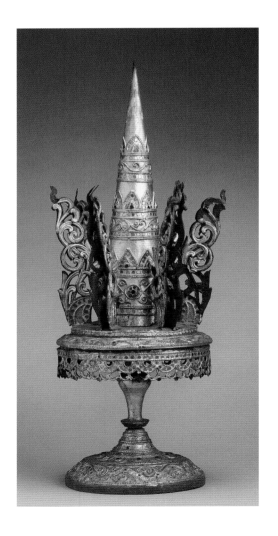

16 Bird-shaped betel box on stand

Approx. 1850–1950
Burma; Mandalay
Lacquered and gilded wood and ferrous metal and
wood with mirrored-glass inlay and textile tassel
H. 41.9 × W. 27.9 cm
Gift of Rhett Mundy/Asia Galleries, F2003.6.2

Two very grand bird-shaped betel boxes on
stands are in the British Museum.[1] F.McG.

1 Isaacs and Blurton, *Visions,* 126–128.

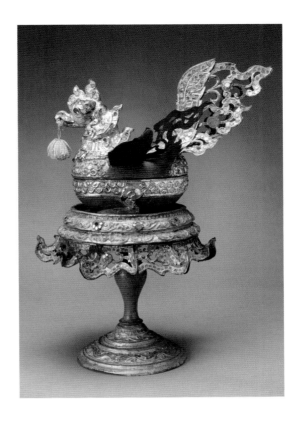

17 Offering container

Approx. 1850–1925
Burma
Lacquered and gilded wood
with mirrored-glass inlay
H. 63.5 × DIAM. 33.0 cm
Gift of Rhett Mundy/Asia Galleries, 2008.84.A–B

Both the shape of this offering container and its
decoration—made up of mirrored-glass inlay in
patterns recalling those on some Burmese tex-
tiles—are unusual. Where and when the container
was made is uncertain.[1] F.McG.

1 A somewhat similar example is illustrated in Capelo, *A
Arte da Laca,* 60–61, there dated to the second half of the
nineteenth century. Another comparable example, but
with larger pieces of mirror, is dated by Fraser-Lu to the
early twentieth century; see *Burmese Lacquerware,* 174. For
related textile patterns see Fraser-Lu, *Burmese Crafts,* 259.

BELOW Photograph labeled "Burmese damsels with
presents of rice and curry for the Phongyis [monks]."

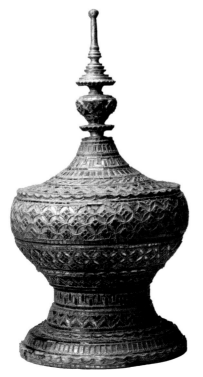

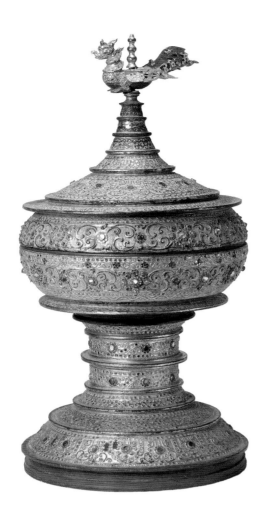

18 Offering container

Approx. 1875–1925
Burma
Lacquered and gilded bamboo with glass
and mirrored-glass inlay
H. 91.4 × DIAM. 45.7 cm
Gift of George McWilliams, 2008.92.A–C

This offering container is comparable in type
and general style to one in the British Museum.[1]

F.McG.

1 Isaacs and Blurton, *Visions,* 200–201.

19 Scenes from the Burmese version of the epic of Rama

Approx. 1850–1900
Burma
Cotton, wool, silk, and sequins
H. 55.3 × W. 580.4 cm
Museum purchase, 1989.25.1

This almost-six-meter-long hanging shows scenes
from the legend of Rama. At the left end the Prin-
cess Sita sits on a couch beneath a tree, attended
by her lady's maids. Next she is shown again,
seated to one side of a royal pavilion. In the
center of the pavilion is her father the king, and
beside him sits a rishi or ascetic, who may be the
young hero Rama's preceptor, called Vishvamitra
in the classical Indian version of the legend.

Sita's father has proclaimed that only the
man who can string his miraculous bow will win
the hand of his daughter. Beyond the royal pavil-
ion the young hero Rama is shown succeeding
with the bow after all other suitors have failed.

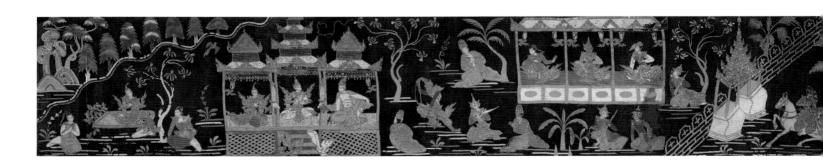

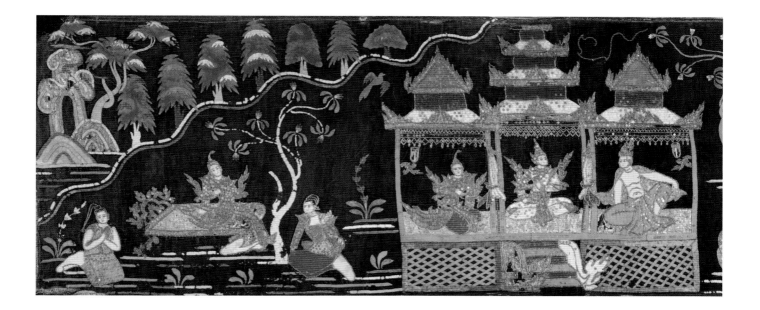

His faithful brother Lakshmana kneels nearby watching.[1]

The next scenes are hard to identify. Within another pavilion a crowned demonic figure appears, flanked by two courtiers. The crowned figure is probably the demon king Ravana,[2] who much later in the story abducts Sita. In some Southeast Asian versions of the Rama legend, but not in the famous Indian version by Valmiki, Ravana hears of Sita's father's challenge and tries his hand at the bow-bending contest. Though he manages to lift the bow, which no other suitors except Rama manage to do, he cannot bend it to attach the string. After Rama's triumph, Ravana, abashed, returns to his own kingdom.

A little farther on a princely figure on horse-back approaches the city gate; perhaps another suitor is arriving to try his hand at the bow contest. Behind him, the demonic figure who may be Ravana flies in an aerial chariot. Perhaps he too is arriving for the contest, in a sort of flashback. Next, in what may also be a flashback, Rama and his brother follow their preceptor through the forest; they may be arriving to try the bow as well.

Beyond a wavy diagonal line that presumably signals a change of scene, a young man in aristocratic garments is seated next to stylized

rocks while two attendants kneel respectfully. This young man, in his red vest and jaunty head wrap, closely resembles one of the figures flanking Ravana in the earlier scene and is presumably the same character, but his identity has not been determined.

Finally, Rama, Sita, and Lakshmana walk through the forest behind a rishi who appears identical, in his orange robes and hermit's turban, to Rama's preceptor shown twice before.

The difficulty is this: though Rama and his wife and brother eventually go into exile in the forest, many events—not least a grand royal wedding—and many years intervene between Rama's winning Sita's hand in the bow challenge and their entry into the forest for a life among the hermits and wild creatures. Is the narrative here radically condensed, or are the proposed interpretations of the later scenes incorrect?[3]

This long narrative textile has along its upper edge a large number of tabs by which it could have been hung. Where it would have been hung, and for what purpose, remains uncertain. One possibility is that it served as a backdrop for puppet performances. Late-nineteenth-century

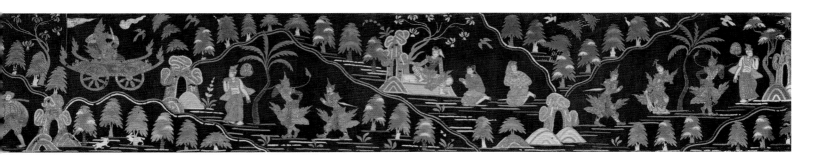

photographs of puppet performances show rather similar sequined narrative backdrops at the back of a puppet stage.[4] Having one narrative depicted on a backdrop while another was performed in front might be thought to have caused confusion, but apparently it did not.

The pre-twentieth-century history of the creation of Burmese textiles with narrative scenes in appliqué, embroidery, and sequins is poorly understood. Preliminary studies have found examples of such textiles that are documented to have been acquired by foreigners or exhibited at or donated to public institutions more than a century ago.[5] Another source of worthwhile data is nineteenth- and early-twentieth-century photographs, in which such narrative textiles sometimes appear.

F.McG.

1 An old tag pasted to the back of this work bears a hand-written inscription in Burmese that reads, according to Min Zin, "Rama bending the bow."

2 However, Ravana would usually be expected to have small versions of several of his ten heads shown in his head-dress; Singer, "The Ramayana," 100; Kam, *Ramayana,* 108.

3 On various versions of the Rama legends in Burma, see Ohno, *Burmese Ramayana;* U Thein Han and U Khin Zaw, "Ramayana"; Singer, "The Ramayana"; and Maung Htin Aung, *Burmese Drama.*

4 Ferrars and Ferrars, *Burma,* fig. 397. A puppet stage was much wider than might be expected—certainly wide enough to accommodate a backdrop of this size—as can be seen in old photographs such as one in the British Library reproduced at http://www.bl.uk/onlinegallery/ onlineex/apac/photocoll/a/019pho0000088s1u00042000 .html. Dimensions for puppet stages are specified in a royal order of 1822; Than Tun, *Royal Orders,* 8:54. See also Singer, *Burmese Puppets,* 48–49.

5 The best survey is Franklin, Singer, and Swallow, "Bur-mese Kalagas." Richard Blurton's article " 'Looking Very Gay and Bright,' " while not focusing on such textiles with old provenances, illustrates two examples in the collection of the British Museum that are quite similar to this one and may have been part of the same set. Also, like this one, they once belonged to the scholar of Thai and Burmese art and literature Henry Ginsburg.

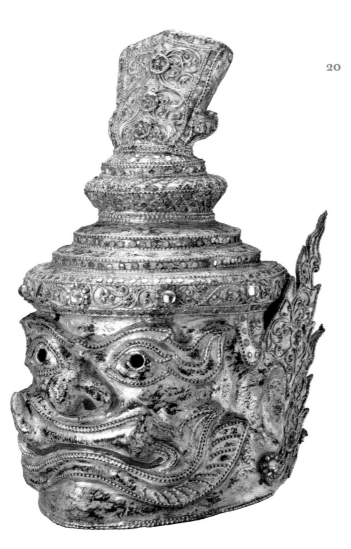

20 Theatrical mask of a high-ranking demon

1950–2000
Burma
Lacquered and gilded papier-mâché, glass, and pigments
H. 38.7 × W. 20.3 cm
Gift of George McWilliams, 2008.93

This mask probably represents a high-ranking demon in the forces of the demon king Ravana, the adversary of the legendary hero Rama. Episodes from the epic of Rama were a primary subject of dance-dramas at the Burmese royal court and continue to be performed today. The masks, though carefully made and elaborately ornamented, were of light materials such as papier-mâché and would not be expected to last many years. The earliest surviving masks are thought to date from the 1870s.[1] Masks in tradi-tional style are still crafted by skilled artisans.[2]

F.McG.

1 Singer, "The Ramayana," 101; this article includes draw-ings of masks for several demon generals, none of which exactly corresponds to this mask. Theatrical masks can be seen (but not very clearly) in a photo published in 1900; Ferrars and Ferrars, *Burma,* 173.

2 Singer, *Burmese Dance,* 22–24 and color pl. 16.

21 Puppet of the hero Rama

Perhaps 1970–1980
Burma
Wood, cloth, and mixed media
H. 77.5 × W. 33.0 cm
Gift of Dr. Vincent Fausone, Jr., F2008.58.4

Though the traditions of shadow-puppet (cat. nos. 109–111) and rod-puppet theater were strong in most countries of Southeast Asia (and by no means intended primarily for children), stringed puppets—marionettes—were used only in Burma. In Burma, as elsewhere, the stories portrayed by puppets were the same as those portrayed by living actors. The influences of puppet theater and human theater on each other in costuming, music, dance movement, and the language of pose and gesture were complex, as were the mutual influences of the theater and other visual arts such as painting, sculpture, and the design of clothing and personal adornments.

In the marionette theater, as in classical dance-drama, episodes of high seriousness alternated with episodes of battle, romance, and boisterous comedy.

Many puppet plays were based on the legends of the hero Prince Rama, who was forced to battle armies of powerful demons to rescue his kidnapped wife. This puppet represents Rama. It wears the requisite royal garments (compare cat. no. 23), including royal shoes with bird heads at the toes,[1] and has green skin, in accordance with the usual mainland Southeast Asian convention of depicting Rama.[2]

This marionette has inlaid glass eyes, a movable lower jaw, and hands articulated at the finger joints. As was customary, its genitals are carved on its wooden body.[3] Despite its careful construction, however, this puppet does not follow the standards of the professional puppet troupes of Mandalay. In the opinion of Ma Ma Naing, cofounder and managing director of the Mandalay Marionettes Theatre, who examined a photograph of this puppet, it is "just [an] ordinary puppet like [a] souvenir."

Both the patterns and the composition of the textiles with which the puppet is dressed (all cotton, with few or no synthetic components) suggest a date of about 1950 to 1975, but as tourism developed only after 1970, it may be somewhat later.

Puppets have long been made in a variety of qualities at different prices.[4] If this puppet was indeed intended to be a souvenir for tourists, how should we think about it? Erik Cohen, who has carefully pondered that question, writes, "The commercialization of the arts and crafts of Third and Fourth world people, involving their re-orientation from a predominantly local, internal audience to some new external and often foreign audiences, tends to be seen as leading to an irretrievable decline and debasement of the 'authentic,' vital, and unchanging traditions of the past.... Terms such as 'tourist arts' or even the more derisive 'airport art' symbolize this attitude." He then discusses the ongoing controversies and suggests useful approaches to such "commercialized" objects.[5] F.McG.

1 King Thibaw can be seen wearing such shoes in old photographs, as in O'Connor, *Mandalay,* 15. See also Conway, *The Shan,* 27, 59. A pair of shoes of this type are illustrated in Fraser-Lu, "Kalagas," 73.

2 A marionette of Rama with green skin is shown in Kam, *Ramayana,* 97, 113; another is on the cover of Ma Thanegi, *The Illusion of Life.*

3 The inclusion of genitals on puppets was required in an 1822 royal order regarding the puppet theater; Than Tun, *Royal Orders,* 8:57.

4 Bruns, *Burmese Puppetry,* 99–100.

5 Cohen, *Commercialized Crafts of Thailand,* 4. See also Phillips and Steiner, *Unpacking Culture.*

22 Puppet of a princess or court lady

Perhaps 1900–1925
Burma
Wood, cloth, and mixed media
H. 53.3 × W. 22.9 cm
Gift of Dr. Vincent Fausone, Jr., F2009.5

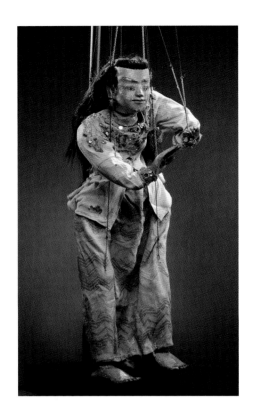

In contrast to cat. no. 21, this puppet resembles those used by professional troupes in Mandalay. Its features are carved and painted with considerable delicacy, it has human hair, and it is constructed with the very broad hips widely separated on the pelvis that are characteristic of classical Mandalay puppets.[1]

The garments are extremely faded and in poor condition, but it appears that the upper garment, of silk crepe, was originally blue, and the lower garment a range of rich purples. F.McG.

1 Bruns, *Burmese Puppetry,* figs. 9, 12; Singer, *Burmese Puppets,* fig. 5.

23 Court costume [DETAIL P. XI]

Approx. 1850–1885
Burma; Mandalay region
Cotton embroidered with sequins and glass
H. 147.3 × W. 127.0 cm (overall)
Gift of Haskia Hasson, 2008.77.A–J

On formal occasions Burmese courtiers wore, over their sarong and light jacket, extremely elaborate decorative garments covered in embroidery, sequins, and glass jewels. Sumptuary laws regulated which designs and colors could be worn by persons of various ranks.[1]

This set of components of such a court costume, made up of separate vest and overvest, sleeves, collar, sawtooth hanging panels, and so on, is probably not complete. Also, examination by conservators indicates that various components were made at different times, or originally belonged to different costumes. Several have one backing fabric and several another, and those with one backing have one sort of handmade sequins while those with the other backing have another sort of handmade sequins. What is shown in the accompanying photograph as the central hanging panel has fins rising along its spine, and was probably (but not certainly[2]) intended to go in back, rather than in front. The set includes another similar panel (not shown in the photograph), but it has the other sort of backing and sequins, and so it is not certain that it was part of the original ensemble.

Similar decorative garments are shown being worn by royal personages in depictions of legends and on puppets (cat. nos. 19 and 21).

It seems likely that after the British abolition of the Burmese monarchy in 1885 some formal court garments passed into use as costumes for actors portraying royal and aristocratic characters on the stage. F.McG.

1 See Franklin, "Burman Court Textiles in Historical Context," in Dell and Dudley, eds., *Textiles,* 95–102; Conway, "Burmese Dress for Shan Princes," in Conway, *The Shan,* 60–70; and Di Crocco, "The Art of Adornment: Court Dresses," in Falconer et al., *Myanmar Style,* 184–187.
2 See Fraser-Lu, *Burmese Crafts,* fig. 252.

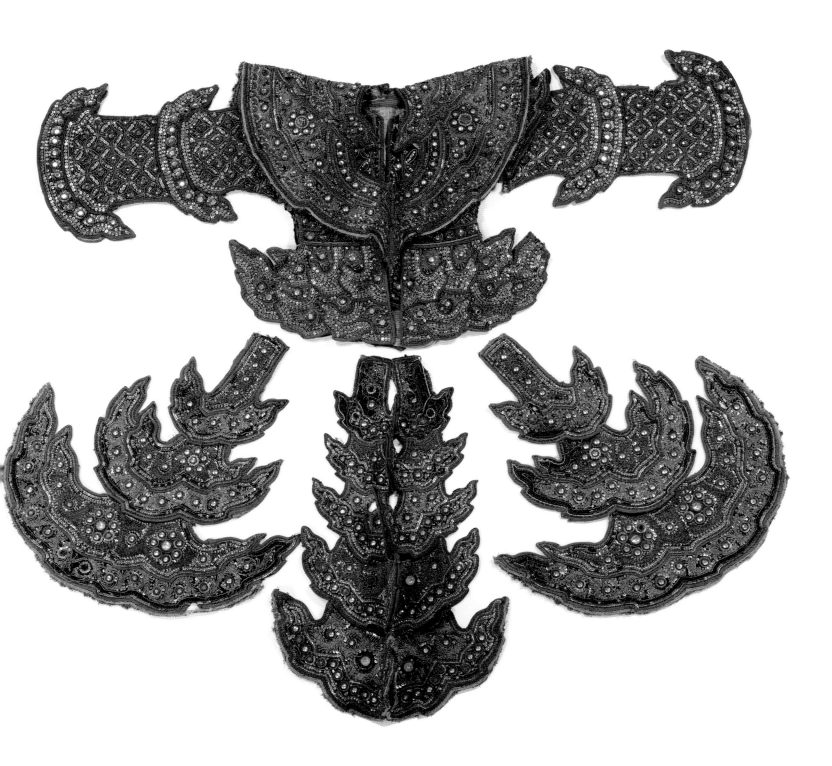

24 Gentleman and lady in an archway [DETAIL P. 2]

Approx. 1880–1906
Burma
Embroidered wool with sequins
H. 123.2 × W. 83.8 cm
Gift of John and Roxanne Harris in memory of
Lewis Hooker (1871–1933), 1998.51

A well-to-do couple, dressed in very similar fabrics, stands in an archway,[1] framed by riotous decoration. Their lower garments are of the costly fabric known as *luntaya acheik,* examples of which can be seen in cat. nos. 25–27. Wall hangings such as this were presumably made for British and other foreign customers. This example was acquired by an American who worked in Burma from 1900 to 1906.[2] F.McG.

1 Similar Western-style arches had been appearing in Burmese architecture since at least the middle of the nineteenth century, as in the masonry ground level of the

Atumashi Temple in Mandalay, built in 1857. The arches of the Atumashi have engaged columns, heavy imposts, and vine-like decorations on the faces of the arches similar to those seen here. See Girard-Geslan et al., *Art of Southeast Asia,* pl. 52.

2 An appliquéd and sequined textile comparable in subject and style, though not in color, is illustrated in Franklin, Singer, and Swallow, "Burmese Kalagas," 68.

25 Man's lower garment [DETAIL P. 74]

Approx. 1875–1925
Burma; Mandalay region
Silk and cotton
L. 375.3 × W. 110.5 cm
Museum purchase, 2004.82

Textiles with horizontal wave- or vine-like bands in interlocking tapestry weave such as this (and the two following entries), called *luntaya acheik,* were always expensive because of the exacting and time-consuming effort required to produce them. Red and green patterns were reserved for the use of members of the royal court. Some lengths of such cloth had their corners sewn together, as here, so that when the cloth was wrapped as a man's elaborate lower garment it would have voluminous pockets. F.McG.

26 Skirt cloth with *luntaya* design

Approx. 1875–1925
Burma; Mandalay region
Silk with plain-weave weft-patterned design
and metal-wrapped threads
L. 116.2 × w. 77.5 cm
Gift of Dr. Stephen A. Sherwin
and Merrill Randol Sherwin, F2008.42.1

27 Cloth with *luntaya* design

Approx. 1875–1925
Burma; Mandalay region
Silk with plain-weave weft-patterned design
and metal-wrapped threads
L. 127.0 × w. 58.4 cm
Gift of Dr. Stephen A. Sherwin
and Merrill Randol Sherwin, F2008.42.2

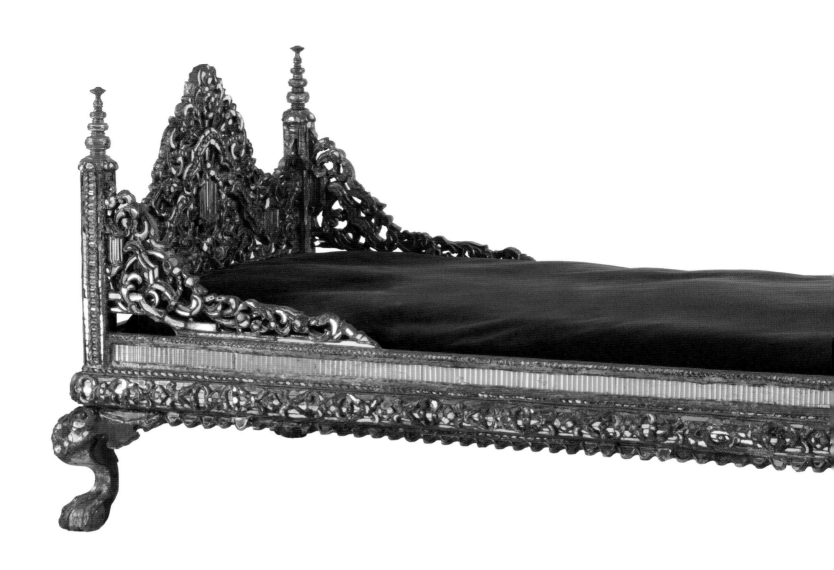

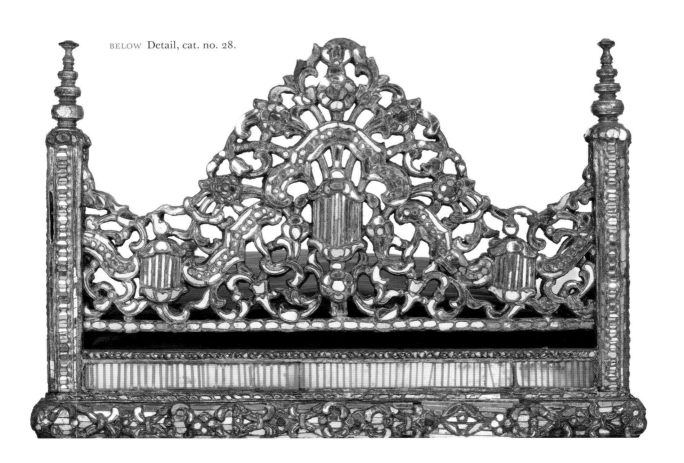

BELOW Detail, cat. no. 28.

28 Couch

Approx. 1850–1910
Burma
Lacquered and gilded wood
with glass rods and mirrored glass
H. 76.8 × W. 182.9 × D. 82.5 cm
Gift from Doris Duke Charitable Foundation's
Southeast Asian Art Collection, 2006.27.51

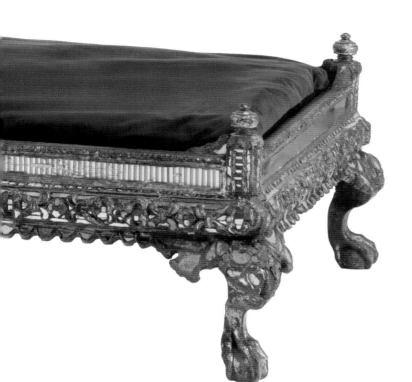

In old photographs Burmese and Shan aristocrats and monks sit on couches such as this, Buddha images recline, and deceased monks are laid out.[1] A similar couch, also with inlay of rather large pieces of mirror and squat cabriole ball-and-claw legs, is in the collection of the Victoria and Albert Museum;[2] it has an apparently original green velvet cushion. The Asian Art Museum's couch had lost its cushion; a new one, also of green velvet, was made for it in 2008. F.McG.

1 Aristocrats: a photo by Philip Adolphe Klier from the 1890s, http://www.bl.uk/onlinegallery/onlineex/apac/photocoll/other/019pho0000088s1u00043000.html; Conway, *The Shan,* 69, 151. Monk: Ferrars and Ferrars, *Burma,* 25. Buddha image: also in a photo from the 1890s by Klier, http://www.bl.uk/onlinegallery/onlineex/apac/photocoll/b/019pho0000088s1u00041000.html. Deceased monk: O'Connor, *Mandalay,* 35.
2 Lowry, "Burmese Art at the Victoria and Albert Museum," 29.

BELOW, LEFT *Burmese Idols* by Philip Adolph Klier, 1890s.
BELOW, RIGHT *Burmese Prince & Princess* by Philip Adolph Klier, 1890s.

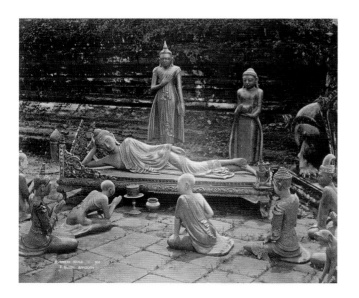

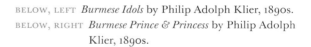

29 Betel box

Approx. 1950–1970
Burma
Lacquered bamboo and basketry,
possibly including horsehair
H. 25.4 × DIAM. 25.4 cm
Gift of Dr. Sarah Bekker, 2008.81.A–D

Cylindrical boxes with trays inside, for holding the ingredients for betel chewing (betel vine leaf, the nut of the areca or betel palm, quicklime, and sometimes spices or tobacco), were among the most common lacquer objects in Burma.[1] The body of the box is made of tightly woven bamboo strips, over which the lacquer is applied and then smoothed, decorated, and polished.

The outside of this box is decorated with the twelve signs of the Burmese zodiac enclosed within the linked-rectangle design associated with Mount Meru, the central mountain of the Buddhist cosmos. On the lid are the symbols of the eight planets and days of the week (Wednesday has two).[2]

F.McG.

1 For more information, see "The Betel Habit and Betel-box" in Isaacs and Blurton, *Visions,* 65–69.
2 See Fraser-Lu, *Burmese Lacquerware,* 56–66 and illus. 4.4, which shows this very box.

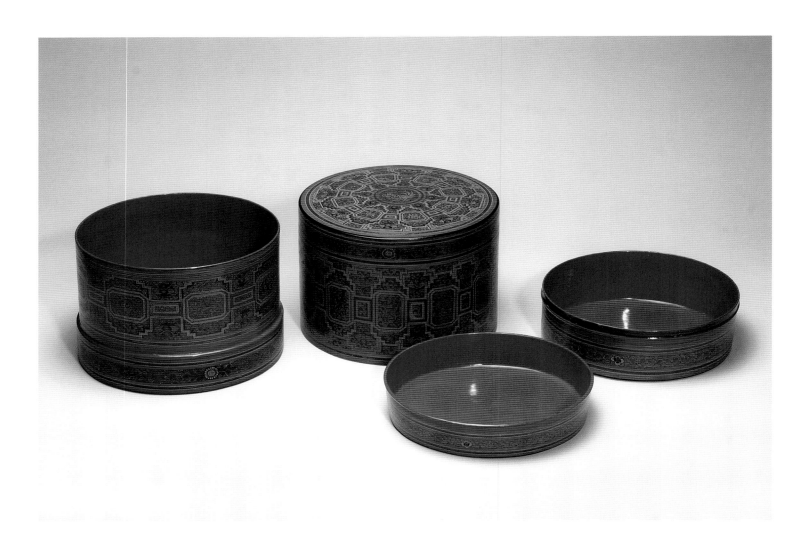

ABOVE Cat. no. 29, disassembled.
FACING Detail, cat. no. 29.

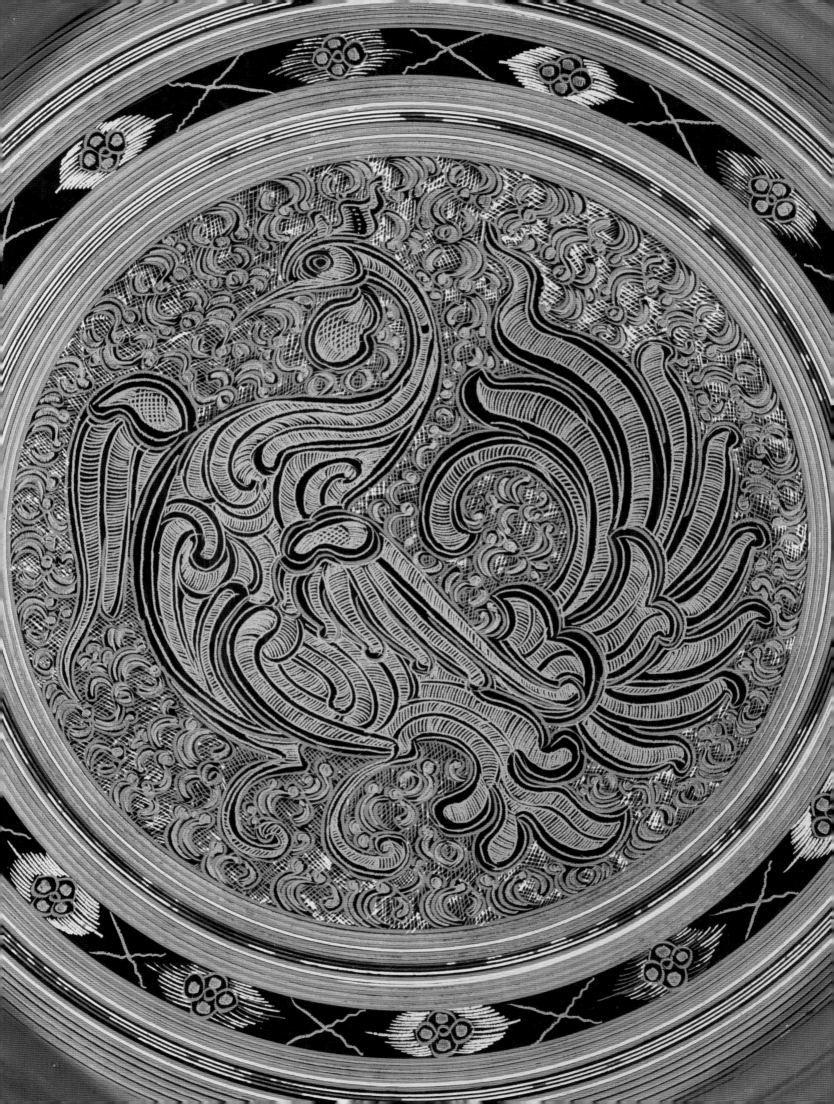

SHAN STATE AND NORTHERN THAILAND

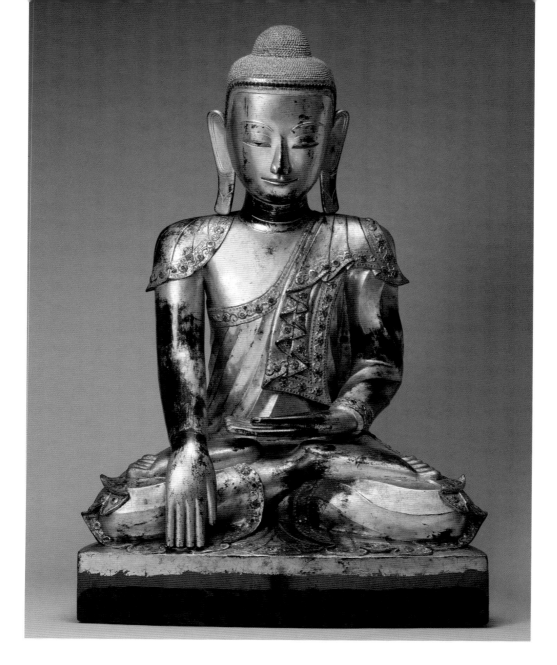

30 Seated Buddha

Approx. 1850–1900
Burma; probably Shan State
Gilded dry lacquer, pigmented natural resin, and
mirrored glass
H. 114.3 × W. 72.4 cm
Gift from Doris Duke Charitable Foundation's
Southeast Asian Art Collection, 2006.27.26

Comparing this seated Buddha image with one
of a type associated with Mandalay (cat. no. 1)
is instructive. Both show the ripples and folds
of the monastic robes (as many Southeast Asian
Buddha images do not), and both have a band at
the hairline. But the folds on this image are orga-
nized into patterns of more or less parallel lines
and appear much more stylized and less natural-
istic than those of the Mandalay-type image. This
characteristic, together with the breadth and rela-

tive flatness of the face, especially at the forehead,
and the projecting ears, suggests that this image
may have been made in the Shan States east and
northeast of Mandalay.[1] The Buddhist arts of
this region are little known; scholars have hardly
begun to study them.

Issues that will need to be considered are
artistic connections with Buddhist art of Tibet
and China. For example, the point of the right
shoulder covered by an edge of the monk's robe
can be observed in Chinese Buddhist art as early
as the fifth century and continues to appear on
and off in both China and Tibet but not, usually,
in Southeast Asia.[2] F.McG.

1 Note, however, that dry lacquer images were sometimes
 sold far from where they were made. See Fraser-Lu,
 Burmese Crafts, 244–245, where a useful discussion of the
 technique appears.
2 Griswold, "Prolegomena," 120–121 and figs. 4A, 22.

31 Seated Buddha

Approx. 1800–1850
Burma; perhaps Shan State
Lacquered and gilded wood with glass
H. 74.9 × W. 38.7 cm
The Avery Brundage Collection, B72S1

This image has a number of features in common with a published example from a mid-nineteenth-century monastery on Inle Lake in the Shan State, such as the highly stylized representation of folds in the robe as raised curves and counter-curves, plus the presence on the proper left shoulder of a long vertical rectangle.[1] On the image in situ this rectangle is filled with more curves that presumably stand for robe folds; on the image in this exhibition the rectangle is now empty but appears to have borne raised decoration similar to that elsewhere on the image. (Note that this image lacks the expected finial at the top of its cranial protuberance, but there is a hole into which one must originally have been fitted. The finial was probably in the form of a teardrop-shaped jewel, like that on the image in the monastery mentioned.)

The base of the image here, with its narrowing and then broadening steps, reflects the structure of Burmese royal thrones, such as the Lion Throne formerly in the palace of Mandalay.[2] Such thrones situate the Buddha or king at an exalted level on the axis of the world in Southeast Asian Buddhist cosmology.[3]

At the back of the base there is a rectangular chamber, the purpose of which is unknown. A published example of a similar image also has a rectangular chamber at the back of the base.[4]

F.McG.

1 The comparable image, at Nga Phe Kyaung, Ywama village, Inle Lake, is illustrated in Falconer et al., *Myanmar Style,* 142. Anne-May Chew associates this sort of image with what she terms the Amarapura style of 1782–1853 in *Cave Temples of Po Win Taung,* 66.

2 A good photo appears in Dhida, *Mandalay,* 80. A very large Buddha image formerly in the Atumashi Temple in Mandalay, seated on a throne similar to the Lion Throne, can be seen in Oertel, *Tour,* fig. 15.

3 The shape of the throne in narrowing and broadening steps is shown, for example, in a Burmese chart, made in 1875, of the "thirty-one levels of existence"; see Herbert, "Burmese Cosmological Manuscripts," fig. 8.1. The great Thai scholar Prince Damrong, visiting Mandalay in 1936, described the royal Lion Throne in great detail, noting, for example, that it had on its frame images of Indra and the thirty-two gods who reside in the heaven at the top of Mount Meru, the central mountain of the universe. He continued, "Europeans say that the throne was decorated with all these images to symbolise that the king, seated on his throne, was the centre of the universe.... I think one might also say that all these images symbolised the king as a Bodhisattva"; Damrong, *Journey Through Burma,* 94. In fact, there is abundant evidence that Southeast Asian Buddhist kings sometimes sought to present themselves implicitly not just as a bodhisattva but as a Buddha.

4 Karow, *Burmese Buddhist Sculpture,* 85.

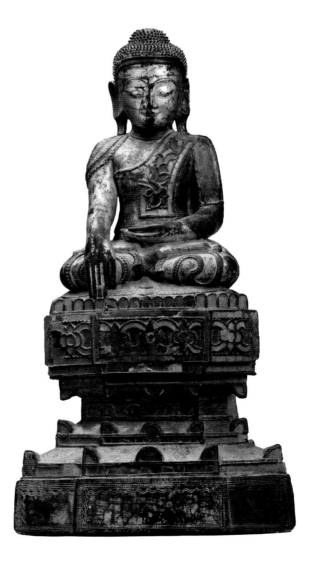

32 Seated crowned and bejeweled Buddha

1895
Burma; possibly Shan State
Gilded dry lacquer with mirrored glass
H. 130.8 × w. 99.1 cm
Gift from Doris Duke Charitable Foundation's
Southeast Asian Art Collection, 2006.27.27

The meanings of the crowned and bejeweled Buddha image are complex. They were no doubt interpreted differently in various places at various times by persons of various backgrounds and status.[1] Burmese, Shan, and Siamese Buddha images

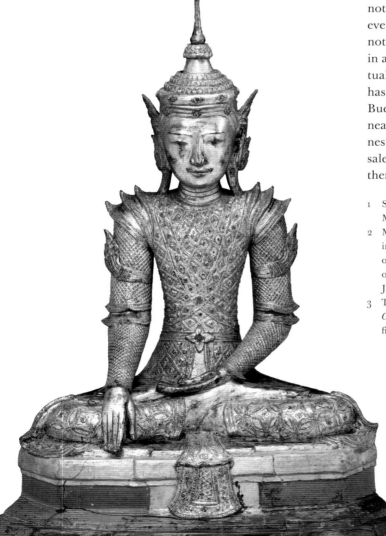

in royal attire are sometimes associated with the legend of the Buddha's overcoming the arrogant monarch Jambupati, but a number of other implications must also have been important.

According to Sittiporn Netniyom of Chiang Mai College of Dramatic Arts, the two inscriptions on the base of this image are in a script characteristic of the Keng Tung region of the Shan State of eastern Burma and the neighboring area of China.[2] Both include dates equivalent to 1895 and express the wish of the donor, along with his wife, children, and relatives, to support the Buddhist religion and gain merit through the sponsorship of this image.

Though this image must once have resided in the Shan area where the script of its inscriptions was used, the place of its manufacture is not certain. Dry lacquer images such as this, even when they are quite large, are hollow and not at all heavy. This image may have been made in another part of Burma and moved to its eventual home in the Shan area of the east. Than Tun has described in detail the creation of dry lacquer Buddha images (though smaller than this one) near the town of Ye-U and their being carried, nestled one inside another, to the Shan areas for sale to pious families who would then donate them to temples.[3] F.McG.

1 See the discussions by Hiram Woodward and by me in McGill, ed., *Kingdom of Siam,* 54–56, 144–146, and passim.
2 Min Zin was instrumental in transmitting photos of the image and its inscription to Professor Sittiporn; the efforts of both scholars are appreciated. Professor Sittiporn's opinions and translation came in an e-mail message of July 7, 2008.
3 Than Tun, "Lacquer Images." See also Fraser-Lu, *Burmese Crafts,* 244–245; Isaacs and Blurton, *Visions,* 100–102 and fig. 75; and Green, *Eclectic Collecting,* 200–201.

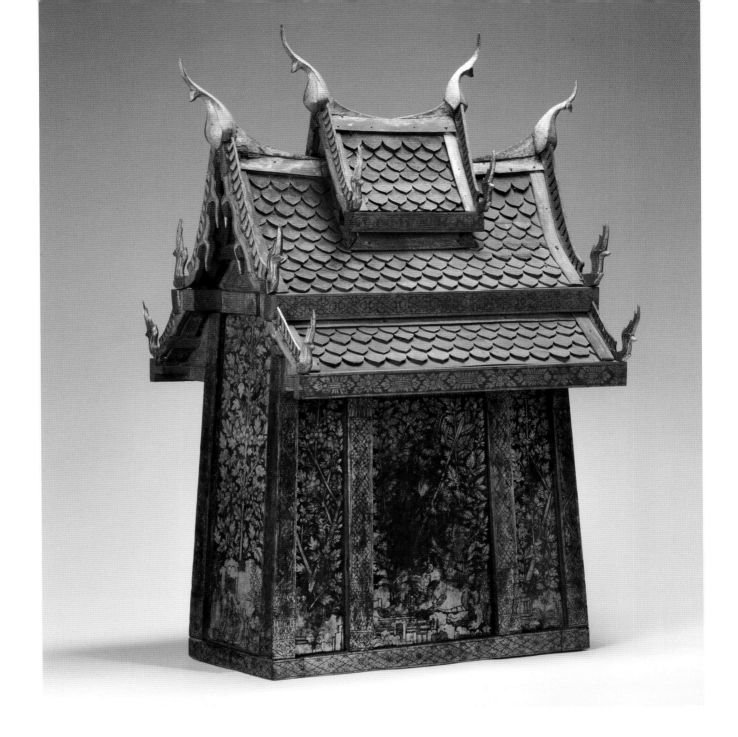

33 Miniature temple

Approx. 1850–1900
Northern Thailand
Lacquer, pigmented natural resin, paint,
and gilding on wood
H. 116.8 × W. 82.5 × D. 50.2 cm
Gift from Doris Duke Charitable Foundation's
Southeast Asian Art Collection, 2006.27.54

Miniature models of temple buildings, shrines,
and stupas were commonly made as offerings.[1]
Like Buddhist icons, they were given by donors
in the hope of accruing merit that would help
them attain nirvana or be reborn during the time
of the future Buddha Maitreya.

According to inscriptions on similar objects,
a miniature temple might contain a Buddha
image. Sometimes the miniature temple also
contained a miniature stupa in which a relic was
housed. For example, an inscription on a metal
miniature temple dated to 1727 in the collec-
tion of the Chao Sam Phraya National Museum
in Ayutthaya states that the miniature temple
functioned as a container of a Buddha image and
stupa. The inscription lists the wish of the donors
for the complete ensemble of temple, Buddha
image, and stupa "to remain as objects of rever-
ence, honor, and worship for human beings,
gods, and Buddhist arahants(?) [saints]...for
five thousand seasons...[gaps in original] the

wish...father...and children, nephews and nieces, grandchildren and great-grandchildren, every one of them. May they achieve their wishes of every kind! [In Pali:] May it be a help for attaining *Nibbana* [nirvana]."[2]

This miniature temple is decorated with floral and vegetal motifs such as lotus flowers. The door is located on one long wall and is adorned with a male door guardian carrying a trident, an

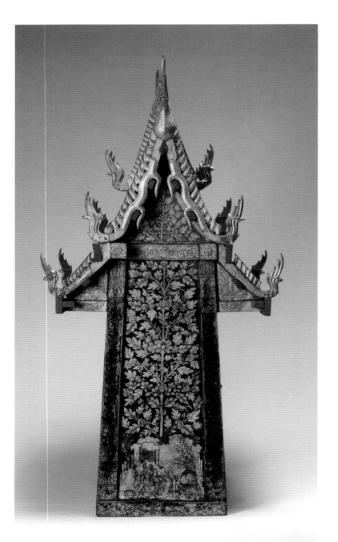

uncommon weapon for such guardians. He wears a headdress commonly worn by figures of hermits or ascetics in Thai art. The guardian stands on a Chinese lion. Whether this guardian can be identified as a specific figure from mythology is doubtful.

It is not clear whether this temple originally housed an object. Interestingly, the rear wall was not painted, so the object was meant to be seen only from the front and was probably placed against a wall.

Even though the decorative ornaments on the exterior walls, the finials on the roof, and the naga motifs on the pediment seem to reflect central Thai styles, the lacquer technique employed here belonged to the northern region.[3]

Several of the roof decorations were broken and have been replicated and replaced. P.C.

1 For examples of miniature temples, see McGill, ed., *Kingdom of Siam,* figs. 174 and 175; Naengnoi and Somchai, *Art of Thai Wood Carving,* 139–140; Naengnoi, Aroonwut, and Somchai, *Charm of Lanna Wood Carving,* 168. For examples of miniature stupas, see McGill, ed., *Kingdom of Siam,* figs. 176 and 177.
2 Nandakic, "An Inscribed Model," 127–128. Also see Skilling, "For Merit and Nirvana," 87.
3 The object was examined carefully by a member of the museum's conservation staff. She states that the lacquer technique is very similar to that of two other objects (cat. nos. 35 and 36) in the exhibition, both of which are apparently from the north. This miniature temple has an insoluble red transparent sealing layer that was applied directly to the timber surface and followed by a thin black lacquer coating and then gilded.

LEFT Detail, cat. no. 33.

34 Shrine

1800–1900
Northern Thailand
Lacquered and gilded wood with mirrored glass,
plain glass, and ferrous and nonferrous metal
H. 193.0 × W. 50.8 × D. 50.8 cm
Gift from Doris Duke Charitable Foundation's
Southeast Asian Art Collection, 2006.27.55

Shrines such as this are used as official receptors
of miniature royal regalia and insignia[1] and for
religious items such as Buddha images, relics,
or scriptures.

This shrine has a high indented pedestal.
Above the pedestal is an open area where the
sacred object is placed. The structure is topped
by several tiers of tapering roofs, a stupa-like
element, and a tiered parasol finial. The shrine is
lavishly decorated with colored glass and gilding,
a popular style for embellishing furniture and the
exterior of structures.

The shape of this shrine and its decoration
indicate that it was made in the northern region.
Several similar shrines bear inscribed dates; a
bronze one is dated to 1727, and wooden exam-
ples to 1890 and 1930.[2]

Several of the roof decorations were broken
and have been replicated and replaced. P.C.

1 Good examples of miniature insignia of five kings of
 the Bangkok period can be seen at the Emerald Buddha
 Temple in Bangkok.
2 Bronze example: Griswold, "Five Chieng Sen Bronzes,"
 101–106; see also Fontein, Lambrecht-Geeraerts, and
 Bakker, *Bouddhas du Siam,* 61. Wooden examples:
 Naengnoi, Aroonwut, and Somchai, *Charm of Lanna
 Wood Carving,* 139, 148; see also Chawingam and
 Saimai, *Butsabok thammat.*

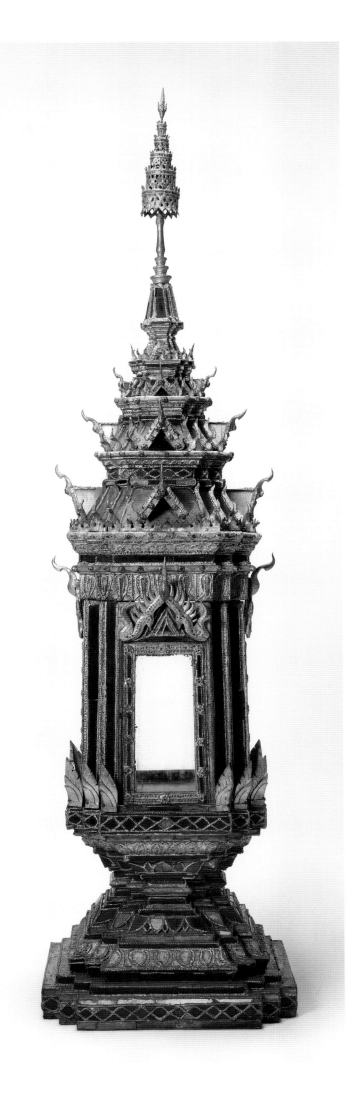

35 Panel with forty Buddhas supported by a demon

1800–1900
Northern Thailand
Wood, lacquer, and gilding
H. 128.3 × W. 52.6 cm
Gift from Doris Duke Charitable Foundation's
Southeast Asian Art Collection, 2006.27.48

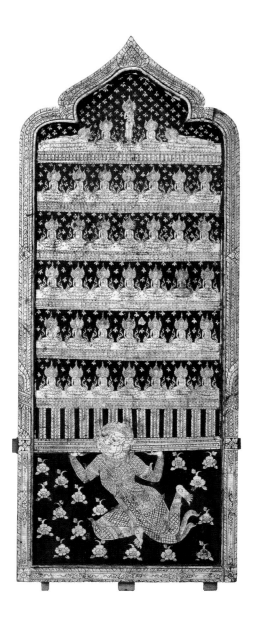

This panel depicts forty Buddhas in three positions: reclining, meditating, and standing. In the center of the upper register, the Buddha stands with his right hand raised in the position of *ham yat,* which symbolizes, in later Thai tradition, the episode when he restrained his relatives from fighting over access to water.[1] He is flanked by two seated Buddhas in meditation and two reclining Buddhas. The other thirty-five Buddhas (seven Buddhas in five rows) are seated on lotus pedestals in the meditation position (one hand placed on the other).[2]

A flower (*michelia champaca*) often used on the tassel of a garland of jasmine in Siam embellishes the background. The structure that holds the forty Buddhas is lifted by a demon. (Demons also support the Buddha in cat. no. 53.) Demon figures commonly appear as supporters holding up the base of monuments and stupas in Siam. Before the Buddha attained enlightenment, he was attacked by troops of demons sent by Mara, a demonic figure who embodies evil and death. Thus, the demon became a supporter of the Buddha.

The wooden tangs on the sides at the bar where the demon is lifting the structure and the three on the bottom of the piece indicate that the panel was once attached to a base or to another structure. The shape of the panel, with its stylized curved top, is similar to that of a Buddhist tablet board (cat. no. 101). Thus the panel could be a merit-making board. The Asian Art Museum piece can be compared with a Buddhist votive board in the collection of Wat Chiangman (in Chiang Mai Province, Thailand).[3] In addition, the lacquer on this panel has a red underlayer for sealing the wood, and a very thin black lacquer coating was applied before the gilding, a technique that was common in the northern region but not in the central region.[4] Therefore this panel most likely was produced in the northern region.

P.C.

1 For a discussion of the history of this gesture in Siam, see Woodward, *Sacred Sculpture,* 124.
2 Peter Skilling explains that people had such representations of multiple images made for many reasons. Sometimes they chose the number of Buddhas to be their age plus one (symbolizing the hope of extended life), so the number varies. Some numbers, however, are associated with specific groupings of Buddhas, such as 3, 5, 24, and 28.
3 Naengnoi, Aroonwut, and Somchai, *Charm of Lanna Wood Carving,* 133.
4 The technique used on this panel is closely related to that of the miniature temple (cat. no. 33) and the chest (cat. no. 36) that were produced in the northern region. The object was studied by one of the Asian Art Museum's conservators.

36 Chest with scenes of the Buddha enthroned, Phra Malai and Indra at the Chulamani Stupa, and guardians [DETAIL FIG. 50]

1800–1900
Northern Thailand; perhaps Nan
Lacquer, pigmented natural resin,
and gilding on wood
H. 52.1 × W. 91.4 × D. 54.6 cm
Gift from Doris Duke Charitable Foundation's
Southeast Asian Art Collection, 2006.27.45

The front of this chest (assuming that the side to which the lid is attached by hinges is the back) shows the scene of the Buddha in Indra's Heaven preaching to his long-deceased mother. The Heaven of Indra, also known as the Heaven of the Thirty-three, because Indra rules there as king of the other thirty-two gods, is situated at the summit of the legendary Mount Meru, the central mountain of the Theravada Buddhist cosmos.[1]

The Buddha is depicted seated on a high throne beneath an elaborate roof, to either side of which celestials fly in to offer lotuses and listen

to the preaching. Indra is displaced, kneeling to the Buddha's left in an attitude of respectful attention. Indra's royal regalia—a parasol, a fan, a fly whisk, and so on (see cat. nos. 37–39)—flank the Buddha, emphasizing the Buddha's king-like glory. Behind Indra kneels the Buddha's mother, and on the opposite side kneel two other figures, a garuda and a serpent-being recognizable by the snake body that coils below his waist.

The inclusion of these creatures in this frequently represented scene is unusual. Traditionally, the garuda and the serpent (associated, respectively, with the sun and the waters) are enemies. Perhaps they are shown to suggest that beings of all sorts have come to hear the Buddha's teaching and in his presence are calmed. The scene also may be alluding to the story, recounted in the Pali-language text the *Visuddhimagga,* of a powerful serpent named Nando-

BELOW Back, cat. no. 36.

pananda that became annoyed when the Buddha and five hundred monks "proceeded directly above his canopy in the direction of the divine world of the Thirty-three." The serpent threatened the Buddha and his disciples until one of the most prominent disciples took on various forms, including that of a garuda, to overcome it. The serpent then paid homage to the Buddha and accepted his teaching.[2]

It might be expected that the Buddha, in this episode of delivering a sermon, would be shown with the hand position often associated, in Buddhist art, with preaching. In nineteenth-century Siam, however, the preaching gesture is seldom seen, and by far the most common gesture is the one shown here, associated with the defeat of the demon Mara and the subsequent attaining of Enlightenment.

On the opposite side of the chest the setting is still Indra's Heaven, but for an entirely different story. The scene, frequently depicted in nineteenth-century Thai art, is of the monk Phra Malai paying homage to the Buddha's relics. When the young Prince Siddhartha, after leaving his father's palace, cut off his long hair to mark his renunciation of his aristocratic status, Indra retrieved the hair and enshrined it in a monument, the Chulamani Stupa, in his capital. This stupa occupies the central position in this scene, as did the Buddha himself on the other side of the chest, reinforcing the ancient notions that the Buddha's relics embody his living presence and that stupa and Buddha image are essentially equivalent.[3]

To one side of the stupa we see the monk

BELOW Side, cat. no. 36.

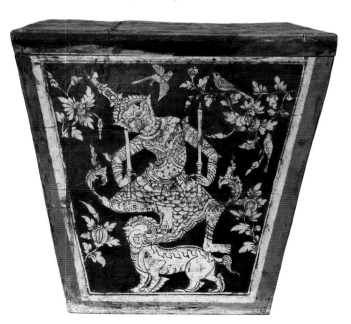

Phra Malai with his frequent attributes, the ecclesiastical fan and monk's bowl (on a stand, with a length of cloth tied around it). (See cat. nos. 93–95.) To the other side are a kneeling male figure and two kneeling female figures with cloud motifs beneath them, suggesting that they are hovering. Presumably the male is the bodhisattva Maitreya, the future Buddha, whom Phra Malai meets when Maitreya descends from a higher heaven to worship the hair relic. (The figure resembles Indra on the other side of the chest and could represent him,[4] but the presence only on this side of the cloud motifs and the halo seem to indicate that the male figures on the two sides are not the same being.) The two female figures are probably celestials in Maitreya's entourage.

On one end of the chest a demonic figure holding two batons stands on the back of a lion. Such a figure would usually be interpreted as a guardian, related to similar figures often depicted on doors and window shutters (and manuscript pages; see cat. no. 100). But on the opposite end of the chest, where we might expect another lone guardian, we see instead the same figure confronting a nobleman who carries a bow. These figures have not yet been identified.

One side of the chest bears a one-line inscription that is barely discernible—so nearly obliterated that it has not yet been deciphered.

The details of the figures and motifs on this chest, as well as the relatively large spaces left blank, are characteristic of lacquer decoration in northern Thailand, rather than in the country's center, where floral or flame-like designs usually (but not invariably) fill the spaces. A chest in a museum in the northern city of Nan bears similar decoration, and both chests may have been made in Nan, which had a long history of semi-autonomy and distinct (though not yet fully studied) artistic traditions. F.McG.

1 Indra's Heaven, called in Sanskrit Trayastrimsha (Pali: Tavatimsa), "the Heaven of the Thirty-three" (Gods), is described in Reynolds and Reynolds, *Three Worlds,* 223–238.
2 Buddhaghosa, *Path of Purification,* 394–396; note that the term *supanna* used in the translation refers to a garuda. The story of Nandopananda is illustrated in the murals of the Phutthaisawan Chapel in Bangkok, but note that he is not seen seated in reverence in Indra's Heaven; Fickle, *Life of the Buddha,* panel 18. See also Fickle, "Story of Nandopananda," and Nyanaponika and Hecker, *Great Disciples,* 96. Boisselier discusses the story in *Thai Painting,* 213.
3 Shorto, "Stupa as Buddha Icon."
4 As in the painting on the inside back of the tiered stand cat. no. 96.

37 Pair of ceremonial standards

Approx. 1850–1950
Northern Thailand
Lacquer, pigmented natural resin, and gilding on wood with mirrored glass
H. 215.9 × W. 19.0 cm; H. 215.9 × W. 19.7 cm
Gift from Doris Duke Charitable Foundation's Southeast Asian Art Collection, 2006.27.113.1–2

38 Pair of ceremonial standards

Approx. 1850–1950
Northern Thailand
Lacquer, pigmented natural resin, and gilding on wood with mirrored glass
H. 203.2 × W. 25.4 cm; H. 209.5 × W. 25.4 cm
Gift from Doris Duke Charitable Foundation's Southeast Asian Art Collection, 2006.27.113.3–4

39 Pair of ceremonial standards

Approx. 1850–1950
Northern Thailand
Lacquer, pigmented natural resin, and gilding on wood with mirrored glass
H. 177.2 × W. 49.5 cm; H. 184.1 × W. 47.0 cm
Gift from Doris Duke Charitable Foundation's Southeast Asian Art Collection, 2006.27.114.1–2

Ceremonial standards, a part of royal regalia in both central and northern Thailand, are used in official processions such as coronations and funeral ceremonies.[1] Officials dressed in traditional costumes carry them to indicate specific sections of a procession. For instance, the king is always accompanied by a ceremonial parasol and fan. The number of ceremonial standards shows the rank of a royal family member. Similar standards can be seen flanking the Buddha or noble figures in other artworks (cat. nos. 36, 70, and 86).

These ceremonial standards are embellished with decorative ornaments such as flame-like, floral, and mythical motifs. One pair (cat. no. 39) is decorated with a mythical water animal that resembles a Chinese dragon. It symbolizes a type of flag generally used in Buddhist ceremonies.

P.C.

1 A group of such standards from the northern city of Nan is illustrated in Naengnoi, Aroonwut, and Somchai, *Charm of Lanna Wood Carving,* 138.

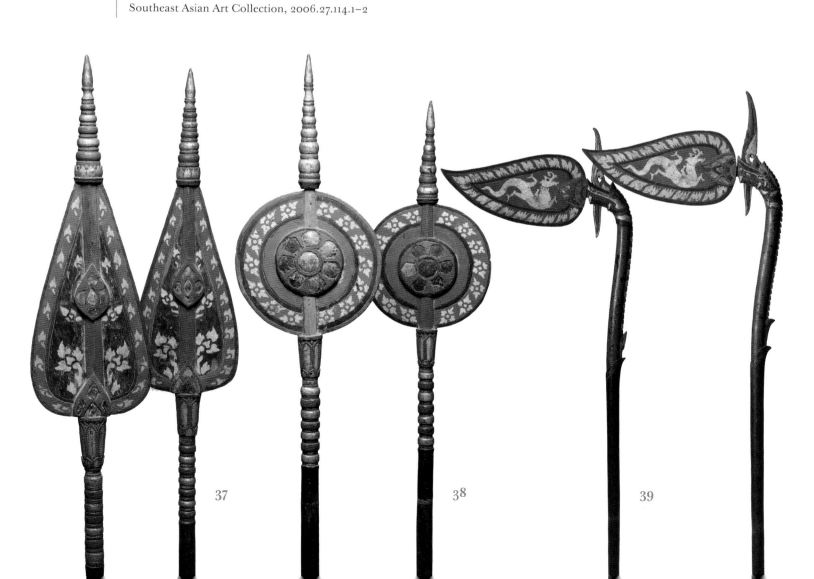

37 38 39

40 *Shan Chiefs*

1903
India; Delhi
Gelatin silver print, printing-out process
H. 12.1 × W. 9.5 cm
From the Collection of William K. Ehrenfeld,
M.D., 2005.64.326

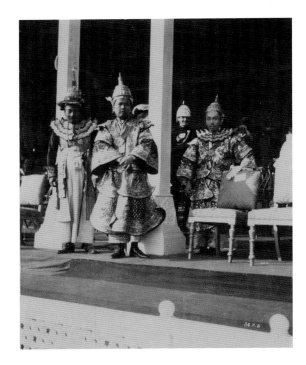

These Shan rulers, attending the British imperial accession durbar in Delhi in 1903, wear their most formal court garments.[1] These garments, with their wide, sometimes finned collars and flaring hanging panels elaborately decorated with gold thread, spangles, and glass gems, recall those of the Mandalay court such as cat. no. 23. In fact, before the fall of the Burmese monarchy to the British in 1885, Burmese kings bestowed aristocratic garments and accoutrements on Shan rulers in recognition of their at least nominal fealty.

Rajas and princes from all over British India (into which British Burma, including the Shan States, had by then been incorporated) attended the ceremonial spectacle in Delhi marking the accession of Edward VII as emperor of India.

The photographer's identity is not known. The letters "F.B" in the photo make one wonder about an association with the well-known photographer Felice Beato (1834–approx. 1905), who worked in Burma as a photographer and seller of Burmese antiques and curios for a number of years beginning in 1886. Apparently, however, by 1903 he was no longer active in either capacity,[2] and no evidence has been found that he attended the Delhi durbar. 　　　　　F.McG.

1　Other than the inscription "Shan Chiefs," this photo bears no indication of its date or exact identification. Other photos taken at the 1903 durbar show the same individuals in the same garments; see Conway, *The Shan,* fig. 86, which reproduces a photo in the British Library.
2　Wong Hong Suen, "Picturing Burma," 8–9.

41 Howdah [DETAIL P. 102]

1800–1900
Northern Thailand
Lacquer and pigmented natural resin
on wood with glass
H. 67.9 × W. 119.4 × D. 57.8 cm
Gift from Doris Duke Charitable Foundation's
Southeast Asian Art Collection, 2006.27.53

An elephant howdah reflected the status of its owner. Designs were similar in the various regions of Siam, although the chosen mediums (for example, ivory or wood) and adornments differed according to each owner's preference.

Royal howdahs were made of precious woods and decorated with mother-of pearl or ivory inlay. Some had a cover of lacquered bamboo with cloth or paper lining for protection from the rain and sun.[1]

This howdah, not elaborate enough for persons of very high rank, is simply carved of wood and decorated with interlocking floral motifs. Glass inlay frames each of the floral panels. The shape of the howdah and the design indicate its northern origin.[2]

This howdah lacked its cushion; the present one was made in 2008. 　　　　　P.C.

1　Warren and Tettoni, *Arts and Crafts of Thailand,* 20.
2　For motifs in northern Thai wood carving similar to those on the side panels, see Kraisri, "Ham Yon, the Magic Testicles."

42 Betel box

Approx. 1875–1925
Burma, Shan State; or Northern Thailand
Silver
H. 6.3 × DIAM. 13.7 cm
The Avery Brundage Collection, B60M130

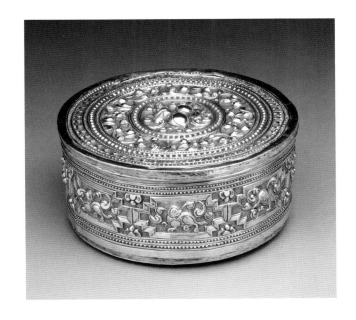

Painstakingly ornamented silver boxes for hold-ing betel or tobacco would have been desirable luxury items among the Shan. The decoration on the side of this box, of eight stepped-cornered rectangles each enclosing an animal, calls to mind that of some Burmese lacquer objects such as cat. no. 29, although here the animals are not easy to identify. They probably stand for the days of the week (with Wednesday, as was usual, divided in two).[1] The bottom of the box is entirely covered with incised fretwork lattice and the separated front and back halves of two small lion- or tiger-like creatures. Perhaps in the future when such silverwork has been more thoroughly studied the motifs on the bottom of this box will help deter-mine when and where it was made. F.McG.

1 Wilkinson, *Indian Silver*, 33. Wilkinson illustrates a num-ber of similar boxes, figs. 68–75, dating them to about 1900. Several have patterns or motifs on the bottom, which he considers to be "pictorial maker's signatures."

41

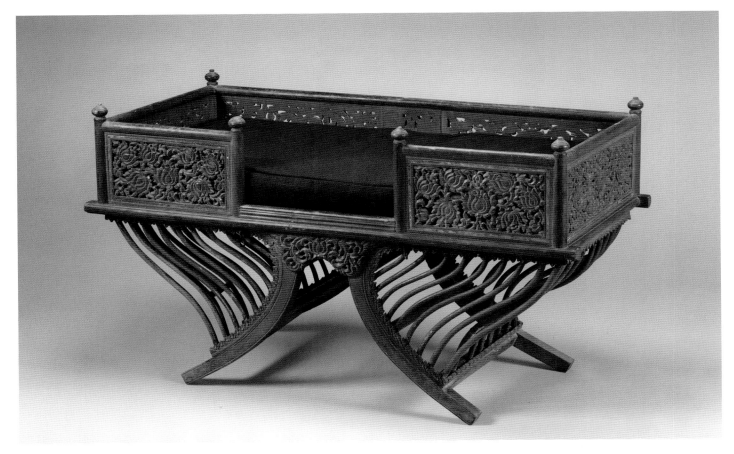

43 Short sword with scabbard

Approx. 1875–1925
Burma or Northern Thailand
Steel with ivory and silver
L. 79.4 × w. 4.4 cm
Gift from Doris Duke Charitable Foundation's
Southeast Asian Art Collection, 2006.27.112.A–B

Short swords of this type with decorations in luxurious materials and techniques were in demand, presumably more for display than for combat, in both central Burma and the Shan areas. By the 1890s they were most likely being produced for the tourist market as well.[1] The ivory carving on this example is of exceptional intricacy. On the scabbard a pierced, lace-like upper layer of vines and foliage covers an underlayer of large human figures in relief.[2] On the handle two figures are shown amid scrolling vines; one, with a demonic face (or mask), bends his head completely backward so that it appears upside down on his upper back. F.McG.

1 George Bird, in his 1897 *Wanderings in Burma,* noted that Felice Beato's shops in Mandalay and Rangoon sold, among their arts and crafts, "costumes and arms of indigenous races"; quoted in Wong Hong Suen, "Picturing Burma," 8.
2 Singer, in "Rhino Horn and Elephant Ivory," illustrates an ivory shrine with carving in two layers; a Buddha image appears behind a filigree of vines. A sword with a scabbard related to this one is illustrated in Ferrars and Ferrars, *Burma,* fig. 236.

44 Knife handle in the shape of a monkey

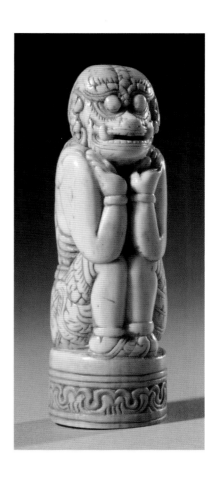

Approx. 1825–1875
Thailand or Burma
Ivory
H. 10.2 cm
Gift of Mr. and Mrs. John B. Bunker, B86W4

This knife handle is carved in the shape of a monkey, probably Hanuman, the simian hero of the Rama legends.[1] F.McG.

1 Handles for knives or short swords carved in the form of Hanuman are known from both Thailand and Burma. See *Sinlapawatthu krung rattanakosin,* 344, and *Treasures from the National Museum, Bangkok,* figs. 136, 137 (both references show the same knife); and Singer, "Rhino Horn and Elephant Ivory," 100–101.

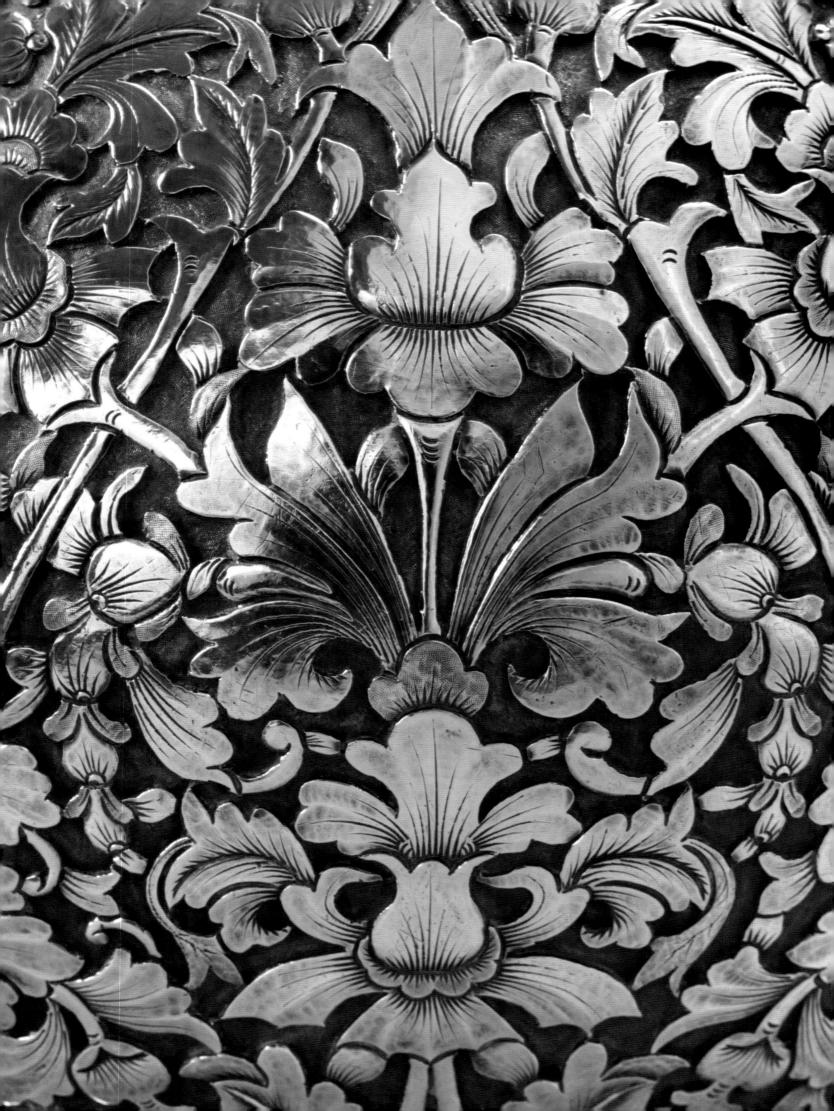

CENTRAL THAILAND

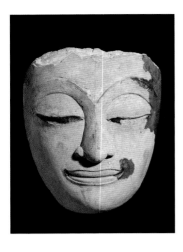
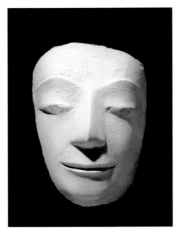

45 Head of a Buddha image [FIG. 5]

Approx. 1800
Thailand, Bangkok; from Wat Phra Chettuphon
(Wat Pho)
Stucco
H. 46.4 × w. 40.6 cm
The Avery Brundage Collection, B60S84+

In the 1790s the first monarch of the new kingdom of Siam with its capital at Bangkok built an important temple called Wat Phra Chettuphon, known informally as Wat Pho, "the temple of the Bo tree." He had hundreds of old Buddha images from other parts of his realm brought south to line the galleries of Wat Phra Chettuphon. These images were of course in a variety of styles; to make them uniform he had them covered with layers of stucco coated in gilded lacquer. In the 1950s the stucco coatings were removed, and presumably most fragments were discarded. This stucco face and at least one other, though, were kept and soon found their way into foreign collections. The impression of the face of the image each once covered is preserved on its inner side, and it is possible to narrow down which images still at Wat Phra Chettuphon they belonged to.[1] F.McG.

1 See McGill and Pattaratorn, "Thai Art," 28; and Griswold, "Medieval Siamese Images." The other known surviving face is in the art gallery of the University of Mary Washington in Fredericksburg, Virginia. The placing of the collected Buddha images in the galleries of Wat Phra Chettuphon is discussed in the dynastic chronicles; see Thiphakorawong, *Dynastic Chronicles, Bangkok Era, the First Reign,* 234.

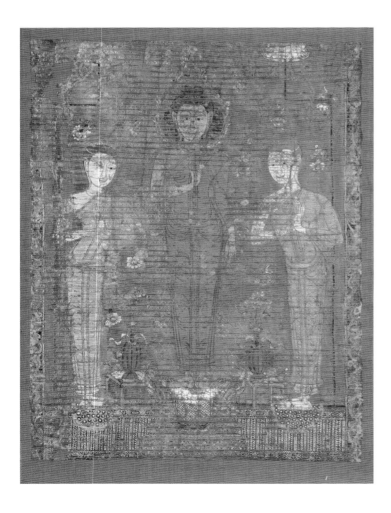

46 Standing Buddha flanked by two disciples

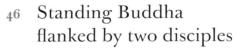

Approx. 1800–1900
Thailand
Paint and gold on cloth
H. 121.9 × w. 92.1 cm
The Avery Brundage Collection, B60D107

In nineteenth-century Siam, as in Burma in the same period, it was common to show the Buddha attended, on either side, by his two most important disciples, Shariputra and Maudgalyayana. (For a sculptured depiction of Shariputra from Burma, see cat. no. 2.)

This painting has clearly been cut down at both top and bottom and probably would have had one or more scenes below the three main figures, like cat. nos. 53 and 69. Poles behind the disciples would have supported honorific tiered parasols similar to those in cat. no. 49. The paired flower vases on either side of the Buddha recall those shown in a similar position in Thai artworks of the fourteenth and fifteenth centuries.[1]

The painting has suffered considerable loss of paint, revealing a rare feature: it is painted on textured cloth with a woven pattern of stripes alternating with bands of fretwork. Several of the large vertical paintings on cloth in the exhibition are on colored or patterned cloth. See cat. no. 68 for a discussion. F.McG.

1 McGill, ed., *Kingdom of Siam,* 116, and figs. 77, 78, and 126.

47 Standing crowned and bejeweled Buddha

Approx. 1850–1900
Central Thailand
Lacquered and gilded copper alloy
H. 120.6 × W. 29.2 cm
Gift from Doris Duke Charitable Foundation's
Southeast Asian Art Collection, 2006.27.4

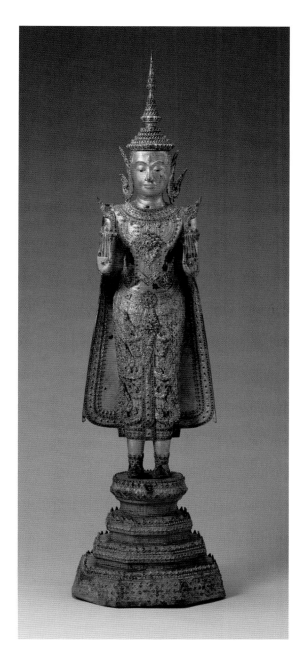

In Siam, standing crowned and bejeweled Buddha images with both hands raised palms outward usually seem to have had associations with ancestors, especially royal ancestors.[1] In the reigns of both Rama I and Rama III such images were dedicated to royal fathers and other relatives.[2]

Images similar to this one exist in considerable numbers; some are larger, but many are a good deal smaller. They are difficult to date, apparently having continued to be made for traditional purposes, and following the same models, into the early twentieth century. One of the few known examples with an inscribed date (equivalent to 1868) is in the National Museum in Bangkok, and though it is larger and finer than this one, the general similarities are fairly close, and the example here may be of a comparable age.[3]

This image (like, it would seem, the dated example in the National Museum) has a removable, separately cast, upper part of its crown. Beneath the crown of this example is a finished chamber at the top of the head. Its purpose is not known: it may have been intended to hold relics of a deceased person, but would the relics of a mortal person, even a king or a high-ranking monk, be of sufficient status to be placed in the head of a Buddha image?[4]

At the back of the base of this image a metal element with a loop at the end extends horizontally. It most likely held the pole of a tall, tiered honorific parasol that once rose over the head of the image.[5]
F.McG.

1 For more discussion of the issues of the Buddha image in royal attire, see the discussions by Hiram Woodward and by me in McGill, ed., *Kingdom of Siam,* 54–56, 144–146, and passim. Frank E. Reynolds, in a discussion of the *Nidanakatha,* a fifth-century Theravada Buddhist text known in Siam and Burma, notes that it "maintains and highlights the canonical emphasis on the royal dimensions of the Buddha's attainment"; "Many Lives," 52. The British envoy John Crawfurd, after an audience with Rama II in 1822, noted another sort of resemblance: "The King, as he appeared seated on his throne, had more the appearance of a statue in a niche, than of a living being"; Crawfurd, *Journal of an Embassy,* 94.

2 Woodward's discussion mentioned in the previous note; Naengnoi and Freeman, *Grand Palace,* 52–54.

3 Illustrated in Chira Chongkol, *Guide,* 4th ed., 101. I thank Pattaratorn Chirapravati for bringing this image to my attention and for supplying a photo of its dated inscription.

4 A number of other Buddha images in royal attire have crowns, the upper part of which can be removed to reveal a chamber in the head, such as two more in the collection of the Asian Art Museum (from the twelfth and nineteenth centuries). Others, in museums in Thailand, appear on visual inspection to have similarly separable crowns, perhaps with chambers beneath, but this has not been confirmed. Among these are the examples illustrated in McGill, ed., *Kingdom of Siam,* cat. nos. 56, 63.

5 Images of this type at Wat Phra Si Rattanasatsadaram (the Temple of the Emerald Buddha) in Bangkok have such parasols; see, for example, Naengnoi and Freeman, *Grand Palace,* 53.

48 Tiered stand for Buddha images, with a depiction of a crowned and bejeweled Buddha [DETAIL FIG. 55]

1850–1900
Thailand
Lacquered and gilded wood,
mirrored glass, and pigments
H. 135.9 × W. 54.6 × D. 40.0 cm
Gift from Doris Duke Charitable Foundation's
Southeast Asian Art Collection, 2006.27.19

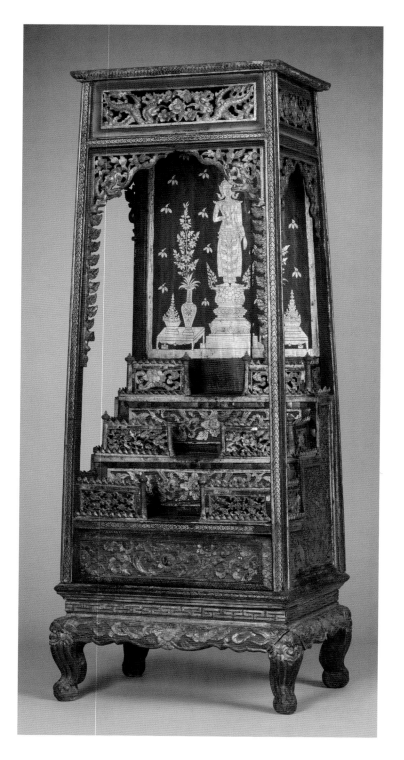

It was common practice for the Siamese to commission and donate Buddhist objects such as Buddha images, manuscripts, cloth banners decorated with Buddhist themes, and furniture to temples. There was no restriction on what could be offered, so people were free to choose their favorite objects and their styles and themes. Before the reign of Rama IV, bringing Buddha images into the home to venerate or collect as art objects was unusual. Thus, tiered stands such as this were often donated to temples. By the reign of Rama V, however, the elite began to collect antique objects. Buddha images were housed in a "Buddha room"[1] and placed on a tiered stand with incense, candles, and flowers. The largest Buddha image was placed in the center on the top tier. Odd numbers of images (generally three, five, seven, or nine) were always placed on the shelves because it was believed that the presence of the Buddha would make an even number.

By the end of the nineteenth century, people were acquiring large numbers of images and offerings for the Buddha room.[2] To accommodate them, a Chinese-style table set became more popular, so tiered stands eventually went out of fashion.[3]

The central panel of this stand is decorated with a standing crowned and bejeweled Buddha (compare cat. no. 47). The Buddha is flanked by two large vases with branches of flowers and traditional Siamese offering flower stands.

BELOW Detail, cat. no. 48.

The side panels are decorated with a depiction of the battle between the legendary hero Rama and his adversary, Ravana the ten-headed demon king (compare cat. no. 104). Although the scene is approximately the same on each side, different actions are depicted. The left side panel represents Rama holding his bow with both hands ready to swing it into Ravana, who has raised his bow to protect himself. Rama's left leg locks with Ravana's left shoulder while his right leg is placed on the demon's right hip, imitating a classical dance position. The right panel depicts another struggle between Rama and Ravana. Here Rama grasps the demon's bow. Their bodies are interlocked in another dance position.

Subject matter of scenes depicted on furniture of the Bangkok period was not restricted. It might seem unexpected that a stand for Buddhist religious use is adorned with scenes from the Rama epic, but in fact the combination was common.

In addition to the main themes, the Siamese often added a pair of animals (hares, squirrels, tigers, or birds) to the composition.[4] Sometimes the animals imitated human activities, while other times they simply engaged in their own behavior.

P.C.

1 The Siamese used the word "rent" instead of "buy" when they purchased a Buddha image because it was not considered appropriate to claim to own a Buddha image.
2 Peter Skilling points out that "the configuration of images on an altar does not refer to a formal or abstracted system of meaning (there are of course exceptions); rather, it is the product of personal relations between donors and worshippers, images, and temples." This statement also applies to the choices made in personal households. Skilling, "For Merit and Nirvana," 77.
3 In general, people who lacked space placed a small display shelf high up in a corner of the living room. It is not appropriate to place a Buddha image in the bedroom.
4 In my opinion, the animals have no symbolic meaning; rather, they are merely amusing ornaments. Moreover, they seem to reflect a Siamese sense of humor. Siamese artists loved to depict unconventional themes alongside serious themes such as the battle between a demon and a hero that requires familiarity with the story. By adding unconventional elements, the artist ensured that anyone could enjoy the work.

BELOW Detail, cat. no. 48.

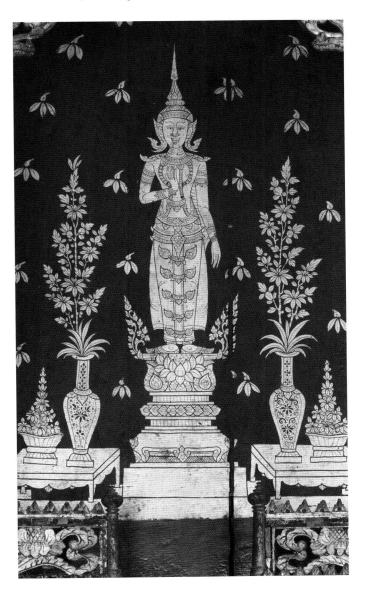

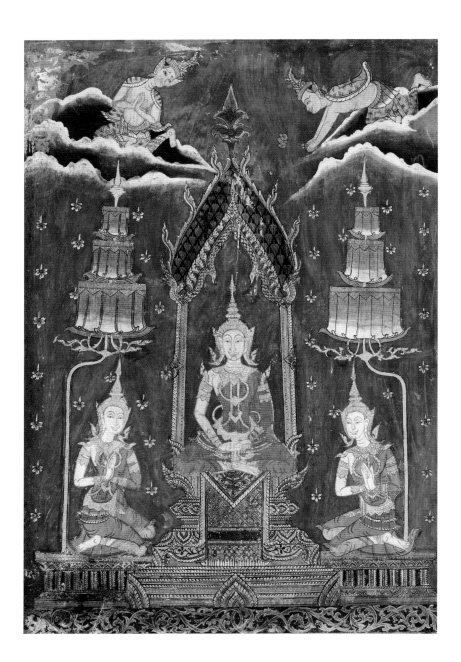

49 Enthroned crowned and bejeweled Buddha

[DETAIL P. 216]

1800–1900
Central Thailand
Paint and gold on wood
H. 66.5 × W. 45.2 cm (image)
Gift from Doris Duke Charitable Foundation's
Southeast Asian Art Collection, 2006.27.56

The Buddha, wearing a crown and jewels over his monk's robe, is seated on a high-backed throne.[1] Two similarly attired monks (presumably Shariputra and Maudgalyayana, the Buddha's chief disciples) pay homage, as do two hovering celestial hermits. Beings of this type are known as *vidyadhara* (Thai: *witthayathon*) and, in Thailand, are ascetics who have gained great magical powers. They are often depicted flying or floating at the uppermost level of temple murals.

While these identifications seem secure, the significance of the scene as a whole is unclear. Some of the meanings and associations of the crowned and bejeweled Buddha are discussed in the entry for cat. no. 47, but what of the crowned and bejeweled disciples, who appear in a number of nineteenth- and early-twentieth-century Thai paintings?[2]

F.McG.

1 In sculpture, large images of the crowned and bejeweled Buddha seated are much less common than those standing. A rare example of such an image being the major ("presiding") image of a temple is at Wat Nangnong in Bangkok, thought to have been created during the period of Rama III (1824–1851); see Santi Phakdikham, "Wat Nangnong." Other examples of crowned and bejeweled Buddha images in a sitting posture can be seen in Somkiat, *Phraphuttharup samai rattanakosin,* figs. 107 and 108.
2 For example, Boisselier, *Thai Painting,* fig. 159, where the three main figures are, however, standing.

50 Seated crowned and bejeweled Buddha, or Maitreya [FIG. 47]

Approx. 1825–1900
Thailand
Paint, gold, and lacquer on wood
H. 104.5 × w. 62 cm (image)
Gift from Doris Duke Charitable Foundation's
Southeast Asian Art Collection, 2006.27.57

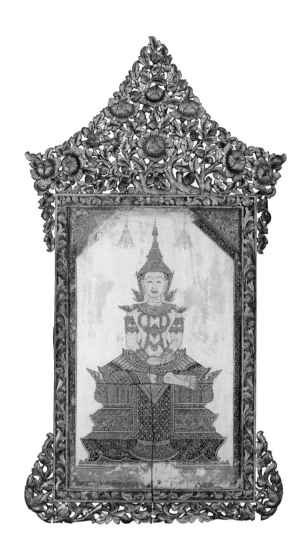

This figure would at first appear to represent the Buddha crowned and bejeweled, like the central figure in cat. no. 49. There is a difference, however: this figure does not wear monk's robes beneath the royal attire. We may in fact be seeing Maitreya, the being who will, in the future, become the next Buddha.[1]

The position and role of Maitreya in Southeast Asian Theravada belief and practice are complicated. Patrons of artworks often expressed in donative inscriptions their wish to be reborn when Maitreya comes to earth to complete his achievement of buddhahood. Kings sometimes implied that they were themselves Maitreya, using the association to suggest the inevitability of their success.[2]

While in other parts of the Buddhist world Maitreya is represented in painting and sculpture fairly frequently, he is rarely seen in Theravada Southeast Asia until the nineteenth century. Then he appears in sculpture[3] and frequently in painting and related mediums in the context of meeting Phra Malai at the stupa of the Buddha's hair relic in Indra's Heaven, as in cat. nos. 36 and 93.[4]

This object might be thought to be a painting in an elaborate frame, but in fact both the central part with the painted figure and the frame (except for its furthest projections at the sides) are made from a single wide plank. (A several-inch piece of the point at the top of the frame was missing and was recreated in the Asian Art Museum's conservation lab in 2008.)

Paintings with elaborate framing elements such as this can still sometimes be seen hanging on temple walls that are themselves covered with murals.[5] F.McG.

1 In some schools of Buddhism it is understood that there can be, and in fact are, many Buddhas throughout many worlds simultaneously, but in Southeast Asian Theravada Buddhism only one Buddha exists at a time. See the discussion of the Buddhas of the past and future in the entry for cat. no. 57. Woodward notes that "images of the future Buddha Maitreya…and those of the Buddha appearing to king Jambupati may overlap to some extent, as was the case in Burma"; in McGill, ed., *Kingdom of Siam,* 55.

2 McGill, "Jatakas," 428–436 and references cited; for donative inscriptions of the sort mentioned, see McGill, "Painting the 'Great Life,'" 197–198, 206–209. See also Skilling, "Pata (Phra Bot)."

3 An approximately life-sized sculpture of Maitreya (the identity of which is confirmed by an inscription), apparently dating from the period of Rama IV (1851–1868), is placed in a niche at the front of the ordination hall of Wat Chumphonnikayaram in Bang Pa-in; McGill, "Art and Architecture of the Reign of King Prasatthong," 180–181 and fig. 153.

4 See also McGill and Pattaratorn, "Thai Art," fig. 5A. Note that the famous stupa contained not only the hair relic but also a tooth relic retrieved by Indra from the brahman Drona; see cat. no. 52.

5 For example, *Wat Dusidaram,* 61, 84.

THE STORY OF THE LIFE OF THE BUDDHA IN THAILAND

The life of the Buddha as known in Thailand follows the general outlines of the story familiar in other parts of the Buddhist world. A number of incidents, however, and many details, are peculiar to Thailand, or shared only with the other Theravada Buddhist countries of Southeast Asia, namely Burma, Cambodia, and Laos. A prime example occurs during the victory over the demon Mara: as the story is recounted everywhere, the goddess of the earth rises to attest to the bodhisattva's perfected virtues, but only in mainland Southeast Asia does she then wring out her hair, creating a flood to inundate Mara and his forces.

The main written account of the life of the Buddha in Thailand is the *Pathomsomphot* (Pali: *Pathamasambodhi*). It has been translated into a Western language only once, and then more than 125 years ago, but is summarized, chapter by chapter, by Jean Boisselier in *Thai Painting*.[1]

Good sources on the depiction of the life of the Buddha in Thailand are *The Life of the Buddha: Murals in the Buddhaisawan [Phutthaisawan] Chapel, National Museum, Bangkok, Thailand,* by Dorothy H. Fickle; *The Life of the Buddha According to Thai Temple Paintings; Une Vie du Buddha dans les Peintures de la Sala de Wat Ruak Bangbamru à Thonburi (Thaïlande)* by Michel Jacq-Hergoualc'h; and *Temples of Gold: Seven Centuries of Thai Buddhist Paintings* by Santi Leksukhum. For painted depictions from nineteenth-century Burma, see Herbert, *Life of the Buddha;* and Pruitt and Nyunt, "Illustrations."

A standard Theravada Buddhist life of the Buddha is the *Nidanakatha,* translated by N. A. Jayawickrama as *The Story of Gotama Buddha.*

A valuable recent treatment of the life of the Buddha, with discussions of variations in a range of old texts, is John S. Strong's *The Buddha: A Short Biography.* F.McG.

1 Paramanuchit, *Phrapathomsomphothikatha;* the translation is in Alabaster, *Wheel;* the Thai version Alabaster translated was not complete, ending after the attainment of Buddhahood, and Alabaster wrote that "my translation is free or literal, according to my judgment. In many parts I have cut out tedious descriptive passages"; Boisselier, *Thai Painting,* 198–212. See also Coedès, "Une Vie indochinoise du Buddha." An important discussion of the *Pathomsomphot* and other central Thai lives of the Buddha is Nidhi Eoseewong's "The Life of the Buddha and the Religious Movement of the Early Bangkok Period" in Nidhi, *Pen and Sail.*

51 Scenes from the life of the Buddha [DETAIL FIG. 58]

| Approx. 1800–1850
| Thailand
| Paint and gold on cloth
| H. 250 × W. 114 cm (image)
| Gift from Doris Duke Charitable Foundation's Southeast Asian Art Collection, 2006.27.122.15

This large painting and the next, cat. no. 52, must have been part of a set illustrating the life of the Buddha. They are almost exactly the same size and are very similar in style and organization. How many other paintings might have been in the set is uncertain, but this painting, judging from the position of its episodes in the life of the Buddha, would likely have been preceded by at least one other. Then at least one more, and probably several, would have intervened before cat. no. 52, which completes the story.

These paintings have sustained considerable damage and paint loss, which makes identifying some of their scenes challenging. Also, the episodes do not appear to be laid out in an obviously chronological way. In general, they seem to start at the bottom and move upward, but there are numerous exceptions.

Sections of the painting have been marked more or less arbitrarily to facilitate the description.

1 The bodhisattva—that is, the Buddha before the achievement of enlightenment—sits in meditation.

2 The bodhisattva is joined by five mendicants, shown wearing tiger-skin garments, the conventional garb of hermits in Thai art.

3 The bodhisattva is troubled about whether to give up the extreme austerities he has been practicing. The deity Indra, depicted as green, appears to him and plucks three strings of a sort of lute to reassure the bodhisattva of the correctness of the Middle Way. The under-tightened string makes unsatisfactory noise, and the over-tightened one snaps; the third string, well tightened, produces a beautiful sound.[1]

4 In an unidentified scene, two hermits sit before the bodhisattva. Perhaps these are two of the five mendicants who had joined the bodhisattva earlier and are now taking leave because they disapprove of his giving up extreme austerities.

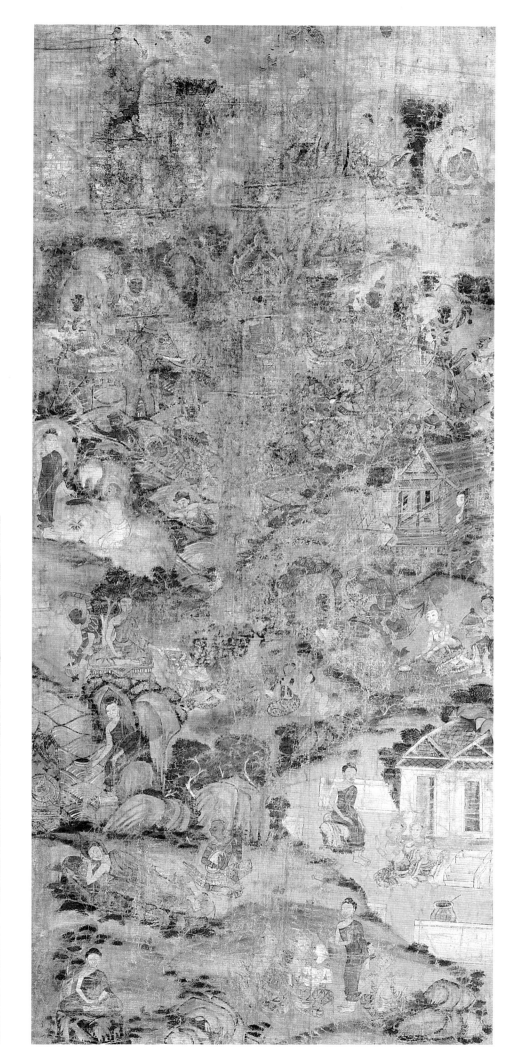

5 The young village woman Sujata cooks rice to offer to the bodhisattva for him to break his fast. Indra flies down to add delicious flavorings to the rice.

6 The rice is offered to the bodhisattva. Behind him Indra seems to be spiriting away his alms bowl. This detail is probably explained by the statement in a Buddhist text known in Siam that "the earthenware vessel given by the Great Brahma Ghatikara, which had remained with the Bodhisattva so long, disappeared at this moment."[2]

7 The bodhisattva releases the golden rice dish onto the river with the wish that if he is to achieve buddhahood that very day the bowl should move upstream. A serpent king watches. (A moment later the dish does move upstream.)

8 On his way to the ultimate meditation during which he will achieve enlightenment and buddhahood, the bodhisattva is given a bundle of grass to sit on.

9 The bodhisattva is attacked by the demon Mara, the embodiment of evil and death, but gains a glorious victory and becomes a Buddha. As is usual in Thai paintings of the scene, Mara (on elephantback) and his horde attack from our right and are shown humbled in defeat on the left. The earth goddess, who is barely visible because of damage to the painting, has wrung her hair, creating a flood against which Mara's followers are shown struggling unsuccessfully.

10 The uppermost part of the painting has suffered severe paint loss and is difficult to read. At the right it is possible to make out that the Buddha is sitting in meditation on the coils of a serpent king and is protected by the serpent's hoods arching over his head. This episode occurs in the sixth week after the Enlightenment. In this damaged upper portion the Buddha can be seen at least twice more, probably in others of the standard episodes of the seven weeks after the Enlightenment.

F.MCG.

1 Paramanuchit, *Phrapathomsomphothikatha,* 162; Alabaster, *Wheel,* 141.
2 The text is the *Nidanakatha;* Jayawickrama, trans., *Story of Gotama Buddha,* 92.

52 # Scenes from the life of the Buddha [DETAILS P. VI, FIG. 62]

| Approx. 1800–1850
| Thailand
| Paint and gold on cloth
| H. 246 × W. 114 cm
| Gift from Doris Duke Charitable Foundation's
| Southeast Asian Art Collection, 2006.27.122.11

This painting continues, but not directly in sequence, the life of the Buddha of which earlier episodes are shown in the previous painting, cat. no. 51. Other unlocated paintings from this set must have carried the narrative through the decades between the episodes in these two.

1 Food is prepared for what will turn out to be the Buddha's last meal.

2 This food is offered to the Buddha. In fact, the identity of this scene is not certain. Usually the Buddha would be shown in the process of eating, and other monks would sit nearby. Another unusual feature of this depiction is the long empty space behind the Buddha in the pavilion in which he sits.

3 The passing away of the Buddha, frequently represented in other nineteenth-century Thai paintings, is not shown. We next see one of the Buddha's disciples, Kashyapa, learning of his master's death from a naked ascetic (shown here wearing a few leaves) he encounters on the road.

4 Kashyapa joins other disciples in paying homage to the coffin of the Buddha. As a mark of favor to Kashyapa, the feet of the Buddha emerge from the coffin.[1]

5 Nobles riding elephants come to claim the Buddha's relics.

6 The brahman Drona, to prevent conflict over possession of the relics, opens the urn to portion them out. He has secreted a tooth relic in his hair; Indra swoops down to retrieve it and later deposits it in the Chulamani Stupa, which also contained the hair relic, in his heavenly city.

7 This scene is difficult to identify. The Buddha, seemingly alive, sits in meditation and is worshipped by five celestials, two hermits, and a garuda.

8 A king-like figure rides in on a horse, surrounded by attendants, pulling a conveyance on

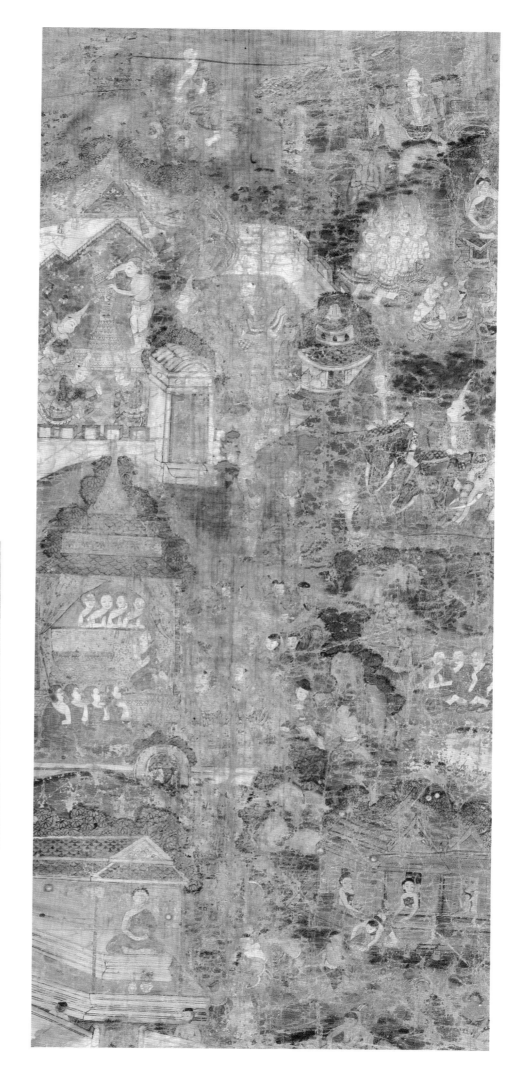

which is placed a relic casket. Presumably this is the great Indian Buddhist king Ashoka, who, in a coda to the story of the life of the Buddha in the *Pathomsomphot,* tries to gather all the dispersed relics of the Buddha but is frustrated by the demon Mara.

9 A great monk named Upagupta, who possesses extraordinary powers, is summoned by Ashoka to overcome Mara. In the painting the two can be seen struggling together. Not depicted is their competition in assuming the forms of bulls, giants, and so on. Upagupta is eventually victorious, and Mara is subdued. Upagupta asks Mara, as a favor, to take on the form of the Buddha, whom Upagupta never saw during his life-time. Conceivably this is what is represented in scene 7 of this painting. But Upagupta would be expected to be shown as the primary worshiper of the simulacrum of the Buddha, and he is not, and so scene 7 remains puzzling.[2] (The conflict between Upagupta and Mara is also depicted in cat. no. 53.) F.MCG.

1 For more information on this unexpected event, see, in addition to the sources listed on page 126, Bareau, *Recherches* 2:240–253. John S. Strong notes in *The Buddha,* 143–144, that "the miracle of the feet, moving of their own accord after the Buddha's death, is significant because it is the first graphic example of the Buddha's ongoing supernatural powers after his *parinirvana.*"
2 See Strong, *Legend and Cult of Upagupta,* chapters 5 and 9, and passim.

BELOW Detail, cat. no. 53.

53 Standing Buddha flanked by two disciples; below: the encounter of Upagupta and Mara

Approx. 1850–1900
Thailand
Paint and gold on cloth
H. 285.0 × W. 92.0 cm (image)
The Avery Brundage Collection, B60D106

The Buddha and two disciples, no doubt Shariputra and Maudgalyayana, stand on a platform supported by two demons beneath the disciples and Hanuman, the monkey hero of the Rama epic, beneath the Buddha. What the demons and monkey are doing here is a mystery.

Beneath these figures part of the story of the struggle between Mara and the powerful monk Upagupta unfolds. (For more on this story, see cat. no. 52). The two characters are shown three times, in space cells defined by trees and rocks. At right, Upagupta ties up Mara with the belt of his monastic garment. At the bottom, Upagupta, having lashed the demon to a mountain, watches him suspiciously from behind a tree. At upper left the demon, having repented (or seemed to repent: he is a trickster and cannot necessarily be trusted), sits respectfully at the feet of Upagupta.

The stories of the struggles of Mara and Upagupta are complex in structure, meanings, and implications. These have been discussed with great insight by the religious studies scholar John S. Strong in his *Legend and Cult of Upagupta*.

This painting is executed with great care and imagination, evident, for example, in the amusing vignette of a goggle-eyed gecko in the lower center that stares, along with Upagupta, at Mara. Its landscapes, especially the one at the upper right of the Upagupta section, reflect familiarity with Western modes of representing deep space by overlapping mountain forms and trees that diminish progressively in size and suggest a date in the second half of the nineteenth century, when Thai artists experimented with adapting certain Western artistic features in their works.

At the damaged lower edge of the painting there are remnants of an inscription, but only a few scattered words can now be read.

The cloth on which the work is painted is unusual in having been dyed a medium brownish purple.

F.McG.

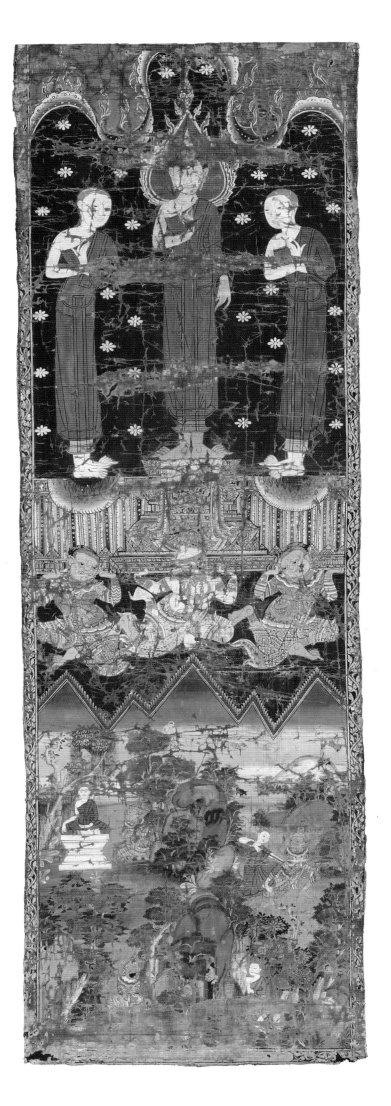

54 The assault on the Buddha by the demon Mara

1800–1900
Thailand
Paint and gold on cloth
H. 64.1 × W. 48.3 cm
Gift from Doris Duke Charitable Foundation's
Southeast Asian Art Collection, 2006.27.71

The Buddha sits enthroned beneath the bodhi tree as Mara and his forces attack. Usually the Buddha would be shown having moved his right hand to his knee as he symbolically touched the ground to call forth the earth goddess to bear witness to his merits, but here his hands are folded in his lap.[1]

Mara, as usual in nineteenth-century Siamese representations, is shown as green in color and having multiple heads and arms. One of his sol-diers aims a gun at the Buddha; another wears a shirt with magic talismans drawn on it to protect the wearer from harm. Such talismanic garments are well known in Southeast Asia, as in other parts of the world.[2]

In several places on the painting, notably above the elephant's trunk, pale drawn lines indicate that the artist considered other positions or contours for various elements of the painting.

On the back of this painting is written "mala-wichai," a nonstandard spelling of the term for the victory over Mara. Whether the inscription is contemporary with the painting is not known.

F.McG.

1 A similar exception to the general rule occurs in the famous depiction of the victory over Mara in the Phutthai-sawan Chapel. See Fickle, *Life of the Buddha,* pl. 18.
2 Gittinger and Lefferts, *Textiles and the Tai Experience,* 118–119.

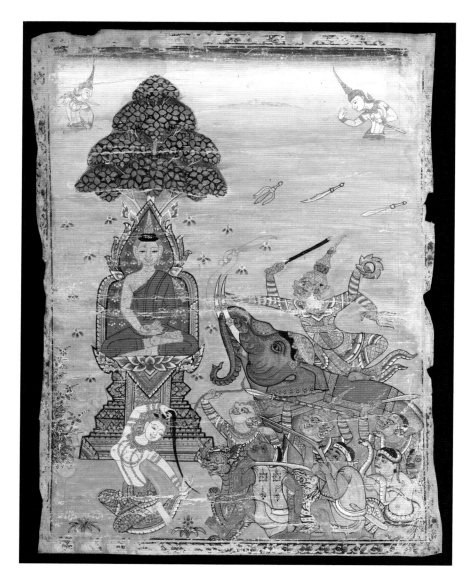

55 The Buddha overcomes the demon Mara and his forces, and the earth goddess creates a flood

Approx. 1800–1850
Thailand
Opaque watercolors and gold leaf on wood
H. 100 × W. 400 cm
Gift from Doris Duke Charitable Foundation's
Southeast Asian Art Collection, 2007.77

The victory over Mara is the central episode of the Buddha's life for Southeast Asian Theravada Buddhists. It stands for the Enlightenment, and thus the achievement of buddhahood, even though it actually takes place some hours earlier. The overwhelming majority of Siamese and Burmese Buddha images are in the position of touching the earth to call it to affirm, in the midst of his struggle with Mara, the bodhisattva's vast store of merit (a position called in Thai "victory over Mara"), whereas representations of the later moment when buddhahood is achieved are rare.

This mural-like painting, perhaps the largest and most impressive outside of Thailand, gives a sense of the cosmic scale of the struggle. In the words of Alabaster's 1871 translation of the *Pathomsomphot,* "King Mara...riding on his elephant, a thousand miles in height, led on his army; the van stretched two hundred and fifty miles before him, and the rearguard extended to the very walls of the world."[1]

In the murals in the interiors of temple buildings the depiction of the victory over Mara is typically situated over the entrance door—in other words, in back of, and over the heads of, visitors as they enter. The primary sculptured Buddha image (usually in the position of "victory over Mara") sits at the far end of the building fac-

ing the entrance, and so visitors find themselves with the victory both in front and behind. They are in the midst of the victory, as awed spectators, together with heavenly and earthly throngs: "Thus the Grand Being conquered King Mara and his army, and forthwith the whole world was filled with the sound of the rejoicings of the angels."[2]

An uncommon feature of this painting is the depiction, beneath the earth goddess, of three nagas (serpent beings) rising from their watery underground region to worship the Buddha. Again we are reminded of the cosmic reach of these events:

> When the heavenly hosts beheld the army of Mara taking to flight, the *nagas* among them sent messengers to the *naga* realm, the Suppannas [garudas] to their kingdom, the deities to heaven, and the Brahmas to the Brahma world, saying "Mara has been defeated, Prince Siddhattha has triumphed, let us honour him at his victory," drew near the Great Being [*sic*].... And they thus advanced [singing]: "For this is the victory to the illustrious Buddha, and defeat to Mara the Evil One. So did the hosts of *nagas* overcome with joy then proclaim.[3]

While the composition and most of the details of this painting are similar to those of many nineteenth-century murals in central Thailand depicting the victory over Mara, other aspects of the work make it difficult to place. Its palette, dominated by blue, bluish gray, and brick tones, is unusual, and so is its treatment of the sky, grading from almost white to blue.

This painting has survived only in a sadly damaged condition. Over the years a good deal

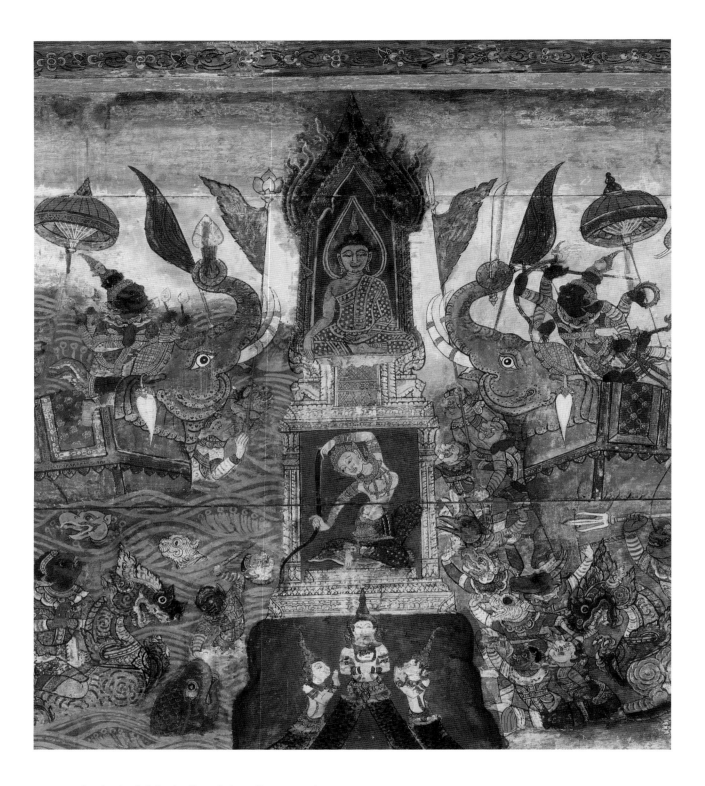

of paint had flaked off, and the adherence of
other areas of paint had weakened. In 2007 a
campaign of conservation, sponsored by the
Doris Duke Charitable Foundation, was begun.
The support and all areas of loose paint were
stabilized, and some of the areas of loss were
carefully filled. During the latter process, conser-
vators and curators consulted frequently on how
much inpainting to carry out. They erred on the
side of caution, filling areas of loss only when
there seemed no doubt whatsoever of the original
appearance. No new paint was applied over old

ABOVE Detail, cat. no. 55.

paint, and all treatments were done so as to be
reversible. Every stage of the process was docu-
mented in writing and photography.

An inscription on the lower edge of the frame
is partly obliterated, and though several words
are readable, the meaning as a whole has not
been worked out. F.McG.

1 Alabaster, *Wheel,* 150; slightly adapted.
2 Ibid.
3 Jayawickrama, trans., *Story of Gotama Buddha,* 98–99.

56 Naga-protected Buddha

Approx. 1825–1900
Central Thailand
Lacquered and gilded copper alloy with pigment
H. 27.0 × W. 13.3 cm
Transfer from the Fine Arts Museums of
San Francisco, F2000.1

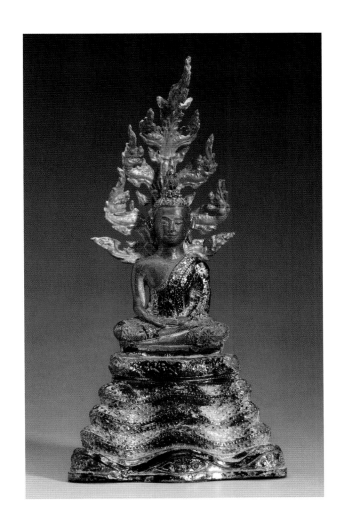

After the Buddha attained Enlightenment he spent the next seven weeks meditating under or near the bodhi tree. During the fourth week,[1] it began to rain heavily. A serpent king (naga) emerged and coiled his body seven times around the Buddha to keep him warm, covering the Buddha's head with his large hoods to protect him from the rain.[2]

The image of the naga-protected Buddha was very popular in Southeast Asia from around the fifth century, though it carried a variety of meanings and associations.[3] During the Bangkok period, the naga-protected Buddha became the Buddha of those who were born on Saturday.[4] Large images of the naga-protected Buddha were rare; the best known is at Wat Phra Chettuphon (Wat Pho).[5]

Here the Buddha is seated in meditation on a lotus pedestal above three coils of the naga's body. The naga's seven heads (the number common in Southeast Asian representations of the naga-protected Buddha) are protecting the Buddha's head from the elements.[6] In addition to the seven heads, two foliage- or flame-like projections appear beneath the lowest pair of serpent heads. These can also be seen on the large image at Wat Phra Chettuphon; what they signify is not certain. The Buddha's robe is decorated with floral motifs, a style popular from the reign of Rama III (reigned 1824–1851). P.C.

1 Which week this event occurs varies depending on the text.
2 Jayawickrama, trans. *Story of Gotama Buddha,* 106–107.
3 It was particularly popular in Cambodia during the Bayon period (middle of the twelfth to the thirteenth century), when the naga-protected Buddha was the most commonly used type of Buddha image. On meanings of such images, see Woodward, *Art and Architecture of Thailand,* 138–139, 151–152. In Woodward's view, "there is no evidence that for the [ancient] Khmers these images represent specifically or primarily the episode in which a serpent shelters Śakyamuni."
4 On the association of Buddha images in certain positions with days of the week, see Matics, *Gestures of the Buddha,* 51.
5 Pictured in Matics, *History of Wat Phra Chetuphon,* 12; and *Samutphap wat phrachettuphon wimonmangkhalaram/ Pictorial Book of Wat Phra Chettuphon,* 57. Another large naga-protected Buddha is at Wat Sawettachat in Bangkok; it is illustrated in Khana Kammakan Chat Ngan Somphot Krung Rattanakosin 200 Pi, *Samutphap pratimakam krung rattanakosin/Sculptures of Rattanakosin,* 45.
6 A number of generally similar small Bangkok-period sculptures of the naga-protected Buddha are included in Somkiat, *Phraphuttharup samai rattanakosin,* and are attributed to various reign periods, but the reasons for the attributed dates are not always convincing.

57 Manuscript cabinet with scenes of the life of the Buddha, and of five Buddhas of the past, present, and future

[FIG. 48; DETAILS PP. XII, 46]

> 1850–1900
> Thailand
> Lacquered, painted, and gilded wood
> H. 165.7 × W. 97.8 × D. 83.8 cm
> Gift from Doris Duke Charitable Foundation's
> Southeast Asian Art Collection, 2006.27.6

Cabinets such as this one were often donated to temples and were used to hold Buddhist texts, manuscripts, and ritual implements. Donors chose the decorative themes, so subjects depicted on the cabinets range from Buddhist scenes to episodes from famous works of literature such as the Rama legend. The combination of subjects on this cabinet incorporates themes popular in the Bangkok period.

This cabinet shows four scenes. The front doors depict the Buddha sheltered by a mythical serpent (left) and the offerings of honey by a monkey and of a bowl of fruit by an elephant to the Buddha (right). In the context of Thai Buddhism, these two episodes not only represent two moments in the Buddha's life but also are associated with two of the "Buddhas of the Week": the protecting naga for those who were born on Saturday and the monkey and elephant offering scene for Wednesday night.

The back panel of the cabinet represents the little-known story of the Buddha's conversion of a man-eating demon known as Alavaka. After trying to unseat the Buddha from his throne with various kinds of magic, the demon was angry and tired. The Buddha preached to him about how to overcome his anger after the demon posed a riddle: "Killing what benefits the killer?" The Buddha replied, "Killing anger benefits the killer."[1] Here the Buddha is seated in meditation on Alavaka's throne in the center. The demon Alavaka (with green complexion) and a king (white complexion) are listening to the Buddha's teaching. In typical fashion, the commoners in the foreground are depicted more informally than divine and courtly beings.[2] Here we see villagers who are finally safe from the demon.

Each of the side panels shows the five meditating Buddhas of the past, present, and future

known as "The Five Buddhas of the Fortunate Eon" (Pali: *bhaddakappa*).[3] A part of each Buddha's name in Pali or Thai is associated by punning with the animal depicted before him: Kakusandha with the rooster, Konagamana with the naga, Kassapa with the turtle, Gotama with the cow, and Maitreya (called Phra Si An in Thai) with the lion.[4] Each side depicts the Five Buddhas in almost the same format, except that the bottom two Buddhas, Gotama and Kassapa, switch places.

The use of shading, the treatment of landscape elements, and the realistic rendering of colors reflect the Siamese artist's interest in Western painting during the second half of the nineteenth century. P.C.

1 Fickle, *Life of the Buddha,* panel 21.
2 The same is true in literature. Commoners' stories are livelier than court literature, which is more serious.
3 For further information, see Peter Skilling's article in this volume and his "Intertextual Landscapes."
4 *Kaku* in *Kaku*sandha's name means "rooster"; the *naga* in Ko*naga*mana refers to the mythical serpent; *Kassapa* means "turtle"; *Go* in *Go*tama means "cow"; *Si* in Phra *Si* An is here taken as an abbreviation of *siha,* which means "lion."

RIGHT AND BELOW Left side and back, cat. no. 57.

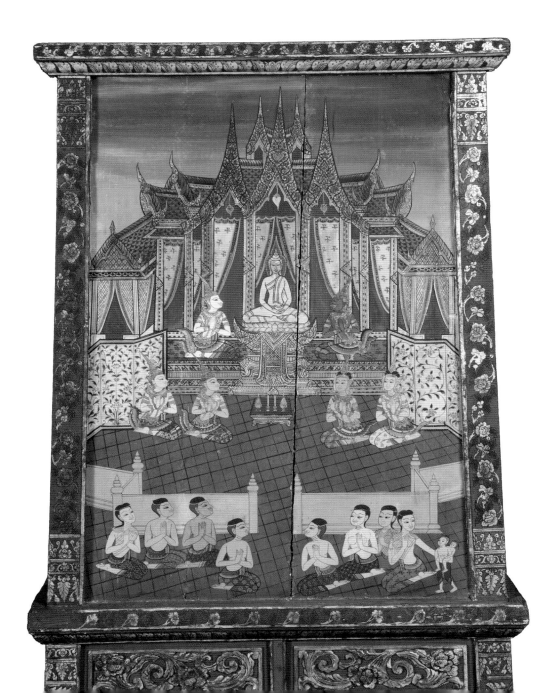

58 *Bimba's Lament* (The wife of the Buddha laments that their son has not received his inheritance)

1800–1900
Thailand
Paint and gold on cloth
H. 63.5 × W. 47.0 cm
Gift from Doris Duke Charitable Foundation's
Southeast Asian Art Collection, 2006.27.70

Once, in the years after the Enlightenment, the Buddha returned to his father's palace for a visit. When he and his former wife, whom he had given up when he set out on his spiritual quest (see cat. no. 3), meet, she laments having been abandoned and worries about the fate of their son. She urges the little boy to ask his father for his inheritance. The Buddha replies that the inheritance will be in wisdom rather than in earthly riches and has him ordained as a novice.[1]

Here, the Buddha's former wife kneels, holding her little boy, before the Buddha. She makes the touching gesture that in nineteenth-century Siamese art signifies weeping.

A notable stylistic feature of this painting is the emphatic shading in some of its architectural details, which is also seen in cat. no. 64. These two paintings, along with cat. no. 60, probably formed part of a larger set. Six more paintings probably from the same set are now in the collection of the Walters Art Museum, Baltimore.

The inscription below the scene reads, "Bimba's lament." The Buddha's former wife is usually known as Yashodhara, or sometimes Bimba.

F. McG.

1 See Swearer, "Bimba's Lament."

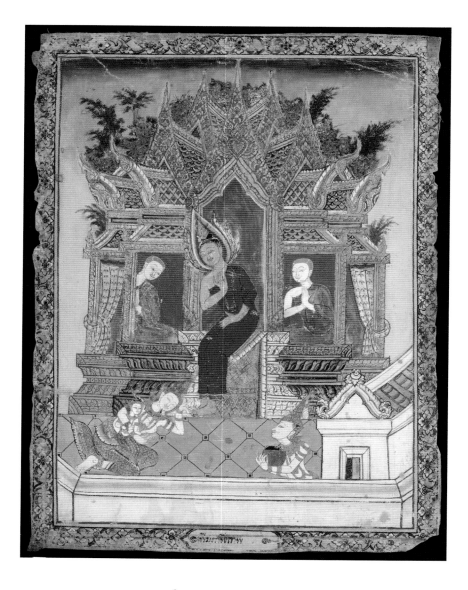

59 The wife of the Buddha implores him for their son's inheritance [DETAIL FIG. 13]

1800–1900
Thailand
Paint and gold on cloth
H. 66.2 × W. 56.2 cm
Gift from Doris Duke Charitable Foundation's
Southeast Asian Art Collection, 2006.27.72.7

Nineteenth-century Thai artists depicting scenes from the life of the Buddha and other religious subjects were the heirs to centuries-long traditions of what to show and how to show it. Also, though paintings of this type were sometimes inscribed with a designation of the scene represented, it was still necessary to ensure that the scene could be recognized easily. Even within these constraints, however, two portrayals of the same episode, such as this painting and the previous one, cat. no. 58, could end up looking quite different.

Here the palace structure within which the Buddha sits has been shifted to one side to allow space to show the Buddha's former wife a second time, entering a moment before she approaches and kneels. Other differences from cat. no. 58 abound: the palace is now a concoction of Chinese and perhaps Western elements as well as Thai; several figures with no obvious role in the sacred narrative, including a Chinese man with a wispy beard and a queue, can be seen in the middle ground; and the background, instead of being shown as an unspecific, flat backdrop, now opens out in a craggy landscape. Where the artist of cat. no. 58 emphasizes still, formal, iconic qualities, the artist of this painting emphasizes bustling activity in something more like everyday time and space.

This painting, as well as cat. no. 65, belongs to a set of ten scenes from the life of the Buddha in the museum's collection. Whether the set originally comprised more paintings than these ten is not certain. F.McG.

60 *The Ordination of the Shakya Nobles*

1800–1900
Thailand
Paint and gold on cloth
H. 63.5 × W. 47.0 cm
Gift from Doris Duke Charitable Foundation's
Southeast Asian Art Collection, 2006.27.83.3

While the Buddha was visiting his family, he preached to and ordained a large number of young nobles of his family's clan, the Shakyas.

An inscription on this painting says, "the ordination of the Shakya nobles,"[1] and presumably the four kneeling princely figures represent the much larger number who heard the Buddha's message and converted. F.McG.

1 Thanks to Peter Skilling for deciphering the oddly spelled inscription.

61 Scene from the life of the Buddha, perhaps the ordination of the Shakya youths [DETAILS P. 26, FIG. 60]

1800–1900
Thailand
Paint and gold on wood
H. 123.5 × W. 250.0 cm
Gift from Doris Duke Charitable Foundation's
Southeast Asian Art Collection, 2006.27.60

What this very large painting represents is not certain, but it seems likely that we see the ordination of the young Shakya nobles mentioned in the previous entry, cat. no. 60.

When the Buddha was returning to his father's city, the Shakyas prepared for his use a monastic retreat—what we would think of as a monastery—outside the city. Perhaps that retreat is shown here, as a monastery building set in a walled compound within a forest.

Indeed, the variety of goings-on depicted recalls the life of a Thai monastery today: some monks sit attentively, as do a number of layfolk. Other layfolk chat and point. One monk prepares a betel quid using a sort of ramrod, while another watches naked children roughhouse outside a gate.

On the left side of the painting are several vignettes of which the meaning is not clear. The deity Indra, recognizable by his green skin, flies in to observe the main scene and pay homage to the Buddha. Below him a child seems to be pulling the tail of a snake that has wound itself around a tree. In the corner a caparisoned white elephant stands with its trainer. Perhaps the elephant has brought the king, the Buddha's father, to the Buddha's retreat and is waiting to carry him back.

F. McG.

62 The Buddha preaches in Indra's Heaven and descends to earth, with hell below

Approx. 1850–1900
Thailand
Paint and gold on cloth
H. 301 × W. 92 cm (image);
H. 303.5 × W. 95.2 cm (overall)
Gift from Doris Duke Charitable Foundation's Southeast Asian Art Collection, 2006.27.122.8

As a sign of favor to his deceased mother the Buddha ascends to preach to her in Indra's Heaven (the Heaven of the Thirty-three Gods; Sanskrit: Trayastrimsha; Pali: Tavatimsa). Later he descends to the human world by way of a miraculous triple ladder. At this moment he makes it possible for the inhabitants of the three worlds—the heavens, the earth, and the hells—to see each other.

In the upper part of the painting the Buddha is depicted sitting in Indra's palace as his mother, to his proper left, and Indra, the green figure at his proper far right, as well as a host of other deities, attend. In the middle the Buddha, flanked by Brahma (who holds a parasol over him) and Indra, descends by the triple ladder as monks and celestial musicians hover in the air. One of the musicians plays a stringed instrument seen in cat. no. 141.

At the lower end of the painting both nobles and common people wait to greet the Buddha, while below, sinners suffer in hell. F.McG.

63 Double-sided screen with scenes
from the life of the Buddha:
Kashyapa pays homage to
the Buddha's remains, and
(perhaps) the infant Buddha-
to-be stands on the head of
the sage Asita [DETAIL FIG. 37]

1800–1900
Thailand
Paint and gold on wood
H. 97.2 × W. 57.1 cm
Gift from Doris Duke Charitable Foundation's
Southeast Asian Art Collection, 2006.27.64.A–B

On the front of this freestanding panel is an
incident depicted also in cat. no. 52 (scene no.
4). The Buddha has died, and one of his senior
disciples who was not present at the deathbed
has come to pay homage to the Buddha's body,
here contained in the sort of nearly cylindrical
container used in Siam for depositing the bodies
of royal persons before cremation.[1] The Buddha's
feet appear for Kashyapa to worship. The Bud-
dha's followers, both monks and nobles of the
Malla clan, witness the event.

On the back a kneeling figure is shown with
a golden figure of the Buddha standing on the
top of his headdress. This is probably the sage
who, in an episode soon after the birth of the
bodhisattva, visited the bodhisattva's father's
royal court to see the baby of whose eminence he
had heard. Normally a child old enough to do so
would greet such a person with signs of respect-
ful abasement, "but instead of doing reverence he
[the bodhisattva] rose into the air, and placed his
beautiful feet on the head of the holy man."[2]

A puzzle, though, is why the sage is shown
wearing not the modest garments that would be
expected but the silks and jewels of royalty.[3] In
the story, just after the encounter between the
baby and the sage, the father bowed to his son in
an almost unimaginable reversal of normal hierar-
chical relationships. Perhaps we see the father
here rather than the sage.

One wonders why these two scenes are paired
on the front and back of this panel. The only
obvious link seems to be that in both episodes a
respected figure is shown subservient to the Bud-
dha's feet. F.McG.

1 A number of these containers are pictured in Sompop,
 Phramerumat phramen lae men.
2 Alabaster, *Wheel,* 108. For another instance when the bo-
 dhisattva or Buddha appears on the head of a high-ranking
 figure, see cat. no. 97.
3 The sage is also shown wearing royal jewelry in the murals of
 Wat Dusitdaram in Bangkok; see *Wat Dusidaram,* 24–25.

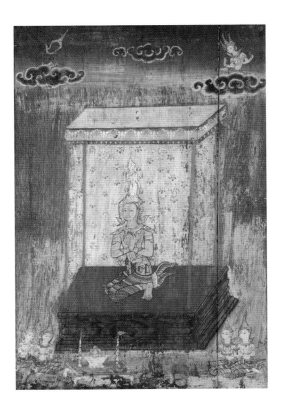

RIGHT Back, cat. no. 63.

64 *The Division of the Holy Relics*

1800–1900
Thailand
Paint and gold on cloth
H. 63.5 × w. 48.0 cm
Gift from Doris Duke Charitable Foundation's
Southeast Asian Art Collection, 2006.27.69

After the cremation of the Buddha a war threatens to break out over custody of the ashes.[1] The brahman Drona takes the responsibility of apportioning them among eight kings, who later enshrine them in stupas in their capitals. Drona manages to hide a tooth relic in his hair, but it is retrieved by the god Indra.

Relics of the Buddha—not just ashes, but also his teeth, hair, and alms bowl—came to have enormous importance in the Buddhist world.

The inscription on the painting reads, "The division of the holy relics." F.McG.

1 The remains of the Buddha were often thought of as more like pearls than like ashes. For a brief discussion, see Strong, *The Buddha*, 144–145.

65 The division of the relics of the Buddha

1800–1900
Thailand
Paint and gold on cloth
H. 67.8 × w. 56.8 cm
Gift from Doris Duke Charitable Foundation's
Southeast Asian Art Collection, 2006.27.72.10

This episode is the same as that depicted in cat. no. 64. As has been observed in the contrast of cat. nos. 58 and 59, here one depiction is more restrained and hieratic, the other more filled with everyday characters and activities. F.McG.

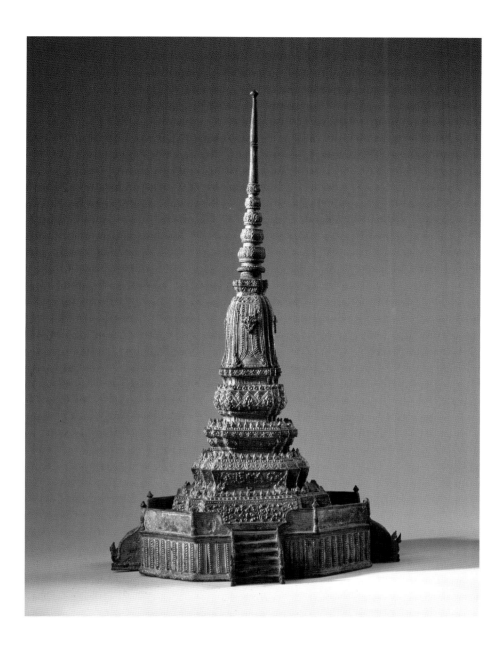

66 Miniature stupa

1800–1900
Thailand
Lacquered and gilded copper alloy with pigment
H. 66.0 × W. 31.1 × D. 31.1 cm
Gift of Jerry Janssen, 2008.82.A–C

This miniature stupa was cast in three pieces: an octagonal base, a four-tiered redented base, and a redented bell-shaped body and a super-structure. The superstructure consists of a square throne element, a spire made up of a tapering stack of open lotuses, and a tall finial.[1] Stupas of this type came into fashion around the end of the Ayutthaya period (in the last part of the eighteenth century) and continued in style at least through the reign of Rama III (reigned 1824–1851).[2]

Representations of the Chulamani Stupa in Indra's Heaven—where hair relics and a tooth of the Buddha are said to be housed—as seen in Thai painting, such as that on the tiered stand of cat. no. 96, are often portrayed in this form.[3]

The low wall around the stupa has eight small tubular receptacles, which probably once held ceremonial umbrellas or flags.

Miniature stupas generally house relics, which are placed in a smaller container inside the bell-shaped body. This miniature stupa was probably donated to the temple for the purpose of merit making. P.C.

1 For further information on redented stupas and decorated stupas see Santi, "Evolution of the Memorial Towers."
2 Ibid., 76. Examples of stupas of this type in Bangkok can be seen at Wat Phra Si Rattanasatsadaram (the Temple of the Emerald Buddha) and at Wat Phra Chettuphon (Wat Pho), where two such stupas were built by Rama III.
3 It is not clear whether this shape of stupa has any specific association to the Chulamani Stupa in the early Bangkok period.

In Siam ten of the stories of the Buddha's hun-
dreds of previous lives (the Jatakas) were singled
out as particularly important and were related
to the perfecting of ten virtues such as patience
and generosity. They were thought of as the last
ten lives before the life in which the bodhisattva
achieved buddhahood, and their order was stan-
dardized. In nineteenth-century painting—murals
on temple walls, illustrations in manuscripts, and
paintings on wood and cloth—these ten stories
are depicted over and over, sometimes with
several illustrations for each story and sometimes
with just one each. The story of what was under-
stood to be the Buddha's immediately previous
life, that of Prince Vessantara, was often depicted
in great detail, with attention paid to subsidiary
incidents as well as to the main narrative.

Translations of the Pali texts of these stories
are found in Cowell, *The Jataka*. The ten stories
mentioned are recounted and related to illustra-
tions in Thai painting in Lyon, *The Tosachat
[Ten Lives] in Thai Painting;* Boisselier, *Thai
Painting;* Wray, Rosenfield, Bailey, and Wray,
Ten Lives of the Buddha; and Ginsburg, *Thai
Manuscript Painting*. F.McG.

67 **Scenes from ten of the
Buddha's previous lives**

1800–1850
Central Thailand
Paint and gold on cloth
H. 190.5 × W. 88.3 cm
Gift from Doris Duke Charitable Foundation's
Southeast Asian Art Collection, 2006.27.73

The arrangement of the ten famous tales pre-
sented here—in squares arranged in two columns
of five squares—is unusual. The first is depicted at
lower right, the second at lower left. The stories

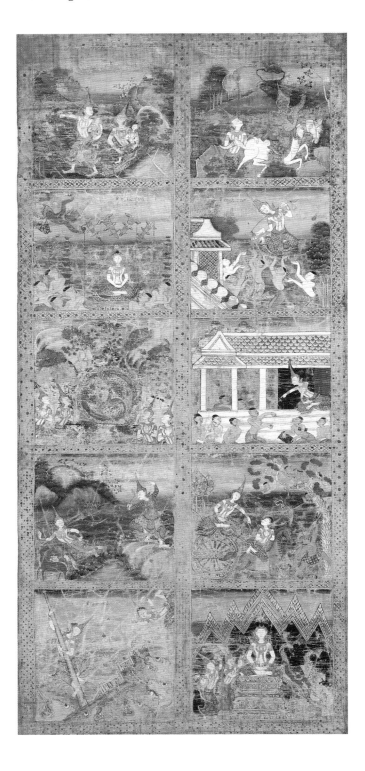

continue upward in an S curve, with the third depicted next to the bottom at left, the fourth next to the bottom at right, and so on. The last, at upper left, shows the Buddha in his final previous life as the generous prince Vessantara.

For occasions such as this when each story needed to be presented in abbreviated fashion as a single scene, it seems that by the nineteenth century conventions had been developed of exactly what scene would stand for each story. (This is less true of the last, which was usually depicted at length in a number of scenes, than of the other nine.) Thus the story of Mahajanaka (lower left) was frequently represented by a ship surrounded by sea creatures, with the bodhisattva clinging to the mast or floating on the waves, and the Chandakumara story (left, second from top) was represented by Indra striking down the ceremonial parasols at the place where the bodhisattva was to be sacrificed. An extensive narrative is encapsulated in a single image that was readily identifiable and readily distinguished from other stories.

Here each scene is also labeled with the name of the bodhisattva in that particular life.

F.McG.

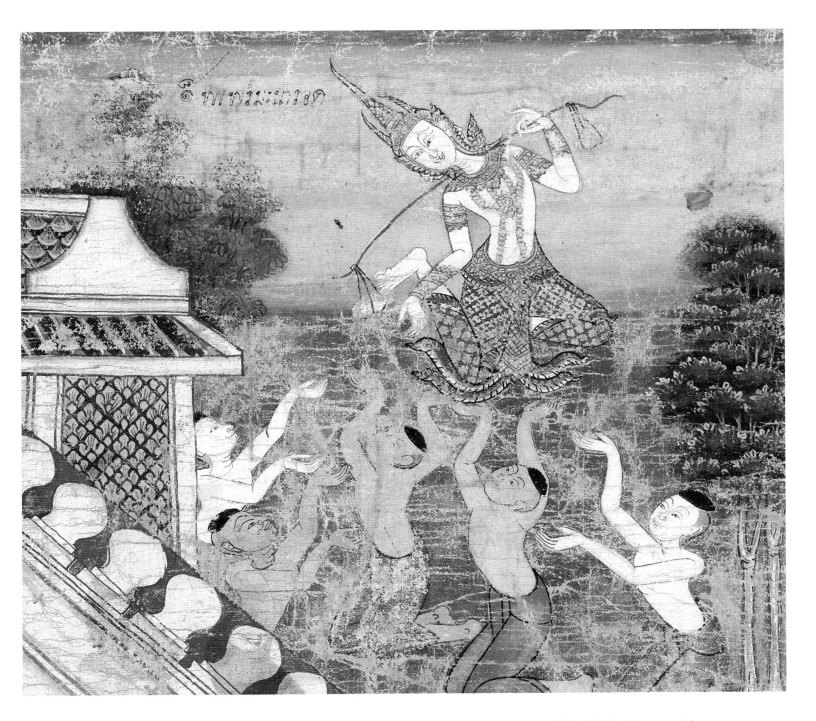

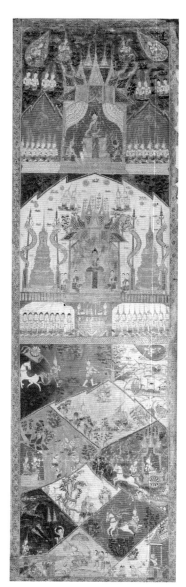

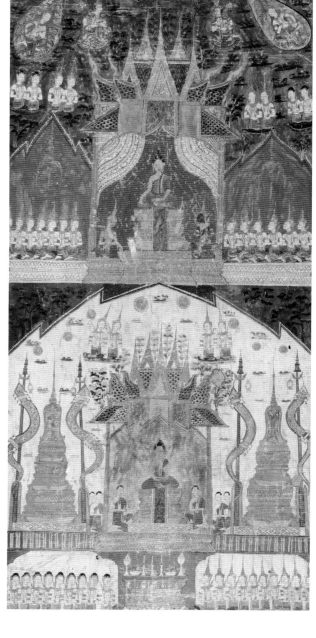

RIGHT Detail, cat. no. 68.

68

68 The Buddha preaching in Indra's Heaven; scenes from ten of the Buddha's previous lives

1800–1900
Perhaps Northern Thailand
Paint and gold on cloth
H. 329 × W. 97 cm (image)
Gift from Doris Duke Charitable Foundation's
Southeast Asian Art Collection, 2006.27.77

The lower half of this painting, like cat. no. 67, is divided into ten compartments that each contain a scene from one of the last ten stories of the Buddha's previous lives. Here, though, the artist either followed a tradition with the stories in a different order from what was standard in central

Thailand or chose not to arrange the stories in order. What was usually the first story is in the upper left corner, and the last story in the lower right, but the order of the others does not follow a discernible pattern. Many of the stories—for example, those of Mahajanaka and Chandaku-mara—are represented by the same standard scenes as in cat. no. 67, but others are not.

The top portion of this painting shows the Buddha sitting enthroned in Indra's Heaven preaching to his mother, Indra, and other celestials. In the portion below this the Buddha is again enthroned within an elaborate pavilion with monks and celestials in attendance, presumably still in Indra's Heaven, but the exact episode is not known. The Buddha is flanked by two tall stupas. One of these must be the Chulamani

RIGHT Detail, cat. no. 68.

Stupa, the monument in which the hair relic is enshrined (see cat. nos. 36 and 96), located in Indra's capital.[1]

The style of this painting is different from the styles of central Thailand, and where it was painted is far from certain.

This work is painted on a handsome piece of fabric decorated with elaborate Thai designs of the sort made in India for the Thai market and imported in large quantities in the eighteenth and nineteenth centuries. It may seem surprising that a painting is painted over—and hiding—what would have been an expensive textile. This might have been an isolated incidence, but in fact a number of examples are known. Henry Ginsburg, a scholar of both Thai painting and such imported fabrics, speculated that after the original owner of such a fabric died, the family would not have wanted to use the fabric again and might have donated it to a monastery for making into a painting.[2] F.McG.

Scenes of ten of the Buddha's previous lives

1	Temiya	6	Bhuridatta
2	Mahajanaka	7	Chandakumara
3	Sama	8	Narada
4	Nimi	9	Vidhura
5	Mahosadha	10	Vessantara

1 For a description, see Reynolds and Reynolds, *Three Worlds,* 232.
2 Ginsburg, private communication.

LEFT AND BELOW LEFT
The stories of Bhuridatta and Narada
(details, cat. no. 69).

69

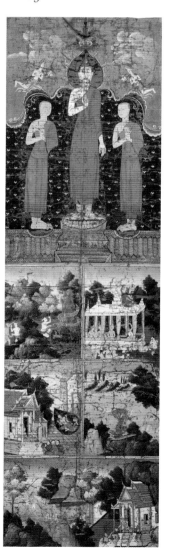

69 Standing Buddha flanked by two disciples; five scenes of the Buddha's previous lives [FIG. 49]

Approx. 1850–1900
Thailand
Paint and gold on cloth
H. 293.1 × W. 91.9 cm (image)
Gift from Doris Duke Charitable Foundation's
Southeast Asian Art Collection, 2006.27.122.4

Beneath the Buddha flanked by two disciples are arranged scenes of the final five of the last ten stories of the Buddha's previous lives. The earlier five stories are depicted on another painting (not included in the exhibition) that is a mate to this one. Each scene is labeled with the name of the bodhisattva in the scene and sometimes several descriptive words. The scenes are arranged with the sixth story (that of Bhuridatta) at upper left and the tenth (that of Vessantara) at the bottom. Along the bottom edge is a brief inscription giving the name of the painting's sponsor as Mother Khong Phu. F.McG.

70 King Nimi is carried through the heavens on a divine chariot, a scene from the Nimi Jataka

Approx. 1875–1925
Thailand
Paint on cloth
H. 37.0 × W. 59.0 cm
Gift of Dr. Sarah Bekker, 2008.78

Sometimes, as here, a story of a previous life of the Buddha was rendered separately (though perhaps as part of a set). In this story, the fourth of the ten, the pious King Nimi is invited by Indra to come to his heaven to speak with the gods assembled there. We see Nimi flying through the skies in the chariot Indra has sent for him, passing a celestial mansion. To the back of the chariot are attached two ceremonial standards similar in type to cat. no. 37. The king's name in Thai is inscribed below the chariot.

This painting, unlike any of the others in the exhibition, is painted on cloth fastened over a Western-type painting stretcher and must date from a time by which Thai artists had become accustomed to using some Western techniques and formats. F.McG.

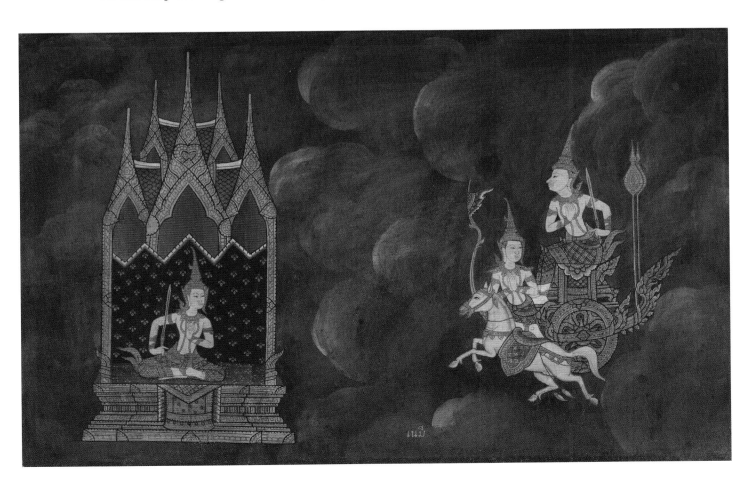

THE STORY OF PRINCE VESSANTARA

By far the most frequently depicted of the last ten stories of the Buddha's previous lives is the one that was understood as number ten, in which the bodhisattva is Prince Vessantara (Sanskrit: Vishvantara; Thai: Wetsandon). Standard central Thai versions of the story, called the "Great Life," had thirteen chapters, and at yearly temple ceremonies all these were recited by monks, with the layfolk listening (or at least present). Various individuals or families would sponsor each of the chapters, which would entail paying for the painting of their chapter—one of a set of thirteen—and also donating sticks of incense and other offerings in numbers equal to the number of verses in their chapter. Scenes of the Vessantara story were also depicted in temple murals, in manuscripts, and on manuscript cabinets.

An early, and still very useful, discussion of the Vessantara tale and its uses in Siam is G. E. Gerini's 1892 *A Retrospective View and Account of the Origin of the Thet Maha Ch'at* [Preaching the "Great Life"] *Ceremony or Exposition of the Tale of the Great Birth as Performed in Siam*. A wonderful account of this ceremony is a small English-language booklet titled *Thet Maha Chat* by the Thai scholar Phya Anuman Rajadhon. A more recent analysis, using four paintings in the Phoenix Art Museum as a starting point, is my "Painting the 'Great Life.'"

F. McG.

71–83 SET OF PAINTINGS DEPICTING THE STORY OF PRINCE VESSANTARA

1850–1900
Central Thailand
Paint and gold on cloth
H. approx. 57 × w. approx. 46 cm each
Gift from Doris Duke Charitable Foundation's
Southeast Asian Art Collection, 2006.27.80.1–13

Complete sets of the standard thirteen paintings for the recitation of the story of Prince Vessantara are extremely rare. Once a set of paintings was used in a recitation it may not have been used again, and no particular provision may have been made to preserve it. The number of single paintings or small groups of paintings surviving from sets suggests that sets were often broken up and dispersed. A mid-twentieth-century tourist buying such paintings as artistic souvenirs or décor items would not have made keeping a set intact a priority.

This set, probably something like 120 years old, remains in fair condition. Most details of the paintings, though scratched and abraded, can still be made out, but the inscriptions along the bottom edges have suffered considerable damage and are now only partly legible.

Just as the recitation of the "Great Life" was sometimes accompanied—to the disapproval of Rama IV—by the addition of sound effects and naughty side stories,[1] in this set of paintings the artist enlivens the main story with bawdy vignettes, monkeyshines, and amusing anachronisms. The artist's interest in some aspects of Western painting is marked, and several of the works make one think of mad parodies of paintings by Poussin or Claude Lorrain.

F. McG.

1 Gerini, *Retrospective View,* 25–26, 58.

71 Indra grants Phusati ten favors before she descends to earth to become the mother of Vessantara

[FACING]

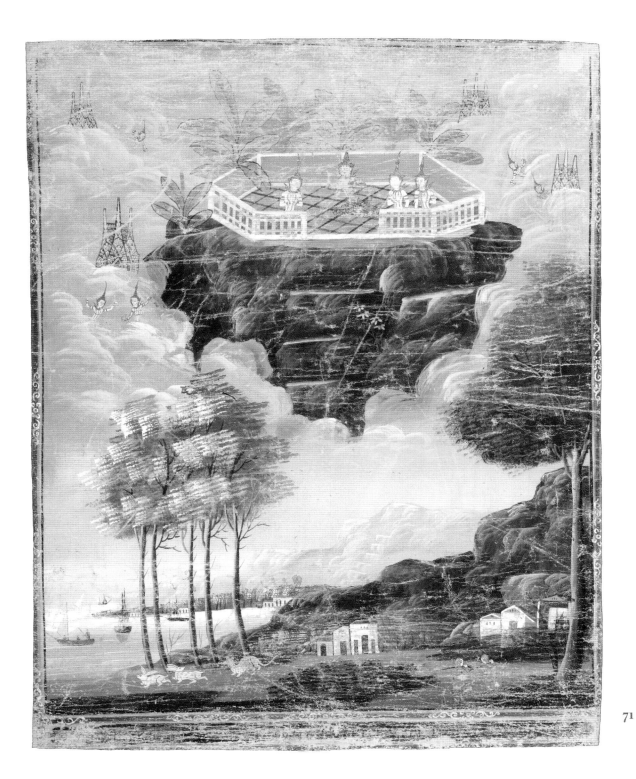

Chapter 1

In a prelude to the main story, Indra, the king of the gods, invites a celestial woman to be born on earth and become a queen, and the mother of the bodhisattva. She agrees and receives from him ten blessings.

In this depiction a part of Indra's Heaven at the top of Mount Meru is revealed through the clouds. The everyday world below is rendered in a style influenced by Western art: distant buildings are smaller than near ones, ranges of hills overlap to suggest depth, and the most distant hills are painted in pale bluish colors in an approximation of Western atmospheric perspective. In the harbor Western-type sailing ships are anchored, and one is shown reflected in the water. Reflections, like shadows, were seldom depicted in Thai painting before Thai artists grew familiar with the conventions of Western painting and illustration.

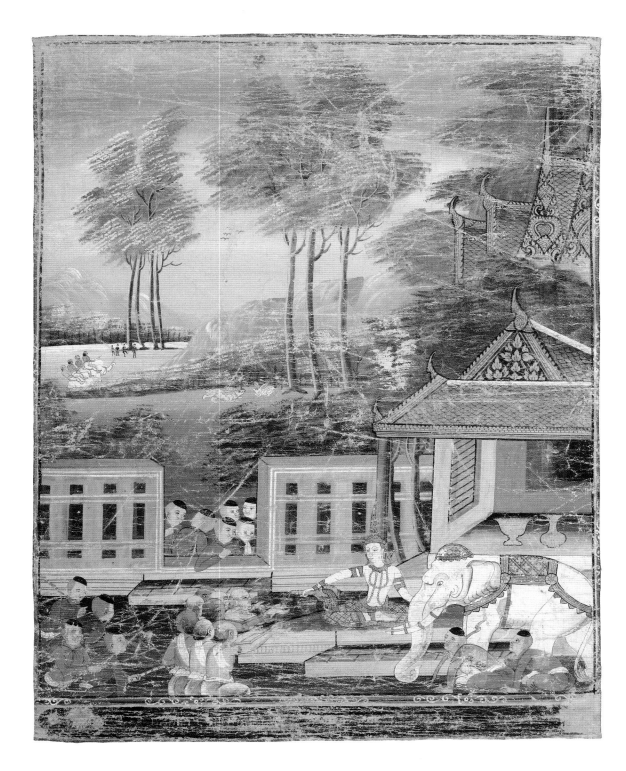

72 Vessantara gives away the elephant

Chapter 2

The bodhisattva Prince Vessantara has now grown up, married, and had two children, a boy and a girl. He practices generosity, the virtue of selfless giving, in the most dedicated way. Eventually, he is asked for his kingdom's rain-bringing white elephant and gives it. His father's subjects, worried that they will face drought, clamor that the prince be sent into exile.

Here, the bodhisattva solemnizes the gift of the elephant by pouring water onto the hands of the brahmans who have asked for it. In the distance on the left the brahmans can be seen riding the elephant away. The artist has again made use of various Western pictorial conventions, particularly those suggesting depth, but in this instance ignores the convention of most Western art from the Renaissance to about 1900 that only one moment in time is shown in a single picture.

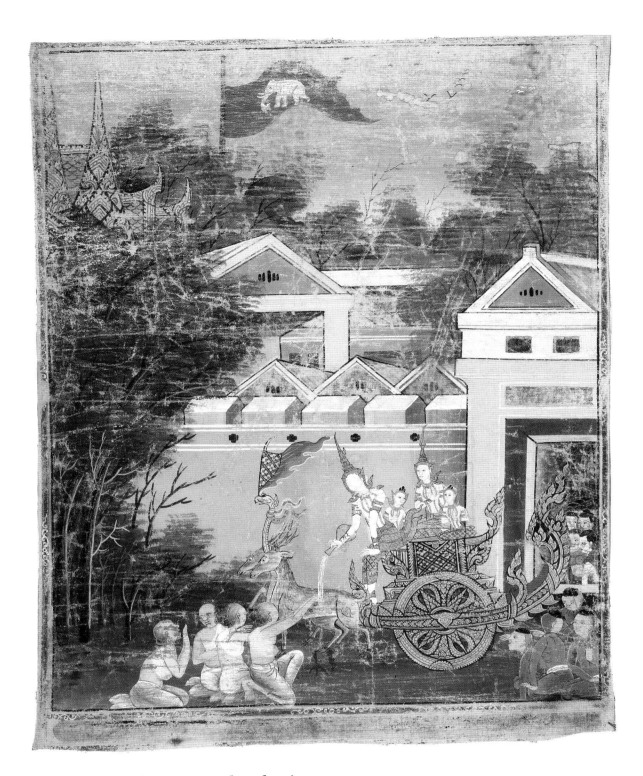

73 Vessantara gives away the chariot

Chapter 3

The prince accepts his banishment but before setting out makes a "Great Seven-Hundred-Fold Donation" of cows, horses, slaves, carriages, and so on. He urges his wife not to accompany him into exile, but she insists that she will not leave him. As they and their children travel along in a chariot, the bodhisattva is asked first for the chariot horses and then for the chariot, all of which he readily relinquishes. The family continues on foot.

After the bodhisattva gave away the horses, celestials descended and took the form of golden deer to pull the chariot. Here Vessantara has been asked for the chariot itself and gives it with the same gesture as in the previous painting. In the sky waves the white elephant flag of Siam adopted in 1855.

74 Vessantara and his family enter the forest

Chapter 4
The family travels on, eventually reaching the forest where they will start their new life. The architect of the gods builds them a hermitage.

Here the bodhisattva and his wife carry their children as they walk through a peaceful forest, but the danger they face is suggested by the fact that three families of gentle animals nearby are stalked by a tiger.

75 Jujaka's wife is ridiculed; she then urges her husband to ask Vessantara for his children

Chapter 5

Meanwhile, an elderly brahman named Jujaka has married a young wife who is ridiculed by the other women for being so obedient to her husband. She wants the opportunity to lord it over tormentors, and having heard of Prince Vessantara's unequaled generosity, she sends her husband to ask Vessantara for his children to bring back to her as servants.

Here Jujaka's wife, standing in the middle holding a large jar, is mocked as she goes for water.

76 Jujaka encounters the hunter

Chapter 6
Jujaka searches for the bodhisattva and his family in the forest and asks a hunter for directions.

Again, peaceful animals are eyed by a tiger, and also by the hunter's tensely alert dogs. The hunter, oddly, sports a mustache and goatee that would have been fashionable in the West in the later part of the nineteenth century, but he carries a crossbow.

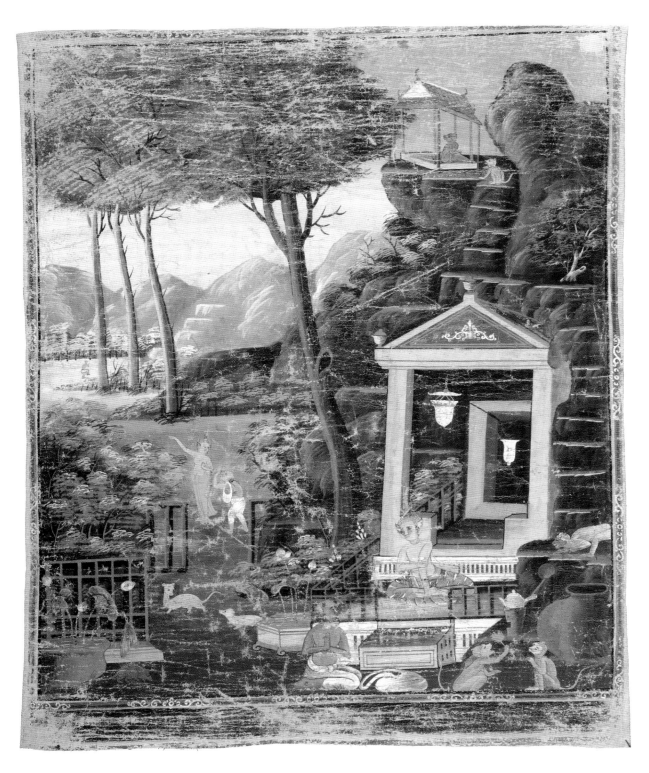

77 Jujaka asks the hermit Acchuta where Vessantara is staying [FIG. 2]

Chapter 7
Jujaka visits a hermit who divines his bad intentions but is persuaded to point the way.

The hermit here—recognizable, as usual, by his tiger-skin garment and unusual headdress—lives not in a hut but in a little European neo-classical pavilion complete with urns at the corners, peaked roof, and glass light fixtures inside. Nearby, monkeys play at fanning the fire for a teapot.

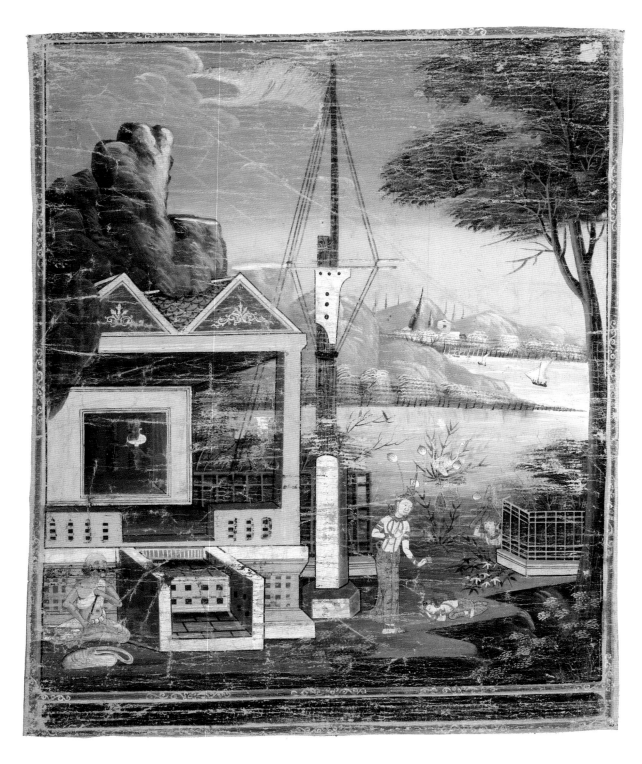

78 Vessantara calls his children from hiding to give them to Jujaka

Chapter 8

Jujaka finds the bodhisattva and, while the bodhisattva's wife is out gathering fruits and nuts, asks for the children. The bodhisattva gives them up. Jujaka drags them away. The children manage to escape and hide, but the bodhisattva finds them and turns them over to Jujaka again. Jujaka beats them for escaping,

and the bodhisattva is distressed at his children's suffering. At the same time he reminds himself that to attain buddhahood he must practice selfless giving without limit.

While Jujaka prepares himself a quid of betel, the bodhisattva calls the children from their hiding places. For some reason we are shown that his hermitage is equipped with an elaborate mast for signal flags.

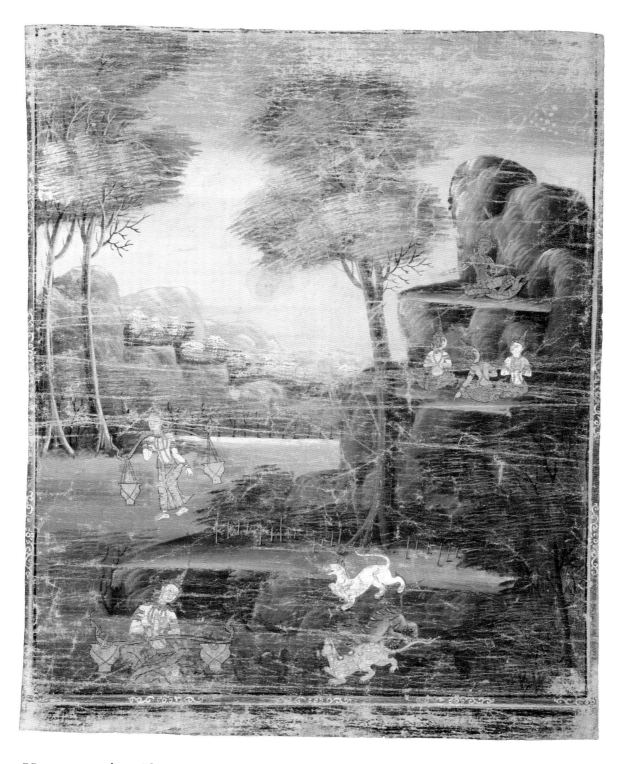

79 Vessantara's wife encounters a lion, tiger, and leopard

Chapter 9

The children's mother returns home with the food she has collected but is delayed, so that she will not have to witness—and will not interfere with—her husband's exercise of perfect charity, by three gods who take the form of wild beasts. When she arrives at the hermitage and learns what has happened, she faints with grief.

Eventually, though, she is persuaded that the most painful self-denial, even to the point of giving up one's children, is meritorious.

Vessantara's wife is shown twice, walking along and then pleading with the wild beasts to let her pass. At upper right we see an earlier moment when Indra instructs the three gods to assume the shapes of animals and hinder her progress.

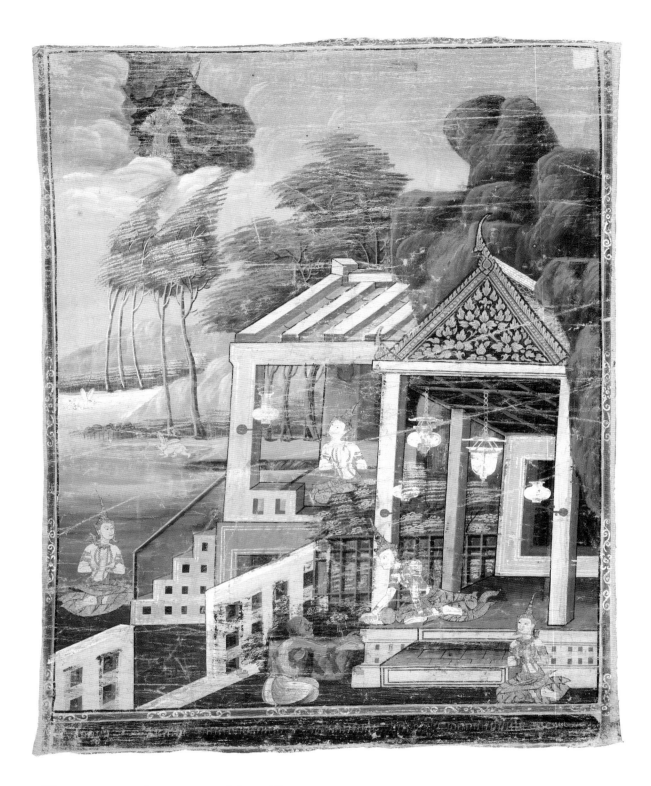

80 Vessantara gives away his wife

Chapter 10

Indra now fears that the bodhisattva will next give away his wife. To prevent this, he takes the form of an old brahman and requests of Vessantara the gift of his wife. Vessantara immediately agrees, but then Indra returns her to him in trust, so that he cannot give her away again.

Here the bodhisattva and his wife are depicted twice. We see Indra in the sky and again in the foreground in his form as an old brahman (colored green to remind us of his real identity) as Vessantara gives him his wife by the gesture we have come to expect, pouring water over the old man's hands.

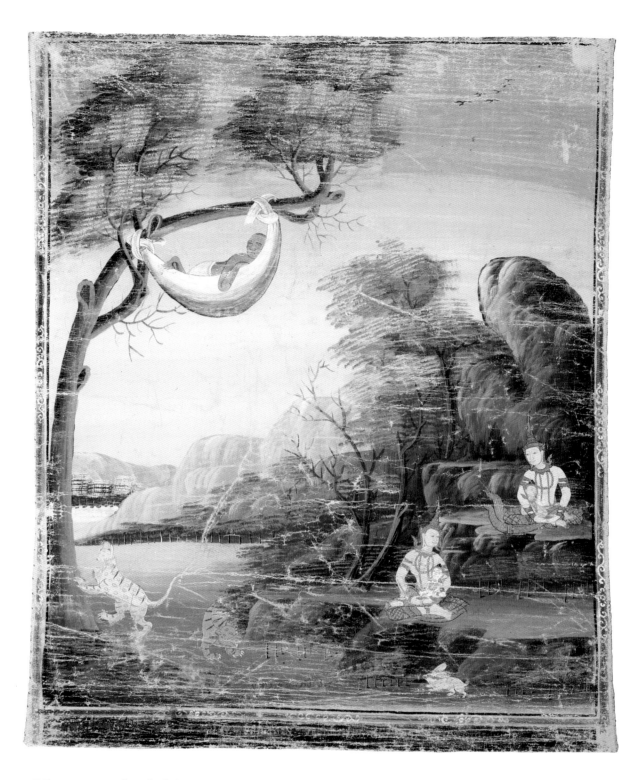

81 Vessantara's children are cared for as Jujaka sleeps

Chapter 11

While Jujaka sleeps he leaves the children tied up. They are miserable and frightened; gods take the form of their parents and care for them. Later, the children's grandfather ransoms them from Jujaka.

Jujaka, newly rich, kills himself through overindulgence. The grandfather determines to take his grandchildren into the forest and find his son and daughter-in-law.

Gods in the guise of the parents cradle the children in their arms while Jujaka sleeps and tigers prowl.

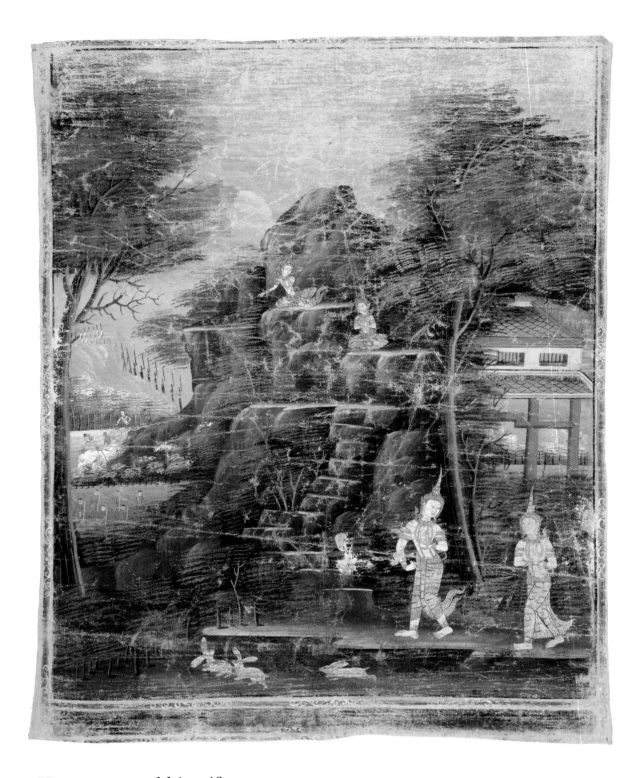

82 ## Vessantara and his wife see the approach of Vessantara's father's retinue

Chapter 12
The grandfather, his wife, and their grandchildren go in regal procession to Vessantara's hermitage. When they arrive there is a touching reunion of three generations, and all weep for joy.

The artist depicts not the reunion but a moment of anticipation as the bodhisattva and his wife (both shown twice) see the procession approaching from a distance, with their son riding the lead elephant. The troop of soldiers following along is suggested only by a line of bayonets appearing over a hill.

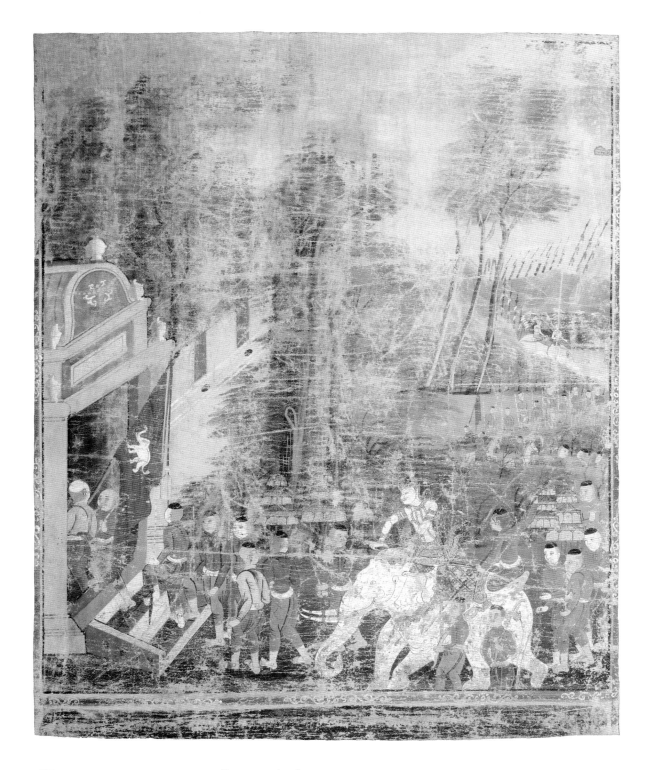

83 Vessantara returns to the capital

Chapter 13
The bodhisattva and his family return to their home city amid general rejoicing.

The long procession, headed by a flag bearer with a quite naturalistically depicted Siamese flag, winds through the landscape and enters the city by a Western-style gateway.

84 Indra grants Phusati ten favors before she descends from heaven to become the mother of Vessantara

1775–1850
Central Thailand
Paint and gold on cloth
H. 62.2 × W. 58.4 cm (image)
Gift from Doris Duke Charitable Foundation's
Southeast Asian Art Collection, 2006.27.122.10

This painting depicts the same scene as cat. no. 71, but the differences of style could hardly be greater. Instead of experimenting with a variety of Western pictorial effects and suggesting a landscape receding into deep space, the artist of this work follows the time-honored traditions of keeping the space shallow and emphasizing the clear, careful arrangement of silhouetted forms. The sky is not an atmospheric blending of white and pale blue with fluffy clouds like that of cat. no. 71 but a solid brilliant orange. The contrast suggests how greatly Thai painting of traditional themes was transformed between 1780 and 1880, and how successful the results were at various points in the process. F.McG.

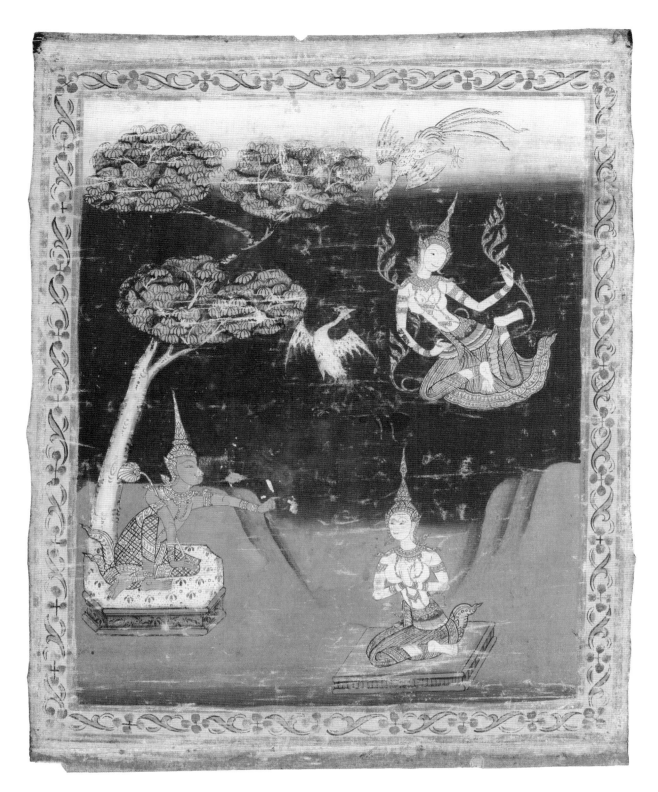

85 Indra grants Phusati ten
favors before she descends
from heaven to become the
mother of Vessantara

1800–1850
Central Thailand
Paint and gold on cloth
H. 73.5 × W. 58.3 cm
Gift from Doris Duke Charitable Foundation's
Southeast Asian Art Collection, 2006.27.81.1

This painting, like the previous one, depicts the
first chapter of the Vessantara story in a style little
touched by Western influence. It comes from the
same beautiful but incomplete set as cat. nos. 86,
87, and 89. Seven more paintings from this set are
in the museum's collection but not included in
the exhibition. F.McG.

86 Prince Vessantara gives away the elephant

Approx. 1800–1850
Central Thailand
Paint and gold on cloth
H. 74.0 × W. 58.4 cm
Gift from Doris Duke Charitable Foundation's
Southeast Asian Art Collection, 2006.27.81.2

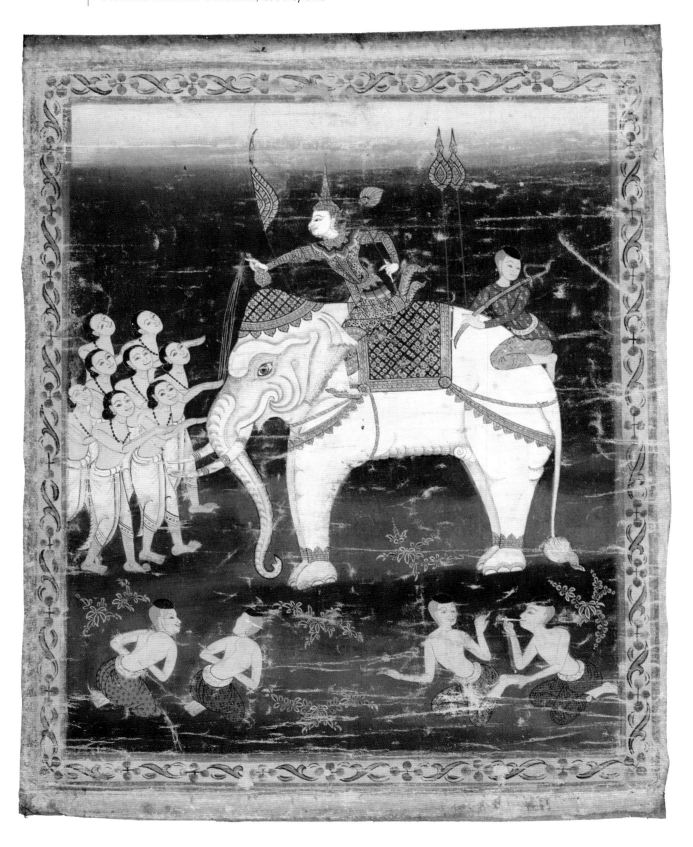

87 Jujaka's wife is ridiculed; she then urges her husband to ask Vessantara for his children [FIG. 52]

Approx. 1800–1850
Central Thailand
Paint and gold on cloth
H. 73.0 × W. 58.5 cm
Gift from Doris Duke Charitable Foundation's
Southeast Asian Art Collection, 2006.27.81.3

The situation in the village where Jujaka and his young wife live is more complicated than mentioned on page 157. Part of the reason that the other women dislike Jujaka's wife is that her obedience to her husband leads their husbands to expect the same from them. Their home lives are filled with quarrels, and they take out their resentment on Jujaka's wife by harassing her.

Here, in the house at right, Jujaka's wife indulges her husband, while in the other houses wives fight with, or are beaten by, their dissatisfied husbands. Below, the same two women (recognizable by the colors and patterns of their lower garments) who have been in conflict with their husbands now mock Jujaka's wife. F.McG.

88 SIDE A: Jujaka's wife is ridiculed; she then urges her husband to ask Vessantara for his children

SIDE B: Another scene from the next-to-last life of the Buddha (Vessantara Jataka)

1800–1900
Thailand
Paint and gold on cloth
H. 80.0 × W. 59.1 cm
Gift from Doris Duke Charitable Foundation's
Southeast Asian Art Collection, 2006.27.61.3.A–B

This work (and two more from the same set in the museum's collection but not included in the exhibition) is unusual because of its stand. The stand holds a double-sided frame that pivots so that the painting on either side can face forward.

On one side other wives pester Jujaka's wife until she (represented a second time) goes crying to her husband. On the reverse side are depicted scenes of domestic violence as husbands punch their wives and beat them with switches in arguments over Jujaka's wife's example of obedience.

This painting is inscribed with the name of the chapter it represents and the number of its verses. F.McG.

89 Jujaka encounters the hunter [FIG. 26]

Approx. 1800–1850
Central Thailand
Paint and gold on cloth
H. 72.0 × W. 58.0 cm
Gift from Doris Duke Charitable Foundation's
Southeast Asian Art Collection, 2006.27.81.4

This painting shows two moments of the episode represented in cat. no. 76. At left Jujaka is treed by a crossbow-wielding hunter and his dogs as a pair of bemused owls observe. At upper right Jujaka, having persuaded the hunter of his good intentions, uses a cylinder and ramrod to prepare a quid of betel as the hunter points him in the direction of his goal. F.McG.

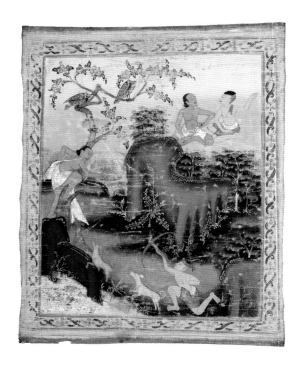

BELOW Detail, cat. no. 89.

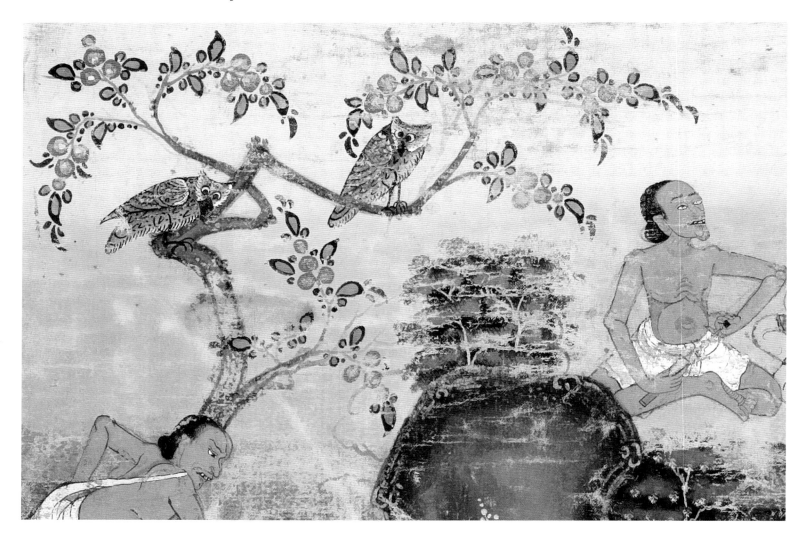

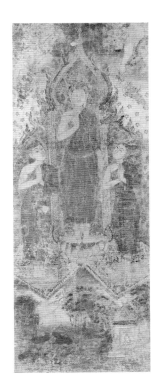

90 Standing Buddha flanked by two disciples; scene from a previous life of the Buddha: Vessantara and his family in the forest [DETAIL FIG. 61]

Approx. 1800–1850
Thailand
Paint and gold on cloth
H. 194.3 × W. 73.7 cm (image)
Gift from Doris Duke Charitable Foundation's
Southeast Asian Art Collection, 2006.27.122.7

A scene from the story of Prince Vessantara occupies the lower third of this tall, thin painting, the main part of which depicts the Buddha standing between two disciples. Vessantara and his family have settled into their forest hermitage. Though the poor condition of the painting makes it hard to see exactly what is going on, it is clear that the little son squats by a pond watching either the fish there or a pair of birds in the lotuses. In the lower right corner his parents and sister keep an eye on him.

The painting, though damaged, is of unusually high quality. All the motifs, such as the sprays of rose-like flowers, are lovingly detailed, and there is an air of real tenderness in the expressions of the disciples and hovering magician-ascetics as they pay homage to the Buddha.

F.McG.

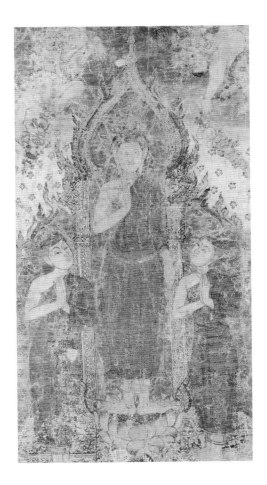

ABOVE LEFT AND RIGHT Details, cat. no. 90.

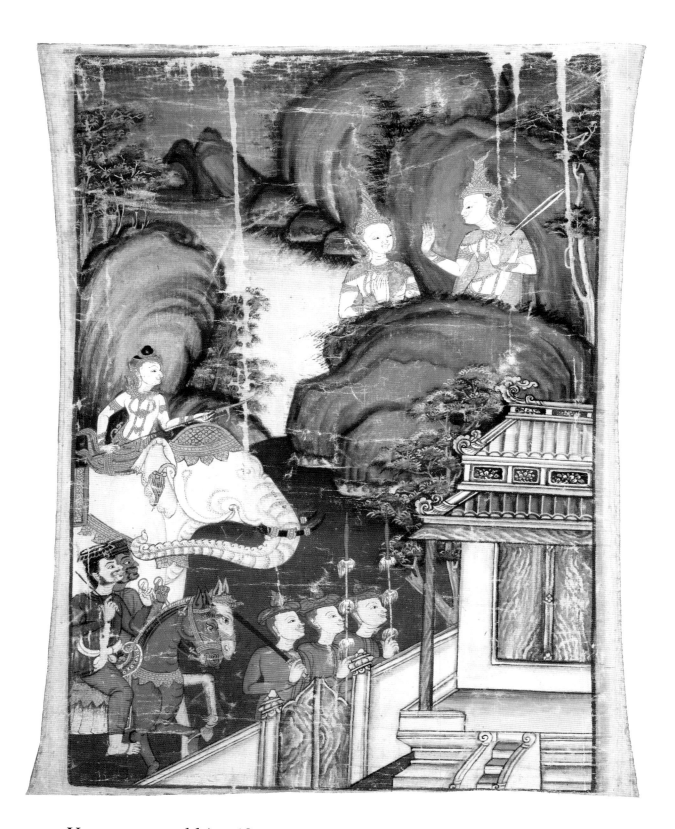

91 Vessantara and his wife see the approach of Vessantara's father's retinue

1800–1900
Central Thailand
Paint and gold on cloth
H. 64.1 × W. 50.2 cm
Gift from Doris Duke Charitable Foundation's
Southeast Asian Art Collection, 2006.27.79

In cat. no. 82 the artist depicted the boy prince and the procession approaching the bodhisattva's hermitage from a distance; here they are shown arriving.

The bold style of this painting, with its large forms, strong effects of shading and texture, and palette dominated by blues and tawny reds, is striking and unusual, raising the hope that other works by this artist will someday be identified.

F. McG.

92 Vessantara and his family weep for joy at their reunion [FIG. 27]

Approx. 1825–1875
Thailand
Paint and gold on cloth
H. 57.0 × W. 47.0 cm (image);
H. 61.6 × W. 52.0 cm (overall)
Gift from Doris Duke Charitable Foundation's
Southeast Asian Art Collection, 2006.27.122.16

At last the "Six Royals"—parents, children, and grandchildren—are reunited. Their gesture, holding a hand to the face with the heel of the palm near the eye, shows that all of them are shedding tears of joy. The female attendants at lower left are touched by the scene and also weep.

The part of the damaged inscription that has been read gives the title of the chapter illustrated and the number of its verses. F.McG.

PHRA MALAI

The compassionate monk Phra Malai used his extraordinary powers to visit both heaven and hell. While visiting hell, he bestowed mercy upon the suffering. They requested that when Phra Malai returned to earth he would advise their relatives to make merit on their behalf. He did so, and as a result, the suffering were reborn in heaven.

On earth, a poor man asked Phra Malai for a favor. The man gave Phra Malai eight lotus flowers in the hope that this pious offering would allow him to avoid poverty in his next life. Phra Malai assured the man that his wish would be granted.

Phra Malai then visited Indra's Heaven to worship the monument enshrining the Buddha's hair and tooth relics, the Chulamani Stupa. To aid the poor man, Phra Malai presented the eight lotuses to the holy monument for him.

Indra, king of the gods and ruler of this heaven, greeted Phra Malai, and the two engaged in conversation. Phra Malai asked Indra when Maitreya, the bodhisattva who would become the next Buddha, would visit the Chulamani Stupa. Indra replied that he would come that very day. When Maitreya and his retinue of celestial

ABOVE Detail, cat. no. 93.

beings arrived, he informed Phra Malai that if people on earth wanted to accrue the merit to be reborn when Maitreya descended to earth for his last human life, during which he would achieve buddhahood, they should listen to a full recitation of the sacred story of Vessantara (see cat. nos. 71–92). (Being reborn at the right time to hear the doctrine preached by an enlightened being such as Maitreya would immeasurably hasten one's own spiritual progress.) Phra Malai returned to earth to pass on Maitreya's advice to people there.[1] F.McG.

1 A detailed summary of the story of Phra Malai, as well as a translation of one version, may be found in Brereton, *Thai Tellings of Phra Malai*. Discussions and illustrations are provided by Boisselier, *Thai Painting,* and Ginsburg, *Thai Manuscript Painting* and *Thai Art and Culture.*

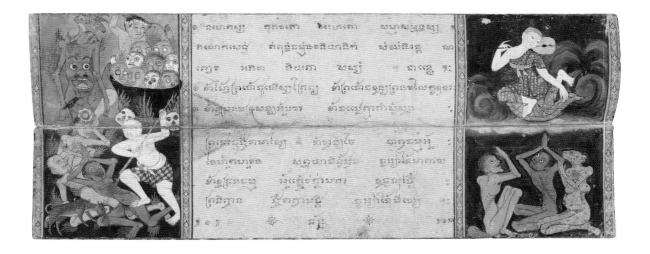

93 Manuscript with scenes from the story of the holy monk Phra Malai [DETAIL FIG. 51]

Approx. 1850–1875
Central Thailand
Paint, gold, and ink on paper
H. 14.0 × W. 67.9 × TH. 8.3 cm
Gift from Doris Duke Charitable Foundation's
Southeast Asian Art Collection, 2006.27.86

This manuscript follows a standard pattern for manuscripts enriched with scenes from the story of the monk Phra Malai, but it is painted more carefully and skillfully than many and has a greater degree of individuality. As usual, the paintings are arranged two to a double page,

flanking a block of text. Six double pages bear paintings, while the rest have only text. The illuminated pages show: 1) Indra and another deity across from a demon and a garuda, all kneeling in veneration; 2) sinners being tortured in hell across from Phra Malai, who floats in the air, hearing the entreaties of other sufferers; 3) a woodcutter gathering lotuses and, on the far side, giving them to Phra Malai as a merit-making act. The distant landscape in these scenes, with tiny trees and overlapping blue mountain ranges, is a reminder of Thai artists' interest in aspects of Western painting from the middle of the nineteenth century onward; 4) Phra Malai, now at the stupa containing the hair and tooth relics of the Buddha in Indra's Heaven, conversing with Indra accompanied by a female celestial and gesturing toward a celestial and his retinue who fly in from the other side; 5) two more hosts of celestials flying in. The golden figure on the right is probably Maitreya himself; 6) two options for society: disorder and violence or calm and security. A variety of ethnic types, indicated by a range of skin tones, facial features, and dress, are included in the scene of disorder. Among the slain is a Westerner, and one of the assailants wears a skullcap, presumably indicating that he is a Muslim.

This manuscript does not bear an inscribed date, but a number of dated Phra Malai manuscripts are known and provide a sequence to which this one may be compared.[1] The Asian Art Museum collection includes two dated examples from 1791 and 1844.[2] F.McG.

1 Ginsburg, "Dated Manuscript Painting," fig. 3 (1813); Ginsburg, *Thai Art and Culture,* nos. 52 (1837), 53 (1839), 54 (1849), 56 (1897), and 57 (1903); and Ginsburg, *Thai Manuscript Painting,* pl. 25 (1868).
2 For the 1791 example, see McGill, ed., *Kingdom of Siam,* no. 80; for the 1844 example, see Ginsburg, "Dated Manuscript Painting," fig. 4.

LEFT Calm in society (detail, cat. no. 93).

Paintings from three manuscripts in the collection of the Asian Art Museum of a poor man giving lotuses to Phra Malai: TOP dated 1791 (2006.27.85, not in exhibition); CENTER dated 1844 (1993.10, not in exhibition); BOTTOM approx. 1850–1875 (cat. no. 93).

Even in a tradition as conservative as the illustration of Buddhist manuscripts, notable changes took place in the late eighteenth and nineteenth centuries. In these examples we see a growing interest in shading, in the suggestion of space and distance, and in the elaboration of the landscape.

BELOW Violence in society (detail, cat. no. 93).

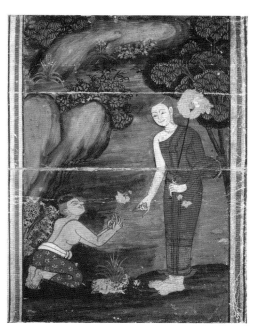

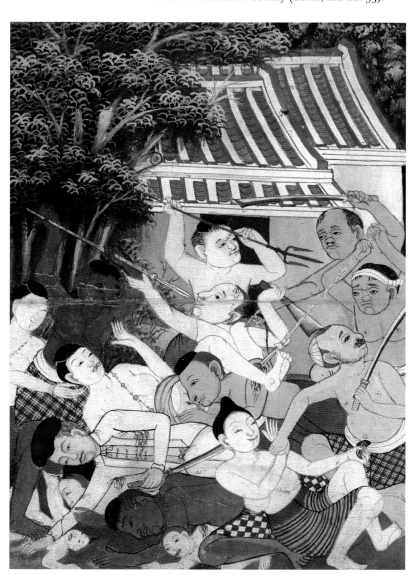

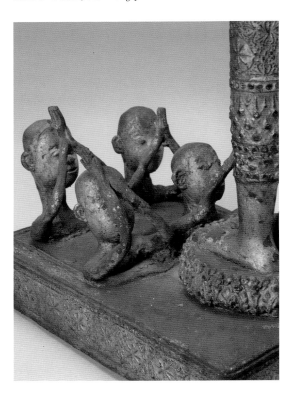

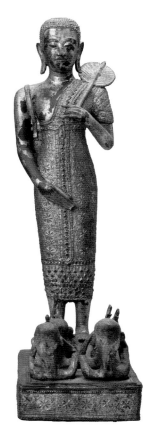

94

94 The holy monk Phra Malai visiting hell

Approx. 1850–1900
Central Thailand
Gilded bronze with mirrored glass inlay
and pigment
H. 49.5 × W. 14.0 cm
Gift from Doris Duke Charitable Foundation's
Southeast Asian Art Collection, 2006.27.37

95 The holy monk Phra Malai visiting hell

Approx. 1850–1900
Thailand
Lacquered and gilded copper alloy with pigment
H. 27.3 × W. 10.2 cm
Gift of Dr. Sarah Bekker, 2008.80.A–B

Though the story of Phra Malai has been known in Siam for centuries, it seems to have been especially important and popular in the late eighteenth and nineteenth centuries. The Phra Malai text focuses on two themes: the rewards of merit making by performing offerings and the effects of sin with an emphasis on punishment in hell to discourage people from committing sinful acts.[1] The Phra Malai text also suggests that the most important act of merit making is to participate in the Vessantara Jataka festival, the ritual recitation of the entire text relating to the previous life of the Buddha as Prince Vessantara.[2] (See cat. nos. 71–92.)

Phra Malai is usually identified in artworks by his monk's belongings: a monastic fan and an alms bowl.

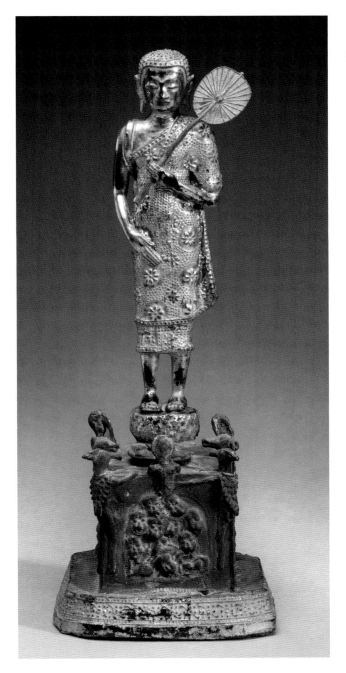

BELOW Detail, cat. no. 95.

Sculptures of the Bangkok period seem to emphasize his trip to hell more than his trip to heaven. Hell is portrayed by grotesque figures on the base of statues. On the base of cat. no. 94 four human beings are paying respect to Phra Malai from hell. On cat. no. 95 frightening animal-headed underworld creatures alternate with skeletal sinners appealing to Phra Malai for assistance so they can be saved and reborn in a heaven, while other sinners stew in vats. On the upper surface of the plinth a corpse is attacked by a huge worm.[3]　　P.C.

1 Further information on the background of the Phra Malai stories in Thailand can be found in Brereton, *Thai Tellings of Phra Malai*. Several versions of the text are used in Siam, such as the *Phra Malai Kham Luang* (used in central Thailand) and the *Malai Ton-Malai Plai* (in northern Thailand). The *Phra Malai Klon Suat* is used for chanting at funerals or memorial services.

2 Ibid., 15.

3 Compare an incomplete statue discussed in Griswold, "A Warning to Evildoers." Other related sculptures are discussed in Fontein, Lambrecht-Geeraerts, and Bakker, *Bouddhas du Siam,* 92; Piriya, "Sculptures from Thailand," 176–177; and Somkiat, *Phraphuttharup samai rattanakosin,* 128.

96 Tiered stand for Buddha images, with a scene of Phra Malai preaching in Indra's Heaven

1850–1900
Thailand
Lacquered and gilded wood with pigments
H. 148.6 × W. 48.9 × D. 44.4 cm
Gift from Doris Duke Charitable Foundation's
Southeast Asian Art Collection, 2006.27.18

The holy monk Phra Malai was a popular subject for depiction on tiered stands such as this. Unlike the sculptures of Phra Malai (cat. nos. 94 and 95), which focus on the theme of hell and the monk's power to assist suffering sinners, the tiered stands emphasize heaven. In the episode painted on this stand, Phra Malai, dressed in a red monk's robe, is seated with his legs crossed and his left hand pointing toward the approaching, but as yet unseen, deities coming to worship the stupa with the holy relics. Indra (with a green complexion) and a high-ranking woman whose identity is not certain are seated side by side with their hands folded in adoration of the relics. (Compare cat. no. 36.)

The Chulamani Stupa is flanked by two flagpoles. On each flies a crocodile flag, which in central Thailand is generally displayed during the offering of a new robe to monks after the rain retreats, in October.[1]

On the sides of the stand are poorly preserved paintings of scenes from the legend of the bird-woman Manora.

Several missing pieces of the stand, such as parts of the enclosures of the shelves, were replicated from existing pieces in 2008. P.C.

1 Sometimes a millipede is also depicted.

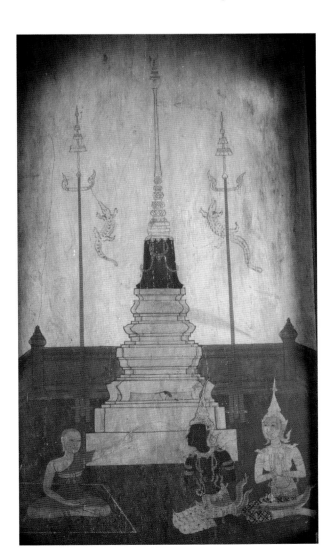

LEFT AND BELOW Details, cat. no. 96.

97 Shiva, with the Buddha on his head, on the bull Nandi [FIG. 59]

1850–1925
Central Thailand
Lacquered and gilded copper alloy
with mirrored glass
H. 55.9 × W. 35.6 cm
Gift from Doris Duke Charitable Foundation's
Southeast Asian Art Collection, 2006.27.36.A–B

The Buddha appeared alongside Hindu gods such as Shiva and Rama in stories that are known only from the early Bangkok period. The story that this statuette depicts was derived from a Buddhist text, the *Trailokavinicchayakatha,* that was compiled and translated from the Pali in 1802 under the orders of Rama I.[1]

 In the story, the Buddha overcame the Hindu god Shiva.[2] To show off his power, Shiva challenged the Buddha to a serious contest of hide-and-seek. Shiva covered himself with one thousand layers of dirt and hid deep within the earth. The Buddha found him easily. When it was Shiva's turn to search, the Buddha placed himself above Shiva's head. After a long and strenuous search, Shiva still could not find the Buddha and begged him to appear. The Buddha appeared and then preached to him. After the Buddha's death, Shiva built a shrine to house a beautiful Buddha image.

A small seated Buddha is seen on Shiva's crown.[3] The costume, the crown, and the jewelry are typical of royal adornments of the Bangkok period, as can also be seen on the crowned and bejeweled Buddha image cat. no. 47. One of Shiva's ten hands holds a trident, one of his standard attributes in India as well as in Southeast Asia. Shiva rides on his bull, Nandi.

P.C. AND F.McG.

1 Thampricha [Kaeo], *Trailokavinicchayakatha* 3:8–19.

2 In Thai, Shiva is usually called "Isuan" or "Mahesuan" (Sanskrit: Ishvara or Maheshvara); in the episode in the *Trailokavinicchayakatha* his name is spelled *mahis[s]ra,* with the addition of *debaputra,* "son of a god," at the end. An alternate explanation of this statuette is that we see the Buddha overcoming the self-important Baka Brahma. See Khaisri, *Les statues du Buddha,* 37, 98–99, 250–251; she discusses the similarities of the two stories.

3 A standing Buddha is also common on this type of image. An example in the National Museum, Bangkok, bears an inscription that mentions the Buddha standing on Shiva. This image is illustrated in Chira Chongkal, *Guide,* 4th ed., 104. Thanks are due to Dr. Peter Skilling, Dr. Santi Pakdeekham, and Dr. Prapod Assavavirulhakarn for interpreting this inscription. For similar statuettes, see Somkiat, *Phraphuttharup samai rattanakosin,* figs. 85 and 87; other examples in the same book show the Buddha seated: figs. 88 and 133–136. Somkiat attributes all of these to the period of Rama III (1824–1851). An earlier example, from northern Thailand, which depicts the Buddha standing on Shiva's head but Shiva having only two arms and not riding his bull, is illustrated in Fontein, Lambrecht-Geeraerts, and Bakker, *Bouddhas du Siam,* cat. no. 58.

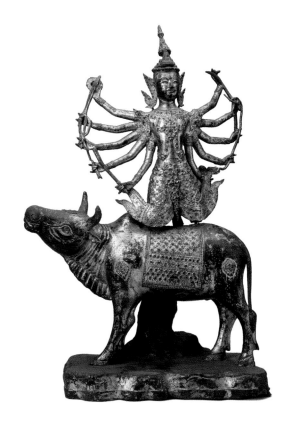

98 Head of a hermit [FIG. 15]

1836
Thailand, Bangkok;
from Wat Phra Chettuphon (Wat Pho)
Zinc tin alloy with traces of color
H. 26.7 × W. 14.0 cm
The Avery Brundage Collection, B60S12

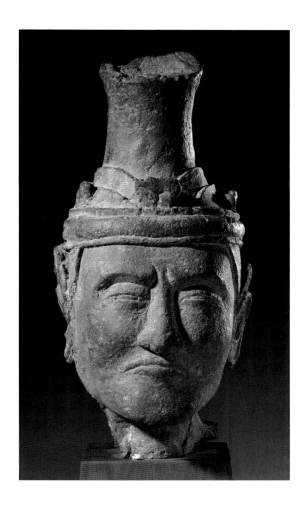

Performing good works for the benefit of his people was a time-honored duty of a Siamese king. The king reigning in the 1830s decided that traditional lore concerned with healing must be preserved and made available to all. He commissioned for Wat Phra Chettuphon (Wat Pho) both inscribed plaques recording such information and a series of sculptures of contorted hermits with medical conditions, to be used as teaching tools.[1] Over the decades many of these sculptures were damaged. This head belonged to one of the sculptures, though how and when it left Thailand (sometime before 1960, when it was already in the possession of the museum's founding donor) is not known.

Much nineteenth-century Siamese sculpture is highly stylized, usually portraying the Buddha or other exalted, superhuman figures. The Wat Phra Chettuphon hermits, however, are touchingly down to earth, grimacing from their various maladies.

In Thai art, hermits (*rishis*) can usually be recognized by their odd headdresses, the upper part of which narrows and then flares out again as it rises. This sort of headdress is supposed to represent a piece of tiger skin wrapped into a head covering. Sometimes, in painting (for example, on the headdresses of the flying figures in the upper part of cat. no. 49), the markings on the tiger skin can be seen. F.McG.

1 For more information, see McGill and Pattaratorn, "Thai Art," 29; Griswold, "The Rishis of Wat Po"; and Matics, "Historical Analysis," 251–268. Apparently a tradition of depicting hermits in contorted positions as part of medical advice predated the creation of these sculptures in the 1830s. The British envoy John Crawfurd, visiting Wat Phra Chettuphon in 1822, mentions that "on the walls were daubed many human figures, thrown into attitudes the most whimsical, distorted, and unnatural.... Under these figures were inscriptions in the vernacular language, giving directions how to assume the attitudes in question, and recommending them as infallible remedies"; Crawfurd, *Journal of an Embassy,* 109. On an 1838 manuscript illustrating hermits related to those at Wat Phra Chettuphon, see, in addition to Griswold, Ginsburg, *Thai Art and Culture,* 134.

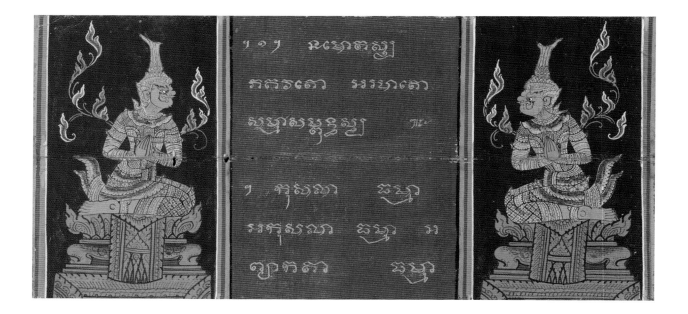

99 Illustrated manuscript of excerpts from Buddhist texts [FIG. 53]

1857
Thailand
Paint, gold, lacquer, and ink on paper
H. 8.3 × W. 35.5 × TH. 5.7 cm
Transfer from the Fine Arts Museums of
San Francisco, Gift of Katherine Ball, 1993.27

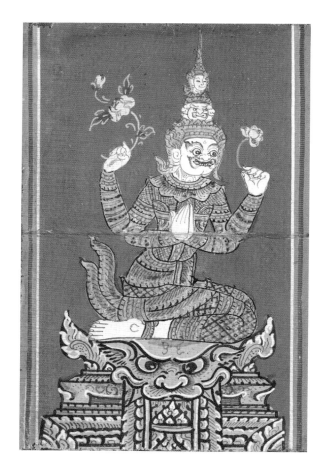

In a common layout of illustrated manuscripts from Siam, a central block of text is flanked by rectangular paintings. Here the paintings are of pairs of beings that inhabit the higher and lower realms of the universe: Brahma deities from the highest heavens (recognizable by their multiple arms and faces), celestials (who appear human), single-headed demons, multiheaded demons (some of whom resemble the great demon Mara, who threatens the Buddha), garudas (mythical birds with some human characteristics), and legendary serpents (personified but recognizable by the serpent heads at the tip of their crowns). All kneel facing the sacred text, holding their hands together in a gesture of reverence.

This manuscript, with a date equivalent to 1857, includes excerpts from several Abhidharma texts in the Theravada Buddhist canonical language of Pali.[1] These are written in two alphabets, the Mon alphabet and a version of the Cambodian alphabet used in Thailand for Pali. The Pali language could be written in a variety of alphabets, just as ancient Greek could today be rendered in the Roman, Cyrillic, or other alphabets. This manuscript's dedicatory inscription is in Thai, and a title is in yet another version of the Cambodian alphabet used in Thailand.

F. McG.

1 Undated note from Henry Ginsburg in the Asian Art
 Museum files. Thanks also to Peter Skilling for clarifying
 matters of languages and scripts in this manuscript.

LEFT Detail, cat. no. 99.

100 Double manuscript page with pair of guardian figures

[FIG. 57]

Approx. 1850–1900
Central Thailand
Paint and gold on paper
H. 24.2 × W. 36.5 cm
Gift of Dr. Sarah Bekker,
2008.79.A–B

This double page was, at some point, cut from an illustrated, accordion-folded manuscript similar to cat no. 99. Again, mythical figures flank a block of text. The figures are guardians of the sort seen on the doors of manuscript cabinets as well as of temples and palaces.[1] Their features are thought by the Thais to look Chinese,[2] and their costume and stance may be compared to those on the ends of the manuscript chest cat. no. 36.

F.McG.

1 Cabinets: Kongkaeo, *Tu lai thong,* part 1, 187–189; shutters: Wannipha, comp., *Chittrakam,* 43. A famous set of such figures, attributed to the reign of Rama III (1824–1851), is in the ordination hall of Wat Phra Si Rattanasatsadaram (the Temple of the Emerald Buddha) in Bangkok; see, for example, Naengnoi and Freeman, *Grand Palace,* 45, 47.

2 Boisselier, *Thai Painting,* fig. 57 caption.

BELOW Details, cat. no. 99.

101 Buddhist tablet board [FIG. 46]

1800–1900
Central Thailand
Lacquer, pigmented natural resin, and gilding
on wood, with mirrored-glass inlay
H. 177.8 × W. 76.2 cm
Gift from Doris Duke Charitable Foundation's
Southeast Asian Art Collection, 2006.27.46

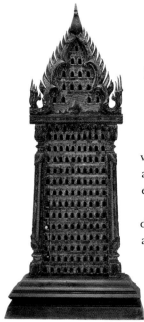

One type of object commonly donated to temples for merit making is the Buddhist tablet board, a wooden board, which was often decorated, inset with small Buddha images or Buddhist tablets. Buddhist tablets were made in a variety of mediums, such as clay (baked and unbaked), stone, and metal (bronze, silver, and pewter).[1] The tablets also were often deposited in the main stupa of a temple or underground inside or outside of the ordination hall in the northern part of a temple compound. From the eighteenth century to the reign of Rama V, tablet boards seem to have been among the most popular offerings to temples.[2] Some bear inscriptions that provide the names of the donors, the date of the offering, the amount spent on the offering, and the donors' goals.[3] Such goals included accruing merit, which was believed to help the donors attain nirvana or be reborn in the time of the future Buddha, Maitreya. Donors generally indicated their wish to share the benefits of merit making with their families, or with all beings, or sometimes even with animals.

This tablet board is divided into two parts: an upper register with 15 niches and a lower section with 130 niches (10 in each row).[4] Each niche once held a tablet, and terra cotta remains can still be seen in some of them, indicating the material of the now-disappeared tablets. The board is set in a newer wooden base made, presumably, in the twentieth century. The upper register of the board is ornate, with two mythical serpents whose bodies outline the shape of the stylized pediment. Their tails reach the apex where the finial ("swan tail," *hung hong*) is placed. Similar stylized serpent ornamentation also appears around each niche. The board is decorated with green glass and a red coating.[5]

P.C.

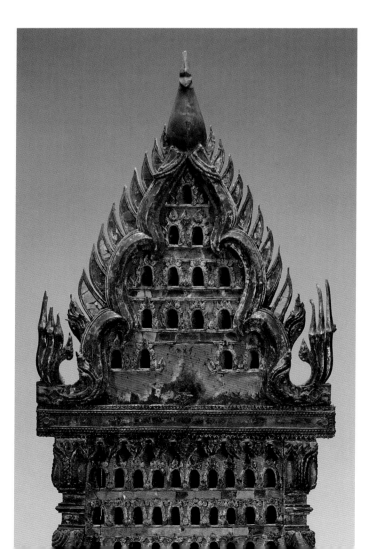

1 For more on tablets, see Pattaratorn, *Votive Tablets in Thailand*.
2 No known Buddhist tablet board dates to earlier than the Ayutthaya period. However, a large stone stele from around 1000–1200 that was discovered at Banteay Kdei Temple in Cambodia strongly resembles a tablet board. The upper register of the stele depicts in relief a triad of Buddha images seated in meditation. The lower register depicts 252 Buddha images in meditation (12 images in 21 rows). All the Buddhas are the same size. The upper register is decorated with mythical serpent bodies, which form a pediment-shaped space. The serpents' heads project sideways similar to those of the Asian Art Museum piece. Because the Khmer stele is the only known "tablet board" made of stone, it is not certain if it was the original prototype of the wooden Buddhist boards of Siam and Laos. See Ishizawa, "La découverte de 274 sculptures et d'un caitya bouddhique," 214.

 A tablet board probably from the late Ayutthaya period can be seen in McGill, ed., *Kingdom of Siam,* 163.
3 One of the longest inscriptions is on a Buddhist tablet board in the collection of Wat Ruak Bamru in Nonthaburi. See Skilling, "For Merit and Nirvana," 86–87.
4 The number of tablets seems to vary from board to board. Some boards follow a number pattern that is associated with certain groupings of Buddhas, such as the Buddhas of the past or the eighty great disciples, but many do not follow any recognizable pattern.
5 The Siamese often used strong color combinations such as red and green or orange and blue for decoration.

LEFT Detail, cat. no. 101.

ABOVE Top view, cat. no. 102.

102 Lidded offering container

1800–1925
Thailand
Lacquered wood with mother-of-pearl
H. 58.4 × W. 52.1 cm
Gift from Doris Duke Charitable Foundation's
Southeast Asian Art Collection, 2006.27.105.A–B

Members of the royal family use lidded offering containers, consisting of a tray and a cone-shaped cover, to present food to monks during royal ceremonies. A container similar to this one in shape and design, but inlaid with gold rather than mother-of-pearl, was used in the funeral ceremonies of Queen Saovabha, a wife of Rama V and the mother of Rama VI and Rama VII, in 1919.[1]

For more information on mother-of-pearl inlay, see cat. nos. 117 and 118. P.C.

1 *Sinlapakam wat ratchabophitsathitmahasimaram*, 85. Another such container, inlaid with mother-of-pearl and attributed to the nineteenth century, is in the Suan Pakkad Palace Collection in Bangkok; *The Suan Pakkad Palace Collection,* fig. 78.

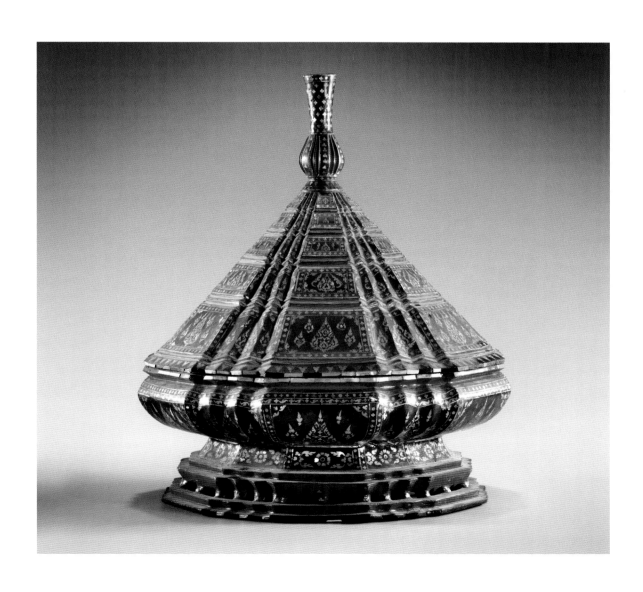

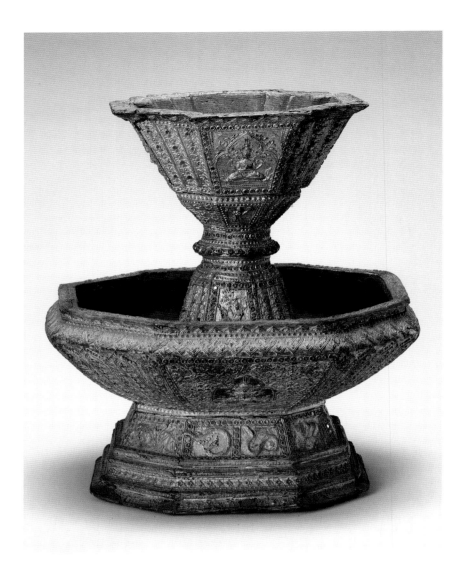

103 Double-tiered offering container

Approx. 1875–1925
Thailand
Lacquered and gilded bamboo
and wood with mirrored glass
H. 40.6 × DIAM. 40.6 cm
Gift from Doris Duke Charitable Foundation's
Southeast Asian Art Collection, 2006.27.106

A double-tiered offering container of this type would usually be used for Buddhist ceremonies such as an ordination or the offering of a new robe to a monk. It also could support Buddhist manuscripts (laid across the top) for sermons.[1]

On the foot of the lower container are depicted the animal symbols of the twelve-year cycle. The cycle traditionally begins with the year of the rat, followed by ox, tiger, rabbit, dragon, snake, horse, goat (or sheep), monkey, rooster, dog, and pig. Each of the animals is thought to represent a different type of personality.

On the main panels on each side of the con-

tainer are a Brahma deity, a woman with a mirror, and a half-woman-half-bird. They may represent 3 of the 108 auspicious symbols that appear on the Buddha's footprint.[2] The artist may have been inspired by the depiction of these symbols on the mother-of-pearl-inlaid foot soles of the huge reclining Buddha at Wat Phra Chettuphon (Wat Pho) in Bangkok.[3]

The upper tier of both the lower and the upper containers show male figures wearing jewelry and ornate crowns with multiple spires. Each has four arms and four heads (of which only three are visible). With two hands they make a gesture of reverence; with the other two they hold bunches of what appear to be lotuses. These figures are ineffable Brahma deities who reside in the Brahma realms in the high heavens of Thai Buddhist cosmology.[4]

On each side of the upper container in the band below the Brahma deities is a woman seated with her legs folded beneath her. She holds what seems to be a mirror (or perhaps a fan) in her left

hand. Probably she resides in the human world, as may be indicated by the tree next to her.[5]

On the foot of the upper container, below the woman with the mirror, is a half-woman-half-bird, whose species lives in the forest on the slopes of the legendary Mount Meru (see cat. nos. 112–115). In Thai Buddhist cosmology this forest is above the human world. Why it appears below the human world on this container is puzzling.

This vessel's technique—the raised decoration of gilded lacquer and tiny glass spangles—seems to have been uncommon in central Siam and calls to mind the technique of Burmese and northern Thai lacquers such as in cat. nos. 12–18. The shape and raised designs of this object imitate central Siamese objects of gold or gilded metal,[6] but the particular technique may have been introduced from Burma or northern Siam.

P.C.

1 A double-tiered vessel of similar shape (though probably of gold or gilded metal) can be seen holding a royal betel

set during a ceremony for the bicentennial of the present dynasty in 1982; Saengsooriya, *Pharatchaphithi somphot krung rattanakosin 200 pi/Royal Ceremonies for the Rattanakosin Bicentennial,* 10–11.

2 Thanks to Dr. Peter Skilling, Dr. Santi Pakdeekham, and Dr. Prapod Assavavirulhakarn for their advice on the iconography of this object. For further information on the 108 auspicious symbols of the Buddha's footprint, see Di Crocco, *Footprints of the Buddhas.*

3 These foot soles are shown, for example, in *Historical Illustrations, Wat Phra Chetuphon,* 108–109.

4 On the Brahma deities of the Brahma realms, see Reynolds and Reynolds, *Three Worlds,* 245–257, 358; Walshe, *Long Discourses of the Buddha,* 38–44 and passim; and Malalasekera, *Dictionary,* 1199 under the word *suddhavasa.* For depictions of these Brahma deities in eighteenth- and nineteenth-century Thai illustrated manuscripts, see Amphai and Kongkaeo, *Traiphum chabap phasa khamen,* 12–18; and *Samutphap traiphum chabap krung si ayutthaya,* 115–120.

5 The foot soles of the reclining Buddha at Wat Phra Chetuphon include a similar figure on the lower left (if the foot soles are looked at "upright"—that is, with the toes at the top).

6 Many beautiful photos of Bangkok-period gold work can be seen in *Khrueangthong rattanakosin.*

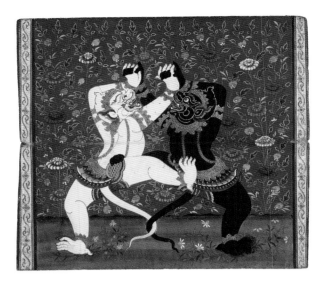

104 Manuscript with scenes
of combat from the Thai
version of the epic of Rama

[DETAILS P. II, FIG. 56]

Approx. 1800–1840
Central Thailand
Pigments and gold on paper
H. 22.2 × W. 49.5 × TH. 6.3 cm
Gift from Doris Duke Charitable Foundation's
Southeast Asian Art Collection, 2006.27.9

This manuscript is unusual in a number of ways.[1] Less elongated than most manuscripts, it is almost square when opened. It is filled with double-page paintings and has no text at all. All of its paintings illustrate the Rammakian, a Thai version of the epic of Rama, which—for all its popularity in late-eighteenth- and nineteenth-century central Thai literature, theater, and some visual arts—is nevertheless rarely depicted in manuscripts. In any event, to say that the paintings in this manuscript "illustrate" the Rammakian is correct only in the most limited sense: all sixty-three show two (or occasionally three or four) figures in hand-to-hand combat. Various important characters are identifiable by their facial features, skin color, type of head-dress, and so on—for example, Rama, his brother Lakshmana, their monkey ally Hanuman, and their enemy Ravana. Once in a while it is possible to place the combat within the larger story: a famous struggle between Lakshmana and Ravana's son Indrajita, or a military exercise in which monkey warriors allied with Rama engage in mock battle.[2] But even in these instances the props and other narrative clues are few. Why so many scenes of hand-to-hand combat and none of any other kind of episode?

The cover of the manuscript bears the words *phaen chap,* which mean something like "representations of holds" in the sense of wrestling holds; perhaps a more natural translation would be "scenes of close combat." There was a tradition of making sets of such pictures as a demonstration of an artist's skill.[3]

This manuscript may have been a sort of pattern book. Such books must have existed, because a study of narrative scenes in murals, on lacquered and gilded cabinets and in other mediums, shows repetitions or near-repetitions of complicated groupings of figures occurring frequently. However, a pattern book would be expected to be a workaday affair, and to show evidence of use and passing from artist to artist; this manuscript is sumptuous and well preserved, and the only similar volume known is in the Thai royal collection kept at the National Museum.[4]

When the manuscript was made is uncertain. The similar volume in the royal collection has been attributed to the period of Rama II (1809–1824) by Thai writers and to the late nineteenth or early twentieth century by no less an authority than Jean Boisselier.[5] However, the points of similarity of the illustrations here to the Rammakian combat scenes on a gilded and lacquered cabinet dated by inscription to 1794 suggest that an earlier date is possible.[6]

Another interesting question is the relationship, if any, between the illustrations in this manuscript and the famous Rammakian reliefs at Wat Phra Chettuphon (Wat Pho) in Bangkok. Both have large, and often few, figures in an essentially square field, and the size of the paintings is within a centimeter or two of that of the reliefs. Some of the combat scenes are quite similar in their compositions.[7] Unfortunately, the date of the reliefs is not known, either (though they could well have been made for Rama III's restoration of Wat Phra Chettuphon in the 1830s and 1840s), and they have never received the intensive study they deserve. Also at Wat Phra Chettuphon are a series of "representations of holds" painted on the walls of the mid-nineteenth-century library of Prince-Abbot Paramanuchit Chinnorot (1790–1853). These wall paintings resemble the illustrations in this manuscript, though their execution is considerably less refined.[8] They too await systematic study and comparison with the reliefs and this and related manuscripts. F.McG.

1 This manuscript is discussed and illustrated in McGill and Pattaratorn, "Thai Art," 32–33, where its unusual arrangement of scenes in related sets of three is described.

2 These paintings may be compared with the representations in the reliefs of Wat Phra Chettuphon; Cadet, *Ramakien*, nos. 62 and 134. A useful summary of the Rammakian can be found in Boisselier, *Thai Painting*, 188–193.

3 Joti, *Photchananukrom*, 569, under the term *phap chap*.

4 Khana Kammakan Chat Ngan Somphot Krung Rattanakosin 200 Pi, *Chittrakam*, 68–70.

5 Ibid.; Boisselier, *Thai Painting*, fig. 145. For a related

woodcarving, see Naengnoi and Somchai, *Art of Thai Wood Carving*, 187.

6 Wannipha, comp., *Chittrakam*, 101–105.

7 Compare, for example, one of the paintings of Lakshmana and Hanuman fighting Munlaphlam with the same scene in a Wat Phra Chettuphon relief (pictured in Cadet, *Ramakien*, no. 146), except its composition is the reverse of that of the relief (that is, one is flipped left-to-right in relation to the other).

8 Niyada, *Hotrai krom somdet phraparamanuchit chinnorot*, 31–103. I thank Dr. Peter Skilling for drawing these wall paintings and this book to my attention, and for his help in understanding the notion of *phaen chap*.

BELOW Combat between Lakshmana and Indrajita (detail, cat. no. 104).

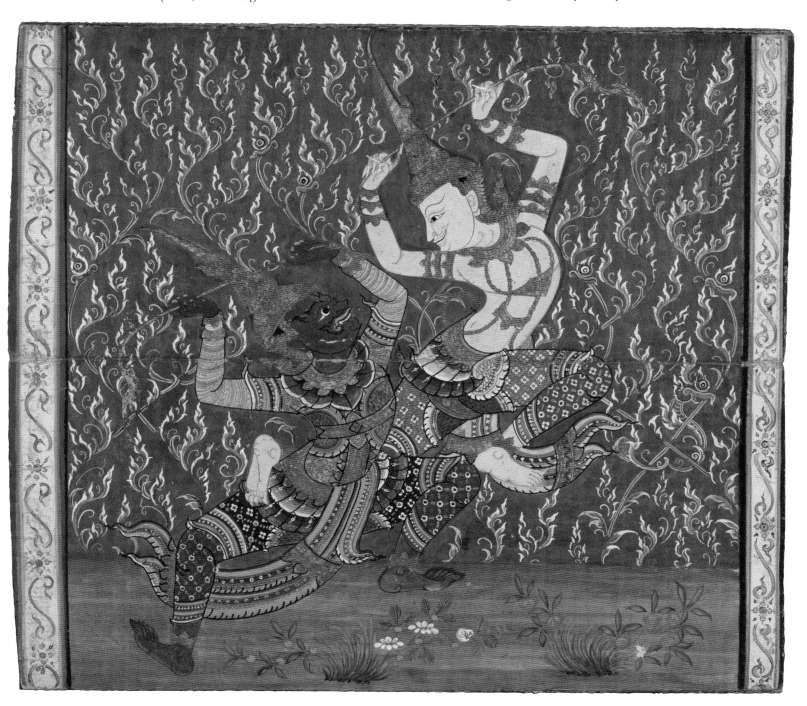

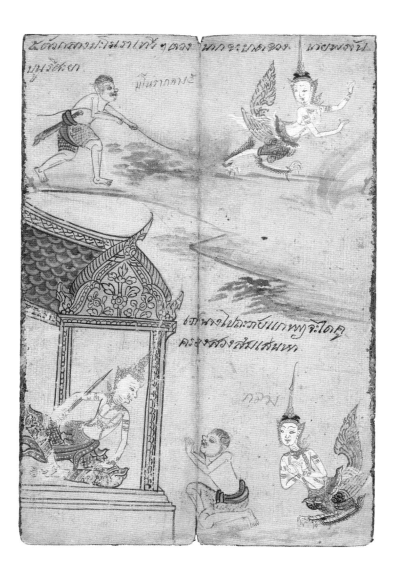

105 Manuscript with fortune-telling lore and illustrations of the stories of Rama, Sang Thong, and Manora [FIG. 23]

Approx. 1800–1850
Thailand
Paint, gold, and ink on paper
H. 36.8 × W. 12.1 × TH. 5.4 cm
Gift of George McWilliams, 2008.89

Divination greatly influenced most aspects of Siamese life. Astrologers were consulted regarding milestones of life, from a child's birth to the ceremonies that marked important ages such as the shaving of the topknot, the wedding, and the building of a new house.

Siamese divination is an amalgam of the Indian and Chinese systems. While it embraced the Chinese twelve-year animal cycle, the lunar calendar, elemental theory, and palmistry, it incorporated the Indian solar calendar, the signs of the zodiac, and the identification of days with planets.[1] Astrologers calculated numbers from the time, date, and year of birth and entered them in a diagram. Then they consulted divination manuscripts to make their predictions.

Divination manuscripts before the twentieth century were produced in an accordion-fold format.[2] Because they were heavily used, they wore out more quickly than other manuscripts. Hence this manuscript is worn and has pages sewn back together; also, some of the original pages are missing.

A divination manuscript is usually divided into three parts: divination diagrams, predictions, and illustrated stories. The stories in this manuscript come from popular Siamese literature such as the Siamese version of the Ramayana (Rammakian) and the stories of Sang Thong and the bird-woman Manora.[3] Important episodes, which are considered the highlights of the stories, are depicted in two-page sections. Short summaries accompany illustrations. For instance, in the episode of the Rammakian when Sita is abducted by Ravana, the golden deer appears in the center of the two-page display. Above the deer, Ravana is shown abducting Sita, and below the deer, Sita is asking Rama to get her the deer. The illustrations serve as reminders of the text's main points, and the fortune-teller would choose characters appropriate for the client from among the stories in the manuscript.[4] All three tales included in this manuscript share the themes of love in separation and the causes and effects of good and bad karma.

The numbers one to ten have specific icons associated with them; for instance, here four and five are symbolized by empty Chinese- and Siamese-style pavilions, respectively, and six is symbolized by one of the planets, Rahu, swallowing the moon. One page shows a sketch associating numbers with important characters in the Rammakian.

The main characters in the stories are portrayed in beautiful pavilions or against simple landscapes. The styles of the architectural structures seem to reflect both Siamese and Chinese elements commonly employed around the reign of Rama III (1824–1851). P.C.

1 Kirsch, Review of Wales, *Divination in Thailand.*
2 For further information on divination, see Wales, *Divination in Thailand.* For divination manuscripts, see Ginsburg, *Thai Manuscript Painting.*
3 For the story of Sang Thong, see Phutthaloetla Naphalai (King Rama II), Ingersoll, and Bunson, *Sang Thong.* A brief summary of the Manora story can be found in Ginsburg, *Thai Manuscript Painting,* 71.
4 Ginsburg, *Thai Manuscript Painting,* 22.

๗๗ กัดาตั้น ๕

ตันๆอเผู้หญฺ

ผะรๅๆ

106

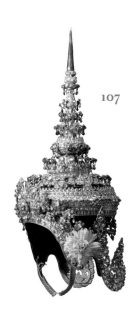

107

106 Headdress for Rama in the dance-drama of the epic of Rama

Approx. 1950–1960
Thailand
Gilded lacquer, wood, silver, glass,
synthetic textile, rawhide, and paper
H. 57.2 × W. 21.6 cm
Gift from Doris Duke Charitable
Foundation's Southeast Asian Art Collection,
2006.27.10.10.A–F

107 Headdress for Sita in the dance-drama of the epic of Rama [FIG. 40]

Approx. 1950–1960
Thailand
Gilded lacquer, wood, silver, glass,
synthetic textile, rawhide, and paper
H. 53.4 × W. 21.0 cm
Gift from Doris Duke Charitable Foundation's
Southeast Asian Art Collection, 2006.27.10.8.A–D

108 Diadem for a classical dancer

Approx. 1950–1960
Thailand
Silver, glass, ferrous metal, paper, and cloth
H. 27.9 × W. 22.9 cm
Gift from Doris Duke Charitable Foundation's
Southeast Asian Art Collection, 2006.27.10.6

When enacted in Siamese classical dance, Rama and Sita (hero and heroine of the Rama epic) wear ornate costumes and headdresses. Their costumes resemble the king's full ceremonial garb (such as the coronation attire). The higher the multitiered gold crown, which tapers to the spire, the more important the character is in the story. Lower-ranking females, such as princesses, wear diadems.

Before the actors and actresses dance, they pay homage to respected teachers and spirits. They place their headdresses, diadems, masks, and musical instruments on an altar along with offerings such as flowers and garlands. After the offering ceremony, the performers put their headdresses on and tuck a fresh flower behind the ear.

These headdresses have tags inside that indicate they came from Narasin, a well-known classical dance paraphernalia store located near the National Theater in Bangkok. They most likely were purchased in the 1950s. P.C.

108

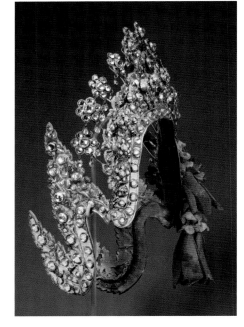

109 Shadow puppet of the demon king Ravana riding a chariot into battle, from the Thai version of the epic of Rama

> Approx. 1850–1900
> Thailand
> Rawhide, pigments, and bamboo
> H. 193.5 × W. 142.0 cm
> Gift from Doris Duke Charitable Foundation's
> Southeast Asian Art Collection, 2006.27.115.2

110 Shadow puppet of the monkey hero Hanuman in the guise of Ravana's heir, from the Thai version of the epic of Rama

> Approx. 1850–1900
> Thailand
> Rawhide, pigments, and bamboo
> H. 193.7 × W. 77.5 cm
> Gift from Doris Duke Charitable Foundation's
> Southeast Asian Art Collection, 2006.27.115.1

111 Shadow puppet of the monkey hero Hanuman in the guise of Ravana's heir riding a chariot into battle, from the Thai version of the epic of Rama [FIG. 39]

> Approx. 1800–1900
> Thailand
> Rawhide, pigments, and bamboo
> H. 176.5 × W. 116.8 cm
> Gift from Doris Duke Charitable Foundation's
> Southeast Asian Art Collection, 2006.27.115.3

Several sorts of puppet performances, using large or small shadow puppets or three-dimensional rod puppets, were popular forms of entertainment in Siam. In the large shadow-puppet theater in which puppets such as those shown here were used, the stories were all drawn from the epic of Rama, known in Thai as the Rammakian.

In performance each large puppet is held and manipulated by a puppeteer while a male narrator tells the story, accompanied by a Siamese classical orchestra.[1] "As he [the puppeteer] manipulates the figure he is automatically bound

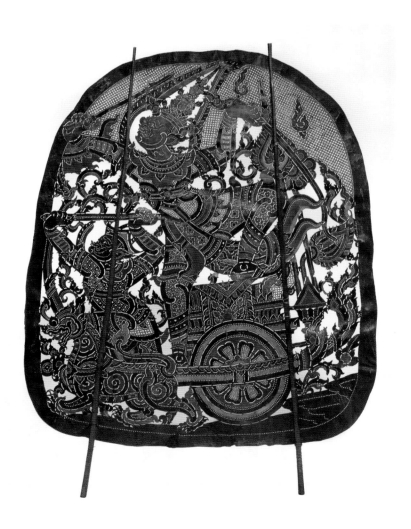

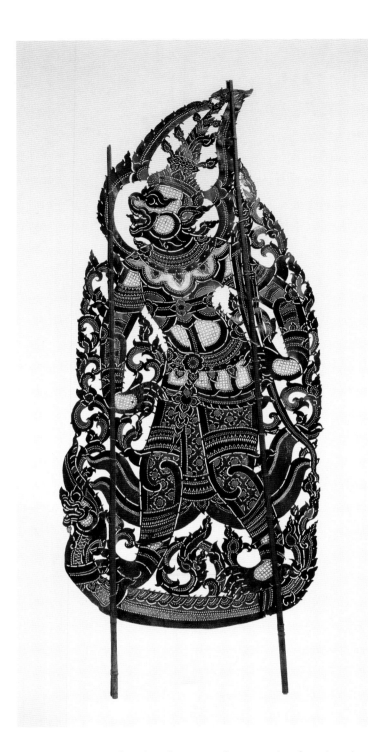

depicted alone and is portrayed only in profile. Here Rama's monkey ally Hanuman has tricked Ravana, the villainous ten-headed demon king of Lanka, into believing that he would like to switch sides and battle Rama.[3] Ravana rewards Hanuman by making him his heir and sends him into battle. Here Hanuman is dressed in a high crown and royal garb instead of his usual costume, a tiara and short trousers.

Another type of puppet, called the "action" or "fighting" puppet, shows at least two characters engaged in an activity such as charging into battle. Here each main character, Ravana (cat. no. 109) and Hanuman (cat. no. 111), stands on his war chariot being drawn by a mythical lion and is accompanied by a lieutenant. Since Ravana is king of Lanka, his chariot is ornamented with royal regalia such as the ceremonial fans at the rear (similar to the ceremonial standards cat. nos. 37–39). Ravana's ten heads are suggested here by the multiple heads piled in two tiers above his main head.[4]

The monkey lord Hanuman is dressed in full royal demon garb similar to that worn by Ravana, indicating that he is again in his feigned role as turncoat. His hand gestures indicate both thinking and battle action.

Shadow puppets of this type are difficult to date because few have documented histories.[5] Cat. no. 111 may be dated somewhat earlier than the other two because the cutting of its decoration and background is a bit freer and less uniform. P.C.

1 Two recent Thai books are important resources for the study of the large shadow puppets and their performances. Jarunee, Khwanchit, and Somchai, *Nang phra nakhon wai,* contains many splendid photos of fine shadow puppets. Chiraphon, *Liao na lae lang du nang yai,* though it focuses on the preservation of such puppets, also has interesting illustrations of performances.

2 Dhani, *Shadow Play (The Nang),* 11–12.

3 See Dhani, "Hide Figures of the Ramakien," 193–194 and no. 5316.

4 Apparently three heads are understood to be in back of the main head, and the second tier has another four heads. There is one at the top, making a total of nine. "It is possible that the tenth one is not given since it is not an auspicious number. Some say that this head is represented by the person wearing the mask, but that may well be a good joke"; Niyada and Sailer, *Illustrations from Thai Literature,* 116.

5 Several that were sent for exhibit at the United States Centennial Exposition in Philadelphia in 1876 are preserved in the collection of the Smithsonian's National Museum of Natural History; see McQuail, *Treasures of Two Nations,* 140–143. One of these ("Two demons in a chariot") is generally similar to cat. no. 109.

to bend and sway, at the same time keeping time with his foot movements. In between recitations there may be pauses for an action without words such as a march when the orchestra would strike up appropriate music and the manipulator would more or less adopt certain steps in consonance with it. He in fact practically dances, the hide figure often doing the mere duty of identifying his role."[2]

The single-character puppet of the monkey hero Hanuman seen here (cat. no. 110) is a type of puppet called the "roaming" or "walking" puppet, used to show the character traveling from one place to another. The character is always

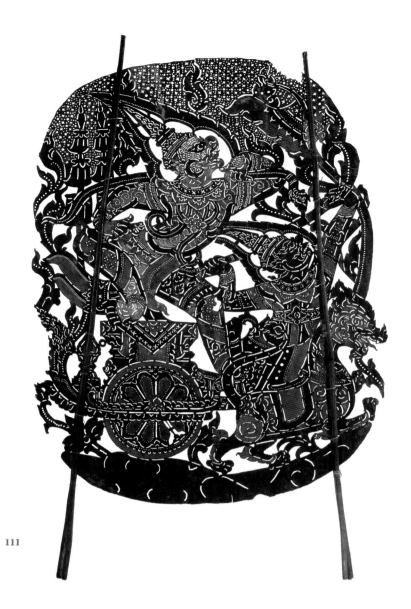

111

RIGHT Detail, cat. no. 111.

112 Mythical bird-man

Approx. 1775–1850
Central Thailand
Wood with remnants of lacquer,
gilding, and mirrored-glass inlay
H. 128.3 × W. 27.9 cm
Gift from Doris Duke Charitable Foundation's
Southeast Asian Art Collection, 2006.27.23

113 Mythical bird-man [FIG. 7]

Approx. 1775–1850
Central Thailand
Wood with remnants of lacquer,
gilding, and mirrored-glass inlay
H. 125. 7 × W. 29.8 cm
Gift from Doris Duke Charitable Foundation's
Southeast Asian Art Collection, 2006.27.24

114 Mythical bird-woman

Approx. 1930–1950
Thailand
Copper alloy with remnants of lacquer
H. 87.6 × W. 26.0 cm
The Avery Brundage Collection, B61B1+

115 Textile with alternating motifs of celestials and bird-women

Approx. 1750–1800
India; for the Thai market
Dyed cotton
H. 57.5 × W. 109.9 cm
Acquisition made possible by Mr. and
Mrs. David Bromwell, 2008.83

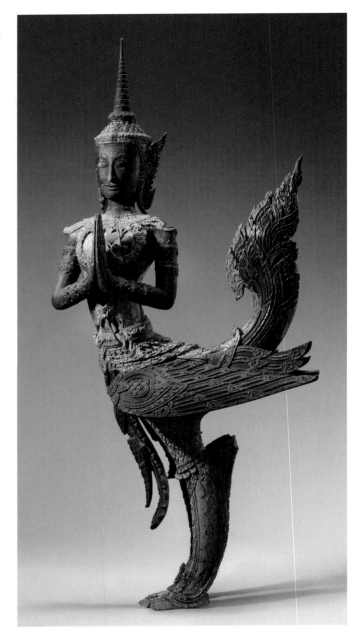

Mythical bird-men and -women are among the wondrous creatures that inhabit the Eden-like Himavanta Forest of Buddhist legend, and they are frequently depicted in Siamese sculptures, paintings, and other mediums. At the famous "Temple of the Emerald Buddha" in Bangkok, bird-men and -women appear among the large sculptures of Himavanta creatures that surround one of the major buildings.

Wooden figures of bird-men such as cat. nos. 112 and 113 were used in several sorts of royal ceremonies. One such statue is mentioned in the royal chronicles' description of the coronation of Rama IV in 1851, where it is said to have contained a relic of the Buddha. In 1865, the chronicles record, when the ritual of cutting the topknot of a royal prince was to be carried out, a huge and elaborate structure in the shape of

the legendary Mount Kailasha was erected, and among its decorations was a statue (or statues) of a bird-man again containing a relic of the Buddha.[1] Illustrated manuals of the 1830s depict statues of bird-men used in the processions for royal cremations, and the custom of using such figures in royal ceremonies most likely went back centuries.[2]

Such statues have rarely survived, and only a handful are known. One in the Bangkok National Museum, rather similar to these, has been attributed both to the last decades of the eighteenth century and to the reign of Rama III (1824–1851).[3]

Starting from around the reign of Rama V (reigned 1868–1910), statues of these mythical beings took on new functions and were placed high up on posts and lampposts along the main

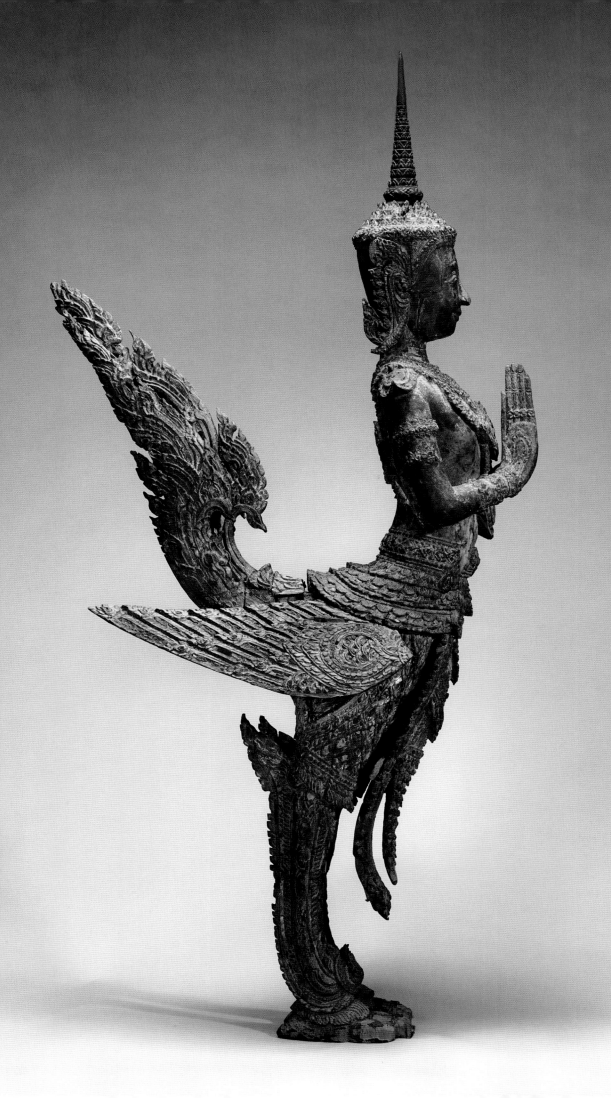

boulevards of Bangkok. This practice continues to the present day in many cities of Thailand. The most recent example is the main exit boulevard of Bangkok's new Suvarnabhumi Airport. It symbolizes the entrance to the capital city, part of the Thai name of which is sometimes translated as "City of Angels."

The bird-woman (cat. no. 114) is portrayed as a young woman wearing a beautiful crown and jewelry. The lower part of her body is similar to a bird's, with long, sharp toes and nails. Her large wings and tail enable her to fly between the human and heavenly realms. The most famous story involving a mythical bird-woman in Siam, "Manora," was derived from a Buddhist story of a previous life of the Buddha, the *Paññasa Jataka*. The lotus base and the upper part of the column indicate this figure's function as a decorative ornament for a post.

The wooden figure cat. no. 112 has been badly damaged. Its wings, part of its tail, and the spire of its crown were replaced at some point, presumably in the twentieth century. The fabrication and carving of the replaced pieces were done with great care. Cat. no. 113 also has had the spire of its crown replaced. P.C. AND F.McG.

1 Thiphakorawong, *Dynastic Chronicles, Bangkok Era, the Fourth Reign,* 8, 348.
2 See Boisselier, *Thai Painting,* 233–234; and Rosenfield, "The Mythical Animal Statues at the Prasat Phratheppha-bidon," fig. 12 and passim; also, Gerini, *Chulakantaman-gala,* 74.
3 *Sinlapawatthu krung rattanakosin,* 13; and Khana Kam-makan Chat Ngan Somphot Krung Rattanakosin 200 Pi. *Samutphap pratimakam krung rattanakosin/Sculptures of Rattanakosin,* 150. For other examples, see Naengnoi and Somchai, *Art of Thai Woodcarving,* 193; and Snong, *Outstanding Sculptures,* 150.

114

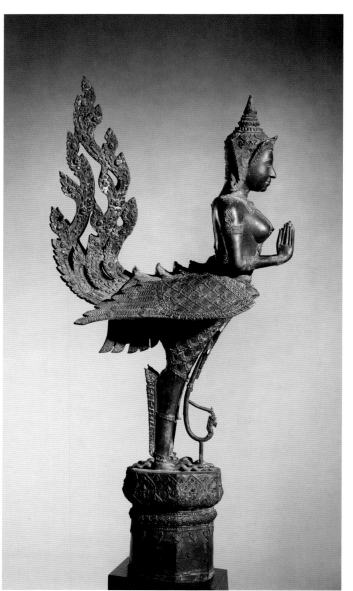

116 Mythical wild goose

Approx. 1850–1925
Thailand
Brass
H. 160.0 × W. 74.9 cm
Gift from Doris Duke Charitable Foundation's
Southeast Asian Art Collection, 2006.27.29

In many Hindu and Buddhist contexts the wild goose (seen here in a highly stylized form) is associated with soaring high above the earth and thus with detachment and spiritual attainment. In both northern and central Thailand a wooden or metal sculpture of the wild goose may be affixed to a tall pole in the precincts of a temple or palace.[1] In central Thailand, lines of poles topped with sculptures of wild geese such as this also have been used in the staging of elaborate royal funerals.[2] In recent times wild goose sculptures atop poles sometimes have been used as lights, with an electrified lamp suspended from the beak.

The hollow rod rising in the middle of this goose's back may have supported a tiered honorific parasol.[3] F.McG.

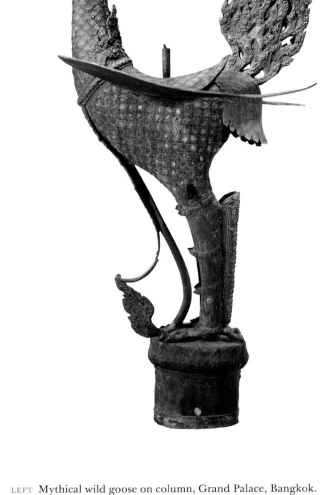

1 Naengnoi and Freeman, *Grand Palace,* 114; Stratton, *Buddhist Sculpture of Northern Thailand,* 357.
2 *Sinlapa satthapattayakam thai nai phramerumat,* 81.
3 Ibid.; and Patiphat, *Laithai phapthai,* 2:97.

LEFT Mythical wild goose on column, Grand Palace, Bangkok.
BELOW Mythical wild geese on columns as part of the decorations for a royal funeral, Bangkok, 1990s.

117 Footed bowl

1800–1900
Thailand
Lacquered bamboo with mother-of-pearl inlay
H. 9.5 × DIAM. 15.2 cm
Gift of Dr. Henry Ginsburg, 1999.6

118 Footed stand

Approx. 1800–1850
Thailand
Lacquered wood with mother-of-pearl inlay
H. 9.2 × W. 26.0 × D. 26.0 cm
Gift of Dr. Henry Ginsburg, 1999.7

Containers with mother-of-pearl inlay such as these are commonly used in Buddhist ceremonies (for example, in merit making, Buddhist Lent, and memorial services) to hold offerings

117

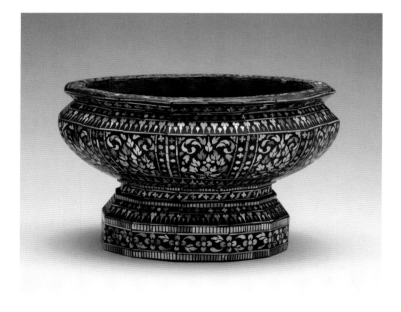

118

such as flowers, incense, candles, or betel-nut ingredients.

Footed bowls such as cat. no. 117 often function as vessels for food offerings to be presented to monks. The food is placed in small ceramic bowls, which are put inside the footed bowl. Footed bowls also hold flowers, candles, and incense. Typically, bowls come in a set of different sizes, which can be stacked when not in use.[1]

A footed stand such as cat. no. 118 generally serves as a tray for a tea set or for holding flowers, candles, or incense for monks. It also may be used in a betel set.

Mother-of-pearl inlay was used in Thailand as early as the ninth or tenth century, as is evidenced by fragments of stucco decorated with mother-of-pearl inlay recovered at a Dvaravati site. By the end of the eighteenth century the technique had reached a high degree of sophistication, as can be seen in lavishly decorated temple doors.[2]

During the early Bangkok period (1782–1824), mother-of-pearl inlay continued to be popular. High-ranking royal family members were appointed to oversee production in the "Department of Mother-of-Pearl Inlay." However, by the end of the nineteenth century, this art form started to lose favor as taste turned toward Western styles, and eventually the department was closed down in 1926.

Mother-of-pearl inlay can still be found on certain sorts of objects, such as musical instruments (cat. nos. 140 and 141) and implements for ceremonial use. P.C.

1 A footed bowl similar to this one, though larger and more elaborate, was sent to the United States as a gift from Rama IV in 1856; see McQuail, *Treasures of Two Nations,* 70. Another similar bowl is illustrated in Döhring, *Siam 2. Die bildende Kunst,* 109.
2 McGill, ed., *Kingdom of Siam,* 162–164; Wenk, *Perlmutter kunst,* passim.

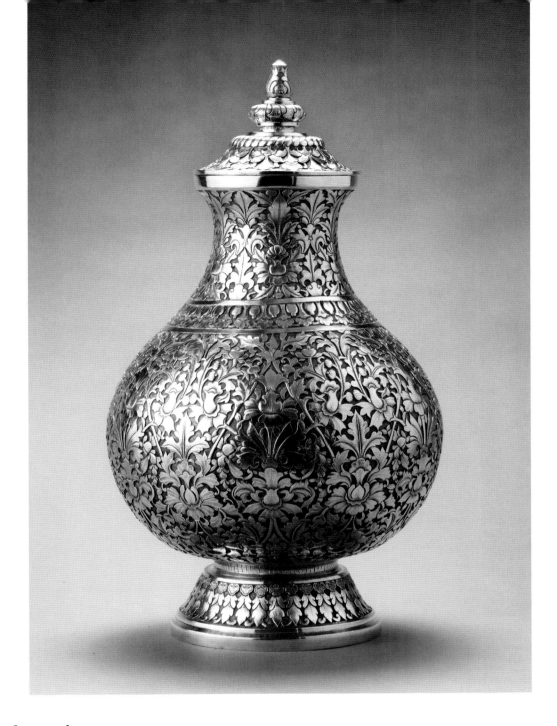

119 Lidded vessel [DETAIL P. 118]

Approx. 1850–1910
Thailand
Silver
H. 36.8 × DIAM. 19.0 cm
Gift from Doris Duke Charitable Foundation's
Southeast Asian Art Collection, 2006.27.103.A–B

This vessel was probably produced by a Chinese silversmith from among the "Shanghai craftsmen" who immigrated to Bangkok from Guangdong province to conduct business in high-quality silverware during the reign of Rama V.[1] On the bottom, it has two identical stamps of a Chinese hallmark that reads *huiyuan*, probably the name of the workshop.

A jar of this shape was commonly used as a container of water or lustral water (consecrated water). During a merit-making ceremony, the head monk blesses the water in the jar, drips some candle wax into the water, and then sprinkles the water onto the people who gather nearby. Typically, people keep lustral water in the shrine room or on a shelf along with Buddha images.

That this jar is made of silver signifies the high rank of its owner. P.C.

1 Songsri, ed., *Thai Minor Arts*, 18. See also Naengnoi, *Silverware in Thailand*.

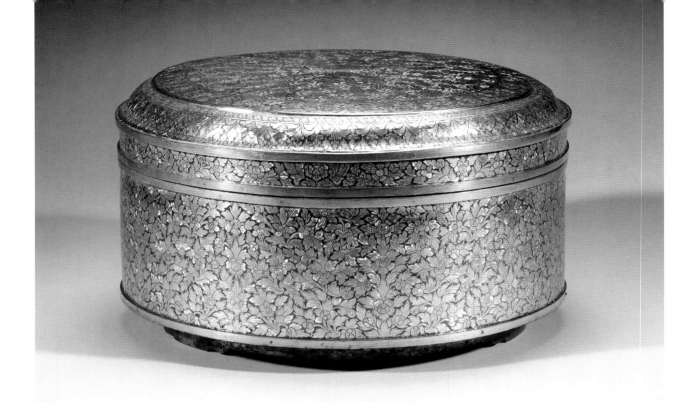

120 Round lidded box

Approx. 1850–1900
Thailand
Gilded silver with niello
H. 20.3 × DIAM. 36.8 cm
Gift from Doris Duke Charitable Foundation's
Southeast Asian Art Collection, 2006.27.104.A–B

This type of box was used to store foods such as dried sweetmeats. It is thought to have become popular among the royal family and nobility around the reign of Rama III (1824–1851).[1] The king gave nielloware containers to noblemen as symbols of rank.

Niello is a combination of sulfides of copper, lead, and, sometimes, silver. The exact proportions of the three can vary and give slightly different colors, but all are essentially dark gray or black. Copper and silver (if used) are melted together in a crucible, then lead is added. The molten combination is then placed in a bowl of powdered sulfur and mixed. The resulting mass is poured out on a metal or stone slab and flattened before it cools and hardens. Once cool, it is brittle and can be broken into small lumps for storage.

To use, some lumps are ground with a mortar and pestle to a fine sand, which is placed in depressions made (by casting, engraving, or chasing) in the metal object being decorated. The object is then heated until the niello powder melts, filling the depressions and adhering to the metal substrate. (Niello powder melts at a temperature far below the melting temperatures

of metal, so there is no danger of melting the object in the process.) The surface is then sanded, ground, or filed to produce a uniform surface and to remove any niello that did not stay in the depressions.

Here the underlying object is silver (about 90 percent silver and 7 percent copper, along with traces of other materials). The depressions that contain the niello were made by chasing and engraving. After the niello was melted in and the surface leveled, all the exposed silver on the outside of the box and the lid was mercury gilded.[2]

The making of silver niello in Siam may have a long history,[3] but few examples that can be confidently dated earlier than the nineteenth century are known. Even in the nineteenth century, pieces inscribed with dates or that have documented histories are rare. Several groups of gilded silver niello vessels were sent to the United States in 1856 and 1876 by Rama IV and Rama V.[4] This box is generally similar to these containers and is likely to date from approximately the same period. P.C.

1 Containers for commoners were made of brass with or without decoration. See Songsri, ed., *Thai Minor Arts*, 121.
2 The general information on niello technique and the results of the scientific testing of this piece were provided by Asian Art Museum conservators Katherine Holbrow and Mark Fenn.
3 Songsri, ed., *Thai Minor Arts*, 83–87. See also McQuail, *Treasures of Two Nations*, 53; and Naengnoi, *Silverware in Thailand*, 26–27.
4 McQuail, *Treasures of Two Nations*, 52–65.

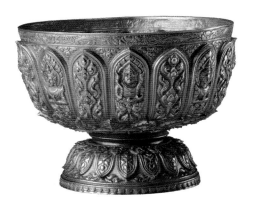

121 Bowl with garudas and celestials [FIG. 22]

1920–1921
Thailand
Gold
H. 9.2 × DIAM. 12.7 cm
Gift of the family of Helen King Gethman,
2008.91

This gold bowl was given in 1921 as a wedding present from Rama VI to the daughter of Hamilton King, a U.S. diplomat in Siam. The bowl was delivered by the Siamese ambassador to King's family in the United States.[1]

Bowls such as this one were made to contain religious objects, offerings, or valuables. In old Siam they were included as part of the insignia of royal family members and high officials. Produced in large and small sizes, they could be stacked when not in use. A gold bowl was a popular wedding gift from the royal family. Silver and brass were also used for producing receptacles given as decorations and gifts to lower-ranking officials.

Even to the present day, the royal palace in Bangkok has its own artisans. They are trained from generation to generation by masters of each technique to produce traditional royal objects. Among them are goldsmiths, silversmiths, mother-of-pearl inlay artists, and jewelers.

This bowl is decorated with three alternating motifs: a mythical eagle with human attributes (a garuda), stylized foliage, and a celestial being with the hand gesture of adoration.

The Siamese traditionally preferred objects of very pure (up to 100 percent) gold with a reddish color. This bowl has been analyzed in the conservation laboratory of the Asian Art Museum. Conservators Katherine Holbrow and Mark Fenn report:

> The composition of the bowl is an alloy of 71% gold, 24.5% silver, and 2.4% copper, with small quantities of manganese, nickel and cobalt. In western terms this would be considered a 17K "white gold" due to its low cop-

per content. The relatively low trace element content indicates that the gold was electrolytically refined. No measurable difference in composition was found between the red surface and the paler gold substrate. The red coloration is insoluble in polar or aromatic solvents and no metallic red pigments (e.g., iron oxide or mercuric sulfide) were found, so a paint, toned varnish, or other coating is unlikely.[2] P.C.

1 Several articles in the St. Petersburg (Florida) *Evening Independent* in February 1921 record the delivery of the royal gift.
2 The elemental composition of metal objects was determined using a Niton XL3t900 portable x-ray fluorescence spectrum analyzer with a silver anode, 50 kV voltage, 3–8 mm acquisition window, optional helium purge for light elements (Z = 12–16), and a thermoelectrically controlled Si-PIN diode detector with a resolution of 275 keV or less at full width of half maximum (FWHM) height of the peak at 5.9 keV (K-alpha for Mn). According to Dussubieux, instrumental accuracy continues to be evaluated, but error for many alloy metals has a standard deviation of approximately ± .1; Laure Dussubieux et al. "Non-destructive elemental analysis: reliability of a portable X-ray fluorescence spectrometer for museum applications." *14th triennial meeting, The Hague, 12–16 September 2005: preprints (ICOM Committee for Conservation).* Isabelle Verger, ed. Earthscan Ltd. (2005), 766–773.

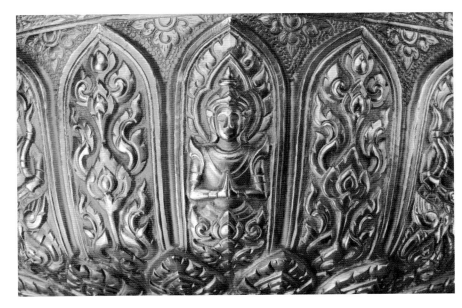

RIGHT Detail, cat. no. 121.

122–124 Three lidded containers from a betel set [FIG. 28]

> 1800–1900
> Central Thailand
> Silver and gold with gemstones and enamel
> H. 7.6 × DIAM. 5.1 cm each
> Gift from Doris Duke Charitable Foundation's
> Southeast Asian Art Collection, 2006.27.13.1–3

125 Lidded container

> 1800–1900
> Central Thailand
> Gold and gilded silver with niello
> H. 11.4 × DIAM. 5.7 cm
> Gift from Doris Duke Charitable Foundation's
> Southeast Asian Art Collection, 2006.27.14.A–B

Silver had a long history of use for royal regalia and religious objects in Siam. The Ayutthaya Chronicles mention that kings would grant insignias of rank made of gold or silver to their chief ministers. Included on the list of such objects are silver betel sets, trays, and containers. During the nineteenth century, silversmiths from China and Burma brought new shapes, techniques, and designs to create new royal silverware.[1]

Until recently Siamese people of all ranks were fond of chewing "betel nut"[2]—actually a mixture of areca nut (the seed of a particular tropical palm), the leaf of the betel plant (a tropical vine in the pepper family that produces no nuts), and other ingredients. The addictive habit required owning a betel set, which typically consisted of three round, small, lidded containers used for broken and cut nuts, a lidded cylindrical jar for lime paste, a small bowl, a receptacle for the betel leaves, and a tray on which to place these containers.[3] Sets varied in value according to the position and wealth of the owners: the higher the rank of the owner, the more elaborate the set. Gold sets decorated with gems or colored glass were reserved for the highest-ranking royal family members, such as the deputy king. Silver containers such as cat. nos. 122–124 would have belonged to chief ministers of state. Sets for ordinary people were made of brass or terra cotta.

Betel sets were brought out to welcome guests or promote friendship. They were included among wedding gifts from the groom's family.

During the latter part of the nineteenth century, betel shops became popular in Bangkok. Customers could purchase fresh rolls of betel preparation, which were made of betel leaves cut and folded into triangles filled with a paste of areca nut mixed with lime and turmeric.[4]

Traditionally, a high-ranking man was accompanied by a servant who carried his betel set. Judging by the decoration of colored-glass inlay on the lids and the high level of craftsmanship, the three silver-lidded containers and the cylindrical lidded container on display in this exhibition would have belonged to a high-ranking official or a minor member of the royal family. P.C.

1 During the reign of King Chulalongkorn (Rama V), approximately thirty silversmith families immigrated to Bangkok from Guangdong in China; they later became known as the "Shanghai craftsmen." Burmese silversmiths were brought from Thaton to work for the royal household in Bangkok. Later they migrated to Chiang Mai, where they continued their silverware work. For further information, see Songsri, ed., *Thai Minor Arts,* 14–19.

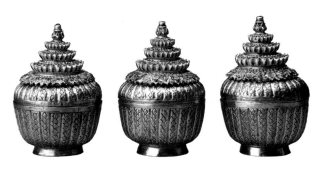

122–124

2 During the era of Field Marshal Phibunsongkhram (in his
 first period as prime minister, 1938–1944), chewing betel
 was prohibited. According to David Wyatt, between 1939
 and 1942 Phibunsongkhram encouraged people "to live
 their lives along modern lines, to eat and sleep appropri-
 ately, and to engage in a full day of productive labor for
 the good of the country." He reformed the dress code to
 follow modern fashion and banned various activities that
 he considered not part of "a new Thai identity"; Wyatt,
 Thailand: A Short History, 255.

3 Some sets have more containers, depending on the rank of
 the owner. Sometimes turmeric or tobacco was added to
 the paste. A spittoon was also necessary because chewers
 would have to spit out their saliva. The paste would red-
 den teeth.

4 For an interesting Western account describing betel use,
 see Sommerville, *Siam on the Meinam,* 40–43.

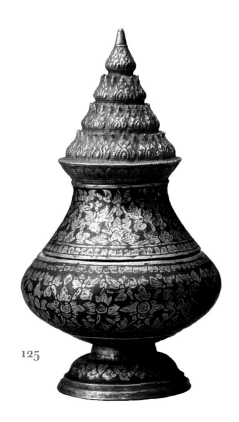

125

126 Jar with gold lid

Approx. 1775–1875
China; for the Thai market. Lid: Thailand
Porcelain with overglaze enamel decoration;
lid: gold with gemstones
H. 7.6 × DIAM. 5.7 cm
Gift of Warren Faus, Marvin Gordon, and Forrest
Mortimer, 1995.44.A–B

This small jar with a gold-covered lid prob-
ably was part of a cosmetic set for a court lady.
Typically, such sets consisted of four or five
similarly sized jars. Here the jar, made in China
for the Thai market, is decorated with traditional
Siamese floral and leafy motifs (see cat. nos.
132–135). Its lid is made of a thin sheet of gold
(or gold alloy) with settings for small gemstones.
The common colored stone used is ruby. P.C.

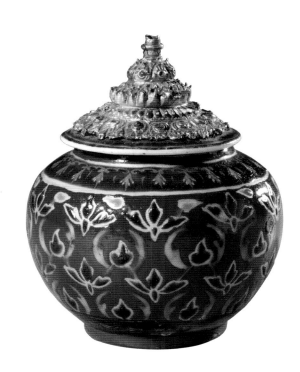

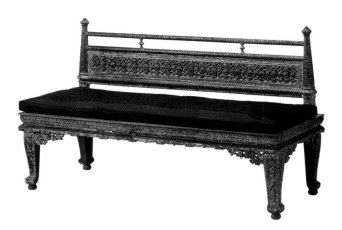

127 Bench [FIG. 32]

1800–1925
Central Thailand
Lacquered and gilded wood with glass
inlay and pigments
H. 88.9 × W. 144.8 × D. 59.7 cm
Gift from Doris Duke Charitable Foundation's
Southeast Asian Art Collection, 2006.27.49

In the old days the houses of Siamese aristocrats, like those of ordinary people, had relatively little furniture. In the mid nineteenth century, however, as Western customs became more familiar (and seemed modern and fashionable) and the availability of both Western-style and Chinese furniture increased, so did the use of tables, chairs, settees, and beds in the homes of those who could afford them.

This elaborately ornamented bench—neither very comfortable nor very sturdy—must have been intended primarily for show. Oddly, its back and seat seem not to have been made together. The design and crafting of the backrest are refined, its frame inlaid with carefully fitted mirror mosaic and the enframed panel decorated on the front with a pattern of eight-pointed medallions (or flowers) amid leafy vines painstak-

ingly carved in pierced relief and on the back with exactly the same pattern in painting.

The bench itself is of notably less precise artisanship and seems to have been made to accommodate a handsome backrest that originally had another purpose and context. (The design of the matching table, cat. no. 128, resembles that of the bench itself rather than the backrest.) Another unexpected feature is that one of the wide planks forming the seat was also repurposed. On its underside can be seen, carved in sunken relief, parts of several Chinese characters and letters of the Roman alphabet: the plank came from a shop sign.

Several rather similar benches are known, including one in the National Museum, Bangkok.[1]

F. McG.

1 Naengnoi and Somchai, *Art of Thai Wood Carving*, 188–189; the back is quite similar, but not the seat.

BELOW Detail, cat. no. 127.

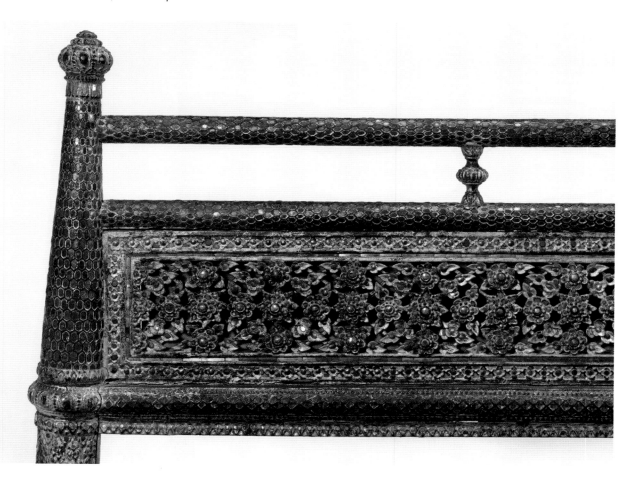

128 Table

Approx. 1850–1925
Central Thailand
Lacquer, pigmented natural resin, and gilding on
wood with mirrored glass
H. 88.5 × W. 181.0 × D. 94.0 cm
Gift from Doris Duke Charitable
Foundation's Southeast Asian Art
Collection, 2006.27.50

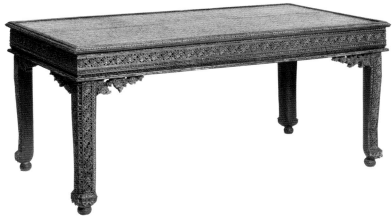

This table appears to have been part of a
set that includes cat. no. 127 and, like it,
must have been more for display than for
function. Unless a sheet of glass covered
the top, decorated with inset pieces of
mirror and far from flat, the table's sur-
face would not have been convenient for
most uses. F.McG.

129 Mirror on stand [FIG. 29]

Approx. 1850–1900
Central Thailand
Lacquered and gilded wood with mirrored glass
H. 86.4 × W. 49.5 × D. 49.5 cm
Gift from Doris Duke Charitable Foundation's
Southeast Asian Art Collection, 2006.27.52

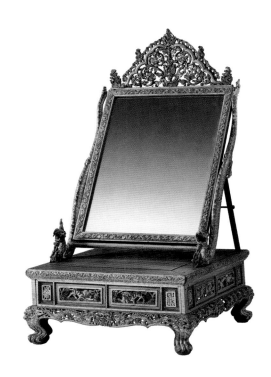

The bedchamber of a royal or high-ranking
noblewoman would contain a carved wooden
bed, a dressing table, and accessories. A mirror
stand was placed on the low dressing table, which
was in turn placed on a wide, rectangular wooden
platform, decorated with carved floral patterns.
Siamese people customarily sat on the floor; the
noblewoman would sit on the platform as though
on the floor. Furniture commissioned for aris-
tocratic homes was mainly inspired by Chinese
models but was made in Siam. Mirrors were
generally decorated with floral and vegetal motifs
such as lotuses, peonies, or a vase of flowers
(which symbolized wealth). Here two elongated
bodies of mythical serpents stretch along the
sides of the mirror.[1] P.C.

1 Mirrors of this general type can be seen in Naengnoi and
Somchai, *Art of Thai Wood Carving*, 186; and *Khrueangruean
rattanakosin*, 141.

130, DETAIL

131, DETAIL

130 Textile with alternating roundels and eight-pointed motifs for the Siamese market

Approx. 1700–1800
India; for the Thai market
Dyed cotton with painted gold
L. 245.2 × w. 120.6 cm
Gift of Mr. and Mrs. M. Glenn Vinson, Jr., 1988.46

131 Textile [FIG. 34]

Approx. 1775–1875
India; for the Thai market
Dyed cotton
L. 289.5 × w. 95.8 cm
Gift of Mr. and Mrs. M. Glenn Vinson, Jr., and anonymous donor, 1989.15

Indian textiles were imported to Siam from at least the seventeenth century. The finest were reserved for the court—for wearing, for decorating palaces and temples, and for use as royal gifts.[1] Specific types of cloths were restricted to particular classes of courtiers, court officials, and visiting ambassadors and envoys.[2]

The most popular textiles were made of silk and printed cotton with Siamese designs. Patterns were sent to India for production, with different grades of cotton specified for various uses and expense levels. The motifs used on the cloths are similar to those depicted on other decorative arts such as lacquerware, mother-of-pearl-inlay containers and cabinets, paintings, and enameled ceramic wares made in China for the Siamese market. Among the popular designs are flame-like motifs, floral and vegetation motifs, celestial beings with their hands held together in the gesture of respect, and mythical animals such as a half-bird-half-man or -woman (cat. no. 115).

The technique employed for fine early textiles of this sort was resist-drawn painting on cotton. Painters used a metal tool to apply fine trails of wax, which caused that part of the cloth to resist the dyes. Later, for less expensive cloths, block printing was used.

Cloths such as cat. no. 130 functioned as wall hangings, curtains, room partitions, throne and platform covers, and floor covers. Mural paintings and illustrated manuscripts depicting such interior decorations provide evidence of this use.[3] While many of the motifs on this cloth seem typically Siamese, some, such as the chains of loops alternating with quatrefoils that encircle the medallions, must ultimately be related to eighteenth-century European designs.[4]

An average cloth for wearing measured about 1.4 meters in width and 2.6 meters in length and was used for both male and female costumes. The skirt cloth has a dominant center field, narrow longitudinal borders, and elaborate end borders, as seen in cat. no. 131. The typical colors were red, yellow, black, and green. Men and women tied skirt cloths differently. When worn by a man, the cloth was arranged similarly to an Indian dhoti, with the excess in front pulled between the legs and tucked in at the back. A woman wore it like a skirt with the ends tied at the waist and a belt securing it, or sometimes with the excess in front pleated and secured with a belt.

Sometimes imported skirt-length cloths similar in design to cat. no. 131 had elaborate religious works painted on them; cat. no. 68 is one example.

P.C.

1 Guy, *Woven Cargoes,* 126.
2 Ibid., 126–127.
3 This textile has been published several times, as in Gittinger and Lefferts, *Textiles and the Tai Experience,* 156.
4 Robyn Maxwell notes in relation to similar cloths that "although many of the designs are now thought of as Thai, they are the eventual result of a long and complex interplay between Indian and Thai textile patterns and design structures"; *Textiles of Southeast Asia,* 208. In fact, the situation is even more complicated; patterns and designs from Europe, Persia, and China no doubt had an impact.

132 Lidded jar with mythological figures

Perhaps 1775–1825
China; for the Thai market
Porcelain with overglaze enamel decoration
H. 23.5 × DIAM. 18.4 cm
Gift from Doris Duke Charitable Foundation's
Southeast Asian Art Collection, 2006.27.89.A–B

133 Lidded jar with mythological figures

Perhaps 1775–1825
China; for the Thai market
Porcelain with overglaze enamel decoration
H. 20.3 × DIAM. 18.4 cm
Gift from Doris Duke Charitable Foundation's
Southeast Asian Art Collection, 2006.27.90.A–B

134 Jar with tiered lid

Approx. 1775–1875
China; for the Thai market
Porcelain with overglaze enamel decoration
and gold
H. 15.9 × DIAM. 12.1 cm
Gift from Doris Duke Charitable Foundation's
Southeast Asian Art Collection, 2006.27.92.A–B

The differences in shapes and sizes of these three covered jars indicate their functions.

Ceramics of this type are known as *bencharong* (Sanskrit: *pancharanga*), which means "five-colored." Such pieces are thought to have been made in Jingdezhen, China, at first exclusively for the Siamese royal household from around the end of the Ayutthaya period.[1] Prince Damrong states that initially the designs and decorative motifs were developed in Siam. Officials were sent along with the samples to oversee production. Later, merchants imitated these wares for the Siamese market, but the design motifs were not as carefully executed and the decorations included both Chinese and Siamese motifs.

Bencharong porcelain pieces were painted with overglazed enamel in three or more colors and received several firings. The main background colors are dark red and dark blue. Green highlights the bases and lids, and the motifs are embellished in yellow. Around the end of the eighteenth century, a gold overglaze known as *lai nam thong* seems to have become more fashionable than the red and blue background.

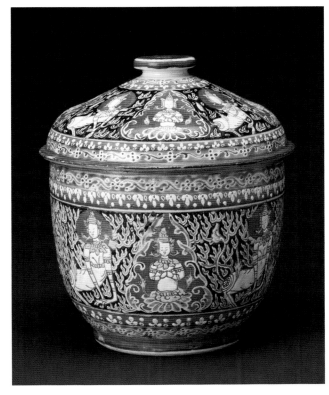

132

Traditionally, meals for royals and nobles are served from large containers on stands. Each person has a tray with individual dishes for rice, chili paste, vegetables, and meat or fish. Dessert is served later on a separate tray, and drinks are served on other trays.[2]

The two larger melon-shaped covered jars (cat. nos. 132 and 133) were used for serving food and condiments. The lid for such a jar generally has a flat handle so that when it is removed and laid upside down, it can stand by itself and not become dirty. The bowls are adorned with two popular motifs alternating against a black back-

BELOW Top view, cat. no. 132.

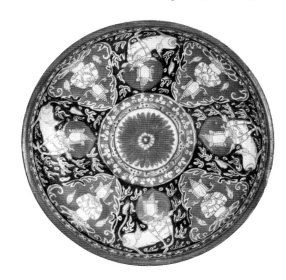

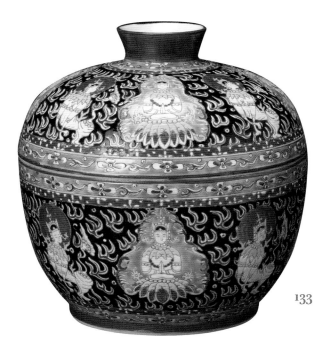

133

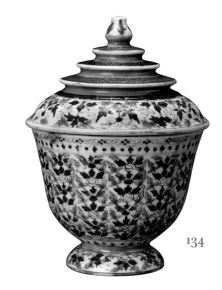

134

ground: a male celestial being with hands folded in a gesture of worship and a half-lion-half-man. Flame-like motifs surround the figures. The pink and light blue may indicate that the pieces were produced during the early Bangkok period.

The urn-shaped jar (cat. no. 134) was used for serving soup or syrup (several types of Siamese desserts require adding sweetness to the coconut sauce base). The twisting stem floral and leafy motifs are outlined with black and filled with color on a white background similar to a style

sometimes thought to have been popular during the reign of Rama I. The date of this piece remains uncertain, however. P.C.

1 Broken shards of *bencharong* ware were found at an excavation of an ancient site in Ayutthaya; Damrong, "Tamnan rueang khrueang to lae thuay pan," 233.
2 Commoners sit in a circle on the floor and take food from large bowls. Each person has his or her own rice bowl.

135 Teapot [FIG. 12]

> Approx. 1775–1825
> China; for the Thai market
> Porcelain with overglaze enamel decoration;
> handle: copper alloy
> H. 29.2 × W. 25.4 cm
> Gift from Doris Duke Charitable Foundation's
> Southeast Asian Art Collection, 2006.27.91.A–B

136 Teapot

> Approx. 1825–1900
> China; for the Thai market
> Porcelain with overglaze enamel decoration and
> gold; handle: wood and metal
> H. 39.4 × W. 31.1 cm
> Gift from Doris Duke Charitable Foundation's
> Southeast Asian Art Collection, 2006.27.97.A–B

Tea drinking was popular among all levels of society in Siam. Teapots were made in China and Siam in a variety of sizes, shapes, and materials. A traditional tea set consists of a teapot; one to four small teacups; and a round or oval-shaped tray made of gold, silver, or brass. Large teapots

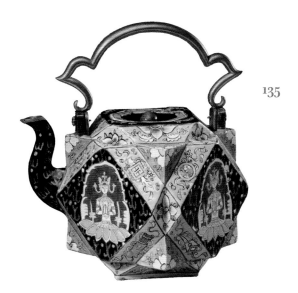

135

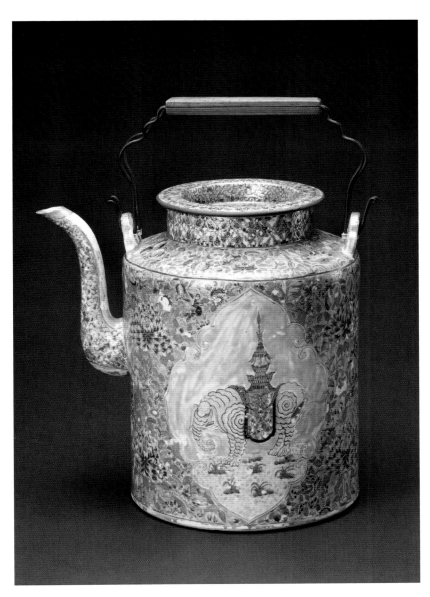

136

such as cat. no. 136 were favored as pious gifts to temples, where they could be used to serve tea to groups of monks. Western teacups and saucers did not come into popular use until the latter part of the nineteenth century.

Five-colored-ware teapots such as cat. no. 135 were made in China for the Siamese market and were decorated with Siamese designs that must have originally come in drawings or pattern books. On this teapot the traditional Siamese figure of a half-length celestial being in a worshipful position is surrounded with auspicious Chinese motifs such as fans, rhinoceros horns, and coins. The elaborately faceted shape of this teapot is unusual, and only a small number of other examples have been published.[1]

"Gold-washed" ware such as cat. no. 136 was also made in China for the Siamese market. Like five-colored ware, it became popular among royalty and the nobility and is thought to have had a special vogue during the reign of

Rama II (1824–1851). Chinese motifs were more often used on the gold-washed ware than were Siamese motifs, which were preferred on the five-colored ware. The white elephant motif seen on this teapot is rare; only a small number of teapots with this motif are known.[2] The elephant carries a doubled-tiered container (which resembles cat. no. 103)[3] that holds a Chinese artist's version of a Thai royal crown similar to cat. no. 106.[4] In Siam, the white elephant symbolized the power of the king and was considered an auspicious symbol of the kingdom.

Several similar teapots with the white elephant and crown motif have been found in Cambodia. One possibility is that they were made on order for the Cambodian royal court (for whom the white elephant and crown would have had the same significance as in Siam). Another possibility is that they were ordered by Rama IV (reigned 1851–1868) or Rama V (reigned 1868–1910) and sent as gifts to monasteries in Cambodia. The

crown was the central motif on the Siamese royal seal in Rama IV's time,[5] and on coins of both reigns. Rama IV was a religious reformer, and during his many years as an abbot (before his accession to the throne) he established a new order of monks, the Thammayut (Pali: *dhamma-yutika,* "those adhering to the doctrine"). Several teapots of this type are in the collections of Thammayut order temples in Thailand;[6] perhaps they were donated by Rama IV or Rama V, who also might have sent similar teapots as gifts to Thammayut order temples in Cambodia.[7]

The other surfaces of this teapot are decorated with blue and red flowers, butterflies, and an arrangement of green tendrils that outline the medallion around the elephant. The only Siamese motif included in the decoration is the "trellis-and-rice-ball pattern" that embellishes the neck. These motifs were popular on ceramic wares of the first half of the nineteenth century.[8]

By the reign of Rama V (1868–1910), five-colored ware and gold-washed ware largely

went out of fashion for teapots. Blue and white porcelain teapots and small unglazed clay teapots (Chinese: *Yixing*) from China grew in popularity. Yixing pots were often referred to by nicknames that were derived from their shape, such as star fruit, rose apple, and olive. The aristocratic fascination with teapots was so great that in the 1870s and 1880s Rama V organized teapot exhibitions and competitions, with prizes for the winners, at the Concordia Hall in the Grand Palace.[9]

P.C. AND F.McG.

1 *Khrueangthuai wat pho,* fig. 125.
2 We are grateful for Dr. Dawn F. Rooney's advice on this particular type of teapot. So far she has come across fewer than ten of them in different collections. Some scholars have suggested that they may have been produced for the royal Cambodian market. These matters will be discussed by Dr. Rooney in her forthcoming book, *Bencharong: Royal Thai Porcelain.*
3 For Chinese depictions of elephants carrying a variety of auspicious objects, see Bartholomew, *Hidden Meanings,* 113, 237–238.
4 The crown on a double-tiered container carried on the back of a (three-headed) elephant appears on the lid of a mother-of-pearl-inlaid monk's alms bowl sent for exhibit in the United States by Rama V in 1876; McQuail, *Treasures of Two Nations,* 74–75. Natalie Robinson mentions that "elephants with howdahs carrying the Sacred Jewel of Buddhism" (presumably a misinterpretation of the royal crown motif) are depicted on Chinese five-colored wares found in Cambodia; Robinson, *Sino-Thai Ceramics,* 36.
5 See, for example, McQuail, *Treasures of Two Nations,* 51.
6 A published example is in the collection of Wat Ratchabophit in Bangkok; *Sinlapakam wat ratchabophitsathitmahasimaram,* 147. Wat Ratchabophit is a Thammayut monastery established by Rama V.
7 The Thammayut order was established in Cambodia, in part on Siamese example, in about 1855. The previous year Rama IV sent to Cambodia a delegation of Thammayut monks, who took as a gift a large number of Buddhist sacred texts; see Harris, *Cambodian Buddhism,* 105–106.
8 Personal communication with Dawn Rooney.
9 These competitions seem to have been exciting events among the royal family and aristocrats. After the first, large quantities of tea sets were ordered from China with new motifs and designs. The second competition in 1887 included both teapots and teacups. On the beginnings of museums in Siam under Rama V, see Sirin and Somlak, *Phrabat somdet phra chunlachomklao chaoyuhua kap kanphiphitthaphan,* 34–37 (in English).

137 Teapot with the monogram of Rama V (Chulalongkorn) [FIG. 33]

1888
China; for the Thai market
Blue and white porcelain; handle: copper alloy
H. 21.6 × W. 19.0 cm
Gift from Doris Duke Charitable Foundation's
Southeast Asian Art Collection, 2006.27.98.A–B

137

138 Lidded bottle with monogram of Rama V (Chulalongkorn)

1888
China; for the Thai market
Blue and white porcelain
H. 31.7 × DIAM. 14.0 cm
Gift from Doris Duke Charitable Foundation's
Southeast Asian Art Collection, 2006.27.99.A–B

139 Lidded bottle with monogram of Rama V (Chulalongkorn)

1888
China; for the Thai market
Blue and white porcelain
H. 31.7 × DIAM. 14.0 cm
Gift from Doris Duke Charitable Foundation's
Southeast Asian Art Collection, 2006.27.100.A–B

Rama V (King Chulalongkorn, reigned 1868–1910) was very fond of Chinese ceramics. He commissioned several types from the kilns of Jingdezhen as gifts to high-ranking monks and members of the royal family and sent an artist to oversee the production. One type of ceramic tea set that he commissioned is popularly known as "The Monogram of Rama V Set."[1] The king ordered a large number of sets as souvenirs in commemoration of the cremation of Prince Siriraj Kakuthaphan in 1888.[2] (This type is not included in the exhibition).

Another monogrammed tea set was commissioned by two wealthy Chinese merchants who

RIGHT Front and back of a coin similar to that shown on cat. no. 137, Asian Art Museum.

138

139

served the court. The king permitted use of the design from his monogrammed set, but the Chinese characters at the bottom are different. The four characters indicate the period of production and the workshop's name: *jintangfa*. *Jin* is the period date, and *tangfa* is a name that can be translated as "Brocaded Hall with Wealth." The three monogrammed pieces in this exhibition display these characters. These ceramics were also made in Jingdezhen. They became very popular and were sold to upper-class people in Bangkok.

The main motif of the monogrammed pieces in the exhibition is three stylized letters of the Thai alphabet that the king used as his initials, which were made to resemble Chinese characters. Two types of the stylized initials can be seen on the two lidded bottles. Sometimes the letters are surrounded with various auspicious symbols such as the "Buddha's hand," a nickname for the citron (a fragrant citrus fruit called *foshou* in Chinese); bats; pomegranates; and peaches, as are depicted on cat. no. 139. These motifs represent blessings, good luck (for example, a wish to have many sons), and longevity.[3]

Another type of motif, seen on the teapot cat. no. 137, depicts a coin issued in 1874. One side of the coin bears the Thai date,[4] and the other side shows the king's monogram in stylized Thai letters. The coin motif is surmounted by a bat (Chinese: *fu*), which symbolizes good luck.

During the reign of Rama V, tea set ceramic competitions were held in the 1870s and the 1880s at the museum in the Grand Palace. Nobles put their best tea sets on display, including the monogrammed type.[5] P.C.

1 Prince Damrong called the monogram set the "monogram of the honored name set"; Damrong, "Tamnan rueang khrueang to lae thuai pan," 251.
2 Prince Siriraj, the son of King Chulalongkorn and Queen Saovabha, died at the age of three on May 3, 1887; Sanur Niladej, "Objects of Art," 13.
3 He Li, associate curator of Chinese Art, the Asian Art Museum of San Francisco, personal communication. According to He Li, the name "Buddha's hand" comes from the shape of the citron's fruit. The first character, *fo*, has a sound similar to the word for "blessing," and the second character, *shou*, is a pun for "longevity."
4 The date on the coin is 1236 in the chunlasakkarat system, to which 638 is added for conversion to CE.
5 Damrong, "Tamnan rueang khrueang to lae thuai pan," 248.

140 Stringed instrument
(*so sam sai*) and bow

Approx. 1950–1960
Thailand
Wood and coconut shell with ivory and
mother-of-pearl inlay, rawhide, horsehair,
copper alloy, and textile
L. 105.4 × W. 25.4 cm
Gift from Doris Duke Charitable Foundation's
Southeast Asian Art Collection, 2006.27.101.A–B

141 Two-stringed instrument
(*so u*) and bow [FIG. 41]

Approx. 1950–1960
Thailand
Ivory, coconut shell, and lacquered wood with
mother-of-pearl inlay, rawhide, and horsehair
L. 76.2 × W. 16.5 cm
Gift from Doris Duke Charitable Foundation's
Southeast Asian Art Collection, 2006.27.102.A–B

These two instruments are used in Thai classical
orchestras, which include other string instru-
ments as well as percussion and wind instru-
ments. For a larger orchestra, other instruments
are added, such as flute-like instruments in sev-
eral sizes and ranges, a drum, and, occasionally,
a small Chinese hammered dulcimer. The string
ensemble is primarily used for indoor instru-
mental performances. A string orchestra often
accompanies Thai rod-puppet theater.

Both instruments are beautifully decorated
with traditional mother-of-pearl inlay and designs
similar to those of the older pieces (cat. nos. 117
and 118) in the exhibition.[1] P.C.

1 A Thai specialist has commented that the coconut shell
 used for this *so u* is not the type that was used tradition-
 ally. Moreover, the body of the *so sam sai* is disproportion-
 ate, and its black color is not traditional. The decorative
 ornaments suggest that both instruments were newly
 made when they were acquired in approximately the
 1950s. Personal communication with Dr. Prapod Assava-
 virulhakarn, Dean of the Faculty of Arts, Chulalongkorn
 University (Bangkok).

140

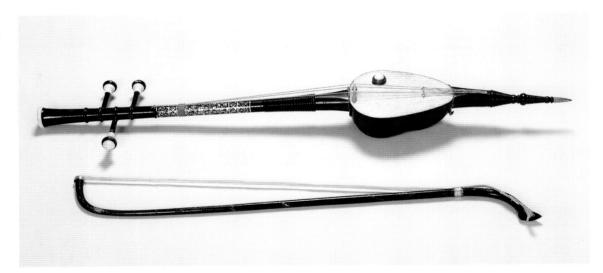

141

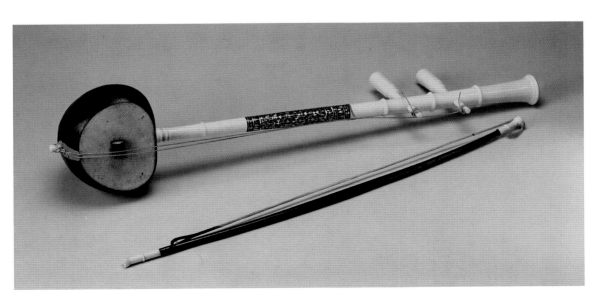

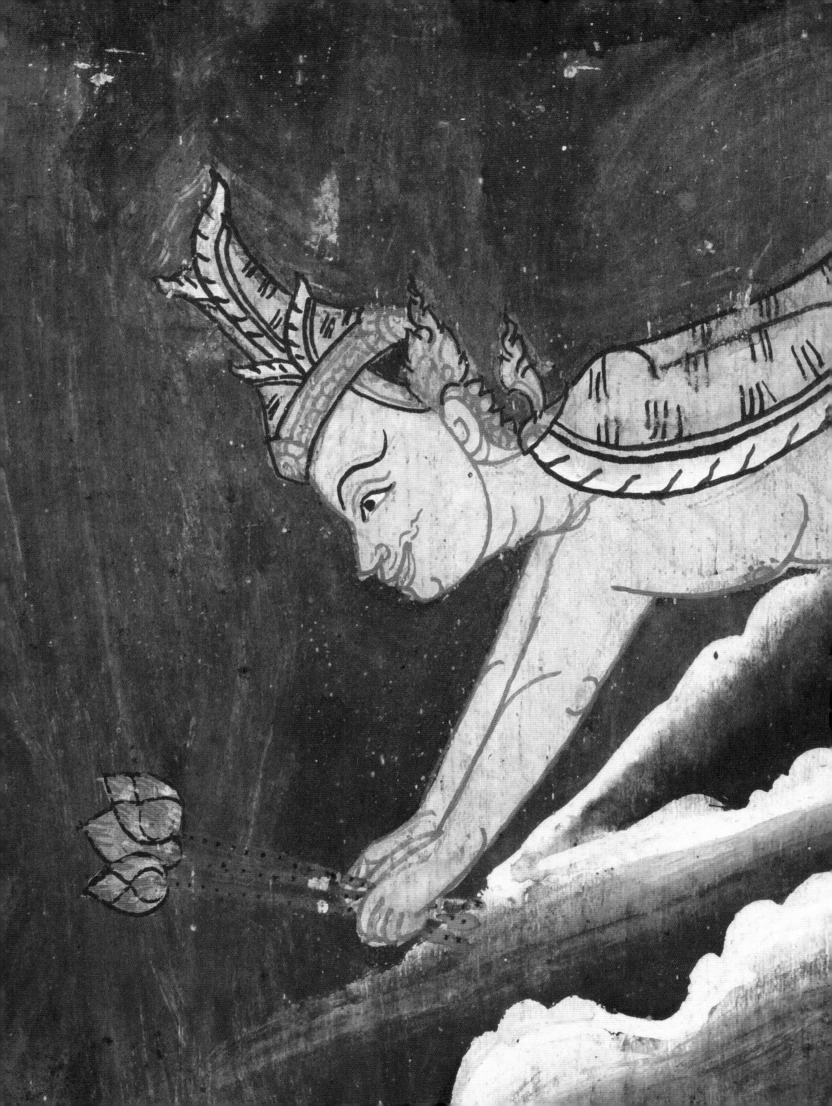

BIBLIOGRAPHY

NOTE: Following Thai and Burmese custom, Thai and Burmese authors are listed by first name. These names are spelled in the Roman alphabet as the authors spell them, if known. Otherwise, they are romanized following the system used elsewhere in this book.

Abbott, Gerry. *The Traveller's History of Burma*. Bangkok: Orchid Press, 1998.

Abha Bhamorabutr. *The History of Bangkok: Summary of Political and Cultural Events from the Age of Establishment to the Present*. [Bangkok?]: P. Chungcharoen, 1982.

Alabaster, Henry. *The Wheel of the Law: Buddhism, Illustrated from Siamese Sources by the Modern Buddhist, A Life of Buddha, and An Account of the Phrabat*. 1871. Reprint, Whitefish, MT: Kessinger, n.d.

Alatas, Farid, Srilata Ravi, Mario Rutten, and Beng-Lan Goh, eds. *Asia in Europe, Europe in Asia*. IIAS/ISEAS Series on Asia. Leiden, the Netherlands: International Institute for Asian Studies, 2004.

Allan, Nigel, ed. *Pearls of the Orient: Asian Treasures from the Wellcome Library*. London: Serindia Publications, 2003.

Amphai Khamtho and Kongkaeo Wiraprachak. *Traiphum chabap phasa khamen*. Bangkok: National Library, 1987.

Anek Nawikamun. *Kantaengkai samai rattanakosin*. Bangkok: Muang Boran, 1982.

Anuman Rajadhon, Phya. *Thet Maha Chat*. Thai Culture, New Series, no. 21. Bangkok: Fine Arts Department, 1969.

Apinan Poshyananda. *Modern Art in Thailand: Nineteenth and Twentieth Centuries*. Singapore: Oxford University Press, 1992.

Aung Thaw, U. *Historical Sites in Burma*. 1st ed. [Rangoon?]: Ministry of Union Culture, Government of the Union of Burma, 1972.

Aung-Thwin, Michael. "The British 'Pacification' of Burma: Order Without Meaning." *Journal of Southeast Asian Studies* 16, no. 2 (September 1985): 245–261.

Ba Han. "The Evolution of Burmese Dramatic Performances and Festal Occasions." *Journal of the Burma Research Society* 49, no. 1 (June 1966): 1–18.

Bailey, Jane T. "On the Evolution of the Buddha Image with Two Adorants in India and Burma." *Mitteilungen aus dem Museum für Völkerkunde Hamburg*, N. F. 1 (1971): 119–140.

———. "Some Burmese Paintings of the Seventeenth Century and Later, Part 2: The Return to Pagan." *Artibus Asiae* 33, no. 3 (1971): 219–227.

Baker, Chris, and Pasuk Phongpaichit. *A History of Thailand*. New York: Cambridge University Press, 2005.

———. "Phlai Kaeo Ordains as a Novice: A Chapter from *Khun Chang Khun Phaen*." *Journal of Siam Society* 95 (2007): 85–110.

Bareau, André. *Recherches sur la biographie du Buddha dans les Sutrapitaka et les Vinayapitaka anciens*, vols. 1 & 2. Paris: École française d'Extrême-Orient, 1963.

Barretto, W. L. *King Mindon (Amya Pyi Thu Chit Kyi Byu Daw Min)*. Rangoon: New Light of Burma Press, 1935.

Bartholomew, Terese Tse. *Hidden Meanings in Chinese Art*. San Francisco: Asian Art Museum of San Francisco, 2006.

Bautze, Joachim K. "Uncredited Photographs of India and Burma by F. Beato." *Indo-Asiatische Zeitschrift* 9 (2005): 68–78.

Bautze-Picron, Claudine, and J. Bautze. *The Buddhist Murals of Pagan: Timeless Vistas of the Cosmos.* Trumbull, CT: Weatherhill, 2003.

Bell, E. N. *A Monograph on Iron and Steel Work in Burma.* Rangoon: Government Printing, 1907.

Bigandet, P. *The Life or Legend of Gaudama: The Buddha of the Burmese.* Second edition 1866. 2 vols. Reprint, Delhi: Bharatiya Publishing House, 1979.

Bizot, François. *Le bouddhisme des Thaïs: brève histoire de ses mouvements et de ses idées des origines à nos jours.* Bangkok: Les cahiers de France, 1993.

———. *Ramaker, ou, l'amour symbolique de Ram et Seta.* Publications de l'École française d'Extrême-Orient, v. 155. Paris: École française d'Extrême-Orient, 1989.

Blackmore, Thaung. "The Founding of the City of Mandalay by King Mindon." *Journal of Oriental Studies* 5, nos. 1–2 (1959–1960): 82–97.

Blurton, T. Richard. "'Looking Very Gay and Bright': Burmese Textiles in the British Museum." *Apollo* 150, no. 453 (November 1999): 38–42.

———. "Scarlet, Gold, and Black: The Lacquer Traditions of Burma." In *The Art of New Burma: New Studies,* edited by Donald Stadtner, 103–116. Mumbai: Marg Publications, 1999.

Bofman, Theodora Helene. *The Poetics of the Ramakian.* Monograph Series on Southeast Asia. [De Kalb]: Northern Illinois University, Center for Southeast Asian Studies, 1984.

Boisselier, Jean. *Thai Painting.* Tokyo: Kodansha International, 1976.

Boribal Buribhand, Luang. *Thai Images of the Buddha.* Bangkok: National Culture Institute, 1956.

Bowring, John. *The Kingdom and People of Siam, with a Narrative of the Mission to That Country in 1855.* London: John W. Parker and Son, West Strand, 1857.

Bradley, William Lee. *Siam Then: The Foreign Colony in Bangkok Before and After Anna.* Pasadena, CA: William Carey Library, 1981.

Brereton, Bonnie Pacala. *Thai Tellings of Phra Malai: Texts and Rituals Concerning a Popular Buddhist Saint.* Tempe: Arizona State University, Program for Southeast Asian Studies, 1995.

Bruns, Axel. *Burmese Puppetry.* Bangkok: White Lotus Press, 2006.

Bruns, Axel, and Hla Thamein. *Birmanisches Marionettentheater.* Berlin: A. Bruns, 1990.

Buddhaghosa. *The Path of Purification (Visuddhimagga).* Translated by Bhikhu Ñanamoli. Seattle: BPS Pariyatti Editions, 1999.

Buddhaisawan Chapel. Mural Paintings of Thailand Series. Bangkok: Muang Boran, 1983.

Cadet, J. M. *Ramakien: Stone Rubbings of the Thai Epic.* Tokyo: Kodansha International, 1971.

Cangi, Ellen Corwin. *Faded Splendour, Golden Past: Urban Images of Burma.* Oxford in Asia Paperbacks. Kuala Lumpur: Oxford University Press, 1997.

Capelo, Francisco. *A Arte da Laca na Birmania e na Tailândia.* Lisbon: Instituto Português de Museus, 2004.

Carter, A. Cecil. *The Kingdom of Siam, 1904.* 1904. Reprint, Bangkok: Siam Society, 1988.

Cary, Caverlee. "In the Image of the King: Two Photographs from Nineteenth-Century Siam." In *Studies in Southeast Asian Art: Essays in Honor of Stanley J. O'Connor,* edited by Nora A. Taylor, 122–142. Studies on Southeast Asia 29. Ithaca, NY: Southeast Asia Program, Cornell University, 2000.

———. "Triple Gems and Double Meanings: Contested Spaces in the National Museum of Bangkok." Ph.D. diss., Cornell University, 1994.

Chadok lae phutthaprawat chak tu lairotnam. Bangkok: Fine Arts Department, 2007.

Chao Phraya Thiphakorawong. *See* Thiphakorawong, Chao Phraya

Charney, Michael W. *Powerful Learning: Buddhist Literati and the Throne in Burma's Last Dynasty, 1752–1885.* Ann Arbor: Center for South and Southeast Asian Studies, University of Michigan, 2006.

Chawingam Macharoen and Saimai Chopkonlasuek. *Butsabok thammat.* Bangkok: Fine Arts Department, 1977.

Chen Yi-Sein. "The Chinese Rangoon During the 18th and 19th Century." In *Essays Offered to G. H. Luce by His Colleagues and Friends in Honour of His Seventy-Fifth Birthday*, vol. 1, edited by Ba Shin et al., 107–111. Ascona, Switzerland: Artibus Asiae Publishers, 1966.

Chew, Anne-May. *The Cave-Temples of Po Win Taung, Central Burma: Architecture, Sculpture and Murals.* Bangkok: White Lotus Press, 2005.

———. "Les peintures du style 'Nyaung Yan' à Po Win Taung." *Arts Asiatiques* 55 (2000): 55–80.

Chira Chongkol. *Guide to the National Museum, Bangkok.* [Bangkok]: Fine Arts Department, 1984.

———. *Guide to the National Museum, Bangkok.* 4th ed. [Bangkok]: Fine Arts Department, 1999.

Chiraphon Aranyanak. *Liao na lae lang du nang yai.* Bangkok: Fine Arts Department, 2008.

Chirapravati, Pattaratorn. *See* Pattaratorn Chirapravati, M. L.

Chittrakam faphanang rueang rammakian rop phrarabiang wat phrasirattanasatsadaram / The Ramakian (Ramayana) Mural Paintings Along the Galleries of the Temple of the Emerald Buddha. Bangkok: Samnakngan Salak Kinbaeng Ratthaban, 1981.

Chot Kanlayanamit, comp. *Photchananukrom sathapattayakam lae sinlapa kiao nueang.* Bangkok: Kanfaifa Fai Phalit, 1975.

Chotmaihet ngan phraborommasop somdet phranangchao ramphaiphanni, phraborommarachini nai ratchakan thi 7. Bangkok: Samnak Phraratchawang, 1986.

Chulalongkorn, King. *Phraratchaphithi sipsong duean.* 1888. Reprint, Bangkok: Sinlapa Bannakhan, 1973.

Coedès, George. "Une vie indochinoise du Buddha: la Pathamasambodhi." In *Mélanges d'indianisme à la mémoire de Louis Renou,* 217. Paris: Éditions E. de Boccard, 1968.

Cohen, Erik. *The Commercialized Crafts of Thailand: Hill Tribes and Lowland Villages; Collected Articles.* ConsumAsiaN Book Series. Honolulu: University of Hawai'i Press, 2000.

Collins, Steven. *Nirvana and Other Buddhist Felicities: Utopias of the Pali Imaginaire.* Cambridge: Cambridge University Press, 1998.

Cone, Margaret, and Richard F. Gombrich. *The Perfect Generosity of Prince Vessantara: A Buddhist Epic.* Oxford, UK: Clarendon Press, 1977.

Conway, Susan. *The Shan: Culture, Art and Crafts.* Bangkok: River Books, 2006.

———. *Silken Threads, Lacquer Thrones: Lanna Court Textiles.* Bangkok: River Books, 2002.

Cooler, Richard M. *British Romantic Views of the First Anglo-Burmese War, 1824–1826.* Dekalb, IL: Northern Illinois University, 1977.

Cowell, Edward B. *The Jataka; Or, Stories of the Buddha's Former Births. Translated from the Pali by Various Hands; Under the Editorship of E. B. Cowell.* London: Published for the Pali Text Society by Luzac, 1957.

Crawfurd, John. *Journal of an Embassy from the Governor General of India to the Court of Ava,* vol. 2. London: Henry Colburn, 1834.

———. *Journal of an Embassy from the Governor General of India to the Courts of Siam and Cochin China.* 1828. Reprint, New Delhi: Asian Educational Services, 2000.

Cushman, Jennifer Wayne. *Fields from the Sea: Chinese Junk Trade with Siam During the Late Eighteenth and Early Nineteenth Centuries.* Studies on Southeast Asia 12. Ithaca, NY: Southeast Asia Program, Cornell University, 1993.

Damrong Rajanubhab, Prince. *Journey Through Burma in 1936.* Translated by Kennon Breazeale. Bangkok: River Books, 1991.

———. *Sathanthi lae watthu song sang nai ratchakan thi 4.* Prachum phongsawadan, phak thi 25. Bangkok, 1922.

———. "Tamnan rueang khrueang to lae thuai pan." In *Khrueangthuai wat pho / Ceramics of Wat Pho,* edited by Damrong Wongupparat, 219–229. Bangkok: Amarin Printing, 2002.

———. "Wat Benchamabopit and Its Collection of Images of the Buddha." *Journal of the Siam Society* 20 (1926–1927). Reprinted in *The Siam Society: 50th Anniversary,* vol. 1, 239–281. [Bangkok: Siam Society], 1954.

Damrong Rajanubhab, Prince, and Prince Naritsaranuwattiwong. *See* Naritsaranuwattiwong, Prince, and Prince Damrong Rajanubhab.

DeCaroli, Robert. *Haunting the Buddha: Indian Popular Religions and the Formation of Buddhism.* New York: Oxford University Press, 2004.

Dehejia, Vidya, Dipti Khera, Yuthika Sharma, and Wynyard R. T. Wilkinson. *Delight in Design: Indian Silver for the Raj.* Ahmedabad: Mapin Publishing in association with Timeless Books, 2008.

Dell, Elizabeth, and Sandra Dudley, eds. *Textiles from Burma: Featuring the James Henry Green Collection.* Chicago: Art Media Resources, 2003.

Dhani Nivat, Prince. "The Gilt Lacquer Screen in the Audience Hall of Dusit." *Artibus Asiae* 24, nos. 3–4 (1961): 275–282.

———. "Hide Figures of the Ramakien at the Ledermuseum in Offenbach, Germany." In *Collected Articles by H. H. Prince Dhani Nivat Reprinted from the Journal*

of the Siam Society, 189–194 plus plates. Bangkok: Siam Society, 1969.

———. *A History of Buddhism in Siam.* Bangkok: Siam Society, 1965.

———. "The Inscriptions of Wat Phra Jetubon." In *Collected Articles by H. H. Prince Dhani Nivat Reprinted from the Journal of the Siam Society*, 5–28. Bangkok: Siam Society, 1969.

———. "The Reconstruction of Rama I of the Chakri Dynasty." 1955. Reprinted in *Collected Articles by H. H. Prince Dhani Nivat Reprinted from the Journal of the Siam Society*, 145–168. Bangkok: Siam Society, 1969.

———. *Shadow Play (The Nang).* Thai Culture, New Series, no. 3. Bangkok: Fine Arts Department, 1968.

Dhanit Yupho. *Thai Musical Instruments.* Translated by David Morton. Bangkok: Siva Phorn, 1960.

Dhida Saraya. *Mandalay: The Capital City, The Center of the Universe.* Bangkok: Muang Boran, 1995.

Dhiravat na Pombejra, Han ten Brummelhuis, Nandana Chutiwongs, and Pisit Charoenwongsa, eds. *Proceedings of the International Symposium "Crossroads of Thai and Dutch History."* Bangkok: SEAMEO-SPAFA, 2007.

Di Crocco, Virginia McKeen. *Footprints of the Buddhas of This Era in Thailand.* Bangkok: Siam Society, 1992.

Döhring, Karl. *The Country and People of Siam.* Translated by Walter E. J. Tips. Bangkok: White Lotus Press, 1999.

———. *Siam.* Der Indische Kulturkreis in Einzeldarstellungen 1–2. Darmstadt: Folkwang Verlag, 1923.

———. *Siam 2. Die bildende Kunst.* Der Indische Kulturkreis in Einzeldarstellungen 2. Darmstadt: Folkwang Verlag, 1923.

Dowling, Nancy H. "Five Nineteenth-Century Burmese Bronzes." *Journal of the Siam Society* 66, pt. 2 (1978): 172–178.

Dupaigne, Bernard, and Hoc Dy Khing. "Les plus anciennes peintures datées du Cambodge: quatorze épisodes du Vessantara Jataka (1877)." *Arts Asiatiques* 36 (1981): 26–36.

Eilenberg, Natasha, Subhadradis Diskul, Robert L. Brown, and Jean Boisselier, eds. *Living a Life in Accord with Dhamma: Papers in Honor of Professor Jean Boisselier on His Eightieth Birthday.* Bangkok: Silpakorn University, 1997.

Englehart, Neil A. *Culture and Power in Traditional Siamese Government.* Studies on Southeast Asia 18. Ithaca, NY: Southeast Asia Program, Cornell University, 2001.

Fajcsák, Györgyi, and Zsuzsanna Renner. *Délkelet-ázsiai buddhista muvészet.* A Buddhizmus Muvészete, 4 / Southeast Asian Buddhist Art. Budapest: Hopp Ferenc Kelet-Ázsiai Muvészeti Múzeum, 1997.

Falconer, John, Luca Invernizzi, and Kim Inglis. *Myanmar Style: Art, Architecture and Design of Burma.* Hong Kong: Periplus, 1998.

Ferrars, Max, and Bertha Ferrars. *Burma.* 1900. Reprint, Bangkok: AVA Publishing House, 1996.

Fickle, Dorothy H. *The Life of the Buddha: Murals in the Buddhaisawan Chapel, National Museum, Bangkok, Thailand.* Bangkok: Fine Arts Department, 1972.

———. "The Story of Nandopananda." *Brahmavidya: The Adyar Library Bulletin* 51 (1987): 327.

Fontein, Jan, Miriam Lambrecht-Geeraerts, and Dirk Bakker. *Bouddhas du Siam.* Ghent, Belgium: Snoeck-Ducaju & Zoon, 1996.

Franklin, Frances, Noel Singer, and Deborah Swallow. "Burmese Kalagas." *Arts of Asia* 33, no. 2 (2003): 57–81.

Fraser-Lu, Sylvia. "Buddha Images from Burma, Part 1: Sculptured in Stone; Part 2: Bronze and Related Materials; Part 3: Wood and Lacquer." *Arts of Asia* 11, no. 1 (January–February 1981): 72–82; no. 2 (March–April 1981): 62–72; no. 3 (May–June 1981): 129–136.

———. "Burmese Art at the Denver Art Museum." *Arts of Asia* 37, no. 1 (1997): 116–127.

———. *Burmese Crafts Past and Present.* Kuala Lumpur: Oxford University Press, 1994.

———. *Burmese Lacquerware.* Bangkok: Orchid Press, 2000.

———. *Handwoven Textiles of South-East Asia.* Singapore: Oxford University Press, 1988.

———. "Kalagas: Burmese Wall Hangings and Related Embroideries." *Arts of Asia* 12, no. 4 (1982): 73–82.

———. *Silverware of South-East Asia.* Images of Asia. Singapore: Oxford University Press, 1989.

———. *Splendour in Wood: The Buddhist Monasteries of Burma.* Bangkok: Orchid Press, 2001.

Frédéric, Louis. *The Art of Southeast Asia: Temples and Sculptures*. New York: Abrams, 1965.

Freeman, Michael. *Lanna: Thailand's Northern Kingdom*. Bangkok: River Books, 2001.

Galerie Beurdeley. *Birmanie: bois sculptés*. Paris: Beurdeley & Cie, 1990.

Gerini, G. E. *Chulakantamangala: The Tonsure Ceremony as Performed in Siam*. 1893. Reprint, Bangkok: Siam Society, 1976.

——. *A Retrospective View and Account of the Origin of the Thet Maha Ch'at Ceremony*. 1892. Reprint, Bangkok: Sathirakoses-Nagapradipa Foundation, 1976.

——. *Siam and Its Production, Arts, and Manufactures*. 1911. Reprinted, Bangkok: White Lotus Press, 2000.

Gethin, Rupert. *Sayings of the Buddha: New Translations from the Pali Nikayas*. New York: Oxford University Press, 2008.

Ginsburg, Henry. "Dated Manuscript Painting from Thailand." In *Living a Life in Accord with Dhamma: Papers in Honor of Professor Jean Boisselier on His Eightieth Birthday*, edited by Natasha Eilenberg et al., 222–228. Bangkok: Silpakorn University, 1997.

——. "A Monk Travels to Heaven and Hell." In *Pearls of the Orient: Asian Treasures from the Wellcome Library*, edited by Nigel Allan, 145–159. London: Serindia Publications, 2003.

——. *Thai Art and Culture: Historic Manuscripts from Western Collections*. London: British Library, 2000.

——. *Thai Manuscript Painting*. Honolulu: University of Hawai'i Press, 1989.

——. "Thai Painting in the Walters Art Museum." *Journal of the Walters Art Museum* 64/65 (issue year 2006/2007, published 2009). NOTE: This important work had not been published by the time this catalogue went into production, and Ginsburg's findings could not fully be made use of here.

Girard-Geslan, Maud, et al. *Art of Southeast Asia*. Translated by J. A. Underwood. New York: Harry N. Abrams, Inc., 1998.

Giteau, Madeleine. *Chefs-d'oeuvre de la peinture cambodgienne dans les monastères bouddhiques post-angkoriens / Capolavori della pittura cambogiana nei monasteri buddhisti di epoca post-angkoriana*. Orientalia 9. Torino: CESMEO, 2003.

Gittinger, Mattiebelle, and H. Leedom Lefferts. *Textiles and the Tai Experience in Southeast Asia*. Washington, D.C.: Textile Museum, 1992.

Glumsom, Pranee. "The Nang Yai (the Great Shadow Puppet) of Wat Sawang Arom: Past to Present." *Muang Boran Journal* 30, no. 4 (October–December 2004): 133.

Green, Alexandra. *Eclectic Collecting: Art from Burma in the Denison Museum*. Honolulu: University of Hawai'i Press, 2008.

Green, Alexandra, and T. Richard Blurton, eds. *Burma: Art and Archaeology*. London: British Museum Press, 2002.

Gréhan, M. A. *Le royaume de Siam*. 1867. Reprinted with Thai translation by Amata Nawamarattana. Nonthaburi, Thailand: Samnakphim Ton Chabap, 2000.

Griswold, A. B. "An Eighteenth-Century Monastery, Its Colossal Statue, and Its Benefactors." *Artibus Asiae* 35, no. 3 (1973): 179–206.

——. "Five Chieng Sen Bronzes of the Eighteenth Century (Continuation)." *Arts Asiatiques* 7, no. 2 (1960): 101–120.

——. "King Mongkut in Perspective." *The Journal of Siam Society* 45, pt. 1 (1957): 1–41.

——. *King Mongkut of Siam*. New York: Asia Society, 1961.

——. "Medieval Siamese Images in the Bo Tree Monastery." *Artibus Asiae* 18, no. 1 (1955): 46–60.

——. "Prolegomena to the Study of the Buddha's Dress in Chinese Sculpture." *Artibus Asiae* 26, no. 1 (1963): 85–131.

——. "The Rishis of Wat Po." *Felicitation Volumes of Southeast-Asian Studies*, vol. 2. Bangkok: Siam Society, 1965.

——. "A Warning to Evildoers." *Artibus Asiae* 20, no. 1 (1957): 18–28.

Guillon, Emmanuel. *The Mons: A Civilization of Southeast Asia*. Translated and edited by James V. Di Crocco. Bangkok: Siam Society under Royal Patronage, 1999.

Guy, John. "Painted to Order: Commissioning of Indian Textiles for the Court of Siam." In *Proceedings of the International Symposium "Crossroads of Thai and Dutch History,"* edited by Dhiravat na Pombejra et al., 477–504. Bangkok: SEAMEO-SPAFA, 2007.

——. *Woven Cargoes: Indian Textiles in the East*. New York: Thames and Hudson, 1998.

Hardy, R. Spence, trans. *A Manual of Buddhism in Its Modern Development; Translated from Singhalese mss.* London: Williams and Norgate, 1880.

Harris, Ian. *Cambodian Buddhism: History and Practice.* Honolulu: University of Hawai'i Press, 2005.

Hasson, Haskia. *Ancient Buddhist Art from Burma.* Bangkok: White Lotus Press; Singapore: Taisei Gallery, 1993.

Herbert, Patricia. "Burmese Cosmological Manuscripts." In *Burma: Art and Archaeology,* edited by Alexandra Green and T. Richard Blurton, 77–98. London: British Museum Press, 2002.

———. "Burmese Court Manuscripts." In *The Art of New Burma: New Studies,* edited by Donald Stadtner, 89–102. Mumbai: Marg Publications, 1999.

———. "An Illustrated Record of Royal Donations." In *Études birmanes: en hommage à Denise Bernot,* edited by Pierre Pichard and François Robinne, 89–111. Études Thématiques 9. Paris: École française d'Extrême-Orient, 1998.

———. *The Life of the Buddha.* London: British Library, 1993.

———. "Myanmar Manuscript Art." In International Symposium on Preservation of Myanmar Traditional Manuscripts, Teruko Saito, and So Kon. *Enriching the Past: Preservation, Conservation and Study of Myanmar Manuscripts: Proceedings of the International Symposium on Preservation of Myanmar Traditional Manuscripts, January 14–15, 2006, Yangon.* Tokyo: Tokyo University of Foreign Studies, 2006.

Historical Illustrations, Wat Phra Chetuphon Vimolmangklararm Rajvaramahaviharn (The Temple of the Reclining Buddha). Bangkok: Wat Phra Chetuphon Vimolmangklararm Rajvaramahaviharn, 1982.

Hobsbawm, E. J., and T. O. Ranger, eds. *The Invention of Tradition.* Cambridge: Cambridge University Press, 1983.

Holt, John Clifford, Jacob N. Kinnard, and Jonathan S. Walters, eds. *Constituting Communities: Theravada Buddhism and the Religious Cultures of South and Southeast Asia.* Albany: State University of New York Press, 2003.

Hoskin, John. *Buddha Images in the Grand Palace.* Bangkok: Office of His Majesty's Principal Private Secretary, the Grand Palace, 1994.

Htin Aung, Maung. *Folk Elements in Burmese Buddhism.* Rangoon: White Lotus Press, 1959.

International Symposium on Preservation of Myanmar Traditional Manuscripts, Teruko Saito, and So Kon. *Enriching the Past: Preservation, Conservation and Study of Myanmar Manuscripts: Proceedings of the International Symposium on Preservation of Myanmar Traditional Manuscripts, January 14–15, 2006, Yangon.* Tokyo: Tokyo University of Foreign Studies, 2006.

Isaacs, Ralph, and T. Richard Blurton. *Visions from the Golden Land: Burma and the Art of Lacquer.* London: British Museum Press, 2000.

Ishizawa, Yoshiaki. "La découverte de 274 sculptures et d'un caitya bouddhique lors des campagnes de fouilles de 2000 et 2001 au temple de Banteay Kdei à Angkor." *Arts Asiatiques* 57 (2002): 206–218.

Jacob, Judith M., trans., with the assistance of Kuoch Haksrea. *Reamker (Ramakerti): The Cambodian Version of the Ramayana.* Oriental Translation Fund, n.s., vol. 45. London: Royal Asiatic Society, 1986.

Jacq-Hergoualc'h, Michel. *L'Europe et le Siam du XVIe au XVIIIe siècle: apports culturels.* Paris: L'Harmattan, 1993.

———. *Une vie du Buddha dans les peintures de la sala de Wat Ruak Bangbamru à Thonburi (Thaïlande).* Paris: Centre d'Études des Monuments du Monde Indien, Musée Guimet, 1984.

Jarunee Incherdchai [Charuni Inchoetchai]. "Phra bot: phutthasin bon phuenpha / Phra Bot: The Buddhist Art on Banner." *Muang Boran* 28, no. 4 (October–December 2002): 51–60.

Jarunee Incherdchai [Charuni Inchoetchai] and Khwanchit Loetsiri. *Phra bot.* Bangkok: Fine Arts Department, 2002.

Jarunee Incherdchai [Charuni Inchoetchai], Khwanchit Loetsiri, and Somchai Supphalakamphaiphon. *Nang phra nakhon wai.* Bangkok: Fine Arts Department, 2008.

Jayawickrama, N. A., trans. *The Story of Gotama Buddha (Jataka-nidana).* Oxford: Pali Text Society, 2000.

Johnson, Andrew Alan. "Re-possessing Lanna: Northern Thai Neo-traditionalism and the Future of the City." *Southeast Asia Program Bulletin,* Cornell University, Fall 2008, 12–17.

Johnson, Paul Christopher. "'Rationality' in the Biography of a Buddhist King: Mongkut, King of Siam (r. 1851–1868)." In *Sacred Biography in the Buddhist Traditions of South and Southeast Asia,* edited by Juliane Schober, 232–255. Honolulu: University of Hawai'i Press, 1997.

Joti Kalyanamitra. *Phonngan 6 sattawat khong chang thai / Six Hundred Years of Work by Thai Artists & Architects.* Bangkok: Kammathikan Anurak Sinlapa Satthapattayakam, 1977.

———. *Photchananukrom sathapattayakam lae sinlapa kiaonueang.* Bangkok: Kanfaifa Fai Phalit haeng Prathet Thai, 1975.

Julathusana Byachrananda [Chunlathat Phayakharanon]. *Thai Mother-of-Pearl Inlay.* Bangkok: River Books, 2001.

Kam, Garrett. *Ramayana in the Arts of Asia.* Singapore: Select Books, 2000.

Kamala Tiyavanich. *The Buddha in the Jungle.* Chiang Mai, Thailand: Silkworm Books, 2003.

———. *Forest Recollections: Wandering Monks in Twentieth-Century Thailand.* Honolulu: University of Hawai'i Press, 1997.

———. *Sons of the Buddha: The Early Lives of Three Extraordinary Thai Masters.* Boston: Wisdom Publications, 2007.

Karow, Otto. *Burmese Buddhist Sculpture: The Johan Möger Collection.* Bangkok: White Lotus Press, 1991.

Keeler, Ward. "Dying Puppets and Living Arts in Burma." *Asian Art & Culture* 7, no. 2 (1994): 65–80.

Kemtat Visvayodhin. *Khrueang kaeo: chat sadaeng na phrathinang wimmanmek phra ratchawang dusit.* 5th ed. Bangkok: Aksonsamphan, 1983.

———. *Khrueang krabueang: chat sadaeng na phrathinang wimmanmek phra ratchawang dusit.* 5th ed. Bangkok: Aksonsamphan, 1983.

———. *Khrueang phipitthaphan: chat sadaeng na phrathinang wimmanmek phra ratchawang dusit.* 5th ed. Bangkok: Aksonsamphan, 1983.

———. *Khrueang thom: chat sadaeng na phrathinang wimmanmek phra ratchawang dusit.* 5th ed. Bangkok: Aksonsamphan, 1983.

———. *Khrueang thong lae khrueang ngoen: chat sadaeng na phrathinang wimmanmek phra ratchawang dusit.* 5th ed. Bangkok: Aksonsamphan, 1983.

Keyes, Charles F. "Millennialism, Theravada Buddhism, and Thai Society." *The Journal of Asian Studies* 36, no. 2 (1977): 283.

Khaisri Sri-Aroon. "Aperçu sur la peinture thaie sous le règne de Rama IV (1851–1868): son optique occidentale." In *Living a Life in Accord with Dhamma: Papers in Honor of Professor Jean Boisselier on His Eightieth Birthday,* edited by Natasha Eilenberg et al., 440–447. Bangkok: Silpakorn University, 1997.

———. *Les statues du Buddha de la galerie de Phra Pathom Chedi, Nakhon Pathom, Thailande / Phraphuttharup thi rabiang rop ong phrapathommachedi.* Bangkok: Prince of Songkhla University, 1996.

Khana Kammakan Chat Ngan Somphot Krung Rattanakosin 200 Pi. *Chittrakam krung rattanakosin / Rattanakosin Painting.* Bangkok: Khana Kammakan Chat Ngan Somphot Krung Rattanakosin 200 Pi, 1982.

Khana Kammakan Chat Ngan Somphot Krung Rattanakosin 200 Pi. *Samutphap pratimakam krung rattanakosin / Sculptures of Rattanakosin.* Bangkok: Khana Kammakan Chat Ngan Somphot Krung Rattanakosin 200 Pi, 1982.

Khin Maung Nyut. "Myanmar Lacquerware: Historical Background and Cultural Perspectives." In *Lacquerware in Asia, Today and Yesterday,* edited by Monika Kopplin. Paris: UNESCO, 2002.

Khrueangruean rattanakosin / Rattanakosin home furnitures [sic]. Bangkok: Akson Samphan, 1982.

Khrueangthom lae khrueangngoen thai / Thai Niello & Silver Ware. Bangkok: Samakhom Khrueangthom lae Khrueangngoen Thai, 1982.

Khrueangthong rattanakosin. Bangkok: Khrongkan Suepsan Moradok Watthanatham Thai, 1999.

Khrueangthuai wat pho / Ceramics of Wat Pho. Bangkok: Amarin, 2002.

Kingkeo Attagara. *The Folk Religion of Ban Nai: A Hamlet in Central Thailand.* Bangkok: Kurusapha Press, 1968.

Kirsch, A. Thomas. "Modernizing Implications of Nineteenth Century Reforms in the Thai Sangha." In *Religion and Legitimation of Power in Thailand, Laos, and Burma,* edited by Bardwell L. Smith, 52–65. Chambersburg, PA: Anima Books, 1978.

———. Review of *Divination in Thailand: The Hopes and Fears of a Southeast Asian People,* by H. G. Quaritch Wales. *Journal of Pacific Affairs* 57, no. 2 (Summer 1984): 363–364.

Koenig, William J. *The Burmese Polity, 1752–1819.* Ann Arbor: Center for South and Southeast Asian Studies, University of Michigan, 1990.

Kongkaeo Wiraprachak. *Tu lai thong / Thai Lacquer and Gilt Bookcases: Part One, Ayudhya and Dhonburi Periods.* Bangkok: National Library, Fine Arts Department, 1980.

———. *Tu lai thong / Thai Lacquer and Gilt Bookcases: Part Two, Volume III (Bangkok Period BKK. 191–285).* Bangkok: National Library, Fine Arts Department, 1988.

Kooij, Karel R. van. "Indra's Heaven in Buddhist Art." In *Studies in Art and Archaeology of Bihar and Bengal: Dr. N. K. Battasali Centenary Volume, 1888–1988,* edited by Debala Mitra and Gouriswar Bhattachararya. Sri Garib Dass Oriental Series 83. Delhi: Sri Satguru, 1989.

Koompong Noobanjong. *Power, Identity, and the Rise of Modern Architecture: From Siam to Thailand.* [S.l.]: Dissertation.com, 2003.

Kopplin, Monika, ed. *Lacquerware in Asia, Today and Yesterday.* Paris: UNESCO, 2002.

Kraisri Nimmanahaeminda. "Ham Yon, the Magic Testicles." In *Essays Offered to G. H. Luce by His Colleagues and Friends in Honour of His Seventy-Fifth Birthday,* vol. 2, edited by Ba Shin, Jean Boisselier, and A. B. Griswold, 133–148. Ascona, Switzerland: Artibus Asiae Publishers, 1966.

The Lacquer Pavilion at Suan Pakkad Palace. Bangkok: Siva Phorn Limited Partnership, n.d.

Lagirarde, François. "Devotional Diversification in Thai Monasteries: The Worship of the Fat Monk." In *The Buddhist Monastery: A Cross-Cultural Survey,* edited by Pierre Pichard and F. Lagirarde. Études thématiques 12. Paris: École française d'Extrême-Orient, 2003.

Lagirarde, François, and Paritta Chalermpow Koanantakool, eds. *Buddhist Legacies in Mainland Southeast Asia: Mentalities, Interpretations and Practices.* Paris and Bangkok: École française d'Extrême-Orient and Princess Maha Chakri Sirindhorn Anthropology Centre, 2006.

La Loubère, Simon de. *The Kingdom of Siam.* 1691/1693. Oxford in Asia Historical reprints. Kuala Lumpur: Oxford University Press, 1969.

Lefferts, Leedom. "The Bun Phra Wet Painted Scrolls of Northeastern Thailand in the Walters Art Museum." *Journal of the Walters Art Museum* 64/65 (2006/2007, forthcoming), 161–182.

The Life of the Buddha According to Thai Temple Paintings. Bangkok: U.S. Information Service, 1957.

Lingat, Robert. "Le culte du Bouddha d'émeraude." *Journal of the Siam Society* 27, no. 1 (1934): 9–38.

———. "La vie religieuse du Roi Mongkut." *Journal of the Siam Society* 20 (1926–1927).

———. "Le Wat Rajapratistha." *Artibus Asiae* 24, nos. 3–4 (1961): 314–323.

Lowry, John. *Burmese Art.* London: Her Majesty's Stationery Office, 1974.

———. "Burmese Art at the Victoria and Albert Museum." *Arts of Asia* 5, no. 2 (March–April 1975): 26–37.

———. "Victorian Burma by Post: Felice Beato's Mail-Order Business." *Country Life* 157, no. 4054 (March 13, 1975): 659.

Lyon, Elizabeth. *The Tosachat in Thai Painting.* Thai Culture, New Series, no. 22. Bangkok: Fine Arts Department, 1972.

Ma Thanegi. *See* Thanegi, Ma

Malalasekera, G. P. *Dictionary of Pāli Proper Names.* 2 vols. 1937–1938. 1st Indian ed. New Delhi: Munishiram Manoharlal, 1983.

The Mandalay Palace. Rangoon: Ministry of Union Culture, 1963. Full text available in the Online Burma/Myanmar Library at www.burmalibrary.org.

Manich Jumsai, M. L. *Thai Ramayana.* Bangkok: Chalermnit, 1977.

Manit Wanliphodom et al. *Sinlapa samai uthong; sinlapa samai ayutthaya; sinlapa samai rattanakosin.* Bangkok: Fine Arts Department, 1967.

Martini, Ginette. "Pancabuddhabyakarana." *Bulletin de l'École française d'Extrême-Orient* 55 (1969): 125–147.

Matics, K. I. *Gestures of the Buddha.* Bangkok: Chulalongkorn University Press, 1998.

———. "Hell Scenes in Thai Murals." *Journal of the Siam Society* 67, pt. 2 (1979): 35–39.

———. "An Historical Analysis of the Fine Arts at Wat Phra Chetuphon, a Repository of Ratanakosin Artistic Heritage." Ph.D. diss., New York University, 1978.

———. *A History of Wat Phra Chetuphon and Its Buddha Images.* Bangkok: Siam Society, 1979.

———. *Introduction to the Thai Mural.* Bangkok: White Lotus Press, 1992.

Maung Htin Aung. *Burmese Drama: A Study, with Translations, of Burmese Plays.* 4th impression. London: Oxford University Press, 1937 (1957 printing).

———. *A History of Burma.* New York: Columbia University Press, 1967.

Maxwell, Robyn J. *Textiles of Southeast Asia: Tradition, Trade and Transformation.* Singapore: Periplus, 2003.

McGill, Forrest. "The Art and Architecture of the Reign of King Prasatthong of Ayutthaya, 1629–1656." Ph.D. diss., University of Michigan, 1977.

———. "Jatakas, Universal Monarchs, and the Year 2000." *Artibus Asiae* 53 (1993): 412–448.

———. "Painting the 'Great Life.'" In *Sacred Biography in the Buddhist Traditions of South and Southeast Asia,* edited by Juliane Schober, 195–217. Honolulu: University of Hawai'i Press, 1997.

McGill, Forrest, ed. *The Kingdom of Siam: The Art of Central Thailand, 1350–1800.* San Francisco: Asian Art Museum, 2005.

McGill, Forrest, and M. L. Pattaratorn Chirapravati. "Thai Art of the Bangkok Period at the Asian Art Museum." *Orientations* 34, no. 1 (January 2003): 28–34.

McQuail, Lisa. *Treasures of Two Nations: Thai Royal Gifts to the United States of America.* Washington, D.C.: Asian Cultural History Program, Smithsonian Institution, 1997.

Mead, Kullada Kesboonchoo. *The Rise and Decline of Thai Absolutism.* RoutledgeCurzon Studies in the Modern History of Asia 22. London: Routledge-Curzon, 2004.

Mechai Thongthep, comp. *Ramakien: The Thai Ramayana.* Bangkok: Naga Books, 1993.

Miettinen, Jukka O. *Classical Dance and Theatre in South-East Asia.* Singapore: Oxford University Press, 1992.

M. L. Pattaratorn Chirapravati. *See* Pattaratorn Chirapravati, M. L.

Moffat, Abbot Low. *Mongkut, the King of Siam.* Ithaca, NY: Cornell University Press, 1961.

Moilanen, Irene, and S. S. Ozhegov. *Mirrored in Wood: Burmese Art and Architecture.* Bangkok: White Lotus Press, 1999.

Mom Ratchawong Saengsooriya Ladavalya. *See* Saengsooriya Ladavalya, Mom Ratchawong

Moore, Elizabeth. "The Royal Cities of Myanmar, 14th–19th Centuries with Reference to China." In *South East Asia & China: Art, Interaction & Commerce,* edited by Rosemary Scott and John Guy, 101–117. Colloquies on Art & Archaeology in Asia 17. London: University of London, 1995.

Moore, Elizabeth, and Daw San San Maw. "Flights of Fancy: Hintha and Kinnaya, the Avian Inspiration in Myanmar Art." *Oriental Art* 41, no. 2 (1995): 25–31.

Moore, Elizabeth, Hansjorg Mayer, and U Win Pe. *Shwedagon: Golden Pagoda of Myanmar.* New York: Thames and Hudson, 1999.

Moss, Peter, ed. *Asian Furniture: A Directory and Sourcebook.* London: Thames and Hudson, 2007.

Mouhot, Henri. *Travels in Siam, Cambodia and Laos, 1858–1860.* 1864. Reprint, Oxford in Asia paperback. Singapore: Oxford University Press, 1992.

Myo Myint. "The Politics of Survival in Burma: Diplomacy and Statecraft in the Reign of King Mindon, 1853–1878." Ph.D. diss., Cornell University, 1987.

Naengnoi Punjabhan, Aroonrut Wichienkeeo, and Somchai Na Nakhonphanom. *The Charm of Lanna Wood Carving.* Bangkok: Rerngrom Publishing Co., 1994.

———. *Silverware in Thailand.* Bangkok: Rerngrom Publishing Co., 1991.

Naengnoi Punjabhan and Somchai Na Nakhonphanom. *The Art of Thai Wood Carving, Sukhothai, Ayutthaya, Ratanakosin.* 1st ed. Bangkok: Rerngrom Publishing Co., 1992.

Naengnoi Saksi. *Moradok sathapattayakam krung rattanakosin.* Bangkok: Samnak Ratchalekhathikan, 1994.

Naengnoi Saksi and Michael Freeman. *The Grand Palace.* Bangkok: River Books, 1998.

———. *Palaces of Bangkok: Royal Residences of the Chakri Dynasty.* London: Thames and Hudson, 1996.

Nafilyan, Jacqueline, and Guy Nafilyan. *Les peintures murales des monastères bouddhiques au Cambodge.* Paris: Maisonneuve & Larose / UNESCO, 1997.

Nanamoli, Bhikkhu. *The Life of the Buddha.* Seattle: Buddhist Publication Society, 1992.

———. *The Life of the Buddha: According to the Pali Canon.* Seattle: BPS Pariyatti Editions, 2001.

Nandakic, K. "An Inscribed Model Vihara from Chieng Sen." In *Essays Offered to G. H. Luce by His Colleagues and Friends in Honour of His Seventy-Fifth Birthday,* vol. 2, edited by Ba Shin, Jean Boisselier, and A. B. Griswold, 121–132. Ascona, Switzerland: Artibus Asiae Publishers, 1966.

Nang phra nakhon wai. Bangkok: Fine Arts Department, 2008.

Narisa Chakrabongse et al. *Siam in Trade and War: Royal Maps of the Nineteenth Century.* Bangkok: River Books, 2006.

Naritsaranuwattiwong, Prince, and Damrong Rajanubhab, Prince. *San somdet.* Bangkok: Munnithi Somdet Chaofa Krom Phraya Naritsaranuwattiwong, 1991.

Nattier, Jan. *Once Upon a Future Time: Studies in a Buddhist Prophecy of Decline.* Nanzan Studies in Asian Religions 1. Berkeley, CA: Asian Humanities Press, 1991.

Nidhi Eoseewong. *Pen and Sail: Literature and History in Early Bangkok Including the History of Bangkok in the Chronicles of Ayutthaya.* Chiang Mai, Thailand: Silkworm Books, 2005.

Nithi Sathapitanon and Brian Mertens. *Architecture of Thailand: A Guide to Traditional and Contemporary Forms.* London: Thames and Hudson, 2006.

Niyada Laosunthon. *Hotraikrom somdet phraparamanuchit chinnorot: laeng rianru phraphutthasatsana lae phumpanya thai nai wat pho.* Bangkok: Khana Song Wat Phra Chettuphon, 2005.

———. *Sila chamlak rueang rammakian: wat phra chettuphon wimonmangkhalaram / The Ramakien Bas-reliefs at Wat Phra Chettuphon.* Bangkok: Wat Phra Chettuphon Wimonmangkhalaram, 1996.

Niyada Laosunthon and Waldemar C. Sailer. *Illustrations from Thai Literature Found on the Door and Window Casings of the Consecrated Ordination Hall of Wat Suthat Thepwararam Ratchaworamahawihan, Bangkok, Thailand.* Bangkok: Munnithi Atthamarachanuson, 1983.

No Na Paknam. *Farang nai sinlapa thai.* Bangkok: Muang Boran, 1986.

———. *Khru Khongpae & Khru Thongyu: Two Great Masters of the Golden Era of Rattanakosin Mural Paintings.* Bangkok: Muang Boran, 1987.

———. *Phra Acharn Nak, the Foremost Muralist of the Reign of King Rama I.* Bangkok: Muang Boran, 1987.

No Na Paknam and Somphong Thimchaemsai. *Chittrakam samai rattanakosin.* Bangkok: Muang Boran, 1982.

Notton, Camille. *The Chronicle of the Emerald Buddha.* Bangkok: Bangkok Times Press, 1933.

———. *Pra Buddha Sihinga.* Bangkok: Bangkok Times Press, 1933.

Nyanaponika, Thera, and Hellmuth Hecker. *Great Disciples of the Buddha: Their Lives, Their Works, Their Legacy,* edited by Bhikkhu Bodhi. Boston: Wisdom Publications, 1997.

O'Connor, V. C. Scott. *Mandalay and Other Cities of the Past in Burma.* 1907. Reprint, Bangkok: White Lotus Press, 1987.

Oertel, F. O. *Note on a Tour in Burma in March and April 1892.* 1892. Reprint, Bangkok: White Orchid Press, 1995.

Ohno, Toru. *Burmese Ramayana: With an English Translation of the Original Palm Leaf Manuscript in Burmese Language in 1223 Year of Burmese Era, 1871 A.D.* Delhi: B. R. Publishing Corporation, 2000.

———. "The Burmese Version of the Rama Story and Their Peculiarities." In *Tradition and Modernity in Myanmar,* edited by Uta Gärtner and Jens Lorenz, vol. 2, 305–326. Münster, Germany: LIT, 1994.

Olsson, Ray A., trans. *The Ramakien: A Prose Translation of the Thai Version of the Ramayana.* Bangkok: Praepittaya, 1968.

Oshegova, Nina, and Sergej Oshegov. *Kunst in Burma: 2000 Jahre Architektur, Malerei und Plastik im Zeichen des Buddhismus und Animismus.* Leipzig, Germany: VEB E.A. Seemann, 1988.

"Paintings During the Reign of King Rama I in Southern Thailand." *Muang Boran Journal* 14, no. 1 (January–March 1988): 8–21.

Paramanuchit Chinorot, Prince. *Phra pathomsomphothikatha.* Bangkok: Department of Religious Affairs, 1962.

Patiphat Daradat. *Laithai phapthai.* Bangkok: 1998.

Pattaratorn Chirapravati, M. L. *Votive Tablets in Thailand: Origin, Styles, and Uses.* Images of Asia. Kuala Lumpur: Oxford University Press, 1997.

Pech Tum Kravel. *Sbek Thom: Khmer Shadow Theater.* Edited by Martin Hatch. Translated by Sos Kem. Ithaca, NY: Southeast Asia Program, Cornell University, 1995.

Peleggi, Maurizio. *Lords of Things: The Fashioning of the Siamese Monarchy's Modern Image.* Honolulu: University of Hawai'i Press, 2002.

———. "Purveyors of Modernity? European artists and architects in turn-of-the-century Siam." *Asia Europe Journal* 1 (2003): 91–101.

———. "Royal Antiquarianism, European Orientalism, and the Production of Archeological Knowledge in Modern Siam." In *Asia in Europe, Europe in Asia,* by Farid Alatas, Srilata Ravi, Mario Rutten, and Beng-Lan Goh. IIAS/ISEAS Series on Asia. Leiden, the Netherlands: International Institute for Asian Studies, 2004.

———. *Thailand: The Worldly Kingdom.* London: Reaktion, 2007.

Peltier, Anatole. "Iconographie de la légende de Brah Malay." *Bulletin de l'École Française d'Extrême-Orient Paris* 71 (1982): 63–76.

Phanuphong Laohasom. *Chittrakam faphanang lanna.* Bangkok: Muang Boran, 1998.

Pharani Kirtiputra. *Art Objects Pertaining to the Chakri Dynasty.* [Bangkok?]: Office of Her Majesty's Private Secretary, 1982.

Phillips, Herbert P. *The Integrative Art of Modern Thailand.* Berkeley: Lowie Museum of Anthropology, University of California, 1992.

Phillips, Ruth B., and Christopher B. Steiner. *Unpacking Culture: Art and Commodity in Colonial and Postcolonial Worlds.* Berkeley: University of California Press, 1999.

Phra bot lae samutphap thai. Bangkok: Fine Arts Department, 1984.

Phra thinang songphanuat. Mural Paintings of Thailand Series. Bangkok: Muang Boran, 2000.

Phranakhonkhiri / Phra Nakhon Khiri. Bangkok: Fine Arts Department, 1984.

Phraphutthapatima nai phraborommamaharatchawang. Bangkok: Samnak Ratchalekhathikan, 1992.

Phutthaloetla Naphalai [King Rama II], Fern S. Ingersoll, and Bunson Sukhphun. *Sang Thong: A Dance-Drama from Thailand.* Rutland, VT: C. E. Tuttle Co., 1973.

Phya Anuman Rajadhon. *See* Anuman Rajadhon, Phya

Pichard, Pierre, and F. Lagirarde, eds. *The Buddhist Monastery: A Cross-Cultural Survey.* Études Thématiques 12. Paris: École française d'Extrême-Orient, 2003.

Pichard, Pierre, and François Robinne, eds. *Études birmanes: en hommage à Denise Bernot.* Études Thématiques 9. Paris: École française d'Extrême-Orient, 1998.

Ping Amranand and William Warren. *Lanna Style: Art & Design of Northern Thailand.* Bangkok: Asia Books, 2000.

Piriya Krairiksh. *Baep sinlapa nai prathet thai / Art Styles in Thailand: A Selection from National Provincial Museums.* Bangkok: Fine Arts Department, 1977.

———. *Das heilige Bildnis: Skulpturen aus Thailand / The Sacred Image: Sculptures from Thailand.* Cologne: Museen für Ostasiatische Kunst, Museen der Stadt Köln, 1979.

———. "Sculptures from Thailand." In *Sculptures from Thailand.* Hong Kong: Urban Council, 1982.

Pitya Bunnag. "Thai Traditional Gabled Doors and Windows." *Journal of the Siam Society* 83, pts. 1–2 (1995): 6–24.

Prachum sila charuek, vol. 3. Bangkok: Office of the Prime Minister, 1970.

Praman Sutabut. *Prachum samutphap samkhan nai prawattisat lem 1.* Bangkok: Khana Kammakan Chatham Ekkasan thang Prawattisat Watthanatham lae Borannakhadi, 1971.

Pruitt, William, and Peter Nyunt. "Illustrations from the Life of the Buddha." In *Pearls of the Orient: Asian Treasures from the Wellcome Library,* edited by Nigel Allan, 123–143. London: Serindia Publications, 2003.

Prunner, Gernot. *Meisterwerke burmanischer Lackkunst.* Wegweiser zur Völkerkunde 9. Hamburg: Hamburgisches Museum für Völkerkunde und Vorgeschichte, 1966.

Ratanapanna Thera. *The Sheaf of Garlands of the Epochs of the Conqueror: Being a Translation of Jinaka-lamalipakaranam of Ratanapanna Thera of Thailand.* Translated by N. A. Jayawickrama. Pali Text Society Translation Series 36. London: Published for the Pali Text Society by Luzak, 1968.

Ray, Niharranjan. *An Introduction to the Study of Theravada Buddhism in Burma: A Study in Indo-Burmese Historical and Cultural Relations from the Earliest Times to the British Conquest.* 1st ed. Calcutta: University of Calcutta, 1946.

Raymond, Catherine. "Wathundayé, divinité de la Terre en Birmanie et en Arakan." In *Études birmanes: en hommage a Denise Bernot,* edited by Pierre Pichard and François Robinne, 113–127. Études Thématiques 9. Paris: École française d'Extrême-Orient, 1998.

Reid, Anthony. "Cosmopolis and Nation in Central Southeast Asia." ARI Working Paper, no. 22, April 2004, www.ari.nus.edu.sg/pub/wps.htm.

Reynolds, Craig J. "Buddhist Cosmology in Thai History, with Special Reference to Nineteenth-Century Culture Change." *Journal of Asian Studies* 35, no. 2 (February 1976): 203–220.

———. "Religious Historical Writing and the Legitimation of the First Bangkok Reign." In *Perceptions of the Past in Southeast Asia,* edited by Anthony Reid and David Marr, 90–107. Singapore: Heinemann Educational Books (Asia), 1979.

Reynolds, Frank E. "The Holy Emerald Jewel: Some Aspects of Buddhist Symbolism and Political Legitimation in Thailand and Laos." In *Religion and Legitimation of Power in Thailand, Laos, and Burma*, edited by Bardwell L. Smith, 175–193. Chambersburg, PA: Anima Books, 1978.

———. "The Many Lives of Buddha: A Study of Sacred Biography and Theravada Tradition." In *The Biographical Process: Studies in the History and Psychology of Religion,* edited by Frank E. Reynolds and Donald Capps. The Hague: Mouton, 1976.

———. "Rebirth Traditions and the Lineages of Gotama: A Study in Theravada Buddhology." In *Sacred Biography in the Buddhist Traditions of South and Southeast Asia,* edited by Juliane Schober. Honolulu: University of Hawai'i Press, 1997.

Reynolds, Frank E., and Mani B. Reynolds, trans. *Three Worlds According to King Ruang: A Thai Buddhist Cosmology.* Berkeley, CA: Asian Humanities Press/ Motila Banarsidass, 1982.

Richter, Anne. *Jewelry of Southeast Asia.* London: Thames and Hudson, 2000.

Roberts, Ursula. "The Burmese Collection at Denison University." *Arts of Asia* 18, no. 1 (January–February 1988): 132–135.

Robinson, Natalie V. *Sino-Thai Ceramics in the National Museum, Bangkok, Thailand, and in Private Museums.* Bangkok: Fine Arts Department, 1982.

Robinson, Richard H., and Willard L. Johnson. *The Buddhist Religion: A Historical Introduction.* 4th ed. Belmont, CA: Wadsworth Publishing Co., 1997.

Rodrigue, Yves. *Nat-Pwe: Burma's Supernatural Sub-Culture.* Gartmore, UK: Paul Strachan-Kiscadale Ltd., 1992.

Rosenfield, Clair S. "The Mythical Animal Statues at the Prasat Phrathepphabidon." In *In Memoriam Phya Anuman Rajadhon,* edited by Tej Bunnag and Michael Smithies, 273–300. Bangkok: Siam Society, 1970.

Rungrot Thamrungrueang. *Wat ruak bang bamrung: prawat lae satsa na watthu.* 1st ed. Bangkok: Khaksopha, 2006.

Saddhatissa, H. *The Birth-Stories of the Ten Bodhisattvas and the Dasabodhisattuppattikatha.* Unesco Collection of Representative Works. London: Pali Text Society, 1975.

Saengsooriya Ladavalya, Mom Ratchawong, Svat Dhanapradiht, and Kriangkrai Viswamitr. *Phraratchaphithi somphot krung rattanakosin 200 pi / Royal Ceremonies for the Rattanakosin Bicentennial.* Bangkok: Office of His Majesty's Principal Private Secretary, 1982.

Saenluang Ratchasomphan. *The Nan Chronicle.* Edited by David K. Wyatt. Translated by Prasoet Churatana. 1919. Reprint, Ithaca, NY: Department of Asian Studies, Cornell University, 1966.

Sakchai Saising. *Ngan chang samai phra nangklao.* Bangkok: Matichon, 2008.

Samut khoi. Bangkok: Khrongkan Supsan Moradok Watthanatham Thai, 1999.

Samutphap prawattisat krung rattanakosin. Sinlapa watthanatham thai, vol. 1. Bangkok: Fine Arts Department, 1982.

Samutphap traiphum buran chabap krung thonburi / Buddhist Cosmology Thonburi Version. Bangkok: Office of the Prime Minister, 1982.

Samutphap traiphum chabap krung si ayutthaya— chabap krung thonburi. 2 vols. Bangkok: Fine Arts Department, 1999.

Samutphap wat phrachettuphon wimonmangkhalaram / Pictorial Book of Wat Phra Chettuphon. Bangkok: Fine Arts Department, 1992.

Sangwan Mahidol, Princess. *Khrueang prakop phraratchaitsariyayot, ratchayan, ratcharot, lae phramerumat.* Bangkok: Ratthaban nai Phrabat Somdet Phraparamintara Maha Phumiphon Adunlayadet, 1996.

Santi Leksukhum. *Chittrakam thai samai ratchakan thi 3: khwamkhit plian kansadaeng ok ko plian tam.* Bangkok: Muang Boran, 2005.

———. "The Evolution of the Memorial Towers of Siamese Temples." In *The Kingdom of Siam: The Art of Central Thailand, 1350–1800,* edited by Forrest McGill, 61–78. San Francisco: Asian Art Museum, 2005.

———. *Khomun kap mummong: sinlapa rattanakosin.* Bangkok: Muang Boran, 2005.

———. *Temples of Gold: Seven Centuries of Thai Buddhist Paintings.* New York: George Braziller, 2000.

Santi Phakdikham. "Wat nangnong: wat haeng phrachao chakkraphatdirat / Wat Nangnong: A Temple of King of Kings." *Muang Boran Journal* 32, no. 3 (July–September 2006): 44–63.

Sanur Niladej. "Objects of Art: Their Value Not to Be Overlooked." *Muang Boran Journal* 12, no. 1 (1986): 10–19.

Sarasin Viraphol. *Tribute and Profit: Sino-Siamese Trade, 1652–1853.* Harvard East Asian Monographs 76. Cambridge, MA: Council on East Asian Studies, Harvard University, 1977.

Sarkisyanz, Emanuel. *Buddhist Backgrounds of the Burmese Revolution.* The Hague: Nijhoff, 1965.

Sarma, P. Neelakanta. "Un album thailandais d'iconographie indienne." *Arts Asiatiques* 26 (1973): 157–189.

Sarupphon kansammana rueang traiphumphraruang: nueang nai okatchalong 700 pi laisuethai phutthasakkarat 2526. Bangkok: Phapphim, 1984.

Schober, Juliane. "In the Presence of the Buddha: Ritual Veneration of the Burmese Mahamuni Image." In *Sacred Biography in the Buddhist Traditions of South and Southeast Asia,* edited by Juliane Schober, 259–288. Honolulu: University of Hawai'i Press, 1997.

Schober, Juliane, ed. *Sacred Biography in the Buddhist Traditions of South and Southeast Asia.* Honolulu: University of Hawai'i Press, 1997.

Scott, Rosemary, and John Guy, eds. *South East Asia & China: Art, Interaction & Commerce.* Colloquies on Art & Archaeology in Asia 17. London: University of London, 1995.

Scott, Sir James George [Shway Yoe, pseud.]. *The Burman: His Life and Notions.* 1882. Reprint, New York: W. W. Norton and Co., Inc., 1963.

Shaw, Sarah. *The Jatakas: Birth Stories of the Bodhisattva.* Penguin Classics. New Delhi: Penguin Books, 2006.

Shin, Ba, Jean Boisselier, and A. B. Griswold, eds. *Essays Offered to G. H. Luce by His Colleagues and Friends in Honour of His Seventy-Fifth Birthday,* vol. 2. Ascona, Switzerland: Artibus Asiae Publishers, 1966.

Shin, Ba, K. J. Whitbread, G. H. Luce, et al. "Pagan, Wetkyi-In Kubyauk-Gyi, an Early Burmese Temple with Ink-Glosses." *Artibus Asiae* 33 (1971): 167–218.

Shorto, H. "The Stupa as Buddha Icon in South East Asia." In *Mahayanist Art after A.D. 900.* Colloquies on Art and Archaeology in Asia 2, edited by William Watson. London: Percival David Foundation of Chinese Art, 1971.

"Siam and the Siamese at the 1878 International Exhibition, Paris." *Journal of Siam Society* 95 (2007): 199–203.

Silpa Bhirasri. *Thai Lacquer Works.* Thai Culture, New Series 5. Bangkok: Fine Arts Department, 1963.

Singaravelu, S. "The Episode of Maiyarab in the Thai 'Ramakien' and Its Possible Relationship to Tamil Folklore." *Asian Folklore Studies* 44, no. 2 (1985): 269–279.

———. "The Rama Story in the Thai Cultural Tradition." *Journal of the Siam Society* 70, pts. 1–2 (January–July 1982): 50–70.

Singer, Noel. "The Artist in Burma from the Earliest Times to 1910." *Arts of Asia* 29, no. 6 (1999): 96–109.

———. *Burmah: A Photographic Journey, 1855–1925.* Gartmore, UK: P. Kiscadale, 1993.

———. *Burmese Dance and Theatre.* Kuala Lumpur: Oxford University Press, 1995.

———. *Burmese Puppets.* Singapore: Oxford University Press, 1992.

———. "Kammavaca Texts, Their Covers and Binding Ribbons." *Arts of Asia* 23, no. 3 (1993): 97–106.

———. "Myanmar Lacquer and Gold Leaf: From the Earliest Times to the 18th Century." *Arts of Asia* 32, no. 1 (2002): 122–126.

———. "The Ramayana at the Burmese Court." *Arts of Asia* 19, no. 6 (1989): 90–103.

———. "Rhino Horn and Elephant Ivory." *Arts of Asia* 21, no. 5 (1991): 98–105.

Sinlapa satthapattayakam thai nai phramerumat; nangsueprakop nithatsakan phiset nueangnai wan anurak moradok thai phutthasakkarat 2539. Bangkok: Fine Arts Department, 1996.

Sinlapakam krung rattanakosin. Sinlapa watthanatham thai, vol. 6. Bangkok: Fine Arts Department, 1982.

Sinlapakam wat ratchabophitsathitmahasimaram. Bangkok: Khana Kammakan Damoen Ngan Chalong Phrachonnamayu 90 Phansa, 1988.

Sinlapakorn University. *Sinlapa rattanakosin, ratchakan thi 9*. Bangkok: Amarin Printing and Publishing, 1997.

Sinlapawatthu krung rattanakosin. Sinlapa watthanatham thai, vol. 5. Bangkok: Fine Arts Department, 1982.

Sinphet. *Nang yai: chut phra nakhon wai (samut phap rueang nang yai rue nang thai samai kon)*. Reprint, Bangkok: Muang Boran, 1983.

Sirin Yuanyaidi and Somlak Charoenphot. *Phrabat somdet phra chunlachomklao chaoyuhua kap kanphiphitthaphan / King Chulalongkorn with His Patronage on Museum* [sic]. Bangkok: Fine Arts Department, 2004.

Siwisutthiwong. *Bot wat pho / The Ubosot of Wat Pho*. Bangkok: Amarin Printing and Publishing, 2001.

Skilling, Peter. *Buddhism and Buddhist Literature of South-East Asia: Selected Papers by Peter Skilling,* edited by Claudio Cicuzza. Materials for the Study of the Tripitaka 5. Bangkok and Lumbini: Fragile Palm Leaves Foundation and Lumbini International Research Institute, forthcoming.

———. "For Merit and Nirvana: The Production of Art in the Bangkok Period." *Arts Asiatiques* 62 (2007): 76–94.

———. "Intertextual Landscapes." *Fragile Palm Leaves* 7 (December 2002): 15–30.

———. "Jataka and Pannasa-Jataka in South-East Asia." *Journal of the Pali Text Society* 28 (2006): 113–173.

———. "King, *Sangha* and Brahmans: Ideology, Ritual and Power in Pre-Modern Siam." In *Buddhism, Power and Political Order,* edited by Ian Harris, 182–215. Routledge Critical Studies in Buddhism. London: Routledge, 2007.

———. "Pata (Phra Bot): Buddhist Cloth Painting of Thailand." In *Buddhist Legacies in Mainland Southeast Asia: Mentalities, Interpretations and Practices,* edited by François Lagirarde and Paritta Chalermpow Koanantakool, 223–275. Paris and Bangkok: École française d'Extrême-Orient and Princess Maha Chakri Sirindhorn Anthropology Centre, 2006.

———. "Worship and Devotional Life in Southeast Asia." In *Encyclopedia of Religion,* edited by Lindsay Jones, vol. 14: 9826–9834. Detroit: Macmillan Reference USA, 2005.

Skilling, Peter, ed. *Past Lives of the Buddha: Wat Si Chum—Art, Architecture and Inscriptions*. Bangkok: River Books, 2008.

Smith, Bardwell L., ed. *Religion and Legitimation of Power in Thailand, Laos, and Burma*. Chambersburg, PA: Anima Books, 1978.

Smithies, Michael, ed. *Descriptions of Old Siam*. Kuala Lumpur: Oxford University Press, 1995.

Snong Wattanavrangkul. *Outstanding Sculptures of Bhudhist* [sic] *and Hindu Gods from Private Collections in Thailand / Phraphuttharup lae thewarup chin yiam khong ekkachon nai prathet thai*. Bangkok: Rian Thong Kanphim, 1975.

Somkiat Lophetcharat. *Phraphuttharup samai rattanakosin*. Bangkok: Tawanok, 1997.

Sommerville, Maxwell. *Siam on the Meinam from the Gulf to Ayuthia; Together with Three Romances Illustrative of Siamese Life and Customs*. Philadelphia: J. B. Lippincott Co., 1897.

Somphon Yupho, comp. *Phraphuttharup pang tang-tang*. Bangkok: Fine Arts Department, 1971.

Sompong Saengaramroungroj. "*Lai Rod Nam:* Thai Gold-Leaf Lacquerware Technique." In *Lacquerware in Asia, Today and Yesterday,* edited by Monika Kopplin. Paris: UNESCO, 2002.

Sompop Piromya. *Phramerumat phramen lae men samai krung rattanakosin*. Bangkok: Amarin, 1985.

Sone Simatrang. "The Art and Industry of Lacquerware in Thailand." In *Lacquerware in Asia, Today and Yesterday*, edited by Monika Kopplin. Paris: UNESCO, 2002.

Songsri Prapatthong, ed. *Thai Minor Arts*. Bangkok: National Museum Division, Fine Arts Department, 1993.

Spiro, Melford. *Buddhism and Society: A Great Tradition and Its Burmese Vicissitudes*. New York: Harper & Row, 1970.

———. *Burmese Supernaturalism*. Englewood Cliffs, NJ: Prentice-Hall, Inc., 1967.

Stadtner, Donald. "Burma on the Eve of the Modern Era." *Orientations* 32, no. 4 (April 2001): 50–56.

———. "The Glazed Tiles at Mingun." In *Études birmanes: en hommage à Denise Bernot,* edited by Pierre Pichard and François Robinne, 113–127. Études Thématiques 9. Paris: École française d'Extrême-Orient, 1998.

Stadtner, Donald, ed. *The Art of New Burma: New Studies*. Mumbai: Marg Publications, 1999.

Stadtner, Donald, and Michael Freeman. *Ancient Pagan: Buddhist Plain of Merit.* Bangkok: River Books, 2005.

Stratton, Carol. *Buddhist Sculpture of Northern Thailand.* Chicago: Buppha Press, 2004.

Strong, John S. *The Buddha: A Short Biography.* Oxford: Oneworld, 2001.

——. *The Legend and Cult of Upagupta: Sanskrit Buddhism in North India and Southeast Asia.* Princeton, NJ: Princeton University Press, 1992.

The Suan Pakkad Palace Collection. Bangkok: Princess Chumbhot of Nagara Svarga, 1982.

Subhadradis Diskul, M.C. *Art in Thailand: A Brief History.* Bangkok: Krung Siam Press, 1970.

——. "Ramayana in Sculpture and Paintings in Thailand." In *The Ramayana Tradition in Asia,* edited by V. Raghavan, 670–680. New Delhi: Sahitya Akademi, 1980.

Subhadradis Diskul, M.C., Chusak Warapitak, et al. *The Suan Pakkad Palace Collection.* Bangkok: Chumbhot-Pantip Foundation, 1991.

Sunait Chutintaranond. "The Image of the Burmese Enemy in Thai Perceptions and Historical Writings." *Journal of the Siam Society* 80, pt. 1 (1992): 89–103.

Swearer, Donald K. *Becoming the Buddha: The Ritual of Image Consecration in Thailand.* Princeton, NJ: Princeton University Press, 2004.

——. "Bimba's Lament." In *Buddhism in Practice,* edited by Donald S. Lopez, Jr., 541–552. Princeton, NJ: Princeton University Press, 1995.

——. *The Buddhist World of Southeast Asia.* SUNY Series in Religion. Albany: State University of New York Press, 1995.

Symes, Michael. *An Account of an Embassy to the Kingdom of Ava in the Year 1795.* 1800. Reprint, New Delhi: J. Jetley for Asian Educational Services, 1995.

Tambiah, S.J. *Buddhism and the Spirit Cults in Northeast Thailand.* Cambridge Studies in Social Anthropology 2. Cambridge: Cambridge University Press, 1970.

——. *World Conqueror and World Renouncer: A Study of Buddhism and Polity in Thailand against a Historical Background.* Cambridge: Cambridge University Press, 1976.

Tamra phap thewarup lae thewada nopphakhro. Bangkok: Fine Arts Department, 1992.

Taylor, Eric. *Musical Instruments of South-East Asia.* Images of Asia. Singapore: Oxford University Press, 1989.

Taylor, Pamela York. *Beasts, Birds, and Blossoms in Thai Art.* Kuala Lumpur: Oxford University Press, 1994.

Tej Bunnag and Michael Smithies, eds. *In Memoriam Phya Anuman Rajadhon: Contributions in Memory of the Late President of the Siam Society.* Bangkok: Siam Society, 1970.

Temple, Sir Richard Carnac. *The Thirty-Seven Nats.* 1906. Reprint, London: Kiscadale Publications, 1991.

Terwiel, Barend J. *A History of Modern Thailand, 1767–1942.* The University of Queensland Press' Histories of Southeast Asia Series. St. Lucia, Australia: University of Queensland Press, 1983.

——. *Thailand's Political History: From the Fall of Ayutthaya in 1767 to Recent Times.* Bangkok: River Books, 2005.

——. *Through Travellers' Eyes: An Approach to Early Nineteenth Century Thai History.* Bangkok: Editions Duang Kamol, 1989.

Thai Minor Arts in the National Museum, Bangkok. 2nd ed. Bangkok: Office of Archaeology and National Museums, Fine Arts Department, 2001.

Thampricha [Kaeo], Phraya. *Trailokavinicchayakatha (Trailok Winichai Katha),* vol. 3. Bangkok: Fine Arts Department, 1977.

Than Htaik. "Myanmar Traditional Lacquerware Techniques." In *Lacquerware in Asia, Today and Yesterday,* edited by Monika Kopplin. Paris: UNESCO, 2002.

Than Tun, ed. *The Royal Orders of Burma, A.D. 1598–1885.* 10 vols. Kyoto: Center for Southeast Asian Studies, Kyoto University, 1983–1990.

Than Tun, U. "Lacquer Images of the Buddha." *Kagoshima Daigaku Shiroku* 13 (1980): 21–36.

Thanegi, Ma. *The Illusion of Life: Burmese Marionettes.* Bangkok: White Orchid Press, 1994.

Thant Myint-U. *The Making of Modern Burma.* New York: Cambridge University Press, 2001.

——. *The River of Lost Footsteps: Histories of Burma.* New York: Farrar, Straus and Giroux, 2006.

Thawisomphot, warokat chaloem phrachonmaphansamaharatchamongkhonsamai nai phrabat somdet phra paraminthara maha phumiphon adunyadet maharat

ratchakan thi 9 / Thongthong Chantharangsu. Bangkok: Kongthap Bok, 1990.

Thein Han, U, and U Khin Zaw. "Ramayana in Burmese Literature and Arts." *Journal of the Burma Research Society* 59 (1976): 415–420.

Thida Saraya, Sangaroon Kanokpongchai, and Prani Kalamsom. *Sombat wat pho*. Bangkok: Muang Boran, 1990.

Thiphakorawong, Chao Phraya. *The Dynastic Chronicles, Bangkok Era, the First Reign: Chaophraya Thiphakorawong Edition*. Translated and edited by Thadeus and Chadin Flood. Vol. 1, *Text*. Tokyo: Centre for East Asian Cultural Studies, 1978.

——. *The Dynastic Chronicles, Bangkok Era, the Fourth Reign: B.E. 2394–2411 (A.D. 1851–1868)*. 2 vols. Translated by Chadin [Kanjanavanit] Flood. Tokyo: Centre for East Asian Cultural Studies, 1965.

Thongchai Winichakul. *Siam Mapped: A History of the Geo-Body of a Nation*. Honolulu: University of Hawai'i Press, 1994.

Thongthong Chantharangsu. *Phrathinang wimanmek*. Bangkok: Thanakhan Thahan Thai, 1983.

Three Worlds According to King Ruang: A Thai Buddhist Cosmology. Translation with introduction and notes by Frank E. Reynolds and Mani B. Reynolds. Berkeley Buddhist Studies Series 4. Berkeley, CA: Asian Humanities Press / Motilal Banarsidass, 1982.

Tilly, Harry L. *Wood-Carving of Burma*. Rangoon: The Superintendent, Government Printing, Burma, 1903.

Tin Myaing Thein. *Old and New Tapestries of Mandalay*. New York: Oxford University Press, 2000.

Tingley, Nancy. *Doris Duke: The Southeast Asian Art Collection*. New York: Foundation for Southeast Asian Art and Culture, 2003.

Treasures from the National Museum, Bangkok: An Introduction. Bangkok: National Museum Volunteers, 1987.

U Aung Thaw. *See* Aung Thaw, U

U Than Tun. *See* Than Tun, U

Van Beek, Steve. *Bangkok Only Yesterday*. Hong Kong: Hong Kong Publishing Company, 1982.

Veidlinger, Daniel M. *Spreading the Dhamma: Writing, Orality, and Textual Transmission in Buddhist Northern Thailand*. Honolulu: University of Hawai'i Press, 2006.

Vella, Walter. *Siam Under Rama III: 1824–1851*. Locust Valley, NY: J. J. Augustin, 1957.

Vrdoljak, Ana Filipa. *International Law, Museums and the Return of Cultural Objects*. Cambridge: Cambridge University Press, 2006.

Wales, H. G. Quaritch. *Divination in Thailand: The Hopes and Fears of a Southeast Asian People*. London: Curzon Press, 1983.

——. *Siamese State Ceremonies: Their History and Function*. Richmond, UK: Curzon Press, 1992.

Walshe, Maurice. *The Long Discourses of the Buddha: A Translation of the Digha Nikaya*. The Teachings of the Buddha. Boston: Wisdom Publications, 1995.

Wannipha Na Songkhla, comp. *Chittrakam samai rattanakosin, ratchakan thi 1*. Chittrakam thai prapheni, chut thi 1, lem thi 5. Bangkok: Fai Anurak Chittrakam Faphanang lae Pratimakam Titthi, Kong Borannakhadi, Fine Arts Department, 1994.

Waranun Chutchawantipakorn, ed. *Phraphuttharup khuban khumueang / The Sacred Buddha Images of Thailand*. Bangkok: Thiphakon, 2004.

Warren, William, and Jean-Michel Beurdeley. *Jim Thompson, the House on the Klong*. Singapore: Archipelago Press, 1999.

Warren, William, and Manop Boonyavatana. *The Grand Palace*. Bangkok: Office of His Majesty's Principal Private Secretary, 1988.

Warren, William, and Luca Invernizzi Tettoni. *Arts and Crafts of Thailand*. London: Thames and Hudson, 1994.

——. *Thai Style*. New York: Rizzoli, 1989.

Wat Bangkae Yai. Mural Paintings of Thailand Series. Bangkok: Muang Boran, 1991.

Wat Bovoranives Vihara. Bangkok: Siva Phorn, 1972.

Wat Chaiyathid. Mural Paintings of Thailand Series. Bangkok: Muang Boran, 1991.

Wat Chong Nonsi. Mural Paintings of Thailand Series. Bangkok: Muang Boran, 1982.

Wat Dusidaram. Mural Paintings of Thailand Series. Bangkok: Muang Boran, 1983.

Wat Khian. Mural Paintings of Thailand Series. Bangkok: Muang Boran, 1999.

Wat Khongkharam. Mural Paintings of Thailand Series. Bangkok: Muang Boran, 1994.

Wat Khongkharam. Bangkok: Fine Arts Department, 1978.

Wat Maha Phruttharam. Mural Paintings of Thailand Series. Bangkok: Muang Boran, 1983.

Wat Mai Thepnimit. Mural Paintings of Thailand Series. Bangkok: Muang Boran, 1983.

Wat Pathumwanaram. Mural Paintings of Thailand Series. Bangkok: Muang Boran, 1996.

Wat Phrachettuphon. Mural Paintings of Thailand Series. Bangkok: Muang Boran, 1994.

Wat Ratchasittharam. Mural Paintings of Thailand Series. Bangkok: Muang Boran, 1982.

Wat Somanat Wihan. Mural Paintings of Thailand Series. Bangkok: Muang Boran, 1983.

Wat Suwannaram. Mural Paintings of Thailand Series. Bangkok: Muang Boran, 1982.

Wat Thong Thammachat. Mural Paintings of Thailand Series. Bangkok: Muang Boran, 1982.

Wat Yai Intharam. Mural Paintings of Thailand Series. Bangkok: Muang Boran, 1982.

Waterson, Roxana, ed. *The Architecture of South-East Asia through Travellers' Eyes.* Oxford in Asia Paperbacks. Kuala Lumpur: Oxford University Press, 1998.

Watt, Sir George. *Indian Art at Delhi, 1903.* Calcutta: Superintendent of Government Printing, India, 1903.

Wells, Kenneth E. *Thai Buddhism, Its Rites and Activities.* 1939. Reprint, Bangkok: Distributors, 1960.

Wenk, Klaus. *Perlmutter kunst / The Art of Mother-of-Pearl in Thailand.* Zurich: Inigo von Oppersdorff, 1980.

———. *The Restoration of Thailand Under Rama I, 1782–1809.* Translated by Greeley Stahl. Tucson: University of Arizona Press, 1968.

———. *Thailändische Miniaturmalereien nach einer Handschrift der Indischen Kunstabteilung der Staatlichen Museen Berlin.* Wiesbaden: F. Steiner, 1965.

Wilkinson, Wynyard R. T. *Indian Silver, 1858–1947: Silver from the Indian Sub-Continent and Burma Made by Local Craftsmen in Western Forms.* London: W.R.T. Wilkinson, 1999.

Wilson, Constance. "State and Society in the Reign of Mongkut, 1851–1868: Thailand on the Eve of Modernization." 2 vols. Ph.D. diss., Cornell University, 1970.

———. "Toward a Bibliography of the Life and Times of Mongkut, King of Thailand, 1851–1868." In *Southeast Asian History and Historiography,* edited by C. D. Cowan and O. W. Walters. Ithaca, NY: Cornell University Press, 1976.

Win Pe. *Shwe Dagon.* Rangoon: Printing and Publishing Corp., 1972.

Wisansinlapakam, Luang. *Tamra wicha chang pradap muk / The Art of Mother-of-Pearl Inlay.* Bangkok: Samnakngan Khana Kammakan Watthanatham Haeng Chat, 1981.

Wiyada Thongmit. *Chittrakam baep sakon sakun chang khrua in khong / Khrua in Khong's Westernized School of Thai Painting.* Thai Painting Series 1. Bangkok: Thai Cultural Data Centre, 1979.

Wong Hong Suen. "Picturing Burma: Felice Beato's Photographs of Burma, 1886–1905." *History of Photography* 32, no. 1 (Spring 2008): 1–26.

Woodward, Hiram W., Jr. *The Art and Architecture of Thailand: From Prehistoric Times Through the Thirteenth Century.* Leiden, the Netherlands: Brill, 2003.

———. "The Emerald and Sihing Buddhas: Interpretations of Their Significance." In *Living a Life in Accord with Dhamma: Papers in Honor of Professor Jean Boisselier on His Eightieth Birthday,* edited by Natasha Eilenberg et al., 502–513. Bangkok: Silpakorn University, 1997.

———. "Monastery, Palace, and City Plans: Ayutthaya and Bangkok." *Crossroads: An Interdisciplinary Journal of Southeast Asian Studies* 2, no. 2 (1985): 23–60.

———. *The Sacred Sculpture of Thailand: The Alexander B. Griswold Collection, The Walters Art Gallery.* Baltimore: Walters Art Gallery, 1997.

Wray, Elizabeth, Clare Rosenfield, Dorothy Bailey, and Joe D. Wray. *Ten Lives of the Buddha: Siamese Temple Paintings and Jataka Tales.* New York: Weatherhill, 1972.

Wright, Michael. "Towards a History of Siamese Gilt-Lacquer Painting." *Journal of the Siam Society* 67, pt. 1 (January 1979): 17–45.

Wyatt, David K. "King Chulalongkorn the Great: Founder of Modern Thailand." In *Studies in Thai History: Collected Articles,* 273–284. 1994. Reprint, Chiang Mai, Thailand: Silkworm Books, 1996.

———. "The 'Subtle Revolution' of King Rama I of Siam." In *Moral Order and the Question of Change: Essays on Southeast Asian Thought,* edited by David K.

Wyatt and Alexander Woodside. New Haven: Yale University Southeast Asia Studies, 1982.

———. *Thailand: A Short History.* New Haven: Yale University Press, 1984.

Young, Ernest. *The Kingdom of the Yellow Robe. Being Sketches of the Domestic and Religious Rites and Ceremonies of the Siamese.* Westminster: A. Constable, 1898.

Young, Patricia M. "The Lacquer Pavilion in Its First Reign Context." *Journal of the Siam Society* 92 (2004): 145–154.

Yule, Sir Henry. *A Narrative of the Mission to the Court of Ava in 1855.* 1858. Reprint, Kuala Lumpur: Oxford University Press, 1968.

Zwalf, W., ed. *Buddhism: Art and Faith.* New York: Macmillan Publishing Company, 1985.

INDEX

Page references in italics denote illustrations.

costume: Burmese, 96–97; cloth for, 208; court (cat. 23), *xi* (det.), 93, 94, *95,* 114; for images (royal attire), 121, *121,* 121nn1, 4, 134n3, 143, *143* (det.), 180; man's (cat. 25), *74* (det.), 94, *95;* royal, 106; Shan State, 114, *114;* Siamese, *37;* skirt cloth (cat. 26), 97, *97;* talismanic, 132, *132;* for theatricals, 41, 192; for the topknot-shaving ceremony, 29–30, *30;* Westernization and, 36–37, *38*

couch, Burmese (cat. 28), 12, 18, *98–99, 98* (det.), 99

Cowell, Edward B., *The Jataka* (1957), 146

Crawfurd, John, 14, 121n1, 181n1

cremation, ceremony for, 38–39, *39,* 45n27. *See also* funeral ceremony

Cremation Grounds (Sanam Luang), Bangkok, 38–39

crocodile, on flag, 179, *179*

crown: as container for relics, 121, 121n4; as royal motif, 211–212, *212,* 212n4, 213, *213*

Curzon, Lord George, Viceroy of India, 23n3

Dalang (Javanese novel), 39

Damrong, Prince (1862–1943), 25n53, 27, 45n24, 105n3, 209, 214n1

dance-drama: Burmese, 92; masked (*khon*), 42–43; Siamese, 40–42, 192; without masks (*lakhon*), 42, 43

dating: of coins, 214n4; of manuscripts, 80, 80n5, 182, 188; of objects in the collection, xiv–xv; of porcelain, 210; of statues of mythical bird-men, 196; of tablet boards, 184

Debsirindra, queen (wife of Rama IV), *20*

deity(ies): crowned (cat. 8), 83, *83;* Vedic, 66

demons, figures of, in Siam, 110, 112, *112,* 131, *131,* 182

dharma, the (Buddha's teachings), 51, 56–66

dhammayutika. See Thammayut monastic order

diadem, for Siamese classical dancer (cat. 108), 192, *192*

disciples, of the Buddha, 66–67,

68 (det.). *See also* Kashyapa; Maudgalyayana; Shariputra

divination, in Siam, 28, 29, 33, 34, 180, 190

The Division of the Holy Relics (cat. 64), 66, 138, 144, *144*

documentation, historical, as lacking, xv

donations, as merit making, 10, 28–29, 38, 80, 122, 136, 145, 149, 152, 211

Doris Duke Charitable Foundation, conservation and, xiii, 134

dowry, in Siam, 33–34

Drona (brahman), 125n4, 128, 144

durbar, Delhi (1903), 114

Dusit Maha Prasat Throne Hall, Grand Palace, Bangkok, *7,* 20, 23n6, 25n52

earth goddess, flood caused by, 128, 132, 133, *133,* 134

education, in Siam, 31, 44n11, 56–58, 67. *See also* scholarship

Edward VIII, king of Great Britain and Northern Ireland, 114

elephant: depiction of, 24n24, *26* (det.), *140,* 141; on flag, *155, 165;* given away by Prince Vessantara (cat. 72, 86), 7, 32, 60, 113, 154, *154,* 167, 168, *168;* howdah for, 114, *115;* as motif on porcelains, 211, *211, 212* (det.), 212n4; as symbol, 211; wild (engraving), *13*

Emerald Buddha, 8, *8,* 23n9, 51, 52, 54. *See also* Wat Phra Si Rattanasatsadaram

Emerald Buddha Temple, Bangkok. *See* Wat Phra Si Rattanasatsadaram

Enlightenment: according to Theravada Buddhism, 133; gesture of (touching the earth), 112, 133; seven sites associated with, 54; victory over the demon Mara as, 133

Europe, translation of Pali and Sanskrit texts in, 50

exhibitions: international, Siamese artworks displayed at, 20, 21, 22, 25n51; of teapots, 36, 45n24, 212, 212n9, 214

feet, of the Buddha, 67, 128, 130n1, 143, 187n5

Fenn, Mark, 203

Fickle, Dorothy H., *The Life of the Buddha: Murals in the Buddhaisawan Chapel…* (1972), 126

Fifth Reign (1868–1910). *See* Rama V

Fifty Jatakas (*Paññasa Jataka*), 57, 198

First Reign (1782–1809). *See* Rama I

"Five Buddhas of the Fortunate Eon" (Pali: *bhaddakappa*), 53, 136, *137* (det.)

flag: depicting crocodile, 179, *179;* depicting elephant, 155, *155,* 165, *165;* depicting millipede, 179n1

flood. *See* earth goddess

food: containers for serving, 202, *202,* 202n1, 209–210, *209, 210;* customs for serving, 209, 210n2; wedding feast, 34, 45n20

footprint, of the Buddha, 186

fortune-telling. *See* divination

foshou. See "Buddha's hand" citron

frames, for religious paintings, 125, *125*

funeral ceremony, 38–39, *39,* 45n27, 58; mural depicting, 41, 42, *42;* offering container used in, 185; royal, 19–20; statues for processions in, 196, 199, *199;* theatrical performance and, 41–42, *42*

furniture: Burmese, *98–100;* Chinese influence on, 14; Siamese, *35–37, 35, 36, 63* (det.), 122, 123, 143, *143,* 206–207. *See also* lacquerwork

Gandhara, Buddhist imagery in, as influence in Siam, 25n46

Ganesha, 19, 25n44, 66

garuda, 111, 112n2, 182, 203, *203* (det.)

Gautama (Gotama), as the Buddha of the present, *12,* 53, 136, *137* (det.)

gemstones, 204, 205

Gerini, G. E., *A Retrospective View and Account of the Origins of the Thet Maha Ch'at Ceremony…* (1982), 152

gesture, 110, 112, 121, 133, 138, 173, *173*

Ghatikara, the Great Brahma, 128

gilding, 52, 76, 104, 202

Ginsburg, Henry, 80, 92n5, 149; *Thai Manuscript Painting* (1989), 146

glass: mirrored, 12, 207, *207;* painting on, 13. *See also* inlay

gold: bowl of, 22, 203, *203;* containers of, *34,* 204, *204, 205* (top); lid of, for porcelain jar, 205, *205* (bottom); overglaze (*lai nam thong*), for porcelain, 209, *210;* in Thailand, 203

goose, mythical wild (cat. 116), 199, *199*

Gotama. *See* Gautama

Grand Palace, Bangkok, 7, *7,* 23n6, *199,* 214

"The Great Life" (Thai: *mahachat;* the story of Prince Vessantara), 59–60, 152; recitations of, 10, 24n13, 31–33, 44n12, 57, 58, 59–60, 176

guardian kings of the directions, 83

guardians, images of: (cat. 33), *107,* 108; (cat. 36), 112, *112;* (cat. 100), *64,* 112, 183, *183*

hair, the Buddha's, as relic, 112, 125, 125n4, 128, 173, 174. *See also* Chulamani Stupa

hair cutting: ceremony for infants, 29; as renunciation, 112. *See also* Buddha, the, Life of, Hair cutting; topknot, ceremony of shaving

hallmark, Chinese, on Siamese vessel, 201

hangings, Burmese: gentleman and lady in archway (cat. 24), *2* (det.), 96, *96;* scenes of the legend of Rama (cat. 19), 90–92, *90–91, 91* (det.), 94

Hanuman (monkey hero), 63; in dance-dramas, 41, 42; image of, as knife handle, 117, *117;* in manuscripts, 188, 189n7; in painting, 131, *131;* in relief, *16;* shadow puppet of (cat. 110), 40, 43, 93, 193–194, *194;* shadow puppet of (cat. 111), 40, *40,* 43, 93, 193–194, *195* (and det.)

headdress: hermit's, 181, *181;* for Rama in dance-drama (cat. 106), 192, *192,* 211; for Sita in dance-drama (cat. 107), 40, 192, *192. See also* diadem

Heaven of Indra (Heaven of the Thirty-three Gods), 24n35, 58, 111, 112, 112n1, 125, 142, *142,* 148, *148, 153,* 173

hell: depiction of Buddhist, *176,* 177, *177;* depiction of Buddhist (cat. 62), 66, 142, *142*

Herbert, Patricia, *Life of the Buddha* (1993), 126

hermit, 159, *159;* celestial (Sanskrit: *vidyadhara;* Thai: *wittayathon*), depictions of, 124, *124;* depictions of *rishi,* and medical diagnostics, 15, *16,* 181n1; head of a (cat. 98), 15, *16,* 181, *181*

Himavanta Forest, 196

Hinduism: and Buddhism, 15, 19, 28, 29, 63–66, 180, *180;* mythology of, 9; ritual in, and Siamese auspicious ceremonies, 27–34, 44n1

Holbrow, Katherine, 203

Hooper, Willoughby Wallace, *Front of King Theebaw's Palace* (photograph, 1885), *5*

housing, in Siam, 34–37, *35,* 45nn21, 22

howdah, northern Thailand (cat. 41), *102* (det.), 114, *115*

Hsinbyushin, king of Burma (r. 1763–1776), 6

"Image of the Birman Gaudma in a Temple at Ummerapoora" (Symes, *Account of an Embassy . . . 1795*), engraving, *12*

imagery, architectural, and Western influence, *7,* 159, *159,* 160, *160,* 165, *165,* 190

Inao (Javanese novel), 40

India: cloth made in, for Thai market, 37, *37,* 149, 196, *198,* 208, *208* (det.); influence of, 25n46; script used for religious texts, 50. *See also* durbar

Indra, king of the gods, 79, 125n4, 128, 144; crowned (cat. 8), 83, *83;* crowned (cat. 10), 84, *84;* depicted in painting, *65* (det.), 126, *127,* 128, *140,* 141, 142, *142, 146,* 147, 151, *151,* 153, *153,* 162, *162,* 166, *166,* 167, *167,* 179; depicted on chest, 111, *111;* and the image of the Buddha, 51; role of, in Buddhist narrative, 63, *65* (det.); and the story of Phra Malai, 173; and the story of Prince Vessantara, 152, 153, *153,* 162, *162. See also* Heaven of Indra

Indrajita (son of Ravana), 188; in combat with Lakshmana (cat. 104), *ii* (det.), *189* (det.)

inlay: in Burma, 12; mirrored-glass, 7, 184, *184,* 186, *186;* mother-of-pearl, 185, *185,* 186, 200, *200,* 215, *215*

Inle Lake, Burma, 105, 105n1

inscription, xiii, 125; on Buddhist tablet boards, 184, 184n3; on chest, 112; date as, 121; on image of Maitreya, 125n3; on manuscript, 182; on miniature temple, 107; on painting, *32,* 131, 132, 134, 138, 139, 144, 151, 152, 169, 173; on seated Buddha, 106

insignia. *See* regalia, royal

instrument, musical: stringed (*so sam sai*) (cat. 140), 40, 200, 215, *215;* two-stringed (*so u*) (cat. 141), 40, *41,* 200, 215, *215*

international expositions, 21. *See also* exhibitions, international

iron, sculpture of (cat. 11), *viii* (det.), 18, 86, *86*

Ishvara (Sanskrit). *See* Shiva

Isuan (Thai). *See* Shiva

ivory: carved, 116, *116–117,* 117, *117;* inlay, 114

Jacq-Hergoulac'h, Michel, *Une vie du Buddha . . .* (1984), 126

Jambupati, king, 53, 106, 125n1

Japan, translation of Pali and Sanskrit texts in, 50

jar: with gold lid (cat. 126), 205, *205* (bottom); lidded, with decor of mythical creatures (cat. 132, 133), 14, 205, 209–210, *209* (and det.), *210;* with tiered lid (cat. 134), 205, 209, 210, *210*

Jataka(s) (stories of the previous lives of the Buddha), 57–58, 146, 151, *151,* 198; in Burma, 60, 71; recitation of, as festival, 31–33, 44n12, 57, 58, 59–60, 176

Java, literature from, translated into Thai, 39–40

Jayawickrama, N. A., *The Story of Gotama Buddha* (2000), 126

jewelry, as wedding gift, 34

Jingdezhen, China, porcelain from, for the Thai market, 209–210, 214

Jujaka (brahman) and the story of

marionettes, in Burma, 93, *93*. See *also* puppet(s)

Marks, Rev. John Ebenezer, 23n3

marriage, in Siam: customs surrounding, 33–35; legal age of, 30

mask, theatrical (cat. 20), 92, *92*

Maudgalyayana (Mogallana; chief disciple of the Buddha), 77; image of, painted, 66, 120, *120*, 124, 131, *131*

McGill, Forrest, "Painting the 'Great Life,'" in Juliane Schober, ed., *Sacred Biography in the Buddhist Traditions*... (1997), 152

Men, Prince, temple restored by, 49

merit, acquisition of, 28–29, 30, 32, 38, 48–49, 60, 62, 110, 173, 175, *175*, 176, 184, 201

"Method of Catching Wild Elephants" (Symes, *Account of an Embassy*... *1795*), engraving, *13*, 24n24

millipede, on flag, 179n1

Mindon, king of Burma (r. 1853–1878), 4, 6, 18–19, 25n49, 70

Mingun Pagoda, Burma, 10, *11*, 24n17

mirror on stand (cat. 129), 35, *35*, 207, *207*

Mogallana. *See* Maudgalyayana

Mon: chronicle of kings of, in Thai translation, 40; language, 50, 182

monastery: Burmese, 71, *71*; Cambodian, 211–212, 212n7; Thai, 67, 140–141, *140–141*, 211, 212n6

monasticism, 49, 67, 70–71, 87

Mongkut. *See* Rama IV

monogram, Rama V's, 213–214, *213*, *214*

mother-of-pearl. *See* inlay

mother of the Buddha, 58, 111, 142, *142*

motif: crown, 211–212, 212n4; elephant, 211, *211*, *212* (det.), 212n4; "trellis and rice ball," 212

Mouhot, Henri, *Travels in Siam, Cambodia and Laos, 1858–1860*, engravings from, *38*, 48, *50*

Mount Kailasha, 44n9, 196

Mount Meru, 24n35, 38–39, 105n3, 111, *153*, 187

Munlaphlam, 189n7

mural(s): depicting elephants,

24n24; depicting funeral ceremonies of Ravana, the demon king, 41–42, *42*; depicting the life of the Buddha, 10, 24n13, 53, 54, 133, 146; depicting the story of King Jambupati, 53; Vedic deities in Buddhist, 66

music. *See* instrument, musical

Myatheindan (Hsinbyume) (temple), Burma, 24n35

naga (mythical serpents), 82, 111, 128, 133, 135, *135*, 182, 184, *184* (and det.). See *also* serpent king

Nagari script, 50

names of the Buddha, 51, 59, 136, 136n1

naming, ceremony of, 28

Nan, northern Thailand, 112, 113n1

Nandi (the bull; Shiva's vehicle), 180, *180*

Nandopananda (a serpent), 111–112

Narada (the Buddha in a previous life), image of, *147*, *149* (dets.), *150* (det.)

Naris, Prince, 20

National Museum, Bangkok, *35*, 121, 180n3, 188, 196, 206

National Theater, Bangkok, 192

nats (Burmese spirits), 84

"The new palace of the King of Siam, Bangkok" (Mouhot, *Travels*, 1864), engraving, *50*

Nga Phe Kyaung, Inle Lake, Burma, 105n1

Nidanakatha, the (fifth-century text on the life of the Buddha), 121n1, 126

niello, 202, *202*, 204, *205* (top)

Nimi (king; the Buddha in a previous life), *149* (dets.); carried through the heavens (cat. 70), 7, 113, 151, *151*

Nimi Jataka, scene from, 151, *151*

Nonthaburi, Siam, Buddha images in, 52–53

numbers, icons associated with, 190

O'Connor, V. C. Scott, 3–4

offering container: double-tiered (cat. 103), 186–187, *186*, *187* (dets.), 211; with inlay (cat. 17), 89, *89*, 187; with inlay (cat. 18), 90, *90*, 187; lidded (cat. 102), 185, *185*

offering stand (cat. 14), 88, *88*, 187

offerings, temple, *89*, 184, 200; flowers as, 122; of new robes, to monks, 28, 33, 179, 186; vessels for, 87–90, 203, *203*

ordination: as ceremony, 27–28, 30, *30*, 44n1, 186, *186*, *187* (dets.); texts for Buddhist, 78, 79

Pagan, king of Burma (r. 1846–1853), 6

painting style, Thai: anomalous, 149; traditional, xv, 13–14, 153, 154, 166, 167, 172, 175, 184n5; Western influence on. *See* Western culture as influence

paintings: on cloth, 90–92, 120, *120*, 126–132, *127*, *129–132*, 138–139, *138*, *139*, 142, *142*, 146–151, *146–151*, 148–149, *148*, *149*, 152–173, *152–173*; on furniture, *63* (det.), 122, 122–123, *122–123*; on glass, 13; on wood panel, *26* (det.), *67* (det.), 124, *124*, 125, *125*, 133–134, *133*, *134* (det.), 140–141, *140–141*, 146

Pali: language, 28, 32, 49, 50, 54, 111, 182; ritual chants in, 51, 54, 60, 66; scholarship and, 56–58

Pali canon (Tripitaka), 57, 62, 70, 71

palm-leaf, for manuscripts, 78

pancharanga. See *bencharong*

panel, with forty Buddhas, northern Thailand (cat. 35), 110, *110*

Paññasa Jataka. See *Fifty Jatakas*

panung. *See* skirt

Paramanuchit Chinnorot, Prince-Abbot (1790–1853), 188

parasol, honorific, 121, 121n5

Paris, Siamese art exhibited in (1867; 1889), 20, 21, 22

Pasuk Phongpaichit, 32

Pathamasambodhi. See *Pathomsomphot*

Pathomsomphot (Pali: *Pathamasambodhi*), the (a life of the Buddha), 58, 126, 126n1, 130, 133

patronage, xiii, xv, 4, 8, 18, 60–62, 70. *See also* Rama I *through* Rama V

pattern book, illustrated manuscript as, 188

Peleggi, Maurizio, *Lords of Things*, 25nn52, 54, 56

Phibunsongkhram, Luang (Field Marshal), 44, 45nn19, 33, 205n2

Phra Bang (Buddha image from Laos), 52

Emerald Cities
Arts of Siam and Burma, 1775–1950
was produced under the auspices of the
Asian Art Museum–Chong-Moon Lee Center
for Asian Art and Culture

PROJECT DIRECTOR Thomas Christensen
PHOTOGRAPHY Kazuhiro Tsuruta

Produced by Wilsted & Taylor Publishing Services
 PROJECT MANAGER Christine Taylor
 PRODUCTION ASSISTANT Andrew Patty
 COPY EDITOR Melody Lacina
 DESIGNER AND COMPOSITOR Tag Savage
 PROOFREADER Nancy Evans
 INDEXER Frances Bowles
 COLOR SUPERVISOR Susan Schaefer
 PRINTER'S DEVIL Lillian Marie Wilsted

Typeset in Perpetua and Storm Baskerville.
Printed and bound on 157 gsm matte art paper
by Regal Printing Ltd., Hong Kong,
through Michael Quinn of QuinnEssentials
Books and Printing, Inc.